MW01070076

Lake Ladoga

Gulf of Finland

● St. Petersburg

SEA

● Psksov

Riga ●

LATVIA

◇ Kelm

Dvina

◇ Moscow

Volga

LITHUANIA

● Vitebsk

RUSSIA

Kovno ◇

◇ Vilna

● Minsk

● Mogilev-on-the-Dnieper

◇ Kalvaria

Niemen

◇ Kapulie

NIA

◇ Bialystok

WHITE
RUSSIA

Ostrów ◇
Mazowieczka

◇ Zabludow

◇ Antopol

Dnieper

POLAND

◇ Bielsk

● Pinsk

Pripyat

◇ Warsaw

◇ Kock

VOLHYNIA

Pripyat marshes

◇ Przytyk

◇ Ostrów
Lubelski

LITTLE
POLAND

◇ Lublin
◇ Tomaszow
Lubelski

● Rovno

◇ Verba

◇ Sudliki

◇ Kiev

Dnieper

◇ Zawichost

Tistula

◇ Jaroslavl

◇ Zolkiew

● Jitomir

Don

Cracow ◇
◇ Wieliczka

◇ Jaworow

◇ Medzibozh

◇ Berdichev

UKRAINE

Preszymysl ◇
Rymanow ◇

Lvov ◇

◇ Mikhalpol

◇ Iatin

◇ Osick

◇ Dukla

◇ Baligrod
◇ Bardajev

◇ Drohobycz

PODOLIA

Bug

OVAKIA

◇ Prešov

BUKOVINA

Dniester

BESSARABIA

SEA
OF
AZOV

CASPIAN
SEA

◇ Khust

◇ Czernowitz

● Odessa

Kuban

TRANSYLVANIA

MOLDAVIA

◇ Iasi

HUNGARY

Mures

Prut

Tisza

RUMANIA

WALLACHIA

Siret

● Bucharest

BLACK SEA

● Belgrade

Danube

Istanbul ◇

Tigris

TURKEY

MESOPOTAMIA

Izmir ◇

Euphrates

◇ Aleppo

◇ Baghdad

Athens ●

SYRIA

SEA

● Damascus

PALESTINE

◇ Safed
◇ Jerusalem

R. C. Forget

Volga

Ural

TRADITIONAL JEWISH PAPERCUTS

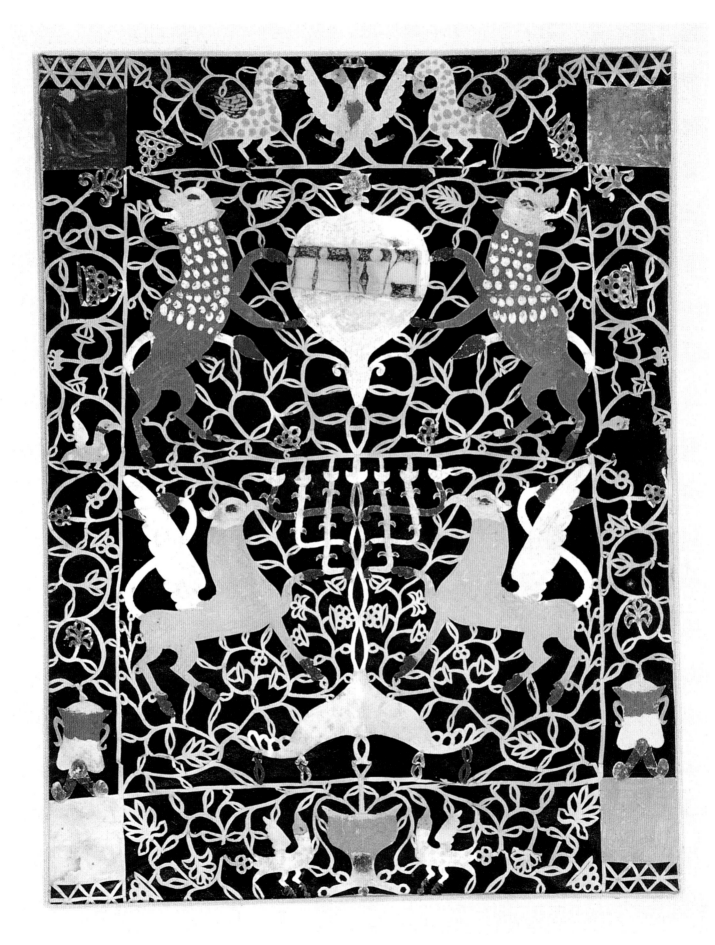

TRADITIONAL JEWISH PAPERCUTS

AN INNER WORLD OF ART AND SYMBOL

JOSEPH AND YEHUDIT SHADUR

UNIVERSITY PRESS OF NEW ENGLAND HANOVER & LONDON

University Press of New England

Hanover, NH 03755

Printed in China

5 4 3 2 1

Library of Congress Cataloging-in-Publication Data

Shadur, Joseph.
 Traditional Jewish papercuts : an inner world of art and symbol / by
Joseph and Yehudit Shadur.
 p. cm.
 ISBN 1–58465–165–2
 1. Paper work—Europe. 2. Folk art, Jewish. I. Shadur, Yehudit.
II. Title.
 NK8553.2.E85 S525 2001
 736'.98'089924—dc21 2001004318

Frontispiece: Mizrah. Naiveté of forms and sophistication of conception characterize many traditional Jewish papercuts. This delightful little work of unknown provenance and date (Galicia, second half of the nineteenth century?), shown here in its actual size, epitomizes the genre. The small, damaged, square corner panels most probably contained a Hebrew inscription. 24.1 × 19 cm. (9½" × 7½"). Yeshiva University Museum, Raphael Patai Collection, New York.

FOR TAMAR AND ADIN

CONTENTS

FOREWORD

There are certain types of artistic creations that do not have a long life. They are of a popular nature, usually made of cheap materials, often by nonprofessionals. In many cases, they are not intended to be of permanent value but serve only for a specific occasion. Nevertheless, despite their transient nature and their popular characteristics, those who create such works lavish on them great love and a rich treasury of associative motifs culled from the artists' traditional heritage.

Frequently, the nature of the medium restricts the expression of complex iconography — such as in the special bread loaves and cakes for Shavuoth baked in the form of a ladder, a ḥamsa, a dove, scissors, the two tablets of the Law, cloves inserted in complex patterns into an ethrog for *besamim* (spice, incense), and so on.[1] In other instances, the medium admits of a vast range of symbolic expression at multiple levels, incorporating numerous interwoven motifs thematically related in intricate and diverse bisecting patterns.

That is true also regarding Jewish papercuts. These works were made for special occasions — a house-*mizraḥ*, as a protective measure at the birth of a child, for decorating the *sukkah* (where the rain would very likely spoil them in the Eastern European autumn), a reminder of a *yortzait* (anniversary of death), and the like. They were made from readily available materials — cheap (not acid-free!) paper, home-made flour paste, colors that would soon fade in strong light, and were backed by cardboard liable to warp and unstick the pasted-on parts in the heat and damp. Their life span was known in advance to be short; their value was for the brief artistic impact rather than for permanence. They endured longer than a musical performance, but more briefly than a Greek temple.

Yet, although those who made them were aware of their impermanent nature, no efforts were spared in creating works of sometimes wondrous complexity, esthetically delighting the eye, and weaving a rich tapestry of themes gleaned from the worlds of the Talmud, the Midrash, and kabbalistic literature. No doubt, they were influenced by local style, but even when local motifs were incorporated, these were invested with a new and authentically Jewish meaning deriving from a treasury of authentic tradition. For example, a common motif in East-European art, the backward-turning deer (or gazelle), has its roots in antiquity. In Jewish contexts, this may have had a special meaning based on a number of passages in the Zohar (2,14a,138b; 3,155a) that describe how the Shekhinah (the Divine Presence) likened unto a gazelle, when distancing itself from sinful Jewry, always looks back, never losing "eye-contact," hoping for repentance.[2]

1. See Daniel Sperber, *Minhagei Yisrael* (Customs of Israel), vol. 3 (Jerusalem: Rav Kook Inst., 1994), pp.138–39. (Hebrew).

2. See T. C. Hubka, "*Beit ha-Knesset be-Gwoździec — Shaar ha-Shamayim: Hashpaat Sefer ha-Zohar al ha-Omanut ve-ha-Adrichalut*" (The Gwozdziec Synagogue — Gate of Heaven: The Influence of the Zohar on Art and Architecture), *Eshel Beer-Sheva* 4 (1996): 312–13. (Hebrew).

Similarly, the motif of storks biting serpents, discussed in this volume and explained in terms of Jewish meaning, has its roots in ancient art and continued to survive throughout the Medieval and Renaissance periods with a variety of symbolic interpretations.[3] Or again, the Tree of Life motif, which is already found in fourth-millennium B.C.E. Mesopotamian art, thus having an iconographic life span of over five thousand years.[4]

The many layers, or levels, of symbolic meaning in a single motif may be demonstrated by reference to the *Keter Torah* (Crown of the Torah). This motif, which is discussed in these pages as referring to the passage in Pirqei Avot where the Crown of Torah is mentioned as one of the Three Crowns, is clearly related to the crown (usually of silver) that was placed on the Torah scrolls, primarily in Ashkenazi ritual practice. The authors correctly point out that "*Keter* (Crown) is also one of the leading kabbalistic concepts." However, there is an additional element to this motif, for the Torah, according to Rabbinic tradition, contains 613 commandments for the Jewish people, and an additional seven commandments for gentiles (*sheva' mitzvot benei no'ah*) which together make 620. The letters (*kaf, tav, resh*) — *keter* add up to the numerical value of 620. Hence, *Keter Torah* expresses the full number of commandments that the Torah imposes upon all humanity. And indeed, Rabbi David Vital published a volume in Istanbul in 1536, entitled *Keter Torah*, which enumerates these commandments.[5] Or also, the *ḥamsa* (five), the open palm of the hand warding off the evil eye, derives from the Muslim "Hand of Fatima." But it is often placed within the Hebrew letter *heh* (five) which is an abbreviated form of the name of God, so that it is God, not Fatima, who protects us.[6]

It is clear, therefore, that a real understanding of Jewish art in general, and of Jewish papercuts in particular, requires a deep knowledge of the manifold aspects of Jewish law and lore. *Halakha* (law), *minhag* (custom), and folkways are here all intertwined. Dangerous spirits inhabited the world of both eastern and western Jewish (and indeed, non-Jewish) communities, and means of protection, kabbalistic in form and content, were most commonly used. The *ushpizin* (the Seven Guests) would really come and visit the sukkah, even if one never actually saw them, just as Elijah the prophet came to every *b'rith milah* (ritual circumcision), and drank from his special wine-cup on the Seder night — the first night of Passover, and would partake of the festivities at the Sabbath night meal (*melaveh malkah*). In the Oriental Jewish communities, people would regularly read passages of the Zohar (*idrot*), and even if they did not understand all the difficult Aramaic, they imbibed and absorbed kabbalistic notions, particularly as many of these concepts were included in introductory passages in their *siddurim* and *maḥzorim* (prayer books).

3. See E. R. Goodenough, *Jewish Symbols in Greco-Roman Art*, vol. 2 (New York: Pantheon, 1953), p. 228; and vol. 3 (New York: Pantheon, 1953), p. 1038; R. Wittkower, *Allegory and Migration of Symbols* (London: Thames & Hudson, 1977), pp. 15–44, especially pp. 20, 27, 191 note 135 (first published in the *Journal of the Warburg and Courtauld Institutes* 2 (1939): 293ff; C. Bonner, *Studies in Magical Amulets, Chiefly Graeco-Egyptian* (Ann Arbor & London: University of Michigan Press, 1950), pp. 212ff, 304–308, etc.

4. For example, Simo Porpola, "The Assyrian Tree of Life: Tracing the Origins of Jewish Monotheism and Greek Philosophy," *Journal of Near Eastern Studies* 52/3 (1993): 161–208.

5. See Daniel Sperber, *Minhagei Yisrael* (Customs of Israel), vol. 2 (Jerusalem: Rav Kook Inst., 1991), pp. 112–13.

6. See ibid., p. 288, where this is also related to the five *sela'im* (pieces of coinage) for the redemption of the first-born son (*pidyon ha-ben*); and see ibid., vol. 6 (Jerusalem: Rav Kook Inst., 1998), pp. 255–56.

Thus we find an enormously rich association of kabbalistic motifs in the architectonic design, and perhaps decoration, of East-European synagogues.[7]

Joseph and Yehudit Shadur have, together, delved deep into the inner world of this rather ephemeral area of Jewish creativity — Jewish papercuts. They have preserved for us a rapidly disappearing folk art form; they have traced its historic evolution and its geographic spread, meticulously catalogued surviving examples and classified them thematically, described techniques of making these works, and explained in great detail and with true understanding their inmost meanings. In a sense this volume is a "museum exhibition" in that it preserves, presents, and explains this very special art form. This book is the product of half a lifetime of study, search in many countries, and research in many libraries and museums. It is a labor of love, which reflects the vision and comprehension of the artist and researcher. We are deeply indebted to the authors for their great investment that has borne such valuable fruits, which we have the privilege of enjoying.

Jerusalem Daniel Sperber

7. See T. C. Hubka, *Beit ha-Knesset be-Gwoździec*, pp. 263–316; T. C. Hubka, "Jewish Art and Architecture in the East-European Context: The Gwoździec-Chodorów Group of Wooden Synagogues," *POLIN* 10 (1997): 141–82.

As a collector of Judaica, all Jewish objects appeal to my sense of Jewish culture and history. The artifacts of Jewish life span a large variety of uses, purposes, designs, and materials. From the elegance of fine handwrought silver Torah finials to the simple, stamped-brass mezuzah for the doorframe, diversity of subject and shape are almost endless. But it is the Jewish papercut, made of the plainest and cheapest of materials, that holds a special place in my heart.

To look at Jewish papercuts is to enter a singular fantasy world. Each papercut evokes memories and images of the places in which these creations were crafted and of the individuals who made them. They come from Italy, Central Europe, Turkey, North Africa, and most especially from the many shtetls and towns of Eastern Europe — Galicia, the Ukraine, Lithuania, Poland.

The fragility and ephemeral nature of papercuts is perhaps symbolic of the fate of the lifestyle that produced them. These delicate creations, so full of charm and beauty, hung on the walls of synagogues and homes. In many ways the papercut served more diverse purposes and folk customs than any other single Jewish object. It could indicate the direction of prayer on the eastern wall of a dwelling or place of worship. As an amulet, it served to protect the birthing mother and her child, or more generally, as a talisman to secure the home and its occupants against fire, illness, and all manner of bad luck and evil spirits. Papercuts were made as calendars for the counting of the Omer, for commemorating the *yortzait* dates of deceased parents. The Shavuot festival was the occasion for decorating window panes with innumerable small papercuts made by students in the many yeshivas of Eastern Europe.

Papercuts are a special category of the folk traditions within the general framework of Jewish Art. People commonly made these papercuts for their own use, although there are indeed some spectacular examples of high professional quality.

The delicate tracery of the foliage, vines, and flowers often defies the imagination for only thin tendrils hold the composition together. Within this virtual garden there sometimes plays an incredible bestiary, a heavenly zoo that includes the full range of animals, both real and imaginary — from eagles to elephants, from bears to unicorns, from lions to griffins. Many of these creatures have near-human faces, an intriguing aspect of the Jewish depiction of these beasts. Such animal forms are sometimes decorative only, but more often are imbued with symbolic meaning, conveying messianic yearnings. As in so much of Jewish art, the devout folk artists have co-opted decorative devices from their surroundings and infused them with a Jewish meaning.

And there are repeating, geometrical decorative patterns such as guilloches or endless knots, as well as abstract forms born in the imagination of the artist. Purely Jewish symbols abound. Moses and Aaron are there, as are the tablets with the Ten Commandments. Most particularly, the Temple menorah appears in a surprising diversity of shapes and forms.

But for me, the primary distinguishing feature of these papercuts is their immediacy, the

almost instant dialogue that they create, directly from the imagination of the maker to the heart of the viewer. They project a warm intimacy, quite different from the elegant but rather more formal appearance of most silver ritual objects. Such intimacy promotes communication between the observer and the papercut.

This book illuminates that connection. Through the words and illustrations, the reader will enter the revealing and enchanted world of Jewish papercuts.

Ramat Aviv William L. Gross

AUTHORS' NOTE

What is "Jewish" art? In our obsessive quest for roots, identity, and self-determination as a people, "Jewish art" has been ranged alongside the esthetic expressions of other ethnic, religious, cultural, and national groupings — Byzantine art, Islamic art, Scandinavian art, African art, Polynesian art, Chinese art, and what not. But among the annals of peoples, the history of the Jews is unique. The Diaspora reinforced separatism, adaptation to more-or-less hostile or tolerant gentile environments, and escape into introverted mysticism. Jewish religious identity is of many varied forms. Zionism and the State of Israel have again attempted to merge territory, nation, religion, and peoplehood. Is "Jewish art" religious? National? Is it enough for someone to be identified as a Jew to mark his or her artistic creation as "Jewish?" Is art made by gentiles for Jews and their religious or cultural purposes "Jewish art?" After many decades of scholarly and popular deliberation, these are still relevant, never really resolved questions.

Nevertheless, a profusion of academic bodies, learned societies, specialized museums, private collectors, and interested amateurs — many of them driven by sentimental associations — are today all concerned with "Jewish art." Books and periodicals on the totality, and on particular and ancillary aspects of Jewish art are legion. "Judaica" has become big business: Lively buying and selling by more-or-less scrupulous dealers and collectors, and widely publicized and attended auctions, have resulted in constantly mounting prices — and in an abundance of fraudulent items. Even the considerable Jewish popular and tourist trade has engendered a whole mass-appeal industry producing Judaica in a wide range of media — never mind the quality.

Out of fascination with "Jewish art" — however defined — since the days of our youth, we happened to stumble upon Jewish papercuts about thirty-five years ago. At the time, we lived with our children at the Sdeh Boqer College of the Negev, where we occupied administrative and teaching positions. One of our first responsibilities there centered on David Ben Gurion's eightieth birthday celebration in October 1966, during the Sukkoth festival. The former first prime minister of Israel was to receive his many guests in a large *sukkah* built for the purpose. As the art instructor at the college, I (Yehudit) took charge of the decorations. The combined efforts of my students and myself resulted in a splendid *sukkah* hung with colored lanterns, clusters of fruit, and traditional wall decorations. At Joe's suggestion, I made a large papercut *mizrah* for the center of the wall facing Jerusalem. The idea was inspired by pictures we had seen in books on Jewish folk art and by memories of my neighborhood *shul* in Milwaukee.

Ben Gurion and the older guests who also stemmed from Poland and Russia, among them the Nobel Prize laureate S. Y. Agnon and the then-president of Israel, Zalman Shazar, were visibly affected by the papercut *mizrah*. They exclaimed in wonder and looked at it a long while. It obviously called forth wisps of recognition and long-forgotten associations, and the atmosphere of their childhood homes in Plonsk, Buczacz, and other *shtetlakh*. We understood then that

although collections of Jewish ceremonial art usually include a papercut or two, here it appeared in its natural setting, serving its original purpose, and so struck a warm chord of memories.

Clearly, this particular Jewish folk art form had strong emotional implications. We resolved to learn what we could about Jewish papercuts, of which we had been only dimly aware until then. And I wanted to make some myself. What unfolded from that moment's decision was the discovery of an unsuspected inner world of quaint beauty, intriguing symbols, and hidden meanings that has captivated both of us ever since. Within the amorphous mass of Jewish art, here was a manifestation that could be nothing *but* Jewish. The traditional Jewish papercut was the unaffected, sincere creation of thousands of ordinary Jews working at home with the simplest of materials and tools. It came *from* the Jewish heart and mind, and spoke *to* the Jewish heart and mind. It was wonderful: We had unwittingly hit upon the quintessence of all Jewish art!

We became curious about the papercuts of other cultures, in the Orient, Central Asia, the Middle East, Western, Central, and Eastern Europe, North Africa, the United States, and Mexico. We found many books and articles about papercuts, but were amazed to discover that the long, very special, rich tradition of Jewish papercutting was barely known outside a few narrow Jewish circles. Until the mid-1970s, very little about Jewish papercuts had appeared in print — mainly brief, repetitive, descriptive articles in half a dozen languages, and almost all hard to come by. Fortunately, Dr. Giza Frankel, who pioneered ethnographic research in this field in the 1920s in Poland, lived long enough to see the publication of her Hebrew album-book on Jewish papercuts shortly before her death in 1984. Now that we had a solid basis to build on, we felt that such a venerable, vital, and beautiful tradition deserved to be made known to the English-reading public.

Our book, *Jewish Papercuts: A History and Guide*, published in 1994 by the Judah L. Magnes Museum (Berkeley) and Gefen Publishers (Jerusalem), aimed at filling the void, both in the context of the current interest in Jewish folk art, and in the general literature on papercuts. Soon after its appearance, and after winning the (American) Jewish Book Council's National Jewish Book Award for that year's best book in the visual arts, we began to receive letters with comments, queries, and corrections of a few minor errors that had slipped through the repeated proofreadings of the text and captions. But more importantly, some of the writers provided information and photographs of unknown old Jewish papercuts that had been preserved in their families, or that they knew about. In the meantime, collections of Judaica in Eastern Europe were opened to the West, among them a number of old Jewish papercuts that had remained hidden from sight for a long time. Most of this "new" old material is incorporated in the present book. It broadens the statistical data for stylistic, typological, and geographic generalizations, and so enhances the basis of our understanding and conclusions. But don't look for the usual catalog information in our sometimes lengthy captions to the pictures: Since the various symbols and inscriptions recur time and again in many of these works, we do not necessarily repeat our explanations for each papercut. For a fuller understanding, the captions should be read sequentially, with constant reference to the illustrations, as integral parts of the text.

In arranging the vast pictorial matter, we had to consider factors such as chronology, geographic distribution and cultural influences, themes and symbols, technique and style, and the like. Rather than focus on any of these criteria, we have done a little of each. And while we have

spared no effort to obtain the very best possible photographic material, we beg indulgence for the quality of some of the photographs — mostly of rare, old items that had been lost and that we deemed important to record despite their poor condition.

Although, for the benefit of those new to the subject, *Traditional Jewish Papercuts* includes relevant material from our earlier work, in total it differs and complements it. Besides rewriting and expanding much of our previous presentation, we have added chapters and sections giving rather detailed insights into our continued investigations and studies. We reproduce many previously unpublished old Jewish papercuts and some that appeared in relatively little-known publications, and add extensive new analyses and discussions. We have almost entirely left out contemporary Jewish "revival" papercuts of the last three decades: Our focus is on what we call "classic" traditional works dating into the 1950s. And we devote a special chapter to the increasingly widespread phenomenon of spurious "old" works created in recent years to cash in on the lucrative Judaica collectors' market.

The dynamic Judaica collectors' world being what it is, some items credited in our first book on the subject to certain persons or institutions may have changed hands and owners in the meantime. Unless new information has been forthcoming, we were not able to trace such changes and have left accreditations as given in *Jewish Papercuts. A History and Guide*. We trust that the present owners — whoever they are — are as open as were their predecessors to sharing their papercuts with the interested public for a better understanding of this still too little-known Jewish folk art form. In the very few cases where our requests for permission to reproduce items of uncertain ownership met with no response, we follow accepted practice in assuming liberty to do so.

Identifying some of the geographic place names where Jewish papercuts were made — to the extent that these are indicated on the papercuts — presents perplexing difficulties. This is mainly so for the Central and East-European regions of mixed populations that changed governments, regimes, and official languages during the last two or three centuries: eastern Germany, Poland, Galicia, Austria-Hungary, Rumania, Russia, and the more recent divisions after World Wars I and II. Baffling variants in languages and orthographies are exacerbated by many of these names appearing on the papercuts in local dialects of Yiddish in cursive or partly illegible Hebrew script. Or, perhaps, some of the places are too small to be found on a map, or ceased to exist at some point. Where we had doubts, we did the best we could.

A word about the Hebrew, Yiddish, and the few Arabic terms in this book: While the English transliterations of Hebrew and Arabic words are fairly standard, this is not the case with the Yiddish words. Yiddish, with its wealth of regional dialects and semi-phonetic orthography, peculiar diminutives, and corruptions of Hebrew and other languages, defies straitlaced English renderings. We have tried hard to do justice to the spirit of such words, but inevitably there are inconsistencies. As you will see, the works we describe are also somewhat erratic.

Translations from Hebrew, Yiddish, and other languages are by Joseph Shadur. In the translations and transliterations from Hebrew, ח *ḥet* = ḥ; כ *khaf* = kh; כ *kaf* = k; ק *qof* = q; א *aleph* = ', and ע *'ayin* is indicated by ' where necessary. For the English renderings of biblical texts we have preferred the Jewish Publication Society's edition of *The Holy Scriptures according to the Masoretic Text: A New Translation* (Philadelphia, 1956), over the current version. Unless the Jerusalem Talmud is

specified, all the Talmudic tractates mentioned are from the Babylonian Talmud. English renderings of Talmudic passages draw on either the Soncino, Schottenstein, or Steinsaltz editions.

Throughout the text, we have purposely adopted a first-person plural (and occasionally, singular) style: All our searches and studies have become a personal quest for discovery and understanding, and the gratification of fitting in yet another piece in the puzzle of this intriguing inner world. We must, however, qualify our enthusiasm: Our fascination with this marvelous folk art of our people does not mean that we identify with all the esoteric folk beliefs and superstitions reflected in the papercuts, nor are we imbued with a sense of nostalgia or idealizing sentimentality for the life and culture of the shtetl. By all accounts, it was a problematic social and physical environment with much crushing poverty and its attendant evils. It is the greater wonder that beautiful artistic folk creations germinated and flourished in such soil.

Our research was assisted by grants from the Memorial Fund for Jewish Art in the Diaspora (Geneva), and from Hilda Clayman (Youngstown, Ohio). The publication of *Traditional Jewish Papercuts* was supported by The Gottesman Fund (Washington, D.C.); The Eugene and Emily Grant Family Foundation (New York, New York); Barbara Alexander (Boulder, Colorado); Alice Bernd (Queens, New York) in memory of Michael Alan Bernd; William L. Gross (Ramat Aviv); Barbara Cohen Pollak (East Brunswick, New Jersey); Belle Rosenbaum (Monsey, New York); Robert C. Shadur (Encino, California) in memory of Henry and Sadie Shadur; and by an anonymous donor. With very few exceptions, museums and private collectors have been generously forthcoming in allowing reproduction of papercuts in their possession and in providing quality photographic material. To Phyllis Deutsch, Mary Crittendon, and Michael Burton of University Press of New England, we owe a great debt of gratitude for their understanding, patience, and professionalism. This book could not have become a reality without them.

The responsibility for the contents of this book is entirely ours.

Jerusalem Y.S. and J.S.
October 2001

TRADITIONAL JEWISH PAPERCUTS

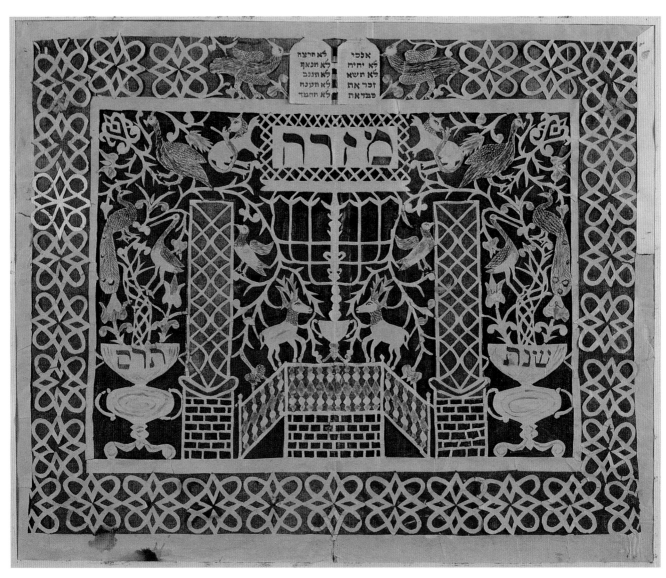

I.1. *Mizraḥ*. This *mizraḥ* plaque, dated 1900, from Komarow near Ostrów-Mazowiecka, northeast of Warsaw, is a fairly representative example of "classical" East-European Jewish papercuts. It features standard symbols: a central menorah flanked by two deer, with the flames on the outer branches of the menorah inclining toward the central one; lions holding a rectangle inscribed with the word *mizraḥ*, surmounted with a representation of the Decalogue; two heavy columns and an ornate balustrade of an architectural podium; two ornate urns, inscribed with the Jewish year (5)660, out of which grows profuse, vine-like vegetation inhabited by various birds; a rather wide, ornate border with a repeating pattern. The more important elements are arranged in hierarchic order in the central panel; the clearly delineated, wide borders are mainly decorative. Mirror symmetry was achieved by cutting the design drawn on one-half of a sheet of paper folded in two (note the faint fold line down the middle). The main inscriptions were cut, and shading, coloration, and other inscriptions were added in pencil, ink, and watercolor on the unfolded work. (Explanations of the symbolic configurations and standard Hebrew inscriptions are given in chapter 3.) 35 × 42.5 cm. (13¾" × 16¾"). Mishkan le-Omanut, Museum of Art, 'Ein Ḥarod.

L et us begin by looking closely at an old Jewish papercut chosen at random. The one in Fig. I.1 was made in 1900, probably in Ostrów Mazowiecka, northeast of Warsaw.

With the brickwork foundations, massive columns, and ornate balustrade, the dominant impression is architectural. The central element is a menorah topped by the word *mizrah* in large Hebrew letters. Out of the large urns at the sides grows a profusion of vines and flowers inhabited by various animals and birds. The wide, partly restored repetitive decorative border, with the tablets of the Decalogue at the top, was initially of one piece with the entire, now damaged, composition. The drawing is both naive and quite realistic.

Try to imagine yourself composing and drawing the design. Think of the planning needed to enable the finished, cut-out work to hold together in one piece. Visualize yourself cutting the intricate, delicate vines and plant parts with a sharp penknife through both halves of a sheet of paper folded down the middle and resting on a wooden board. What patience and precision! Yet, during at least three centuries, very many young and old Jews throughout the Jewish Diaspora lovingly drew, cut out, inscribed, and colored even much more complex designs.

How can such a tradition be explained? Jewish learning is rooted in the Holy Scriptures, the voluminous commentaries of the Talmud, and other religious as well as mystical texts. Awe and love of the written word are prominently expressed in Jewish art through calligraphy and embellishment of scriptural texts and prayers. Psalm 29:2 urges us to "Worship the Lord in the beauty of holiness." In this spirit, the Talmudic dictum of *hiddur mitzvah* (Shabbat 133b) instructs Jews to observe the commandments in the most esthetic way possible — to make a beautiful *sukkah*, a beautiful *lulav*, a beautiful *shofar*, beautiful *tzitziyot*, and a beautiful scroll of the Law written with fine ink and a fine reed by a skilled penman and wrapped in beautiful silks. In brief, the purpose of all traditional Jewish art is to adorn, beautify, and enhance the Torah in love and devotion to the Almighty. The work of the artist becomes the embodiment of Exodus 15:2, "He is my God, and I shall glorify Him."

There is no better example of a popular art form that took its inspiration from these hallowed sources than Jewish papercuts, all of them serving some religious, ritual, or mystic purpose. Many of the objects that we revere and treasure today as traditional Jewish folk art were made of expensive materials according to accepted patterns and styles of the day and region by skilled craftsmen — often non-Jews commissioned by private individuals or congregations. But even the poorest Jew had access to the humble materials and tools — paper, pencil, penknife, water

colors and colored crayons — with which he could express his own form of *hiddur mitzvah* by making a papercut. Of all Jewish ritual and folk art, papercuts (and also some calligraphic sheets) lent themselves to the freest expression of religious spirit. Unlike metal, wood, or textiles, paper was so cheap and so easily replaceable that the artist-craftsman was never afraid of spoiling it. He could be bold and inventive within the simplest of technical means. And indeed, he took full advantage of the medium and let his imagination run to fanciful extremes.

But how did Jews come to make papercuts in the first place? As all art, the custom of cutting designs in paper did not arise and develop in a cultural vacuum. In our attempts to trace the origins of the Jewish papercutting tradition, we must go back in history and across Asia.

1

PAPER, PAPERCUTTING ARTS, AND SHADOW THEATER FIGURES IN DIFFERENT CULTURES

Papercutting is a very ancient craft. Its antecedents are probably to be sought in the cutting out of figures from thin leather, parchment, papyrus, and bark.[1]

Paper was invented in China sometime around the first century of the common era. When the Muslims captured Samarkand in 712, they learned from the Chinese living there the technique of beating flax and other fibrous plants into a pulp and drying this into thin sheets. Introduced into the Near East as a substitute for parchment and leather at a time when papyrus was still in use, the new material was also called papyrus, or paper. Papyrus proper gradually disappeared from common use in Europe after the Islamic conquest of Egypt in 639 to 642.

The first Muslim paper manufacturing plant opened in Baghdad in 794. The craft was brought by the Arabs to Sicily and Spain, and from there passed to Italy, France, and Germany. We know of paper used in Egypt in 800, Spain in 950, Constantinople in 1100, Sicily in 1102, Italy in 1154, Germany in 1190, and England in 1309.

At first paper was imported to France and Germany from Muslim Spain, where Jews were among the most enterprising paper manufacturers. But by 1190, a paper mill was operating in Ravensburg, and in the thirteenth century, paper was being made of linen in Europe. The main raw material for papermaking was linen rags. At a time when cloth was tediously made by hand, the cost of a sheet of paper was only slightly less than of a similar piece of parchment.

An important step in making paper less expensive was the invention toward the end of the eighteenth century of a mechanized manufacturing process. The use of wood pulp, the cheapest raw material from which paper is made, became widespread from the late 1840s, and it is from then on that paper became the universally used material that we know — and waste with impunity. Just as Jews had been prominent in the early paper manufacturing industry of medieval Spain, Jewish family names such as Papierer, Papierman, Papiermacher, Papierowitz, Papiermeister (Papermaster), Papirtchik, and Papirny, attest to their involvement in this trade in Central and Eastern Europe.

The availability of paper and the simplicity of the tools with which it could be worked must have led to the making of papercuts in many unconnected localities. Similarities in technique and in the appearance of cut-paper work can thus represent totally independent developments — although there is also much evidence of cross-cultural influences in some types of papercuts.

The predecessors of the papercut picture in the Old World are generally considered to have been the figures of the Oriental shadow theater, popular from very early times in China, Japan, Thailand, Java, and in the Indian subcontinent, where they can be traced at least to the eleventh century. While there are hints that shadow figures may have been used in ancient Egypt, shadow

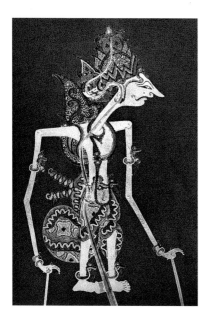

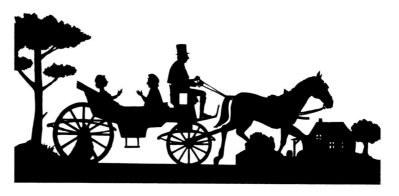

(LEFT) 1.1. Puppet from the traditional Southeast Asian shadow theater, cut out of thin leather, painted, and oiled to make it translucent. Museum der Kulturen (Abteilung Asien), Basel.

(ABOVE) 1.2. *Ombres chinoises* (Chinese shadows). Playlets performed with black paper or cardboard silhouette figures against an illuminated screen were a popular entertainment in Europe during the eighteenth and nineteenth centuries.

theater performances are known to have taken place in thirteenth-century Muslim Egypt. In the Ottoman empire, the *Karagöz* shadow theater was a highly popular form of mass entertainment, spreading from Turkey to Greece and the Balkans, the Middle East, and the distant lands of the Maghreb in North Africa. *Ombres chinoises* (Chinese shadows), as the shadow theater was called in Europe, are thought to have been introduced there in the eighteenth century from North Africa via Italy.

Leather bookbindings with incised, openwork tracery designs underlaid with gold or colored backgrounds are known from Chinese Turkestan and from Egypt in the eighth and ninth centuries. This decorative art form survived a thousand years in the Middle East and was also practiced by European bookbinders. The techniques by which such bindings were made may have been applied to paper. Beautiful papercut work dating from the second half of the fifteenth century is known from Herat in western Afghanistan, and shortly afterwards from Tabriz in northwest Persia.

The earliest European cut parchment or paper work has been traced to both Muslim and Christian Spain, where the writing of billets-doux, special personalized letters, and of "immaterial" books with cut-out "non-existent" letters was fashionable in the fourteenth century and persisted into the eighteenth. Books with cut-out calligraphic letters, cut-out border designs, arabesques, and entire cut-out pictures are known from sixteenth-century Turkey and Western Europe.

From sixteenth- and seventeenth-century Istanbul we have records of papercut-artists' guilds with ten to twenty members maintaining several workshops. Some of their incredibly delicate work is preserved in the Topkapı Museum archives. At the time, it aroused the admiration of Western European visitors, who brought such items home with them and preserved them as valued heirlooms. Although no evidence has yet been found that this Turkish work directly influenced European papercuts, it is quite likely that it did.

From the fourteenth century (possibly even earlier) and well into the nineteenth, monks and especially nuns in the Rhineland and in South-German, Swiss, Austrian, and French convents

 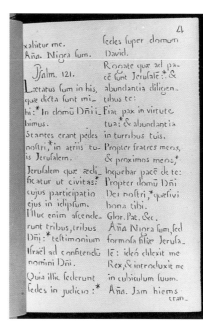 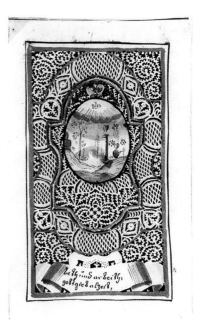

(LEFT) 1.3. Islamic book cover with incised and underlaid, open-work tracery. Egypt, fifteenth century. 27.5 × 18 cm. (10¾" × 7⅛"). After F. Sarre, 1923.

(CENTER) 1.4. "Immaterial" books and pages with letters cut out of the paper or parchment were fashionable from the late medieval period and into the eighteenth century in Western Europe and Islamic lands. In this small book of hours, made in 1765 by Vicente Fernandez of Arcos in Spain, the entire text and illustrations were meticulously cut in the paper. The page depicted here shows Psalm 122 in Latin. Errors were cut away and replaced by pasting corrected sections on the reverse side of the page. At least one Hebrew work in this technique is known to have been made in medieval Spain. 12.7 cm. × 9.3 cm. (5" × 3⅝"). Hispanic Society of America, New York.

(RIGHT) 1.5. Hand-cut *Spitzenbilder* (lace pictures) were sold as souvenirs of pilgrimages to venerated Catholic shrines and usually were kept in missals and breviaries. 10.5 × 6.7 cm. (4⅛" × 2⅝"). Museum der Kulturen (Abteilung Europa), Basel.

made small devotional "lace pictures" of cut parchment and paper to fit into prayer books. Depictions of Jesus, Mary, saints of the Church, and biblical scenes were surrounded with intricate, delicately cut out, punched, or pricked border designs. Such artificial lace borders and intertwining floral papercut patterns obviously reflected locally produced textiles — lace, damask, printed silks, and the like.

From the 1840s on, these meticulously cut and crafted creations were increasingly supplanted, or at least supplemented, by blank sheets of paper with die-cut and embossed machine-made border designs — a direct result of the technological advances of the age, mainly in Germany and Bohemia. The areas of blank paper encompassed by delicate, precision-made machine-cut lace borders were filled with pasted-in or printed, but also cut-out pictures — religious as well as secular, such as Valentines. Some Jewish items were made in this technique (Figs. 4.1–4.5).

Larger papercuts from southern Germany, Austria, Switzerland, and the contiguous regions of France are known throughout the following centuries, both as signed artistic works and as anonymous, popular folk creations. From the seventeenth century on, a rich papercutting tradition also developed in Holland, possibly influenced by Turkish or Persian work reaching its cosmopolitan trading ports. Well-documented papercutting traditions can be traced during the last two centuries in Germany, Switzerland, Austria, France, Holland, England, Italy, Poland, and

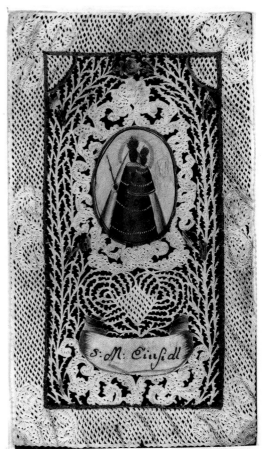

1.6a

1.6. Parchment *Spitzenbilder* from Mariazell in Austria (1709) and Einsiedeln in Switzerland (mid-eighteenth century). (*a*) 6.6 × 4.4 cm. (2⅝" × 1¾"). (*b*) 12 × 7 cm. (4¾" × 2¾"). Museum der Kulturen (Abteilung Europa), Basel.

1.6b

1.7. Silhouette portraits. Paris, twentieth century. 11–15 cm. (4"–6") high. Collection of the authors, Jerusalem.

the United States, as well as in Islamic countries, China, Japan, Korea, and Southeast Asia. As will be seen below, although maintaining their distinct character and iconography, most known Jewish papercuts reflect influences ranging from Western European to obviously Islamic ones.

The European papercutting arts also included silhouettes, so fashionable in eighteenth- and nineteenth-century Europe and America. Most probably derived from the *ombres chinoises* and the Oriental shadow theater introduced to Europe in the eighteenth century, silhouette portraiture gained widespread popularity. It declined only when photography began to provide more satisfying, low-cost personal mementos.

Before examining Jewish papercuts in detail, let us briefly look at some of the different national papercutting traditions that may serve as a basis for comparison, and may hint at possible Jewish connections, however tenuous.

China

The land in which paper was invented is also the generally acknowledged birthplace of the papercut and the shadow theater figure. Archeological excavations in northwestern China in

1959 brought to light actual papercuts dating to the sixth century C.E., and ancient Chinese literature contains references to papercuts. The various regions of China evolved their own styles and favored motifs. Papercutting was considered a desirable accomplishment for marriageable girls, who in this way adorned the window panes, interior walls, and ceilings of houses.

Papercuts were important decorative elements for festivals and funerals. Itinerant papercutters visited towns and villages, peddling their simple wares. The Chinese shadow theater very probably influenced similar folk entertainment in Japan and Southeast Asia — although according to some authorities, it may have spread to these regions from India, where it reputedly antedated Buddhist times (sixth century B.C.E.). Today, in China, papercutting is a respected folk art, actively encouraged and supported by the state.

Chinese papercuts are usually nonsymmetrical. Some types are cut in wads of tens (even up to a hundred) very thin, firmly grained sheets of paper, sewn together or nailed to a board. Starting with the small details in the center and working outward to end with the outline, the designs are cut with a knife, punches, and other sharp tools. Scissors are also employed where convenient. Most of the designs are traditional and follow accepted patterns, although modern themes have become common. If, as has been claimed, European papercuts owe their origins to the Chinese papercutting tradition, this is not apparent in the techniques used in Europe, including those of Jewish papercutters.

(ABOVE) 1.8. Discovered in archeological excavations in Northwest China, these are the most ancient known papercuts (fourth to sixth centuries CE).

(RIGHT) 1.9. Chinese papercut (date unknown).

1.10. Figure cut of thin leather, from the medieval Egyptian shadow theater. After P. Kahle, 1908.

Egypt

Egyptian shadow theater figures are the oldest ones known from the Middle East and Europe, with a continuous record from the twelfth century on. Surviving texts of shadow plays substantiate the early dating. Egyptian shadow theater figures of the fourteenth century and later are preserved in several museums. Although any resemblances may well be fortuitous, they are somewhat reminiscent of Javanese and Siamese shadow puppets; perhaps the art reached Egypt through itinerant performers. These characteristic figures, cut out of thin leather and oiled, were made for the standardized repertoires of the classic Egyptian shadow theater, which persisted until the sixteenth and seventeenth centuries, when the Turkish *Karagöz* began to replace it.

1.11. Egyptian-Turkish decorative cut-out paper wall panelling (eighteenth century). After Prisse d'Avesnes, 1885.

Ottoman Empire

Travelers and chroniclers of the sixteenth and seventeenth centuries mentioned guilds of professional papercutters in Istanbul. The English traveler Edward D. Clarke, who visited Palestine in 1801, was received by the notorious Ottoman governor of Akko, Ahmed el-Jazzar — "the Butcher" — and noted his practice of cutting figures out of paper with a pair of scissors while entertaining guests, sitting in judgment, and handing down sometimes sadistic sentences.

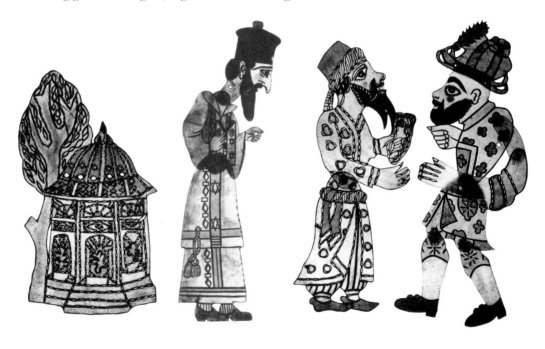

1.12. Figures from the Turkish *Karagöz* shadow theater: Karagöz (right) facing two standard stock figures of Jews, with kiosk stage prop. ca. 60 cm. (24") high. Collection of the authors, Jerusalem.

Delicately cut out end-flaps of bookbindings, and calligraphic compositions cut out in paper, are today prized museum pieces. We know the names of several highly esteemed artists excelling in this medium. At least one of them stemmed from Bursa, where tradition also places the origin of the Turkish shadow theater — the *Karagöz* — in the late fifteenth or early sixteenth century.

The amusing puppets of this greatly beloved popular entertainment were cut with a knife out of thin leather, painted, and oiled to make them translucent. In later times, and in the North African Ottoman provinces, *Karagöz* figures were also made of cardboard. It is generally assumed that the performing artists made their own puppets. The French traveler Jean de Thévenot, who visited Istanbul (Constantinople) in 1655/56, reported that "Now it is commonly Jews that show puppet shows . . . I never saw any but them play." Several stock figures of Jewish types formed part of the standardized *Karagöz* repertoire.

The shows were put on well into the 20th century, mainly during Ramadan nights, at circumcisions, weddings, fairs, and other joyous occasions, and are being revived and maintained today as a national folk art in Turkey and Greece. An article in the *Palestine Post* in September 1943 described a three-hour-long Arabic "*karakoz*" performance at the Tetrapylon café in the Jerusalem Old City on a Ramadan night: The gray-haired manipulator handled figures "which would be the envy of any folk-art museum." Evil characters were cut out of thick black paper; virtuous ones in translucent, gaily-painted parchment. Monsters were delicately scissor-cut. The age-old, traditional repertoires were brought up to date with amusing, adlibbed, topical allusions.

During intermissions and before the performances started, the attention of the audience was maintained by hanging intricate cut-out compositions against the illuminated screen. Such showpieces, known as *göstermelik*, were sometimes inspired by European book or magazine illustrations. Some *göstermelik* had decorative and conceptual features reminiscent of Jewish papercuts, but whether a connection can be established remains a matter of speculation.

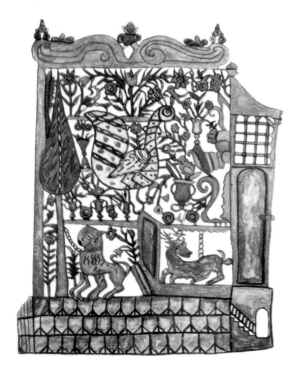

1.13. *Göstermalik* screen decorations displayed during intermissions of *Karagöz* shadow theater performances. As in the Chinese shadow theater, all these figures were cut, painted, and oiled to make them translucent. Note the animal forms that have fortuitous counterparts in European Jewish papercuts. ca. 70 cm. (27½") high. Collection of the authors, Jerusalem.

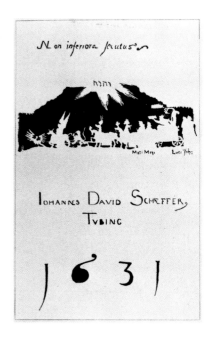

(RIGHT) 1.14. Papercut *Liebesbrief* (love-letter) in the South-German tradition, cut on a four-fold. Archival collection of the authors.

(FAR RIGHT) 1.15. Early German papercut, dated 1631. Note the Tetragrammaton in Hebrew, in the clouds. After M. Knapp, 1916.

Germany

Among the earliest known papercuts from southern Germany, Austria, and Switzerland were those made in monasteries and convents from the sixteenth and seventeenth centuries on. Small and larger *Andachtsbilder* (devotional pictures) in the form of *Spitzenbilder* (lace pictures) of varying intricacy, cut in paper or parchment, were sold at Catholic pilgrimage shrines such as Einsiedeln and Mariazell, to be kept as mementos between the pages of prayer books, breviaries, missals, and Bibles, or hung on the wall. Other popular religiously inspired papercuts, which were framed and displayed at home, showed the instruments of Jesus' passion arranged around a large, central cross. Systematic study of these common works has shown that the decorative, cut-out borders surrounding the central picture or medallion gradually came to occupy more and more of the entire composition.

If these forms reflected Catholic religious decoration — lace-trimmed cloths of the altar and priestly vestments — German Protestants seemed to prefer native peasant motifs. Among these were papercut baptismal certificates (*Taufscheine*); blessings of the home, its inhabitants, and the fruit of their labor (*Haussegen*); as well as personal, stylized love letters (*Liebesbriefe*) and marriage certificates. In the German Protestant and secular papercuts, inscriptions from the Bible, proverbs, or personal dedications replaced the sacred pictures. *Liebesbriefe* were cut in a characteristic form as circular rosettes from a multifold pattern. The earliest known large German papercut of more sophisticated composition dates from the early seventeenth century. From then on, the record is continuous and includes works by artists renowned in this field, often cut from black paper and mounted on white backgrounds. Natural forms — plants, animals, landscapes — and people engaged in all sorts of activities were favorite subjects.

As will be seen in the following chapter, there are decided stylistic and other similarities between Germanic and Central European Jewish papercuts. Some of the latter were clearly adaptations of Christian ones, with medallions of Jesus, saints, or the Virgin replaced by Hebrew inscriptions and motifs within neutral decorative borders (Figs. 2.30–2.34).

The Netherlands

Is there a recognizable Dutch style of papercutting? Just as in Germany, France, England, and other European countries, individual artists and amateurs turned to making silhouettes and papercuttings as forms of fashionable artistic expression, in Holland the art was practiced at least from the early decades of the seventeenth century. It has persisted continuously to this day.

Many Dutch papercuts — especially the earlier ones — are remarkable for their exceedingly delicate workmanship. As in Turkey and Germany, some of the papercut artists were greatly admired for their skill, and their work fetched high prices.

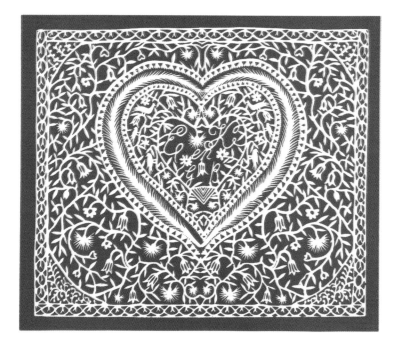

1.16. Papercut love token from West Friesland, nineteenth century. 32 × 39.5 cm. (12⅝" × 15½"). Westfries Museum, Hoorn, the Netherlands.

1.17. Typical Dutch papercut work, nineteenth century. Westfries Museum, Hoorn, the Netherlands.

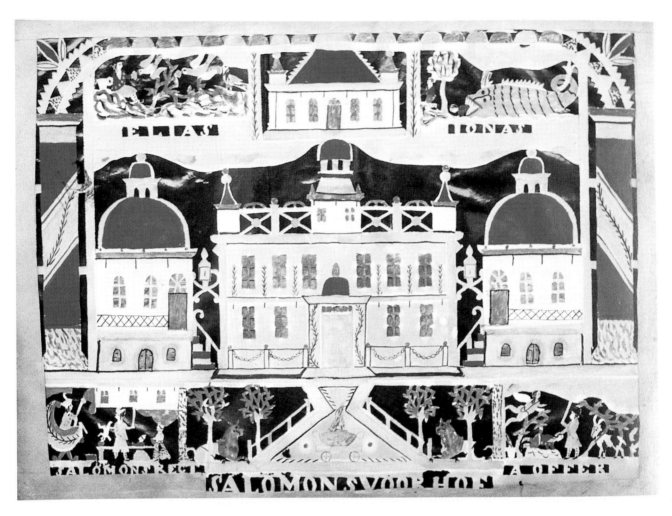

1.18. "The Courtyard of Solomon." Biblical themes were, and are still, favorite subjects of many gentile, particularly Protestant, papercut artists. Jan Huijszoon from Zeeland (1798–1870), better known in the Netherlands as Jan de Prentenknipper, made this and other brightly colored, charming papercuts in the mid-nineteenth century. His work bears entirely fortuitous conceptual similarities with some of the Central and East-European Jewish papercuts. Besides vertical and horizontal registers, the papercuts show a clear hierarchical structure, with the Temple of Solomon (in the form of an eighteenth-century Dutch mansion) — the abode of the Lord among His people, and related architectural elements such as columns and arches. The cut-out vignettes of biblical scenes in the corners convey clear messages: Elijah fed by the ravens ("Fear not, the Lord cares"); Jonah and the whale ("Trust the Lord"); the judgement of Solomon ("The Lord gives wisdom"); and the binding of Isaac ("Obey the Lord, and all will be well"). 30 × 40 cm. (11¹³⁄₁₆" × 15½"). Joke and Dr. Jan Peter Verhave, Malden.

No traditional Jewish papercuts are known from Holland. An eighteenth-century (?) depiction of the Amsterdam Ashkenazi synagogue in cut paper may not be Jewish work. A fortuitous affinity with Jewish papercuts of Eastern Europe can be detected in the charmingly naive papercuts on biblical themes by Jan Huijszoon "de Prentenknipper" in the first half of the nineteenth century.

England

Except for English texts and inscriptions, there is not much to distinguish cut-paper work from Britain from some of the more sophisticated Dutch and German genres. The items we know of were made by individual artists in this medium. It apparently never became a popular folk art.

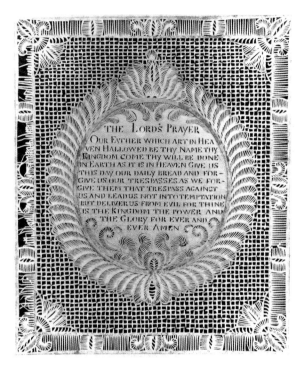

1.19. Incredibly, within this tiny papercut made in England around 1738 to 1750, the entire text of the Lord's Prayer was cut into a circular space only 2 centimeters ($^{25}/_{32}$") in diameter. British Museum, Department of Prints and Drawings, London.

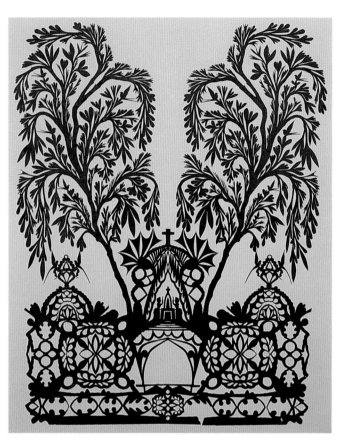

1.20. Memento mori papercut (ca. 1860) by Joseph Gorst who immigrated to the United States from England and continued creating his fine papercuts in his new home in Andover, Massachusetts. Some of his work is kept today in major museums, including the Metropolitan Museum of Art in New York. 43.2 × 33 cm. (17" × 13"). Collection of the authors, Jerusalem.

Switzerland

The Swiss folk tradition of papercutting is part of the south German and east-central French ones. However, characteristic Swiss motifs became prevalent in the nineteenth century. These were widely known and appreciated through the work of several individual artists who formalized folk motifs of the Alpine pastoral transhumance cycle that was, and still is, celebrated with much festivity in rural regions.

1.21. Swiss papercut design.

Are these true folk papercuts? Yes and no. Folk art, too, must begin somewhere and be started by someone. One such artist, Jacob Hauswirth, a charcoal burner by vocation, created his beautiful, complex papercuts in the spirit of the traditional peasant decorations, rather than as a conscious revival of a dying folk art. His work captured the imagination of others, and its unmistakable character and iconography caused this type of papercut to become representative of a Swiss national style. Swiss papercuts were often made up of a number of separate pieces pasted together on a mounting board to form a composed picture.

1.22. Swiss papercut of the mid-nineteenth century by the charcoal-burner Jacob Hauswirth. The symmetrical, cut-out elements are pasted on a backing to form a balanced composition. Note the infinity symbol — *Liebesknoten* — at bottom center. Tuck Family Collection, New York.

Poland

Polish papercuts (*wycinanki*) were exclusively a peasant art, dating — according to Polish ethnographers — only from the latter third of the nineteenth century. These decorative papercuts were skillfully cut with sheep shears, a common Polish peasant household tool made by village blacksmiths. Papercut home decorations, rather than more sophisticated compositions, apparently originated in the Warsaw region, in the east-central districts of the Vistula and Bug basins, all of which, until the Holocaust, were thickly populated by Jews. Each region — Lodz, Kielce, Lublin, Bialystok — developed its own recognizable style and techniques. The attractive, colorful decorations were usually made by women and children for Easter, Christmas, and other holidays and festive occasions. Cottages were decorated with papercuts after the spring cleaning.

Does this comparatively recent Polish Christian papercut tradition owe its origins to that of the Jews who lived in Poland? Although the Jewish tradition is much older than the Polish one, a decided similarity in general appearance and technique — if not in motifs — is evident between some of the simpler Jewish works and Polish peasant papercuts. It may well be that a largely illiterate, poor peasantry, closely intermingled with the Jewish population, adopted this simple decorative art form at a time when cheap, brightly colored paper became readily available. Jews, wherever they lived, always had parchment and paper close at hand, which certainly was not true of these peasant communities.

1.23. Polish cut-paper work is usually made from cheap, brightly colored gloss paper.

1.23a

1.23b

The United States

The folk papercuts in the United States reflect the various traditions brought by immigrants: Englishmen, Germans, Poles, Chinese, Jews. Especially well-known are the Pennsylvania Dutch papercuts (*Scherenschnitte*). Close in spirit and content to the German ones, they also incorporated patriotic motifs such as American flags and eagles — as did Jewish-American papercuts made by immigrants, some of whom even added Masonic symbols.

1.24. Modern laser-cut reproduction of a Jewish *shiviti* papercut made in 1861/62 by Philip Cohen (Rabbi Naftali son of Rabbi Moshe HaCohen) in the United States (where?). Note the Gothic-style towers topped by American flags and the Masonic symbols in the lower corners. The overall conception is well within the Central or East-European Jewish tradition. Cohen's papercut, without the original border, was made into an attractive, mass-produced greeting card. The original work is 64.1 × 49.2 cm. (25¼" × 19⅜"). Hebrew Union College Skirball Culture Center, Museum Collection, Los Angeles.

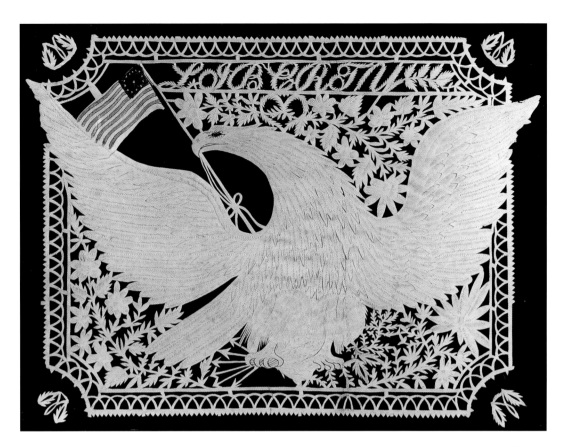

1.25. "Liberty," by an anonymous American papercut artist, 1830. The American eagle was a favorite motif. Note the knife-pricked and slashed detailing. IBM Corporation, Armonk, New York.

1.26. A contemporary American papercut in the Pennsylvania-Dutch *Scherenschnitt* tradition. Biblical topics were common subject matter of Quaker and German immigrant folk artists in Pennsylvania, as they were in New England. The "Peaceable Kingdom" (Isaiah 11:6) was a long-time favorite. Mary Lou "Sukey" Harris, a founding member of the Guild of American Papercutters, perpetuates this tradition in Lebanon County, Pennsylvania. 19 × 22.8 cm. (7½" × 9"). Collection of Lebanon Valley College, Annville, Pennsylvania.

2.1. *Mizraḥ*. Made probably in Germany (Uhlfeld?), this *mizraḥ* dated 1910 was the work of a man named Nathan Holländer. It is nevertheless very much in the East-European tradition. The main inscription, "*mizraḥ*," in the crowned roundel is flanked by two rather awkward-looking birds — really representing the *kruvim* — cherubs "screening the ark-cover with their wings, with their faces one to another" (Exodus 25:20). The inscription in the band dividing the composition into two registers, which should read *el mool pnei ha-menorah* ("over against the menorah") (Numbers 8:2), contains a spelling error (*mil* instead of *mool*). The central menorah merges in a profuse plant configuration representing the Tree of Life. The presence of lions, deer, and the (double) eagle evokes the commonly used and known "Four Animals" aphorism of Judah ben Tema (see p. 97). 39.5 × 31 cm. (15⁹/₁₆" × 12³/₁₆"). Musée Juif de Belgique, Brussels.

2 JEWISH PAPERCUTTING TRADITIONS IN ASHKENAZI AND SEPHARDI COMMUNITIES
AN HISTORICAL/CULTURAL OVERVIEW

The earliest known reference to a Jew who created cut paper work dates to 1345, when Rabbi Shem-Tov ben Yitzḥaq ben Ardutiel composed a witty treatise in Hebrew entitled *The War of the Pen against the Scissors*. He relates that when the ink in his inkwell froze on a cold winter's evening, he resorted to cutting the letters out of the paper — apparently in keeping with a conceit fashionable at the time (and later) in Spain (Fig. 1.4).[1] To students of Christian Spanish literary history, Rabbi Shem-Tov is better known as Santob de Carrión de los Condes (1290?–1369?), the courtly Castilian troubadour who composed the *Proverbios morales* for Pedro the Cruel.

Individual Jews (including an apostate) proficient at making papercut images are mentioned here and there in Dutch and German writings of the seventeenth and eighteenth centuries. Later, a notice of 1853 tells of Jews in Amsterdam selling cut out pictures of Catholic prelates hanging from a rope, as part of Protestant opposition to the reestablishment of a Catholic hierarchy in the Netherlands.[2] At most, such incidental bits of information indicate that some Jews also engaged in papercutting — not an unusual practice at the time. It provides no meaningful clues as to how the making of devotional papercuts started and spread through the Jewish world.

From around the mid-eighteenth to the mid-nineteenth centuries we have Italian — or at least, Italianate — *ketubot* (marriage contracts) and *megillot esther* (scrolls of the Book of Esther read during the Purim festival), in which the parchment or paper of the border design or of the illustrative vignettes was cut out in parts.[3] But here, too, we cannot conclude that these inspired the Jewish folk tradition of papercutting that was practiced concurrently.

Among the earliest known or recorded Jewish papercuts as such, very few can be dated with certainty to the latter part of the eighteenth century. Most of the items known today range from the early nineteenth century to the first decades of the twentieth and were made in Central or Eastern Europe — Alsace, Germany, Bohemia, Austria-Hungary, Galicia, Poland, Lithuania, White Russia, the Ukraine, Volhynia, Podolia, Rumania; in Turkey and parts of the Ottoman empire, French North Africa, Syria, Baghdad, and Palestine; and also by immigrants to North America and Western Europe.[4]

Since the earliest, datable, surviving Jewish papercuts of the late eighteenth century already reflect a distinct folk-art genre, they attest an older tradition. That so few items remain is not really surprising considering the extreme fragility of their construction and the vulnerability of the material. Some of the simpler designs were made for special occasions, and because of their ephemeral character were little valued and discarded after being used only once or twice. The

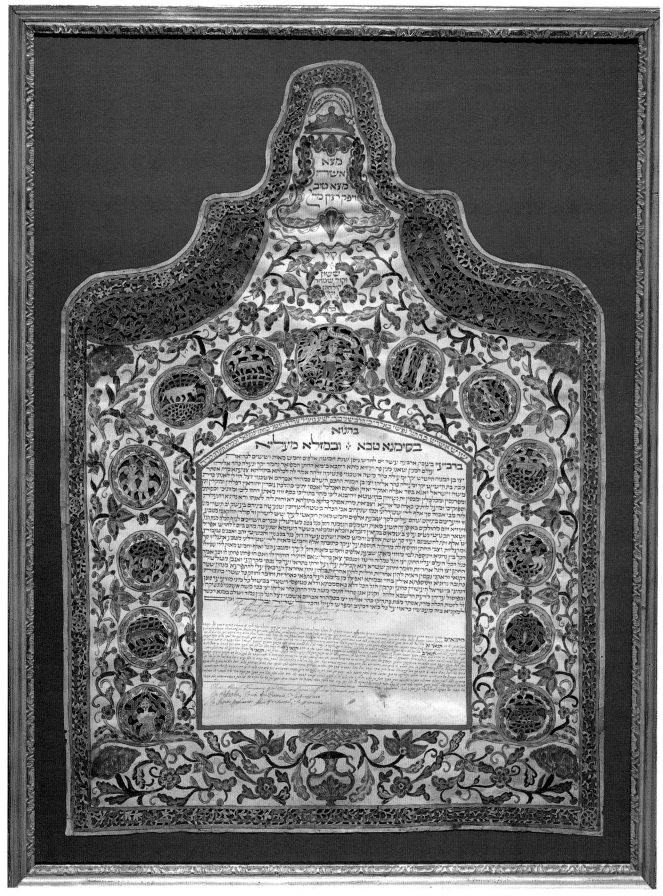

2.2

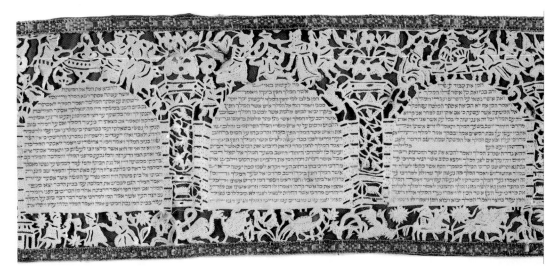

2.3. Scroll of Esther. Several parchment *megillot esther* with cut-out border designs and vignettes are known. This one, of which a section is shown here, is backed with red silk. Like the *ketubot* with cut-out decorative elements, it probably comes from eighteenth- or early nineteenth-century Italy and reflects similar style and artistic conception. 12.5 × 200 cm. full length (4²⁹/₃₂" × 78¾"). Joods Historisch Museum, Amsterdam.

Holocaust marked the disappearance of much Jewish ceremonial and folk art; the more so of such frail items as papercuts.

Among a highly literate people like the Jews, paper was always on hand, even among the poor, and especially after the introduction of cheap wood-pulp paper in the mid-nineteenth century. The more we learn about Jewish papercuts in one form or another, the more reason we have to believe that they were once exceedingly common, at least in Ashkenazi-Jewish homes. They served daily religious and other ritual needs, such as indicating the direction of prayer (*mizrah*, *shiviti*, *menorah*), decorating the home for holidays (*'omer* calendars, *shavuosl/roisele*, *ushpizin*, etc.), warding off the evil eye (*shir hamalosl/kimpetbrivl*, *menorah*), remembering family deaths (*yortzait*), and the like.[5]

These papercuts feature most of the traditional symbols and inscriptions found in Jewish ceremonial objects and amulets — many of them kabbalistic — characteristic of the various Diaspora communities. The real or fantastic animals and birds, vegetation, utensils, urns, columns, the menorah, tablets of the Law, stars of David, the signs of the twelve tribes and of the zodiac, *yadayim/hamsas*, eternal lights/lamps-in-niches, and the like, which appear and reappear in the compositions, had almost all meanings that were widely, if not universally, understood in the community. They were supplemented with calligraphic inscriptions in Hebrew (and sometimes in other languages), mainly passages from the Bible, the interpretive and homiletic texts, the prayer

(OPPOSITE) 2.2. *Ketubah*. A very large, sumptuous, vellum *ketubah* from Venice, 1800. The central panel bears the text of the marriage contract between the groom, Eliyahu the son of Moshe Ashkenazi-Fonseca, and the bride, Esther the daughter of Eliyahu the son of Avraham Ashkenazi. The inner, decorative border design comprises thirteen cut-out roundels — twelve representing the signs of the zodiac, and the one at the top, the Binding of Isaac. The entire finely cut-out outer border incorporates the standard opening formula, *mazzal tov* ("Under a favorable sign; with good fortune),") in large, gilt lettering. 92.5 × 67 cm (36¹³/₁₆" × 26⅜"). Abraham Halpern, New York.

book, cryptograms, acronyms, wise sayings, and magic formulas and incantations. Personal dedicatory and memorial inscriptions commemorating special family events were sometimes included as well. And occasionally — to the delight of those of us who crave to know more about them — the name of the maker of the papercut, the date and place, and the name of the owner are indicated.

The Statistical Basis

Before launching into more detailed characterizations of this intensely parochial Jewish folk art, we must establish an important criterion for assessing Jewish papercuts: the statistical basis for drawing generalized conclusions. Or, in other words, how many old Jewish papercuts are known to exist today, or are at least recorded photographically.

Here we must define the term "classic" that we have adopted for our discussion: We distinguish "classic" Jewish papercuts and papercut compositions from simple, generally small cut-outs such as were made by children to paste on windowpanes for Shavuoth and for the *sukkah*, and also from *ketubot* and *megillot esther* with cut-out decorative borders. However, size is not a criterion, for "classic" Jewish papercuts can vary from very small to huge, from less than ten centimeters to over one meter in height or width. All of these were intended to serve the purposes outlined above and reflect religious or apotropaic concepts representing extensive knowledge of Jewish lore. They bear appropriate inscriptions, many of decided esoteric purport, and show meticulous planning and painstaking execution.

Thus, not counting possibly several hundred smaller, plain, *shavuosl/roisele*-type of cut-outs, many of them made by young boys (see below), or the relatively few *ketubot* and *megillot esther* with cut-out decorative elements, we know of no more than about 250 or so "classic" Jewish papercuts — both existing ones and photographs of lost items — to give us a glimpse into the widespread Jewish papercutting tradition, from the earliest known ones of the mid-eighteenth century to the 1950s. Of these, more than 80 can be ascribed with fair certainty to Galicia and the adjacent Carpathian Mountains regions; some 30 to 40 to Poland proper and the Russian pale of settlement; at least as many to Central Europe, from Alsace in the west through Germany to western Poland, Bohemia-Moravia, and Germanic Austria-Hungary; 25 or so to the United States; and about 30 to 40 Sephardi papercuts of which about one-third stem from Ottoman Turkey and two-thirds from the lands of the Maghreb in North Africa. A few come from northern Italy, Palestine/Syria, and Baghdad. Others are of indeterminate, varied provenance. Since most of the Jewish papercuts from the United States, and the few in England, were the work of immigrants from Central and Eastern Europe carrying on their traditions, many of these show affinities with the Jewish work from German-speaking, Galician, and Polish/Russian regions.

Among the relatively small number of known and recorded Sephardi papercuts are several items made by the same persons, and their dating is also largely concentrated within a few decades around the end of the nineteenth and the turn of the twentieth century. Therefore, they may be less representative of their respective cultural styles and content than would 35 different works made throughout two centuries. Nevertheless, the Turkish and North African Jewish

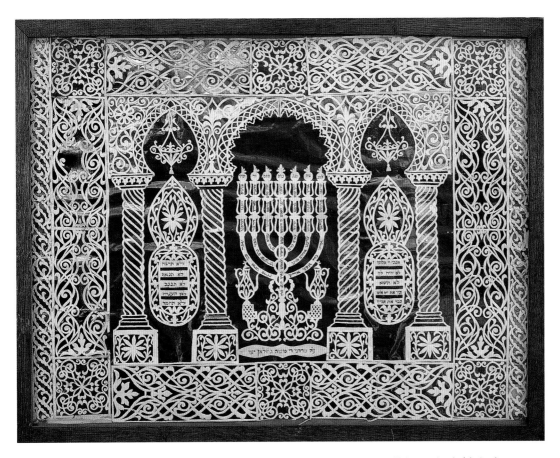

2.4. *Menorah*. Of high professional workmanship, this *menorah* papercut (ca. 1900?) is unmistakably in the western North-African Islamic style (note the lamps-in-niches and cf. Fig. 2.43). The first words of the Decalogue are inscribed in the oval panels at either side of the central menorah. Close examination reveals that only the menorah itself was cut on the centerfold. All the other parts were stencil-cut separately and pasted together to form the entire composition. As in other Moroccan-Jewish papercuts, the cut work is backed by brightly colored metal foils. Beneath the menorah, the artist pasted a label with his name: Mordecai di Moshe Guzlan. 47 × 63.7 cm. (18½" × 25"). Musée d'art et d'histoire du Judaisme, Paris.

papercuts, although created far apart geographically, do show decided influences of their Islamic cultural environments. They differ in many ways from the Central and East-European works.

In view of the overwhelming numerical preponderance of European Jewish papercuts, our discussion addresses primarily the Ashkenazi papercutting traditions, and relates to the Sephardi works by emphasizing the differences where warranted. More specific descriptions of the Turkish and North African Jewish works are found in the captions to the illustrated items. Sephardi and Ashkenazi representational traditions come together in the few papercuts known to have been made in Jerusalem (and Safed?) where the two communities were closely intermingled.

In this connection, we must also consider an important factor of Jewish social, economic, religious, and cultural history through the ages: the constant communication and contacts between communities and individuals of the far-flung Diaspora, and with the Land of Israel. Advice and halakhic rulings of renowned rabbinical authorities were sought and imparted across the Jewish world in the form of an intensive question-and-answer correspondence. The

Cairo genizah documents, for example, attest the great scope of such interaction from the early medieval period on, and there is no lack of other evidence. Thus, we hear of a rabbi-physician persecuted in Venetian Crete (Candia) who is next heard of in Prague, and others who from Lithuania went to Sephardi communities in the Ottoman empire. Ashkenazi Jews lived and traded in Morocco, and many interconnections existed between the Jews of Galicia and the Jews of the Ottoman provinces. Rabbinical emissaries from the Holy Land reached the most remote corners of the Diaspora; besides collecting funds, they served important functions of spreading information throughout the Jewish world. Commercial relations brought Jews of many disparate communities together. These movements and interchanges undoubtedly served to spread folk traditions as well.

(BELOW) 2.5. *Sofer stam* — scribe of sacred texts. Eastern Europe, probably early twentieth century. Central Archives for the History of the Jewish People, Jerusalem.

(RIGHT) 2.6. Young *yeshivah* student. Eastern Europe, probably early twentieth century. Central Archives for the History of the Jewish People, Jerusalem.

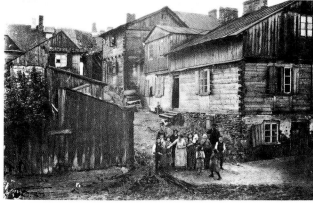

2.7. Shtetl scenes (ca. 1890?). Central Archives for the History of the Jewish People, Jerusalem.

Typologies and Techniques

Who made these papercuts (*oissherenishen*, אויסשערעניש in Yiddish; *recortes*, in Ladino) of Eastern Europe and the Sephardi communities? Most of the simpler ones were apparently the work of boys studying in the *ḥeder* and of their teachers and teachers' assistants (*belfers*, in Yiddish) and were made to decorate the sukkah and window panes for some of the festivals, especially Shavuoth. These little compositions were often cut into rosettes on a multifold — hence their Yiddish name *roizalakh*, or *shavuoslakh*, after the holiday. The popularity of papercut decorations in the shtetl is epitomized by a passage from a German-Jewish novel, *Das Rosele*, by Nathan Samuely (1892):

> If you were to come into a small town in Galicia during Shavuoth, your eyes would be immediately drawn to numerous pictures cut out of paper looking at you from every window. And if you were to ask any Jewish boy what they are, he would look at you in surprise and say: "Are you a Jew? Don't you know what these are? They are 'roiselekh' which have always decorated the windows of our fathers and forefathers during this festival."

One type of very small plain, often heart-shaped papercut, also known as "cheese slices," was pasted on the front cover of books and copybooks.[6] These were the only types of East-European Jewish papercuts that were sometimes cut with scissors, and may have also been made by women or girls.[7] To convey something of the atmosphere that inspired these humble creations, we quote here from some of the early writings on the subject:

2.8. "Cheese slices" (*ḥaritzei gevinah*) is what children called small papercut patterns that they pasted on the front covers of copy books and school texts. After M. Narkiss, 1944.

> One week before Shavuoth, in the *ḥeder* instead of their Gemara lesson, the boys would sing *aqdamut* — introducing the Torah in the form of ninety rhymed acrostic blessings, composed in the twelfth century. These evoked a poetic vision of paradise and of the angels surrounding the Divine Throne with the glorious participation of the righteous. All this inspired the children to make papercut decorations of Bible motifs. Nowadays, these ornaments are thrown away and replaced by other things. (1909)[8]

> Some of the subjects of *shavuoslakh* were profane and had nothing to do with typical Jewish motifs: foot soldiers and cavalrymen that aroused the imagination of young boys. *Ḥeder* pupils, who made these before the holiday, sold them to friends: soldiers on foot, one or two pennies; horsemen, twice as much. (1929)[9]

> If in other centers the making of silhouettes became a game for dilettantes and wealthy amateurs, and of monks and nuns, in Jewish circles this craft was the work of children. It is the Jewish boy who made these white papercuts — or at least they were made for him by his teachers. It was the child who perpetuated this tradition, inspired it with his imagination so that it influenced the creation of adults. (1944)[10]

Plausibly, as the *ḥeder* boys grew up and became *yeshivah* students, or began to earn their living, some of the more complex *shavuoslakh* led to the making of more serious papercut works. In any case, Jewish papercuts of more enduring character were the work of mature men, many of them

scholars of the holy books steeped in the lore of the Kabbalah and the Zohar. Some *sofrei stam* (professional copyists of the Torah and devotional texts) supplemented their income by making papercuts that were sold by itinerant peddlers (see, for example, Figs. 2.19; 3.11).[11] Nor was this art form confined to the shtetl or the yeshivah. It was practiced wherever Jews lived, including in large cities — in some cases by highly proficient graphic artists.

There is no doubt, however, that papercuts (occasionally, parchment-cuts) were made by ordinary Jews simply working in the traditions of their people. Again and again, we have been told by elderly people recalling their fathers, grandfathers, and other aged male relatives cutting religious pictures in paper tacked onto wooden boards, often at the kitchen table. When we have them, signatures often paraphrase Isaiah 60:21: "The work of my hands, wherein I glory," with

(ABOVE LEFT AND RIGHT) 2.9. Early twentieth century picture postcards showing the street and gate to the mellāḥ of Fez, Morocco. Collection Dr. Paul Dahan, Brussels.

2.10. *Sofer stam* — scribe of sacred texts from Morocco, early twentieth century. Collection Dr. Paul Dahan, Brussels.

2.11. *Roizalakh* for
Shavuoth from
Poland. After
M. Goldstein &
K. Dresdner, 1935.

the added name and the father's name of the man who made it; but also: "The work of my hands
and not for my glorification, the little [in the sense of unpretentious] so-and-so, son of so-and-
so [family name], of the holy congregation such-and-such of [place]." Although undoubtedly
very proud of his achievement, the devout folk artist took pains to "walk humbly with his God"
and to proclaim this in his signature. Others simply say that the work was "Made by so-and-so,
son of so-and-so [family name], may the Almighty protect and guard him." The date, if given, is
more usually incorporated as a chronogram in the signature text, with dots above those Hebrew
letters whose numerical values total up to the number of the Jewish year.

These often amazingly sophisticated compositions were cut with a sharp knife into a sheet
of white paper resting on a wooden board. They were almost always symmetrical; that is, they
were designed on one half of a sheet of paper folded vertically in two, or occasionally folded
again horizontally, and cut out through both halves (or quarters) so that on being opened out,
a mirror image was revealed. Inscriptions and some of the decorative elements were added to
uncut spaces of the opened-out design, providing visually interesting departures from absolute
symmetry.

The papercuts, frequently cut from white, standard-size commercial sheets or copybook paper
(although there are also several very small and very large ones), were sometimes left as they were
and mounted on a colored background. More often, they were colored in parts with water paints,
inks, or crayons, and some of the figures were outlined in pen or pencil, or had details and shad-
ing drawn in. Underlaid contrasting backgrounds could be of plain or colored paper — blue
being the most popular color in Eastern Europe.

Most of the known Sephardi papercuts from the Maghreb and the Ottoman-Turkish prov-
inces are cut out of, or mounted on, fancy gilt-embossed papers. A few of these works that have
survived are quite large, reaching up to one meter (40 inches) in height or width. Some are made
up of smaller units pasted together to form the entire composition, with underlays of paper-
thin copper foils painted in garish metallic purples, pinks, greens, and silver (Figs. 2.4, 3.2, 3.41,
5.27, etc.).

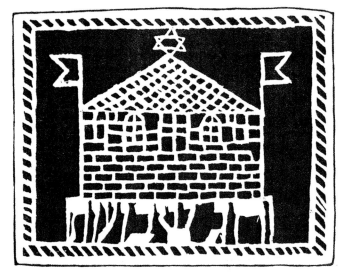

2.12

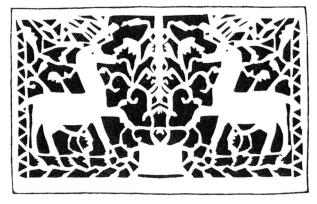

2.13

(LEFT) 2.12. *Shavuosl* from Kock (Siedlecki district, north of Lublin). After R. Liliental, 1908.

(ABOVE) 2.13. *Shavuosl* from Jarczów (Tomaszowski district, Lublin province). After R. Liliental, 1908.

2.14. *Shavuoslakh.* Horsemen and coach. Compare these with the gentile Polish papercut of a horse and wagon in Fig. 1.23. After R. Liliental, 1908.

2.14a

2.14b

2.15a

(ABOVE AND RIGHT) 2.15. *Shavuoslakh* from Galicia. (*a*) 16.8 ×
15.4 cm. (6⅝" × 6¹/₁₆"). (*b*) 17.7 × 10.5 cm. (6¹⁵/₁₆" × 4⅛").
Yitzḥaq Einhorn Collection, Tel Aviv.

2.15b

Many of the Ashkenazi papercut designs are highly complex with improbably thin intersect-
ing lines, the entire papercut nevertheless remaining in one gossamer piece (*miqshah aḥat* in
Hebrew, and see p. 232). Dividing the layout into two or more horizontal registers, and more
rarely vertical ones as well, has the effect of stabilizing the work compositionally. Calligraphic
texts are all-important: there are very few Jewish papercuts — either Sephardi or Ashkenazi —
without inscriptions.

A hierarchic arrangement of the various symbols, with the most important ones occupying
the central areas of the composition, precludes realistic representation of space. The margins
and borders are usually wide and constitute an important part of the entire papercut. Often, they
are composed, as are the less important areas of the central sections, of geometrical repeat pat-
terns, vines, tendrils, and floral elements, sometimes with birds or animals among the foliage.
In this regard, reflecting Islamic iconographic and artistic principles, the Sephardi papercuts are
almost entirely devoid of animal figures — let alone human representations — with only an
occasional bird within the stylized vegetation.

2.16. *Shavuosl.* A very competent, unfinished work collected by Shlomo Yudovin in Podolia in 1938, probably made by an older yeshivah student rather than a young *ḥeder* boy. The conception, graphic design, and precise execution are on a qualitative par with the "classic" devotional Jewish papercuts. The double eagle indicates a pre-World War I dating. Photo: courtesy Giza Frankel Archival Collection, Jewish and Comparative Folklore Department, The Hebrew University of Jerusalem.

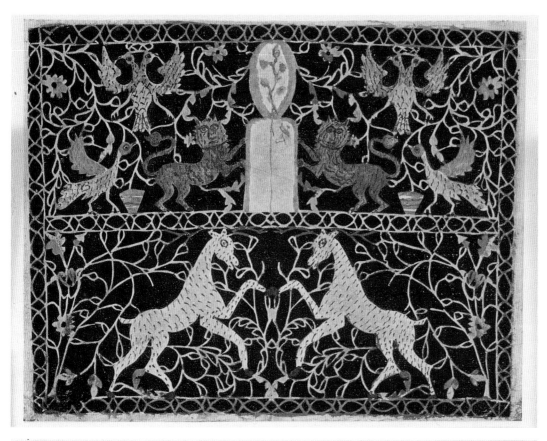

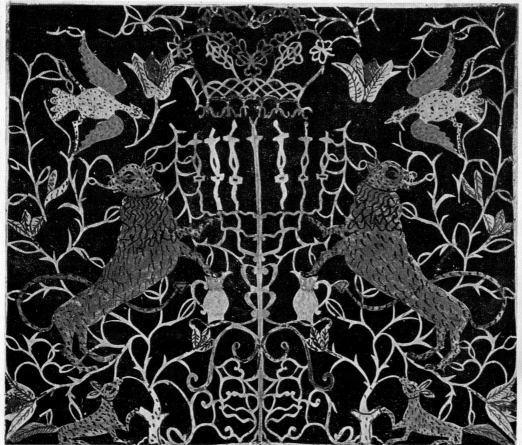

2.17. *Shavuoslakh.* Two rare, early color reproductions of Jewish papercut work from Przytyk in the Radom district (northwestern Galicia). Although no inscription appears on the lower one, and only the Hebrew letter *aleph* can be made out on the simplified tablet of the Decalogue on the upper one, the style, the animals and birds, and the overall haphazard treatment unmistakably identify these as East-European Jewish work — probably elaborate *shavuoslakh.* After R. Liliental, 1908.

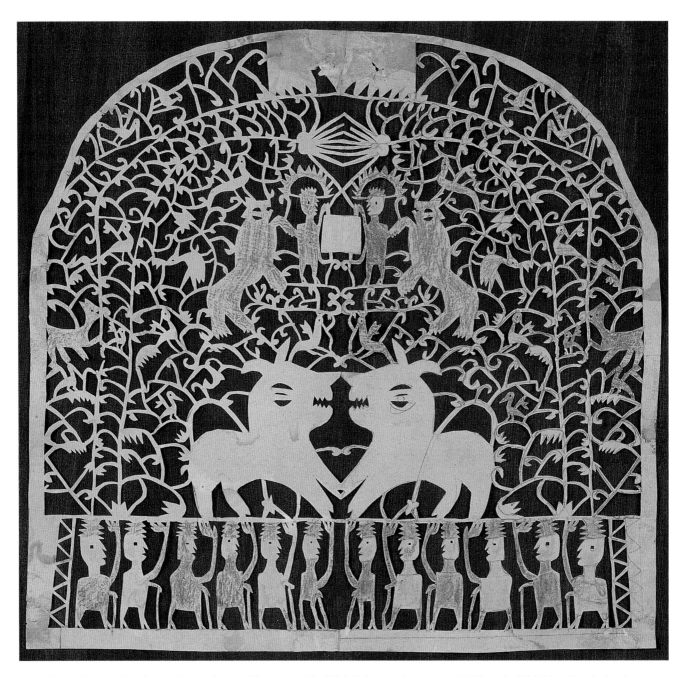

2.18. *Shavuosl*. We wish we knew where, when, and by whom this delightful *shavuosl* was created. Although childishly whimsical and "primitive," it attests a marvelous, intuitive sense of good design and is entirely satisfying visually. See if you can discover the twenty-two birds (eleven on each side) among the delicate vines! The scene undoubtedly represents the giving of the Law (in the form of a Torah scroll!) to Moses and Aaron on Mount Sinai as related in Exodus 19:24. The twelve tribes of Israel camped at the foot of the holy mountain are represented by the twelve figures, staff in hand.

It may just be a curious coincidence, but in 1924, the Viennese physician, Dr. Josef Reizes who, among other Jewish folk art, collected *shavuoslakh*, told of acquiring a *shavuosl* depicting Moses and Aaron at Mount Sinai from an elderly Jew who had just finished cutting it. Reizes noted that the man had a peculiar look — a mixture of fear at having committed a transgression by depicting human figures, and of childish pleasure at the joke. And why the lions? In Jewish folk and religious art — papercuts in particular — it's invariably "lions with everything!" (but see the explanation on p. 97).

What is really significant about this work is that it may well exemplify a development from simple, childish folk *shavuosl* papercuts to the more sophisticated, devout creations whose origins and evolution we try to fathom in these pages. 27.5 × 28.8 cm. (10¹³⁄₁₆" × 11⅜"). Yitzḥaq Einhorn Collection, Tel Aviv.

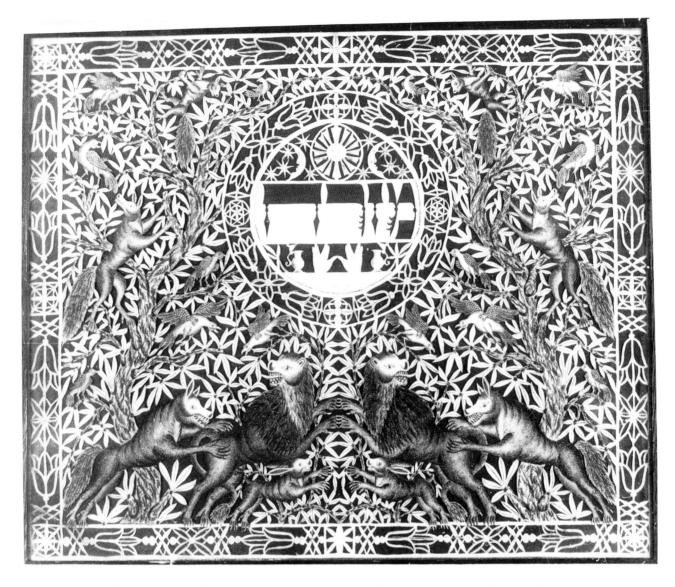

2.19. *Mizraḥ*. Exhibiting horror vacui in its tight treatment, the composition features many carefully detailed and shaded animals (lions, wolves, rabbits, foxes, squirrels, birds) among profuse foliage, recalling Persian decorative work or medieval woven textiles. The central medallion, in which the word *mizraḥ* is lettered large, also features the sun, crescent moons and stars, blessing priestly hands, and oil jugs. Below these, a faded, now almost illegible inscription in cursive German reads: "Made by and obtainable from Elias Dankhauser Sohn [son] and in Horbourg near Colmar, 1822." The text supports the contention that paper and parchment *mizraḥim, megillot esther*, amulets, and other items were made by scribes for sale by itinerant peddlers, and indeed, another very similar papercut, with the same inscription, is known from an old photograph in the old Bezalel Museum archives. These are among the westernmost European Jewish papercuts known to us, which may explain the absence of the rich Jewish iconographic figures so characteristic of Eastern European Jewish folk and ritual art. 32.5 × 44.3 cm. (12¾" × 15⅞"). The late Robert Weyl, Strasbourg.

The central elements of the compositions are often architectural, with ornate columns, arches, and balustrades. In many instances, metal or cardboard templates and coins were employed to trace more even repeat patterns in borders and in other recurring elements of the design. In some papercuts, animal figures that were hard to draw were cut out of printed pictures and pasted into the composition. Most of the Jewish papercutters had no formal artistic training. They aimed at naturalistic representations, shading some of the two-dimensional figures; but their drawing is usually naive, with no foreshortening or perspective. These works generally have a flat, decorative quality, with color applied whimsically.

As in Islamic art, and much of folk art generally, Jewish papercut compositions show a horror vacui — aversion to empty space — and the intricate designs also hold the delicately cut paper picture together in one piece. But unlike the endless, repetitive arabesques and geometrical patterns of Muslim art, which to a certain extent also characterize some of the Sephardi works, Jewish papercuts of Eastern and Central Europe embody an ebullient outpouring of figures, ritual objects, and traditional symbols all intertwined with religious inscriptions. Such Jewish papercuts vary greatly in form and decorative configuration, and even when more than one cut was made from the same design, the final result was inevitably different because of the improvised finishing touches applied by the folk artist.

Most Jewish ceremonial art is essentially symmetrical in design. Symmetry is the simplest and most satisfying form of artistic balance. It characterizes much of European and Middle Eastern folk art. Silversmiths, woodworkers making shrines for the ark in the synagogue, embroiderers designing Torah mantles and curtains for the ark, and carvers of tombstones all used paper patterns or stencils cut on a fold from which the design was transferred to the material to be worked — sewn, embroidered, cast, embossed, engraved, sawn out, or carved. We can only speculate whether papercuts evolved originally from such working patterns, or whether they were inspired by ceremonial objects so crafted and by architectural elements of the synagogue.

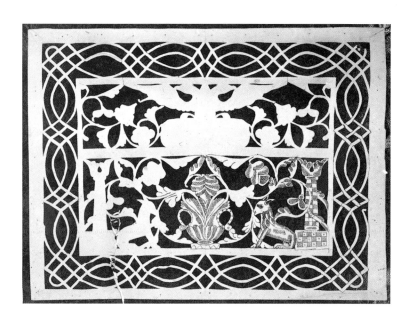

2.20. *Mizraḥ*? A quite simple, unfinished papercut collected by Shlomo Yudovin in Podolia in 1939, featuring the essential classic elements: two horizontal registers, the double-eagle, columns, deer?, the vegetation (Tree of Life) growing out of an ornate urn, a central medallion for the key inscription, probably "*mizraḥ*" — all within a decorative linear border design. The double eagle bespeaks a pre–World War I dating. The drawn-in detailing was never completed. Photo: courtesy Giza Frankel Archival Collection, Jewish and Comparative Folklore Department, The Hebrew University of Jerusalem.

2.21. Templates. Not every papercutter was good at drawing. One way to overcome this deficiency was to paste pictures of animals and complex decorative patterns from printed pages on cardboard, cut these out and use them to trace the papercut design. These plain cardboard templates were made and used by Arieh Skolnick of the Bronx (see p. 196). Penina Skolnick-Halevy, Kibbutz Ḥatzor-Ashdod.

Being true folk creations, Jewish papercuts were made for a closed group or society. Just as Chinese or Mexican papercuts and Turkish or Greek shadow theater figures are unmistakable and can be spotted at a glance among any international selection of cut-out work, so traditional Jewish papercuts are also readily identifiable — not only because of specifically Jewish symbols and inscriptions, but also by their special character. And this is true despite any non-Jewish influences.

For example, some Jewish papercuts from regions of Germanic culture, especially those dating from the early nineteenth century (we have very few earlier ones) include secular German folk motifs: human figures in peasant dress, landscapes, animals, hunting scenes, and the like. These non-Jewish motifs, however, are almost invariably relegated to the decorative borders and secondary space, and do not dominate the central themes, which are always recognizably Jewish. So, for example, in the cut shown in Fig. 8.8c, dated 1818, the two "Jewish" lions hold a typical Germanic heraldic shield on which the Hebrew word *mizrah* is lettered.

Moreover, many Jewish papercuts — not only of Germany proper, but also of Alsace, western Poland, Bohemia, Slovakia, and Austria-Hungary — show some affinity in their decorative background and border designs, as well as in their coloration, with popular types of Germanic papercut *Andachtsbilder* (devotional pictures), *Liebesbriefe* (love letters), and others described in the previous chapter. This is noticeable mainly in the treatment of floral elements, vines, and small animal and bird figures, and also in some of the geometric patterns. In view of the universal popularity of papercuts in Germany and the adjacent lands in the eighteenth, nineteenth, and twentieth centuries, Jews were undoubtedly familiar with them and adapted the technique to their ends.

2.22. *Mizraḥ* and *Sukkah* Decoration. Shmuel Eliezer Singer created these charming, naive designs that repeat the basic conception and details. Date and exact provenance are unknown, but most probably from Slovakia or the Carpathian Mountains region. (*a*) 35.7 × 43 cm. (14¹⁄₁₆" × 16¹⁵⁄₁₆"). (*b*) 33.5 × 41 cm. (13³⁄₁₆" × 16¹⁄₈"). Jewish Museum, Prešov, Slovakia.

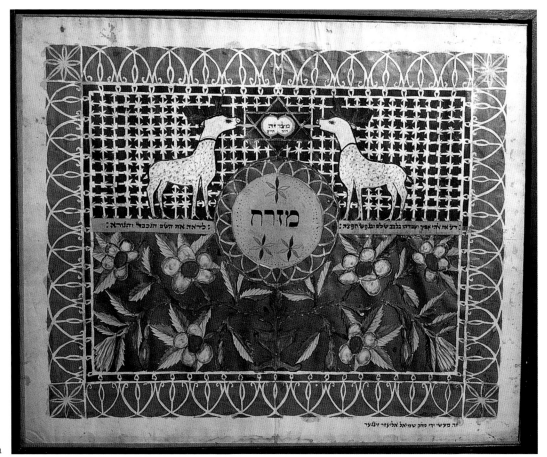

2.22a

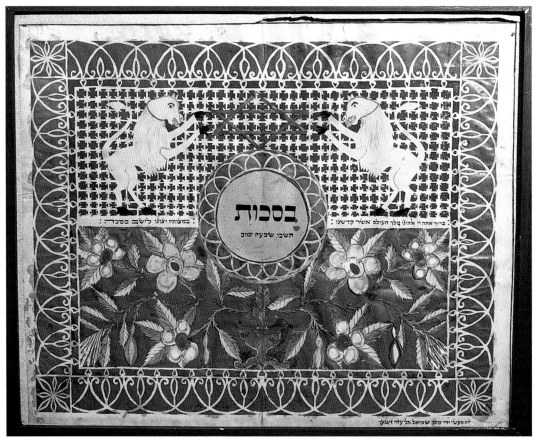

36

2.22b

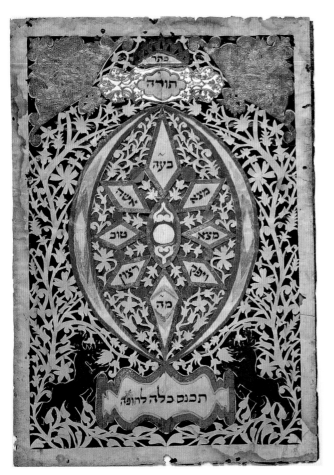

2.23. Blessing for Marriage. Machine-embossed, gilt papers are combined with the hand-cut parts of the composition, made around the turn of the twentieth century in Turkey. The stylistic treatment of the vegetal motifs, and indeed the entire conception, resembles some contemporaneous non-Jewish Turkish papercut work. The central design is a crescent-and-star inscribed with: "With the help of the Almighty." "Whoso findeth a wife findeth a great good, And obtaineth favour of the Lord" (Proverbs 18:22). The small blue crown at the top bears the words "Crown of Torah"; and at the bottom, the escutcheon maintained by the two blue deer reads "Let the bride enter under the wedding canopy." The deer are unusual in Sephardi Jewish iconography. Here, they may have been intended to evoke passages in the Song of Songs (2:9 and 8:14) comparing the bridegroom to "a gazelle or a young hart." 43 × 30 cm. (16¹⁵⁄₁₆" × 11¹³⁄₁₆"). Israel Museum, Jerusalem.

(BELOW AND RIGHT) 2.24. Papercuts as Patterns. Symmetrical patterns used by artisans — woodcarvers, silversmiths, jewelers, embroiderers — are most conveniently cut out of folded paper. Jerusalem silversmith Benjamin Ben-Zazon, who came from Morocco, cuts a shape to be fret-sawed or engraved in metal. The same technique must have been used in preparing the prototype pattern for items such as the (unfinished) sheet-metal Menorah amulet (c) (from the collection of Dr. Paul Dahan in Brussels), and molds for cast-bronze Ḥanukkah lamps as this one from Poland (b) (now in the Mishkan le-Omanut, Museum of Art at 'Ein Ḥarod).

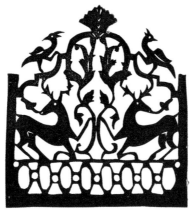

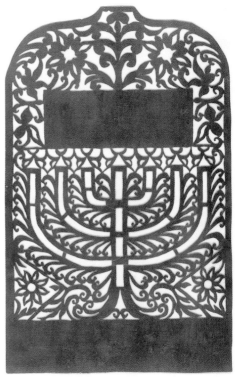

2.24a

2.24b

2.24c

2.25. *Parokhet*. Compare the overall conception, the symmetrical composition, and the symbols in this sumptuous embroidered velvet and brocade Torah ark curtain made in 1772 by a Jewish embroiderer in Bavaria, with Central and Eastern European Jewish papercuts. 213.4 × 163.8 cm. (84" × 64½"). Jewish Museum, New York (F 1285a). Gift of Dr. Harry G. Friedman.

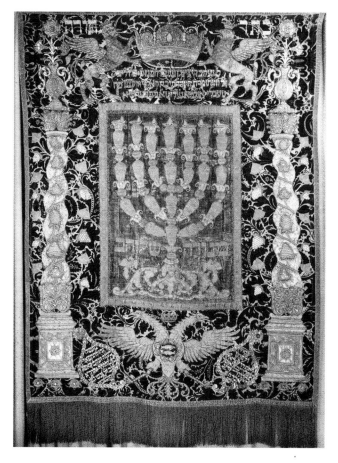

2.26. Unfinished Blank. Although there is nothing — no inscriptions or readily recognizable Jewish symbols such as a menorah, the tablets of the Law, or star of David — that might identify this unfinished papercut as Jewish, there can be no doubt that this is a European Jewish work, probably a *kimpetbrivl* amulet. The style and conception are unmistakable. But look closely at the four corners! The eye of a Jew steeped in traditional lore will immediately recognize the Four Animals of the aphorism of Judah ben Tema — the gazelle (deer), lion, leopard, eagle. 21 × 17.5 cm. (8¼" × 6⅞"). Jewish Museum, Prešov, Slovakia.

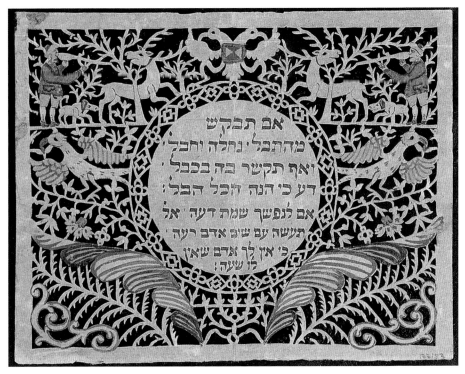

2.27

2.27. Memento Mori.

Although pithy sayings are frequently inscribed on Jewish papercuts, they are seldom the central theme, as is the case here. This small papercut, probably from Central Europe and made in the nineteenth century, bears a quaint text in the central medallion:

> If you seek in the world a place to settle,
> And even tie yourself to it with a rope,
> Know that all is for nought.
>
> If to your soul you would give direction,
> Do not do evil to anyone
> For there is no man whose hour will not come.

The hunting scene in the upper register — hardly a traditional Jewish theme — occurs only on papercuts from German-speaking regions. Apart from the Hebrew inscription, the only clearly Jewish element in this papercut is the small menorah at bottom center. 14.5 × 18.9 cm. (5¾" × 7½"). Feuchtwanger Collection, purchased and donated to the Israel Museum, Jerusalem, by Baruch and Ruth Rappaport of Geneva.

2.28

2.29

2.28. German-Swiss parchment *Spitzenbild*, mid-eighteenth century. The theme is secular. 7.7 × 3.9 cm. (3" × 1½"). Museum der Kulturen (Abteilung Europa), Basel.

2.29. Blank *Spitzenbild*. Christian cut-out lace-pictures, as also some Jewish papercuts, were sometimes made as blanks to be filled in by the purchaser with an image and inscription according to his or her religious or secular inclinations.

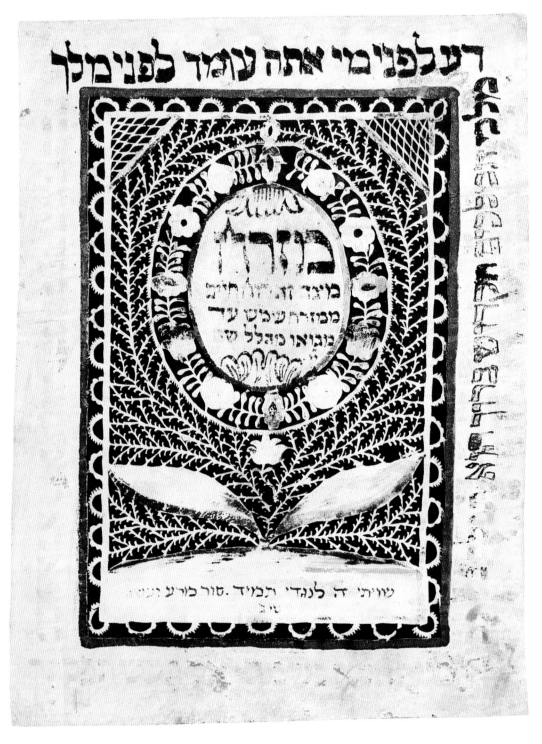

2.30. *Mizrah/Shiviti.* An adaptation to Jewish use of a Germanic Christian *Spitzenbild* blank cut in parchment. 18.3 × 13.5 cm. (7¼" × 5⁵⁄₁₆"). Jewish Museum, Prešov, Slovakia.

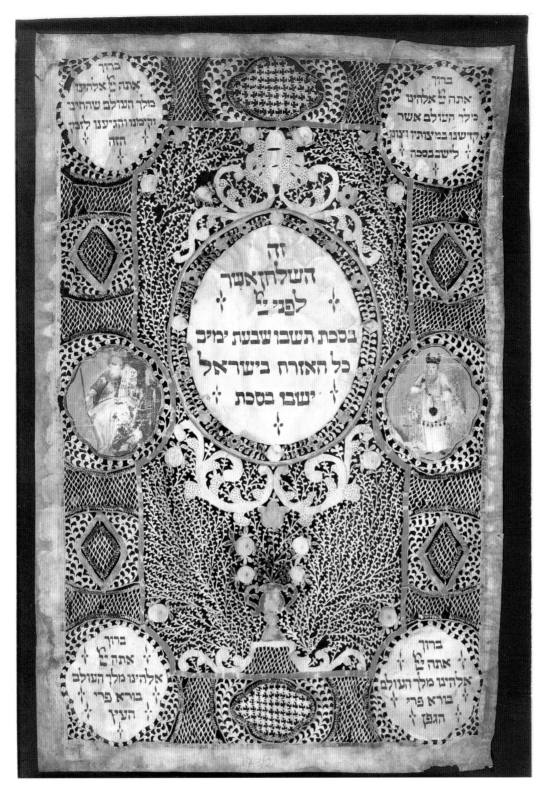

2.31

2.31. *Sukkoth*. The main prayers to be said in the *sukkah* are inscribed in the five medallions of this large, painstakingly cut out parchment item. The style, conception, and technique differ radically from most other Jewish paper-cuts. Except for the Hebrew inscriptions, no Jewish symbol of any kind forms part of the cut design. The two vignettes representing Moses and Aaron are obviously derived from Christian sources: the Tablets of the Law held by Moses have Latin numerals reading from left to right rather than the Hebrew alphabetical numbers ranged from right to left. Although we do not know when and where this work was made, it is clearly an adaptation of large-size Germanic eighteenth or early nineteenth century Catholic *Spitzenbilder* as in Figs. 1.5, 1.6a–b, 2.28, 2.29. The central inscription, "This is the table that is before the Lord" (Ezekiel 41:22), suggests a Bohemian or Moravian origin. (See Figs. 5.28, 5.30). 32 × 21.2 cm. (12⅝" × 8⅜"). Israel Museum, Jerusalem.

(RIGHT) 2.32. *Shiviti* in the style of small West/Central-European Catholic *Andachtsbilder* (devotional pictures) cut in parchment and usually kept between pages of prayerbooks. This one was indeed found in a *siddur* printed in Amsterdam. The text in the oval beneath the menorah is Numbers 8:4, "And this was the work of the candlestick, [in one piece — "*miqshah*"] beaten work of gold . . . according unto the pattern which the Lord had shown to Moses. . . ." As in the entire parchment-cut, the figures of Moses and Aaron flanking the menorah show direct influences from Christian motifs that were widely adopted by Jews of the Germanic regions in their ritual and folk art (but see also the North-African works in Figs. 4.22a–b). Exact provenance and date (eighteenth century?) are unknown. 8.5 × 5.5 cm. (3⁵⁄₁₆" × 2³⁄₁₆"). Gross Family Collection, Ramat Aviv.

(FAR RIGHT) 2.33. *Shiviti*. Nor do we know where and when this tiny (reproduced here in actual size) colored, Jewish parchment-cut was made. It was purchased in Rotterdam in 1940 by a Dutch collector of *Spitzenbilder*. The arms of the menorah merge with vegetal motifs. The standard *shiviti* text (Psalm 16:8) is inscribed over the menorah and is repeated in the side margins. 7 × 4.5 cm. (2³⁄₄" × 1³⁄₄"). The late Hans Peskens, Bossum, Holland.

2.34. *Shiviti*/Amulet. A very attractive, small parchment-cut that suggests its derivation from the *Spitzenbild* genre. As usual in both Ashkenazi and Sephardi work of this type, the menorah is inscribed with the seven verses of the sixty-seventh Psalm. Most of the other inscriptions are standard kabbalistic formulas, including the *SAMUT* and *ATLAS* acronyms. The upper verse in the dividing band between the two registers is from Psalm 36:10: "For with Thee is the fountain of life; In Thy light do we see light." Provenance and date are unknown, but this work probably comes from the general region of Bohemia, nineteenth century. It is regrettable that the inscription in the outer margins is hidden by the framer's mat. 12 × 10 cm. (4¹¹⁄₁₆" × 3¹⁵⁄₁₆"). Židovské Muzeum Praha, Prague.

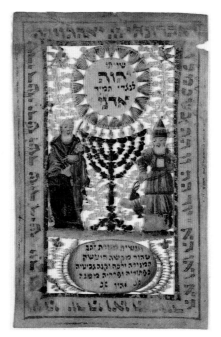

2.32

2.33

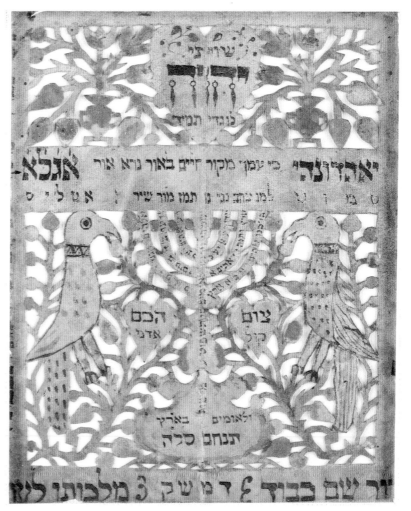

2.34

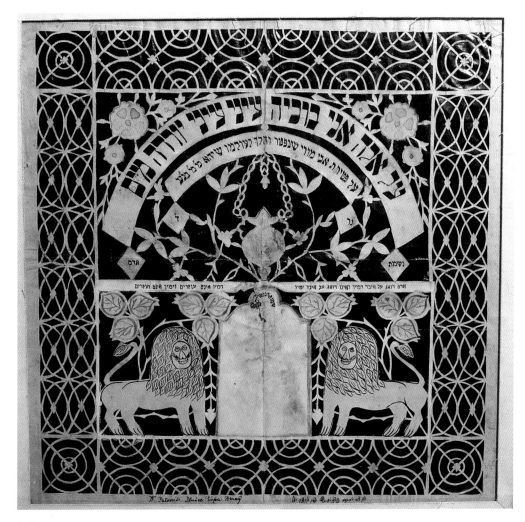

2.35

2.35. *Yortzait*. Tzvi Avigdor Palkovits from Ilnice žúpa Bereq(?). "May He protect his going out and coming in" is hand-written in the bottom margin in Hebrew and German. The two mustachioed, very human faced lions flank the memorial tablet commemorating the death of his father, on which the inscription has either faded completely, or was never filled in. The text in large letters in the upper arch is from Lamentations 1:16: "For these things I weep; Mine eye, mine eye runneth down with water." 32 × 32 cm. (12⅝" × 12⅝"). Jewish Museum, Prešov, Slovakia.

One looks in vain, however, for parallels between the traditional, late nineteenth-century Polish peasant *wycinanki* (cut-outs) and the complex, intricate Jewish papercuts of the same regions. It is true that some of the simpler *shavuoslakh* and *roizalakh* are similar in concept and appearance to certain types of Polish papercuts (except, of course, for their Jewish themes). Considering that Jews and Poles lived in close proximity to each other, they surely must have exercised some mutual influence.[12] But the more serious, "classic," Jewish papercuts from Poland, Galicia, and the Russian pale of settlement have a clearly distinct character and most definitely do not reflect the traditional gentile folk art of the country (Figs. 1.23a–c).

Our reference to the lions in Fig. 8.8c as "Jewish" requires explanation. Many of the faces and facial expressions of animals appearing on Central and East-European Jewish folk and ceremonial art bear striking human traits. Often these are humorous and almost invariably quite charming.[13] The representations are usually naive, but attest to an intuitive esthetic sensitivity. The designs and compositions, as well as the detail and coloring, frequently show remarkable sophistication of concept and planning. The East-European Jewish papercuts of the eighteenth to the early twentieth century epitomize the special character of this particular folk art.

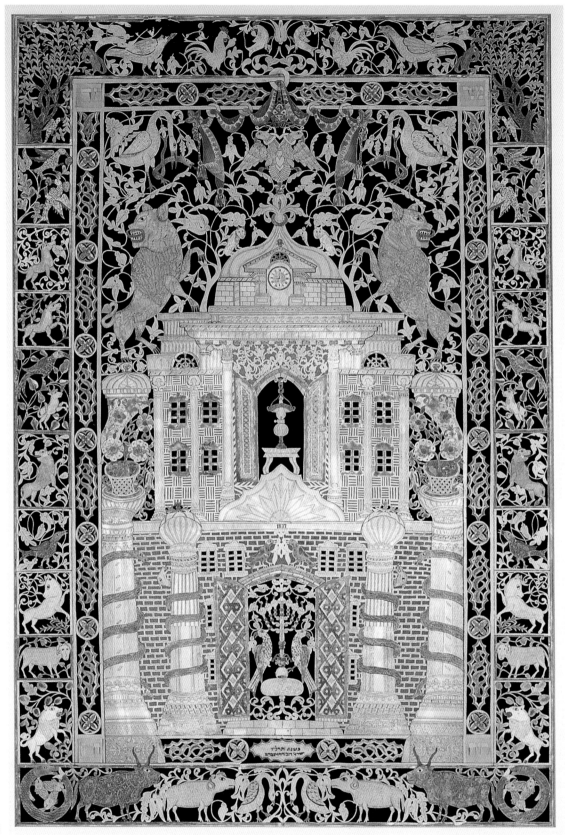

2.36

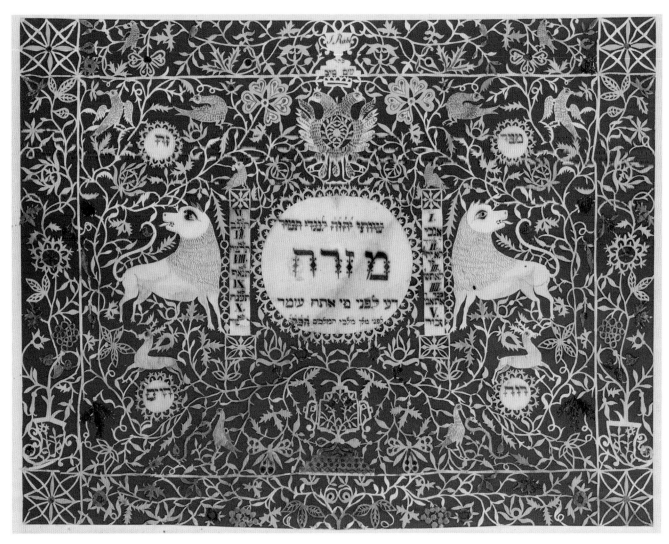

2.37. *Mizraḥ/Shiviti*. As usual, the purpose of this delicate work is clearly stated in the central medallion: "I have set the Lord always before me" (Psalm 16:8); *mizraḥ*; "Know before Whom you stand, before the King, King of Kings, the Holy One blessed be He" (Berakhot 28:1). The first word of each of the Ten Commandments is inscribed under the appropriate (Latin) numerals on the small columns flanked by the lions. In the four small medallions is the formula "From this direction the spirit of life" synonymous with the word *mizraḥ* (east) as explained on p. 57. The "Four Animals" aphorism is here represented by the lions, deer, and eagle. Note the cornucopia in the side margins from which grows the Tree of Life. Above the double-eagle is a small crown inscribed with the words "Crown of a good name" (see p. 91), and in the urn above it, the name in German of the man, J. Rab, who created this lovely, devotional papercut. 32.3 × 41 cm. (12¹¹⁄₁₆" × 16¼"). Židovské Muzeum Praha, Prague.

(OPPOSITE PAGE) 2.36. *Mizraḥ*. A large, finely drawn masterpiece in cut paper made in 1877 by Israel Dov Rosenbaum in Podkamien(?) (Ukraine?). Among the eclectic, symbolic bestiary, all the "Four Animals" of the aphorism of Judah ben Tema (Pirqei Avot 5:23) are concentrated near the top of the composition: the "bold" leopard (on the domed roof of the clocktower), the (double) eagle above, the "fleet" gazelle or deer (in the margin), and the "powerful" lion (between the gazelle and the leopard). Note Leviathan (in the lower corners) and the long-horned Wild Ox (*shor ha-bar*) next to it; and unicorns in the margins, beneath the deer. The stylish kerosene lamp in the center represents the *ner tamid* (eternal light). Rosenbaum was remembered in the family as the clockmaker to the local nobleman (whose palace may have served as the architectural inspiration for the composition?). 77.6 × 53.3 cm. (30⁹⁄₁₆" × 21"). Jewish Museum, New York (1987-136). Gift of Helen W. Finkel in memory of Israel Dov Rosenbaum, Bessie Rosenbaum Finkel, and Sidney Finkel.

2.38. *Shiviti/Menorah.* No one familiar with the Ottoman baroque style could have any doubts about the provenance of this highly ornate work, dated 1858/59. Around the large, central crowned menorah are typical Turkish floral patterns replete with tulips. Note the crescents-and-stars in the palms of the inscribed *yadayim* (*ḥamsa*s) warding off the evil eye, with the fingers spread in the manner of the priestly blessing. Ritual texts and kabbalistic cryptograms are everywhere. Although, except for birds, animal and human forms are rare in Sephardi folk art, note the partly covered-up lions beneath the hands at the lower corners and the inscription: "Judah is a lion's whelp" (Genesis 49:9) above them. Machine-embossed, gilt, and other printed papers are combined in collage work with the cut-out parts of the design. Except for a few elements of the composition, this papercut is not really symmetrical. 71 × 43 cm. (28" × 17"). Israel Museum, Jerusalem.

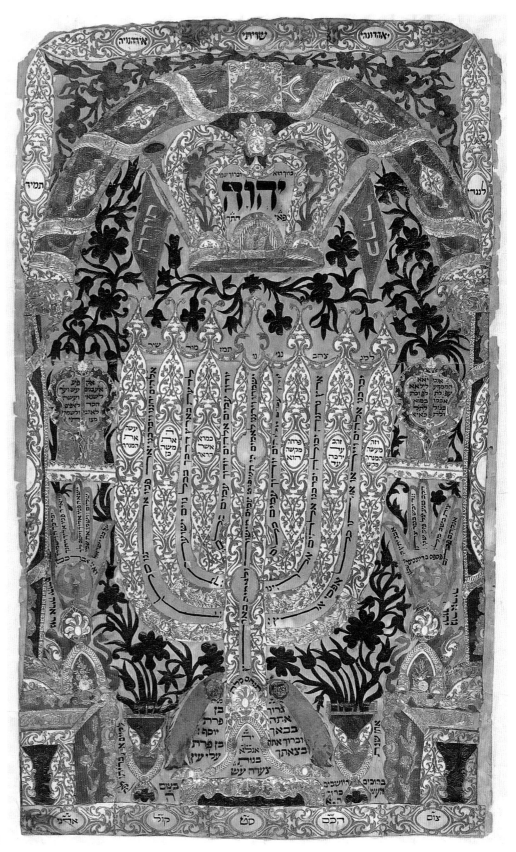

2.38

The Jewish Baroque

The artistic treatment of traditional, specifically Jewish symbols and lettered texts, together with the use of certain decorative elements derived from a variety of sources, justify the designation of a recognizable "Jewish Baroque" style.[14] It is naive and exuberant, but also disciplined in a haphazard way. It is decidedly baroque in its obvious appeal to the emotions, its fluidity of movement, florid designs, freedom of line, and richness of motifs — all within a formalistic symmetrical composition. The Jewish Baroque style (perhaps "feeling" or "mood" would be more apt) marks the Central and East-European Jewish papercuts throughout at least a century and a half. Contemporaneous Jewish religious art, including papercuts, of the Balkans and Turkey reflects the more decorous Frenchified Levantine Baroque style that permeates so much of later Ottoman art and architecture. Thus, unlike the Ashkenazi work, Sephardi papercuts from these regions tend to be more formal and rigid in concept and execution.

How and when did this peculiar style evolve among the Jews of Central and Eastern Europe? To what extent was it influenced by the cultural environments in which they lived? These questions are, of course, relevant also to most Jewish ceremonial art of the region and period. Since papercut patterns, as we have seen, were often the generators of objects made of more durable materials, examining them more closely may provide some clues.

We have remarked how certain of the secondary decorative motifs, such as vines, tendrils, and small animal figures, may show the influence of Germanic folk papercuts (Fig. 1.14). But there can be no doubt about the affinity of the overall composition of many of these papercuts with the elaborately carved, baroque, wooden *aronot qodesh* (Torah shrines) of East-European

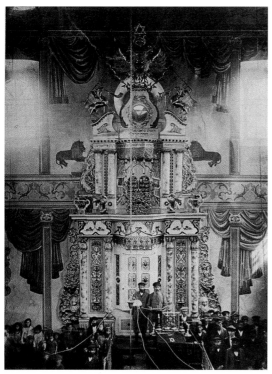

2.39a

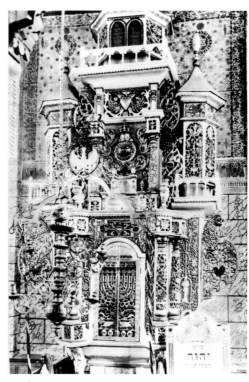

2.39b

2.39. Caption overleaf.

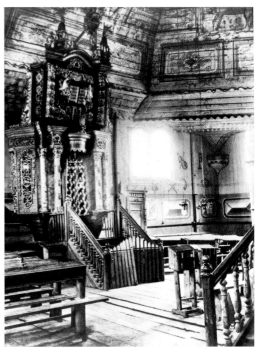

2.39. Torah Shrines (*aronot qodesh*) in eastern walls of wooden synagogues were often elaborate, monumental structures of wood, with intricate, painted baroque carvings. They were the focus of the synagogue, marking the direction of prayer by the worshippers. They incorporated the full range of symbols and textual inscriptions that inspired the *mizrah*, *shiviti*, and *menorah* papercuts. Most of those that had somehow survived fire and pogroms were finally destroyed in the Holocaust together with the communities that cherished these devout architectural creations. The schematic drawing (*d*) represents a typical *aron qodesh* and bimah structure in Ashkenazi synagogues. (*a, b, c*) Archives for the History of the Jewish People, Jerusalem. (*d*) After *Yevreyskaya Entsiklopediya*, St. Petersburg, 1906–1913.

2.39c

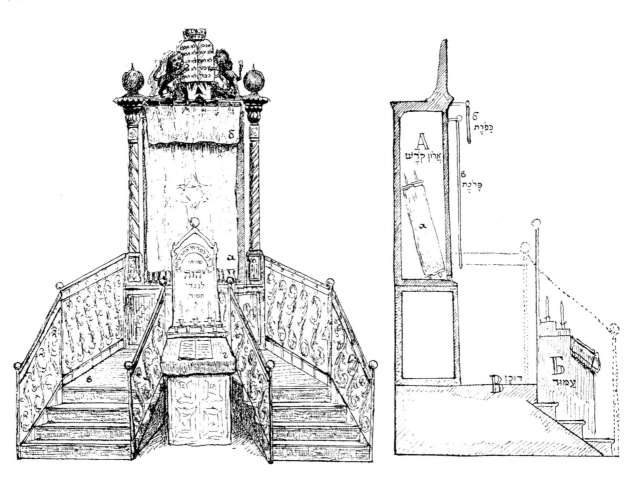

2.39d

synagogues that evoke the Holy of Holies of the ancient Temple in Jerusalem. How did Italianate baroque influences permeate the remote *shtetlakh* (townlets) of Poland, White Russia, the Ukraine, and Galicia, and shape so much of the Jewish artistic esthetic there?

This question has intrigued students of Jewish folk art ever since the subject began to arouse academic attention. A plausible explanation was offered by the Russian-Jewish painter El Lissitzky (1890–1941), on the occasion of his visit in 1916 to some of the old wooden synagogues in the region of Mogilev-on-the-Dnieper in White Russia.[15] The interior walls and ceiling of the Mogilev synagogue were covered with a rich profusion of vignettes, motifs, inscriptions, and decorations painted in bright primary and secondary colors: red, yellow, blue, green, violet, and black on a white background. Lissitzky was overwhelmed by the effect of this masterpiece of Jewish Baroque and by the artistic genius of the painter who signed himself Ḥayyim Yitzḥaq ben Eiziq Segal. The work was completed in 1740. Lissitzky summed up his vivid description of the painted wooden synagogue of Mogilev in these words:

Where does this art come from? Where did this Vulcan [the artist] drink in order to pour himself out in such a magnificent manner? Let the scholars seek and creep about in the sea of art history — I can only impart what I have seen myself. In every synagogue there is always a small library. In the old synagogues, the books in the cupboards are old editions of *gemaras*, *ḥummashim*, and other works, with splendid frontispieces and with a few decorations and vignettes throughout the printed text. These pages once served the same function as our illustrated journals in acquainting people with the latest art styles. I once saw a tombstone with a carved bas-relief of a bear standing on its hind legs and embracing an ornamental, flowering acanthus. In a heap of old books printed in Amsterdam in the sixteenth and seventeenth centuries, in the attic of the Druya synagogue, I came upon an end-paper with this exact motif. There can be no doubt that the sculptor of the tombstone was influenced and guided by this picture. Another example are the carvings and the entire composition of the multilevel *aron qodesh* [holy ark] of the synagogues and the Renaissance-Baroque title pages of Jewish books. The Jewish woodcarver used these title pages as models, just as architects used the *Four Books of Architecture* of Andrea Palladio and other compendiums of stylized design for decorative motifs.[16]

In the seventeenth and eighteenth centuries, Jews in Germany and Italy were often forbidden to operate their own printing shops. Jewish publishers had to produce their books in gentile printing establishments, where Jews would set the type and prepare the layout of the Hebrew books. The decorative woodcuts, engravings, and other typefaces found in these print shops were also used in the Hebrew books — to the extent that their subject matter was acceptable — in title pages, border decorations, vignettes, illustrations, colophons, and the like. There are many examples of the same cuts being used in both Christian and Jewish books. The blocks were copies of, or inspired by, the works of Renaissance artists, including Michelangelo, Raphael, and Bernini.

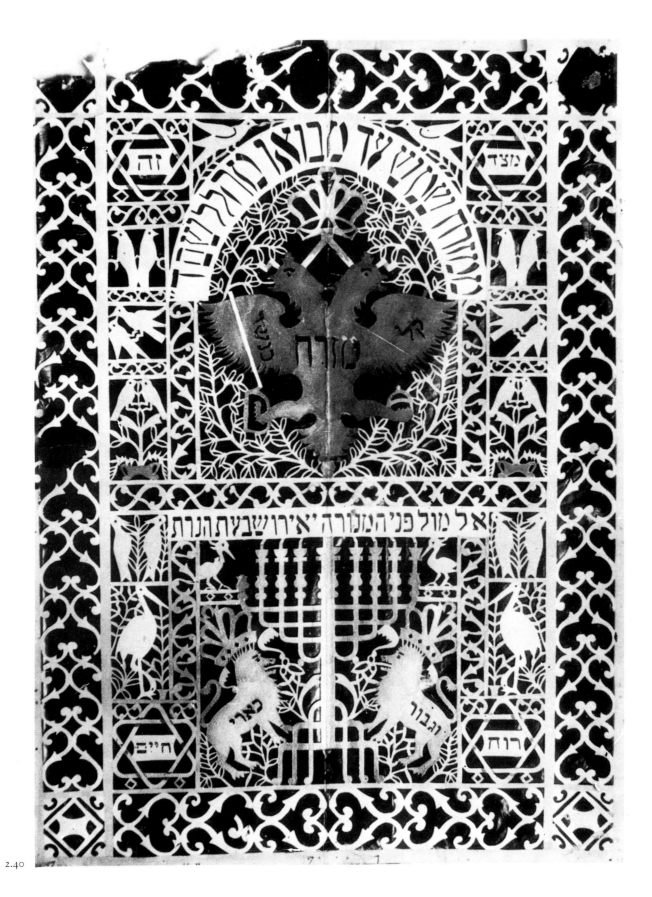

2.40

(RIGHT) 2.41. Early twentieth-century photograph of the wooden synagogue of Zabludow (southeast of Bialystok).

(LEFT) 2.42. The paintings on the synagogue walls in Mogilev-on-the-Dnieper in White Russia dated to 1740.

(ABOVE) 2.43. Entrance to the synagogue at Zarzis in Tunisia (cf. Figs. 2.4, 3.2, 3.26, 4.22, 5.27, 9.2). After Y. Pinkerfeld, 1954.

(OPPOSITE PAGE) 2.40. *Mizrah.* The structures of multi-tiered *aronot qodesh* (holy arks or Torah shrines) in the eastern walls of synagogues in Poland, Lithuania, White Russia, the Ukraine, and Galicia inspired the designs of many papercuts made to indicate the direction of prayer in the home. This old photograph shows a somewhat damaged *mizrah*, by Dawid Rosengarten, dated about 1900, from the collection of Maksymiljan Goldstein in Lvov (Lemberg). The central panel consists of two superimposed tiers or registers. In the top tier is the crowned Austro-Hungarian double eagle, having also decided Jewish symbolic connotations as explained on p. 98. The candelabrum at the bottom is not a seven-branched menorah but a Ḥanukkah lamp (originally) with eight arms and a servitor: In the synagogue, a large, brass Ḥanukkah menorah frequently stood in front of the *aron qodesh*. The heavy, inscribed arch resting on pillars at the top emphasizes the architectural quality of the composition. (See also the three-tiered composition [Fig. 8.6B] by the same artist). 59.5 × 44.3 cm. (23⁷⁄₁₆" × 17⁷⁄₁₆"). Photo: courtesy Giza Frankel Archival Collection, Jewish and Comparative Folklore Department, The Hebrew University of Jerusalem.

2.44b

2.44a

(HERE AND OPPOSITE PAGE) 2.44. Title pages of Hebrew books printed in Fürth (1798), Warsaw (1887), and Vilna (1891 and 1898) using printer's blocks with Renaissance architectural motifs. The Hebrew term for book title-page is *sha'ar* (gateway), a word having multiple symbolic meanings (see p. 93).

Moreover, during the Renaissance and later, Italian architects, stone masons, sculptors, and painters worked throughout all of Western and Central Europe, and also in Poland and Russia. Some of them were commissioned to build or remodel synagogues. In this way, Renaissance and Baroque artistic concepts and motifs passed into the consciousness of Jewish folk artists and craftsmen of remote East-European regions, who adapted and molded them to their own artistic vision and folk memories.[17]

These were probably the sources of a Jewish Baroque style of remarkable vitality. It apparently struck a warm response in the artistic soul of the shtetl dwellers, who in their daily life-style hardly evinced esthetic sensitivity. The Jewish Baroque found its grandest expression in the marvelous murals of the old wooden synagogues. It spread through the Jewish communities of Eastern Europe from the seventeenth century on, and moved back to Central Europe — to Franconia and South Germany — with some of the itinerant Jewish painters.[18]

Of all East-European Jewish ceremonial art, papercuts and calligraphic works on paper show the most direct influence of these synagogue paintings and of architectural elements such as

2.44c

2.44d

the *bimah* (reading stage) and the *aron qodesh*. Some papercuts are, in effect, two-dimensional reproductions in miniature of the eastern (*mizraḥ*) walls of synagogues in which the Holy Ark occupies the central position. By virtue of their symmetrical nature, their texture recalling fretwork and wrought iron grilles, their vivid coloration, and the cheap, easily worked and inscribed material of which they are made, papercuts were ideally suited for bringing the intimate beauty of the decorated synagogue and of the ornate *aron qodesh* into the home of every Jew. They introduced a little of the sanctity of the Holy Temple in Jerusalem into the poorest of dwellings.

Papercuts could be adapted to any religious and family occasion — marriages, births, deaths, counting the days of the Omer (the forty-nine days between Pessaḥ and Shavuoth) and indicating the direction of prayer. They were much-appreciated gifts to friends or persons to be honored, within the means of the most humble. Thousands of anonymous folk artists must have lovingly expressed deep, personal identification with their ancient heritage in the papercuts they made.

We owe our acquaintance with this beautiful folk tradition to the great popularity and ubiquity of the Jewish papercut. The immense quantities that were produced made possible the survival of the few hundred items known today. Even after the old painted wooden synagogues had been destroyed by fire, pogroms, and wars, and new stylistic influences began to affect synagogue architecture and decoration and the form of Jewish ceremonial objects, papercuts still perpetuated the Jewish Baroque tradition well into the twentieth century.

The Fate of the Jewish Papercut

Gentile friends interested in Jewish papercuts have asked us why Orthodox Jews today do not continue this long tradition so intimately connected with pious observance and expressive of deep religious faith. In effect, the practice was just about lost by the time of the Second World War. From the end of the nineteenth century, cheap lithographed and printed *mizraḥ*, *shiviti*, amulets, and similar sheets in gaudy colors, depicting holy places in the Land of Israel, the standard symbolic configurations and inscriptions, pictures of biblical characters and scenes, and portraits of revered rabbis began to replace the laboriously made Jewish papercuts in the home and in communal settings. The availability of these printed items, rather than the violent upheavals that destroyed the Jewish communities of Europe, is the most likely reason for the decline of the Jewish papercut.

2.45a

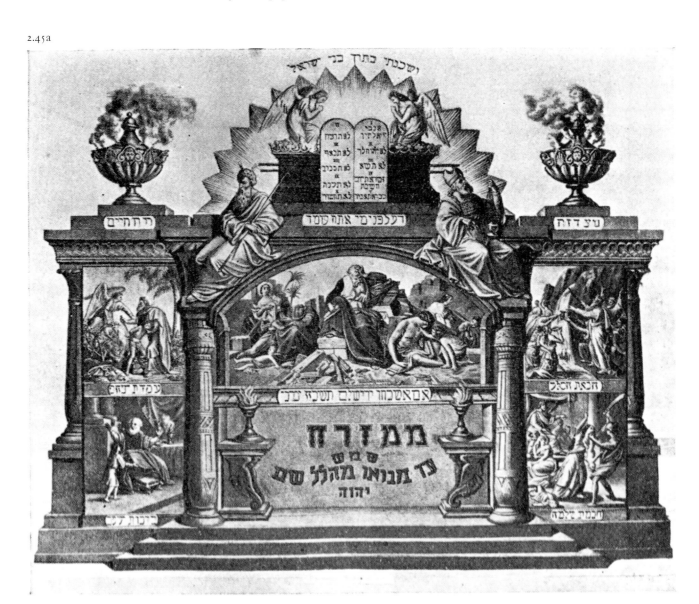

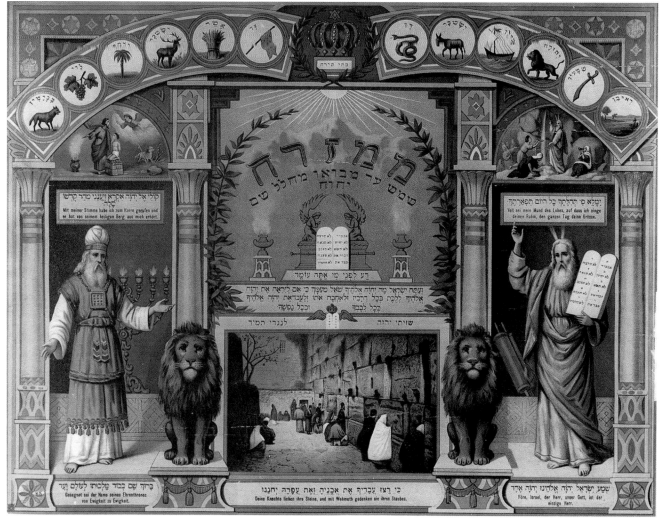

2.45b

(OPPOSITE PAGE AND ABOVE) 2.45. Color lithograph printed *mizrah* sheets (late nineteenth century). Although item (b) was apparently printed in Jerusalem in Hebrew and German, the many crass errors in the Hebrew lettering suggest that the text on the lithographic plate was most probably redrawn by a non-Jew. (*a*) After M. Goldstein & K. Dresdner, 1935. (*b*) 32.5 × 42 cm. (12¹³⁄₁₆" × 16½"). Musée Juif de Belgique, Brussels.

Nevertheless, the venerable tradition of making papercuts never entirely died out. Here and there, yeshivah students, ordinary working men, and old grandfathers devoted their spare time to this holy work and translated the intricacies of Talmudic casuistry into papercut tracery in glorification of the sacred texts and symbols. In the new lands of the Diaspora, feelings of nostalgia guided the hand of many a papercut artist. Wonderfully elaborate papercuts were made by Russian, Polish, Galician, and Rumanian Jewish immigrants to America. Some of their papercuts incorporate American eagles, the Stars and Stripes, and Masonic emblems and slogans. The designs now also begin to reflect the artistic styles of the period — Art Nouveau and Art Deco — as well as the new synagogue architecture of America.[19]

2.46. *Yortzait*. Jewish immigrant folk artists transplanted to America from Eastern Europe gradually assimilated new stylistic influences. Here, for example, is a memorial *yortzait* wall plaque, dated 1917, made by the scribe Barukh Zvi Ring (ca. 1870–1927), who apparently came to Rochester from Lithuania in 1902 or 1904. The Hebrew and Yiddish inscriptions and candles identify it as a Jewish papercut. The classic Doric columns and the decorative treatment reflect current American styles. Other papercuts by Baruch Ring are held and treasured by private owners and museums (see Fig. 4.26). This one was found in a flea market in dirty and shabby condition. 39 × 34 cm. (15⅓" × 13½"). Temple B'rith Kodesh Museum, Rochester, N.Y.

With the demise of the older generations, and with them the personal memories and associations of the Jewish shtetl and the *mellāḥ*, the Jewish papercut passed into the realm of a conscious and intellectual revival of traditional Jewish folk art. Today, papercuts are made almost exclusively by trained artists or amateurs of varying talent, among them a large proportion — if not a majority — of women. Their new interpretations reflect the individual approach and cultural background of each artist. Some of them work within the general spirit of the Jewish Baroque, albeit in modern language. The work of others is Jewish only in the subject matter and the declared identity of the artist, bearing little if any relation to the old traditional forms and symbols.

3
USES, SYMBOLS, AND INSCRIPTIONS

In the previous chapter, we mentioned in passing the subject matter and the occasions for which Jews made papercuts. In our attempts to fathom the inner world of these works, we strive at an understanding of how those who created them translated their religious and cultural heritage into visual form. We therefore go into some detail in categorizing, explaining, and querying the imagery of the Jewish papercut — much of which is true for Jewish ritual art generally.

Papercuts for Different Purposes

Very few, if any, traditional Jewish papercuts were intended as purely decorative secular creations. Usually, they fulfilled religious and mystic needs. They could be specific to any particular festival, ritual, or folk cult, or they could combine two or more such functions. Most were conceived as holy work in glorification of the Almighty. We list here some of the more common purposes of Jewish papercuts.

Mizrah

By far the most popular of traditional Ashkenazi Jewish papercuts were made to indicate the direction of Jerusalem toward which Jews face when praying: ". . . he went into his house . . . his windows were open . . . toward Jerusalem — and he kneeled upon his knees three times a day, and prayed . . . before his God . . ." (Daniel 6:11). *Mizrah* means "east" (literally, the "splendor of the rising sun"). The custom of hanging plaques bearing the word *mizrah* in the Ashkenazi Jewish home has been traced back to the eighteenth century. A *mizrah* should properly be hung on the wall facing Jerusalem; and in Jerusalem, toward the site of the Temple. But Jerusalem is southeast rather than east of Central and Eastern Europe, so that indicating the eastern wall of the home may be a survival of a Spanish-Jewish tradition (although *mizrahim* are not used by Sephardi Jews). The four Hebrew vowels — *mem* מ, *zayin* ז, *resh* ר, *het* ח — that make up the word *mizrah* have become an acronym for the phrase, *mi-tzad ze ruah hayyim* — "from this side the spirit of life." The appearance of this phrase and/or the word *mizrah* on a papercut (or any other wall marker) is what makes it a "*mizrah*."[1]

Shiviti

Shiviti (*shivissi* in Ashkenazi pronunciation) is the first word of the passage in Psalm 16:8, *shiviti adonai le-negdi tamid*: "I have set the Lord always before me." *Shiviti* plaques are often hung on the synagogue wall or set on the ḥazzan's (cantor's) reading desk below and facing the *aron qodesh*, but are also affixed to the *mizraḥ* wall of the home to serve as a guide to prayer and to remind one of the Almighty's constant presence. Many papercuts combine the *mizraḥ* and *shiviti* functions, the latter being used by both Ashkenazi and Sephardi communities.

3.1. *Mizraḥ*. The word *mizraḥ* in the central roundel is supplemented by the four Hebrew words for which it is the acronym: "From this side the spirit of life," in the smaller medallions. The crown of Torah and the menorah, the vegetation representing the Tree of Life, and the lions and deer of the "Four Animals" aphorism of Judah ben Tema are all the common, typical, symbolic configurations of European *mizraḥ* papercuts (and other such plaques). From Żólkiew in Galicia. 64 × 48 cm. (25⅜" × 18⅞"). After G. Frankel, 1929.

3.1

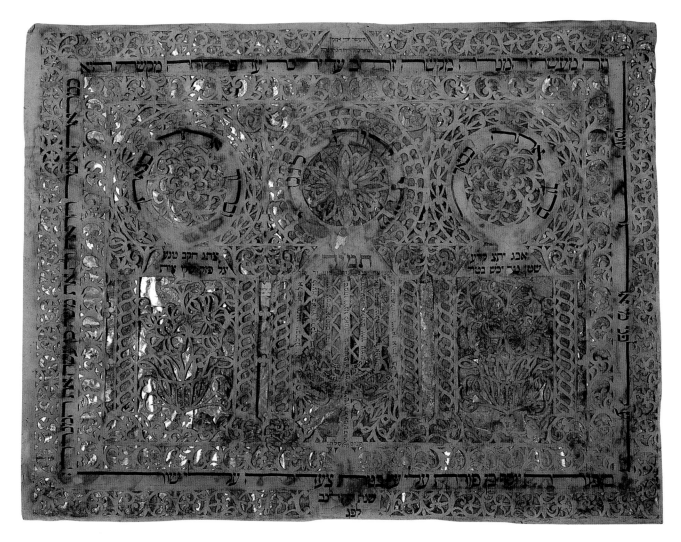

3.2. *Shiviti/Menorah*. This is one of the very few papercuts from the Maghreb in which both the name of the maker — "The handwork of the artist, the youth, the honorable Rabbi Eliyahu HaCohen, may the Merciful One protect him and bless him" — and the year (1892) are indicated. It thus serves as a comparative dating marker for similar papercuts from this region. The entire work, with its three Moorish horseshoe arches (cf. Fig. 2.43), is cut along templates on a centerfold to hold together in one piece. The colorful metallic paint of the underlying foil has almost entirely flaked away and faded to a rusty silver color, so that there is today almost no contrast between the cut-out parts and the background. Besides usual devotional and mystic apotropaic inscriptions, the text running from the upper right-hand corner to the lower left-hand corner is noteworthy. It is Numbers 8:4, rendered into English as "And this was the work of the candlestick, beaten work of gold . . . according unto the pattern which the Lord had shown to Moses. . . ." Elaborations of the making of the menorah in the Book of Exodus (25:36 and 37:22) use the phrase "*miqshah aḥat*" — "of one piece," which has come to be endued with philosophic connotations of completeness and wholeness (see p. 232). 48.5 × 63.3 cm. (19⅛" × 24¹⁵⁄₁₆"). Musée d'art et d'histoire du Judaisme, Paris.

"Menorah" wall plaques are still common in North African and Middle Eastern Jewish communities, where they often also serve as a charm against the evil eye. Frequently, the seven verses of Psalm 67 — probably based on the shorter Priests' Blessing in Numbers 6:24–26 — are each inscribed in one of the seven branches of the menorah design. *Menorah* papercuts can incorporate *shiviti* functions and may also feature the *ḥamsa* — the open palm of the hand popular with Muslims and with Jews of Muslim countries for warding off the evil eye.[2]

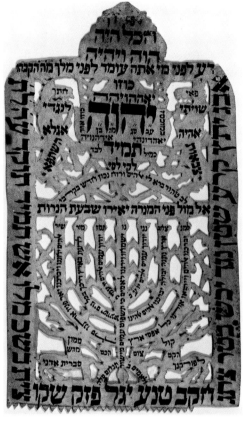

3.3a

3.3b

3.3. *Shiviti/Menorah* Amulets from the Middle East:

(*a*) Small, symmetrical parchment-cut from Syria or Palestine, possibly dating to the eighteenth century. As in the early Italian amulet papercut in Fig. 4.6, one of the inked-in inscriptions (in the arch above the menorah with Psalm 67) is: "Create me a clean heart O God, And renew a steadfast spirit within me" (Psalm 51:12). All the other texts and word combinations are the standard kabbalistic cryptograms and biblical passages endued with mystic connotations. Note the barely recognizable lions holding the escutcheon with the large Tetragram in the upper register, and the equally roughly delineated long-horned deer flanking the base of the menorah. Such small, usually crudely made amulets were also produced in quantities for sale to tourists and collectors.

(*b*) A badly-damaged, non-symmetrical amulet, from eighteenth or nineteenth century Baghdad or Syria, cut with a knife in thick parchment. As in all such works, the inscriptions are biblical texts and standard magic apotropaic formulas. This and a few similar parchment-cut amulets were part of the old Bezalel Museum collection under the curatorship of Mordechai Narkiss (1897–1957). Almost nothing is known of their dating or exact provenance. Nor do we know if these rather crude little amulets can in any way be considered forerunners of the Jewish papercutting tradition, or whether they represent a local adaptation of the technique and genre under the influence of their non-Jewish environment, or of papercut work brought by Jews from elsewhere. (*a*) 11.5 × 8 cm. (4½" × 3⅛"). Israel Museum, Jerusalem. (*b*) 14.7 × 8.8 cm. (5¹³⁄₁₆" × 3⁷⁄₁₆"). Feuchtwanger Collection, purchased and donated to the Israel Museum, Jerusalem by Baruch and Ruth Rappaport of Geneva.

3.4. Yiddish New Year card from Poland (ca. 1900) and later reprinted in New York showing a nursing mother ("*kimpetarin*"). The *ḥeder* boys and their *helfer* (young assistant teacher) have come to sing the *shema' yisrael* prayer for the forthcoming circumcision of the newborn baby boy. Collection of Prof. Shalom Sabar, Jerusalem.

Amulets, *shir hamalosl*, *kimpetbrivl*

Amulets with standard magic formulas, especially to protect nursing mothers and newborn babies, were (and still are) widely used in Sephardi, Ashkenazi, and other Jewish communities. The two opening words of Psalm 121, which is usually inscribed in full in these amulets, have given them their Yiddish name, "*shir hamalosl*" ("Song of Ascents"; *shir ha-ma'alot* in Hebrew, with the Yiddish diminutive "l" tagged on to it). They are also referred to as *kimpetbrivl* — "letter for the childbed" — and are hung over the crib or mother's bed, or next to the door and windows of the room. Among the standard incantations and formulas invoked are the names of the three angels Sanvai (Sinav), Sansanvai (Sinsinav), and Semangalof of Jewish legend, who are believed to be particularly effective against the witch Lilith.[3]

3.5. *Kimpetbrivl* (*shir hamalosl*). This very simple, little papercut amulet to protect the nursing mother and her newborn baby has all the essential features of such apotropaic charms in both Ashkenazi and Sephardi contexts. The central, pomegranate-like space is inscribed with the one hundred and twenty-first Psalm, and in the other roundels are the standard kabbalistic formulas, as described in Figs. 3.6, 3.7, 3.11, etc., and in the section on inscriptions in this chapter. 17.1 × 20.8 cm. (6¾" × 8³⁄₁₆"). Židovské Muzeum Praha, Prague.

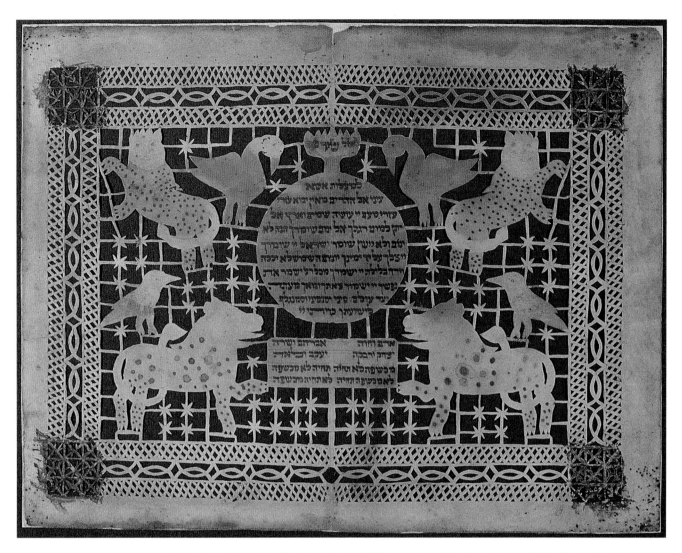

3.6. *Kimpetbrivl* (*shir hamalosl*). *Kimpetbrivl* is the Yiddish version of *Kindbettbrief*— "childbed letter." Such amulets were commonly hung on walls next to doorways or windows of the room in which the nursing mother and baby lay, or over the crib. In the central, pomegranate-shaped medallion of this charming, delightful amulet for the nursery, probably from Germany, is the entire text of Psalm 121, beginning with the words *shir ha-ma'aloth* — "*shir ha-malos*" in Yiddish. The rectangle below contains some of the standard, conventional formulas for thwarting the evil intents of the witch Lilith who carries off newborn infants:

> Adam and Eve. Abraham and Sarah
> Isaac and Rebeccah Jacob and Leah

followed by the common incantation (based on Exodus 22:17) against Lilith:

> Witch [shall] not [be suffered to] live; not live witch; live witch not; witch live not; live not witch; not witch live.

24 × 29 cm. (9⁷⁄₁₆" × 11³⁄₈"). Gross Family Collection, Ramat Aviv.

3.7. *Kimpetbrivl* (*shir hamalosl*). When in his eighties, the Israeli sculptor Tzvi Aldouby (1904–1996) told us that this badly tattered papercut is the sole survivor of four identical amulets made by his maternal grandfather in the 1880s, on the birth of one of Aldouby's brothers. At that time, the family, numbering thirteen children, lived in the Baligrod region of the Carpathian Mountains. Since no one could be sure from where the witch Lilith might appear to harm the newborn baby, the amulets were hung on four different walls. Cut in cheap newsprint and inscribed in black ink, each of the papercuts was backed by paper of a different color. This is a good example of the Tree of Life and the menorah motifs merging into one. The artist, Yitzḥaq Sheḥter, was a *sofer stam* (scribe) who, besides making papercuts, also turned his hand to crafting ritual objects of cast metal — Ḥanukkah lamps, *dreidels*, mezuzah cases, and the like. 28 × 21 cm. (11" × 8¼"). The late Tzvi Aldouby, Tel Aviv.

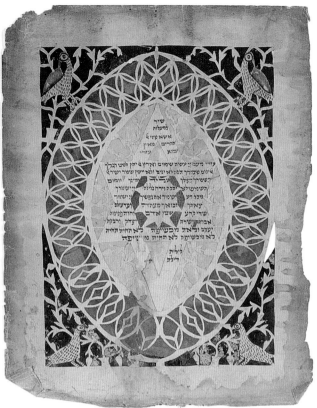
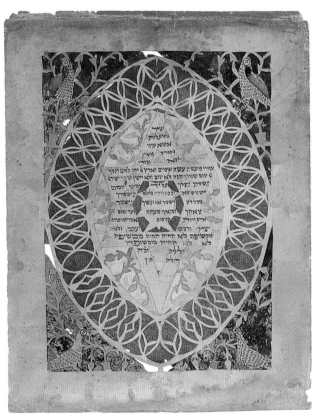
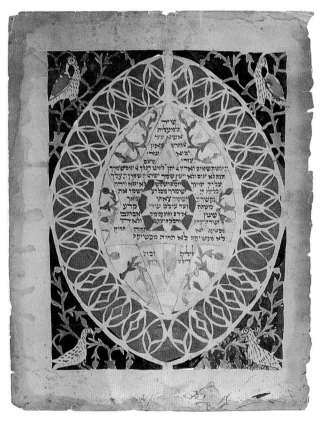

3.8

(OPPOSITE PAGE) 3.8. *Kimpetbrivlakh (shir hamaloslakh)*. Just as Tzvi Aldoubi told us, such amulets were usually cut in fours — one for each wall of the room, and in different colors. These probably also come from the Carpathian Mountains region. 28 × 21.5 cm. (11" × 8⁷⁄₁₆"). Jüdisches Museum Wien, Vienna.

3.9a

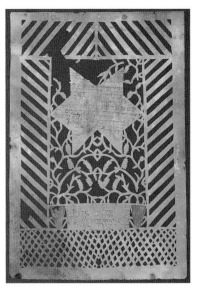

3.9b

(ABOVE, LEFT AND RIGHT) 3.9. *Kimpetbrivl (shir hamalosl)*. Here is another, very plain pair in different coloration but identical in size. 26 × 17.6 cm. (10¼" × 6¹⁵⁄₁₆"). Jüdisches Museum Wien, Vienna.

(BELOW, LEFT AND RIGHT) 3.10. *Kimpetbrivlakh (shir hamaloslakh)*. These two companion amulets were apparently the work of the same man who made the two in Figs. 3.11a and b. Note, for example, the similar marginal and corner patterns, and the backward-facing birds preening themselves. The amulet to the right has delightful fish-tailed lions at the top. 21 × 17 cm. (8¼" × 6¹¹⁄₁₆"). Jüdisches Museum Wien, Vienna.

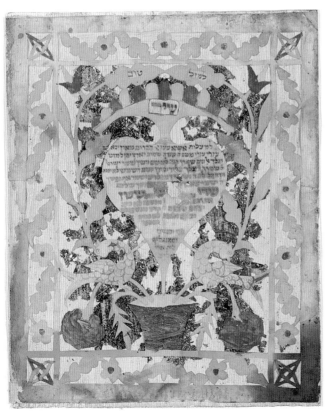

3.10a

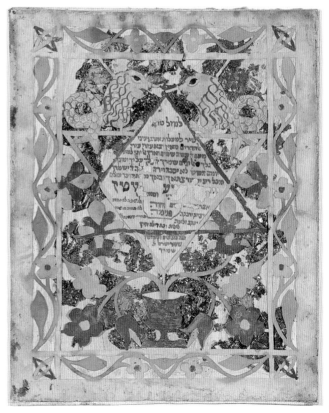

3.10b

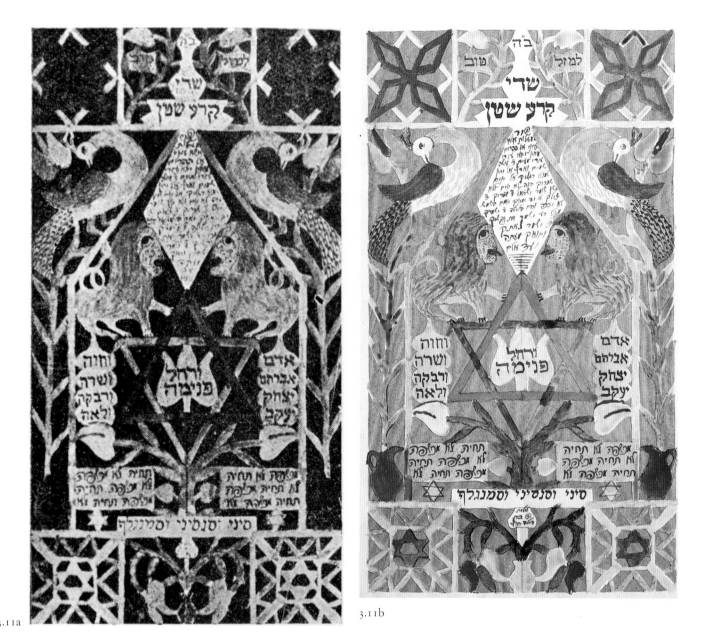

3.11a

3.11b

3.11. *Kimpetbrivlakh* (*shir hamaloslakh*). The poor black-and-white photograph (*a*) is all that remains of a brightly water-colored papercut amulet to protect the nursing mother and her newborn baby that was once in the Berlin Jewish Museum. Apart from some minor differences in the inked-in text and other details, it is almost identical to the one (*b*) acquired in 1932 by the Schweizerisches Museum für Volkskunde in Basel. Both were made by the same hand, probably around the turn of the twentieth century in Khust (Ruthenia), in the Carpathian Mountains region. Such amulets were hung on several walls of the room to offer maximum protection against Lilith. Because they were deemed essential, they were probably "mass-produced" for sale, and so the details of the design and the workmanship are rather careless compared to many of the individually worked-out masterpieces depicted in this book. Both works — and probably more — were delineated with a traced pattern or template for cutting on a vertically folded sheet of paper. The cursive inscriptions, and even the lettered texts, show hurried execution. But the usual kabbalistic apotropaic formulas are there (from top to bottom): "With God's help"; "For good luck" (or, "Favorable star"); "Almighty rend Satan"; the entire text of Psalm 121 in the large lozenge flanked by peacocks and lions; "Adam and Eve, Abraham and Sarah, Isaac and Rebecca, Jacob and Leah"; (within the Star of David) "Rachel, in!"; "Thou shalt not suffer a sorceress [witch] to live" — in all possible orders of the three Hebrew words (Exodus 22:17); "Sanvai (Sinav), Sansanvai (Sinsinav), Semangalof," the mystic names of protecting angels particularly effective against Lilith; "Lilith and all her breed, out!" 30 × 21 cm. (11¹³⁄₁₆" × 8¼"). (*a*) After R. Wischnitzer-Bernstein, 1936. (*b*) Jüdisches Museum der Schweiz, Basel.

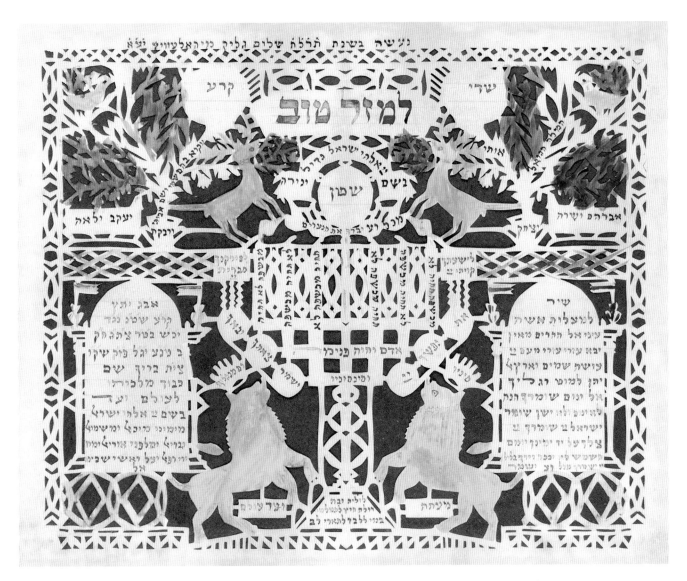

3.12. *Kimpetbrivl (shir hamalosl)*. The large inscription at the top says "For Good Luck." The rectangular menorah flanked by crowned lions is, as usual, inscribed with the sixty-seventh Psalm. The one hundred and twenty-first Psalm is on the right-hand monument, and the *anna be-khoah* prayer on the left-hand one. All the other inscriptions are the standard kabbalistic apotropaic formulas to protect the nursing mother and her baby from evil influences, notably the witch Lilith. The design and execution are rather primitive, yet forceful. This work was made by one Shalom Glick from Jaklovce, near Prešov and Kosice (eastern Slovakia), in 1878. 34 × 42 cm. (13⅜" × 16⁹⁄₁₆"). Židovské Muzeum Praha, Prague.

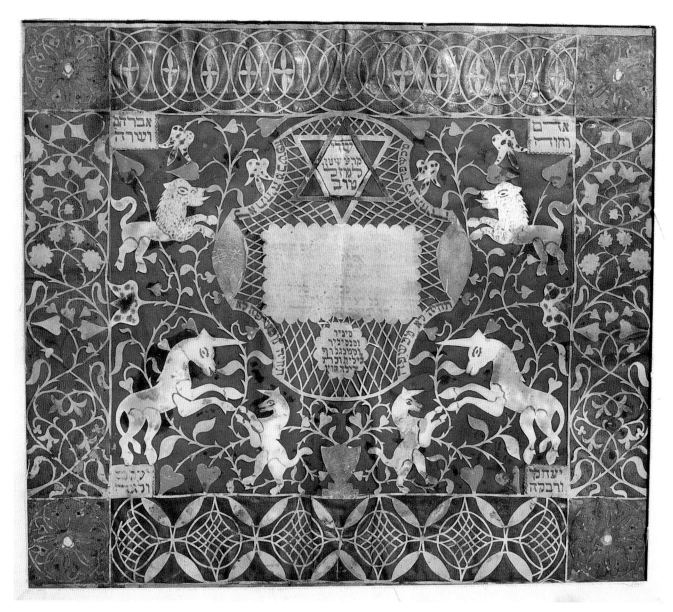

3.13. *Kimpetbrivl.* This utterly delightful amulet for the nursing mother is notable for the unicorns. The inscriptions are the standard incantations; the text of the one hundred and twenty-first Psalm in the center panel has just about faded. With very few exceptions, most of the known surviving amulets of this type happen to come from the region of the Carpathian Mountains and southern Galicia. 26 × 29.3 cm. (10¼" × 11⁹⁄₁₆"). Jewish Museum, Prešov, Slovakia.

(OPPOSITE PAGE) 3.14. *Kimpetbrivl (shir hamalosl).* Although a family tradition has it that David Elias Krieger (1880–1935) made this amulet aboard ship on the way to America in about 1900, presumably on the birth of a child (his own?), a cursive Hebrew inscription at the lower left corner indicates that it was in fact made in Dikla (or, Dukla) near Rymanów in Galicia. Like other such amulets of which up to four were required to protect the nursing mother and her infant from the witch Lilith, it was not cut on a fold, but probably in stacks of several sheets of paper. While not really symmetrical, it is well-balanced and visually satisfying. Apart from the standard apotropaic formulas — the one hundred and twenty-first Psalm, the mystic names of the protecting angels, the names of the Patriarchs and Matriarchs, "Rend Satan," "Thou shalt not suffer a witch to live," and "For good luck" — the crown at top in the form of an endless knot is labeled "Crown of a good name" (Pirqei Avot 4:17).

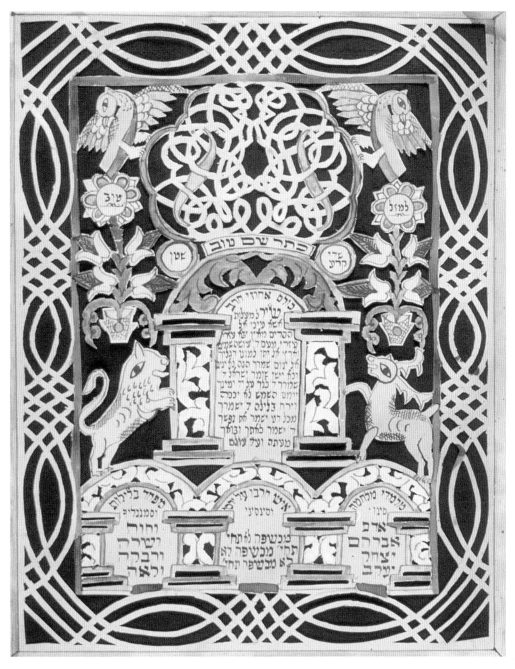

3.14

Moreover, a really intriguing inscription, which we have never seen in any similar context, appears sequentially just under the four arches: "They all handle the sword/ And are experts in war/ Every man hath his sword upon his thigh/ Because of dread in the night" (Song of Songs 3:8). In German, *Krieger* (*krigger* in Yiddish) means warrior. There can be no doubt that David Elias Krieger added this apposite passage to the standard, stereotypical formulas of such *kimpetbrivlakh* as a personal statement, hinted at by his pride in his "good name." It all strongly suggests that the child was in fact his own — a little *krigger*! The artist's great-granddaughter, Sara Arditti, told us that Krieger married his wife Hermina around the turn of the twentieth century in a Galician shtetl (Dikla?) and later emigrated to New York, where he worked as a signpainter and artist. They had seven children. 23.3 × 18.3 cm. (9³/₁₆" × 7³/₁₆"). Yeshiva University Museum, New York, Gift of Lillian Krieger.

B'rith milah (Ritual Circumcision)

Special papercuts were made on the occasion of the circumcision of baby boys. These incorporate the ritual prayers for this all-important ceremony of entering the eight-day-old into the "covenant of Abraham" (Genesis 17:9–14), performed by a *mohel* qualified for the operation. A special chair is provided for the Prophet Elijah, who in popular belief is present at every *b'rith milah*, and for the child's godfather. The boy is named on completion of the ceremony.

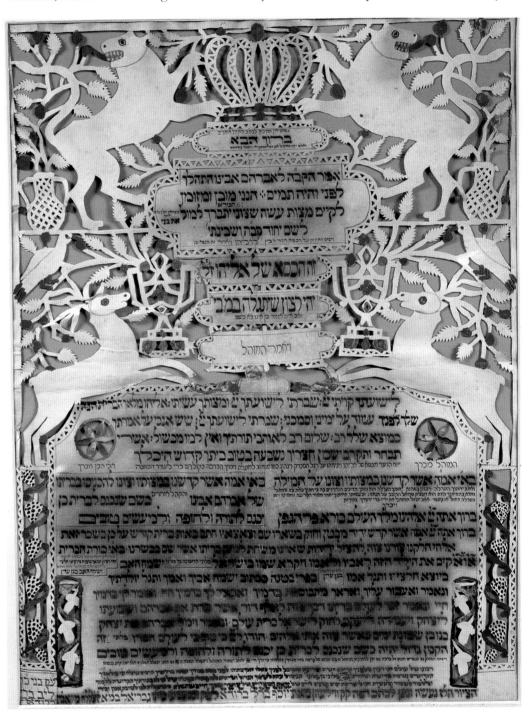

3.15a

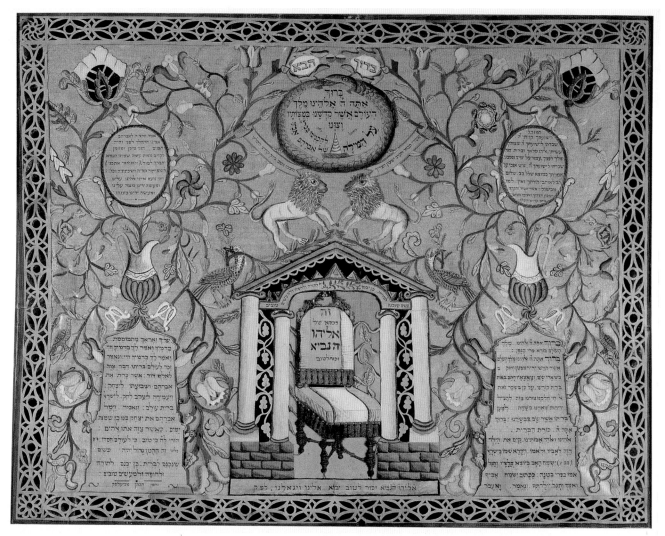

3.15b

(OPPOSITE PAGE AND ABOVE) 3.15. *B'rith milah* (circumcision). The texts in both these works are the prescribed prayers and blessings of the circumcision ritual, ending with the customary: "This little one, great will be;" and, "May God raise him unto learning of the Torah, the wedding canopy, and good deeds." Papercut *a* was made in 1833 by Yosef Berl Broda with his son Leib Ber of Wielún (southwest of Lódź) for Gabriel Bama of Kubin (northern Slovakia?). Papercut *b* by one Naḥman HaCohen Bialsker [from Bialsk], dated 1862, commemorates the circumcision of an unnamed baby boy. This delicate work was formerly owned by Dr. Chaim Weizmann, the Zionist leader and first president of the State of Israel. The fancy, finely drawn chair under the canopy is the Chair of Elijah reserved for the prophet who, tradition has it, is present at every circumcision. The child was named at the ceremony's conclusion. (*a*) 52 × 40 cm. (20½" × 15¾"). The Sir Isaac and Lady Edith Wolfson Museum, Hechal Shlomo, Jerusalem. (*b*) 33 × 42.5 cm. (13" × 16¾"). Weizmann Archives, Weizmann Institute of Science, Reḥovot.

Memorials, Commemoratives, *nerot zikaron*

Papercut wall plaques were made in remembrance of the deceased, usually giving the dates on which the *yortzait* (anniversary of death) was to be observed and the *ner zikaron* (memorial candle) lit. Some papercuts recall the wedding day, and sometimes even combine the commemoration of happy and sad family events.

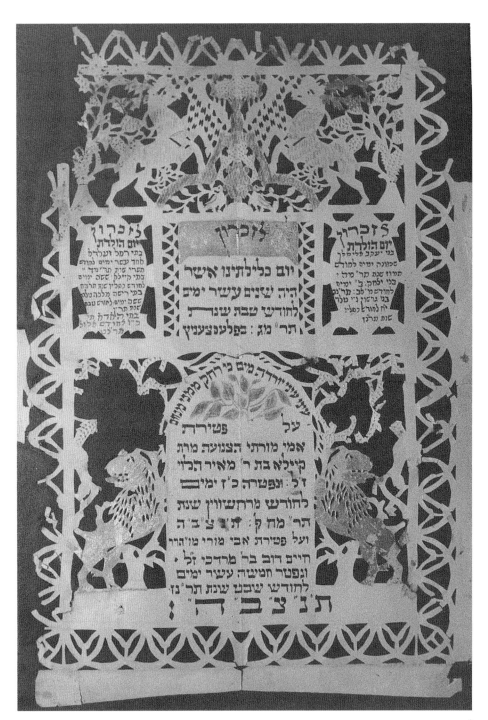

3.16. Wedding/Birthday/Death (*Yortzait*) Commemorative. The inscriptions, partly in Rashi letters, in the upper register of this sadly damaged work give the date of the artist, Morris Meyer's, marriage (1883) in Plietnitz in Posen (West Prussia), and the names and birth dates of his four daughters (in 1884, 1888, 1890, 1899) and three sons (in 1885, 1895, 1897). In the memorial tablet in the lower register are the names of his parents and the dates of their deaths: Kayla daughter of Meir Halevi (in 1888) and Ḥayyim Dov son of Mordekhai (in 1897). Morris Meyer and his large family arrived in the United States around the turn of the twentieth century and settled in Rochester. A learned man, Meyer was a *sofer stam* and *mohel* (performer of ritual circumcisions). 32.5 × 22.5 cm. (12¾" × 8⅞"). Temple Brith Kodesh Museum, Rochester, New York.

3.16

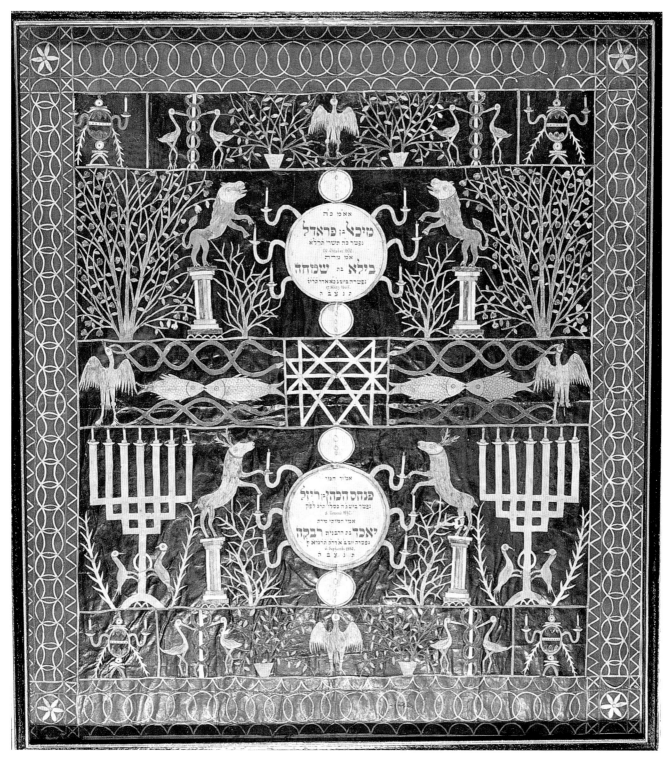

3.17. *Yortzait.* A finely cut, delicate work marking the days of death, between 1867 and 1880, for remembrance of several family members referred to only by their and their parents' first names. Note the storks and blue snakes worked into recurring decorative patterns. This papercut, probably from Galicia, was apparently once part of the Reizes collection in Vienna. 46.5 × 42.6 cm. (18⁵⁄₁₆" × 16¾"). Anonymous owner, Haifa.

3.18. *Yortzait*. Rabbi Wolf Oisterlitz, who died in 1868/69, and his wife Reizl, who died in 1855, are commemorated in this work by their son. The large inscriptions *"yortzait"* at the top are in Yiddish; all the others in Hebrew. From Eisenstadt (south of Vienna). 21.5 × 15.5 cm. (8⁷/₁₆" × 6⅛"). Jewish Museum, Prešov, Slovakia.

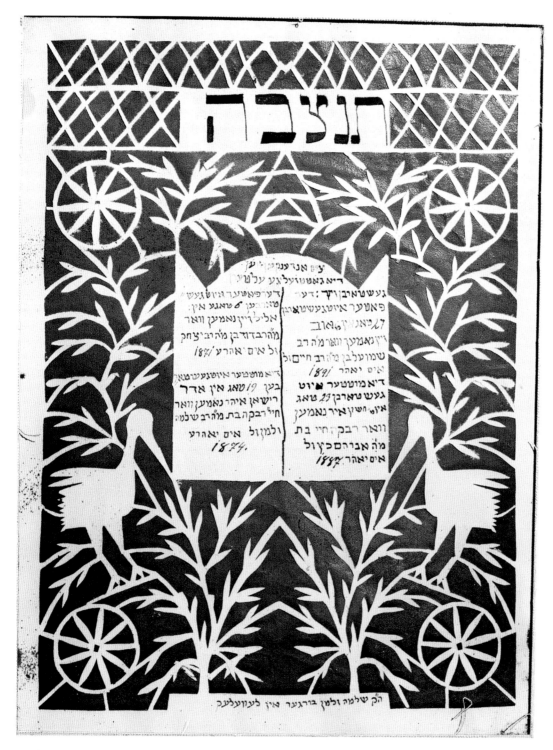

3.19. *Yortzait.* Shlomo Zalman Burger from Levelec(?) inscribed the names and dates of death of parents and close relatives in 1871, 1874, 1887, and 1891 in Yiddish in the memorial tablet. 28 × 21 cm. (11" × 8¼"). Jewish Museum, Prešov, Slovakia. Gift of Henrika Burger from Kaschau (Košice).

Blessings, Proverbs, Memento Mori, Pithy Sayings

Papercuts with central inscriptions giving parts of the *birkat ha-mazon* (the after-meal blessing), sayings to remind man of his mortal status, and all sorts of wise precepts, mostly enjoining humility, are fairly common.

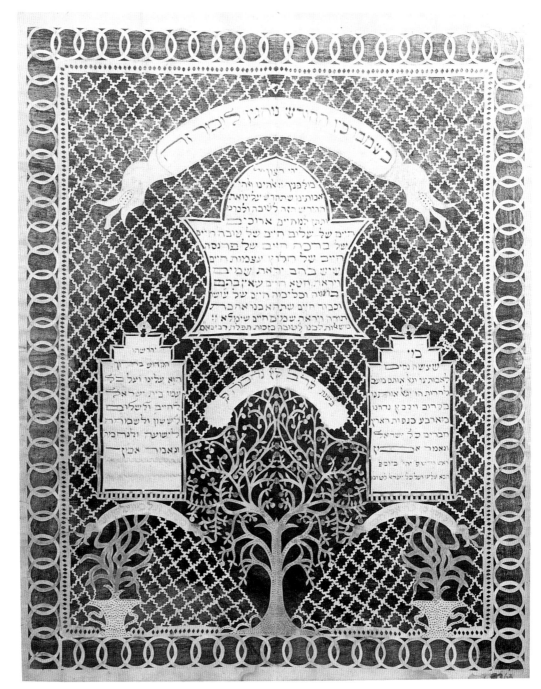

3.20. Blessings for the New Moon are the theme of this finely cut work dated 1835. Note the pricked decoration on the flower pots in the lower corners, and on the trunk of the Tree of Life. This is a technique known from Christian papercuts but very rare in Jewish work. 52 × 41 cm. (20½" × 16⅛"). Jewish Museum, Prešov, Slovakia.

3.20

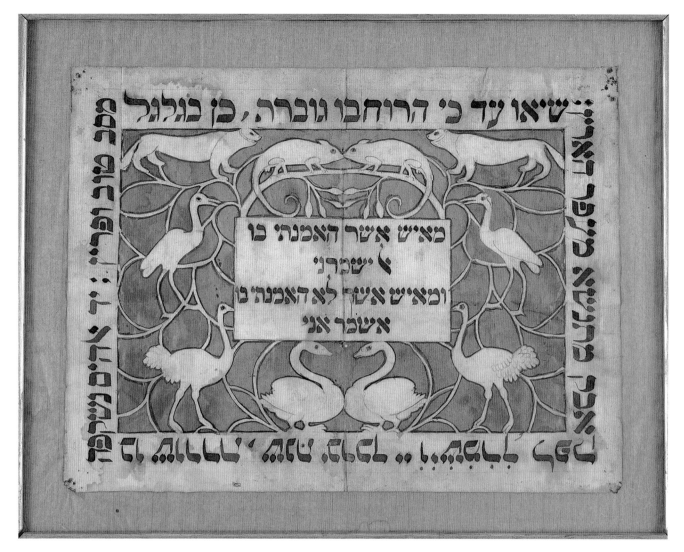

נשיאו עד כי הרוחכו גוכרה, כן כגלגל

מא־ש אשר האמנ־י בו
יא ־שמרני
ומא־ש אשר לא האמנ־י בו
אשמר אנ־

3.21. Pithy Sayings. The central inscription proclaims rather cynically: "From the man in whom I trusted protect me God. From the man I did not trust I shall protect myself." Starting at the lower right-hand corner, the text in the margin reads: "Dust rises from the ashes of the land; Bearing it until the spirit in it overpowers; As a wheel turns bringing goodness and calamity: Behold the hand of God that pervades it. The year 'God bless you and protect you'." The dots over the six letters of the word *ve-yishmerekha* ("and protect you") indicate that the numerical value of these letters adds up to the date — in this case, 5666 (1806). Were it not for the beautifully lettered Hebrew inscriptions, there is nothing to identify this work as Jewish. It most probably comes from a region of Germanic influence. 29.3 × 39 cm. (11⁹⁄₁₆" × 15⅜"). Yitzḥaq Einhorn Collection, Tel Aviv.

Ketubah

The marriage contract between the bride and her husband was sometimes lavishly decorated. Some eighteenth- and early nineteenth-century *ketubot* from northern Italy have cut-out border designs and vignettes (Fig. 2.2).[4]

Gifts and Presentations

Papercuts were often presented as gifts, perhaps where there was no money to buy anything else. Usually these are *mizraḥim* or *shiviti*s, or *menorah*s with dedicatory inscriptions. Some were made to honor (or flatter) wealthy donors or influential dignitaries.

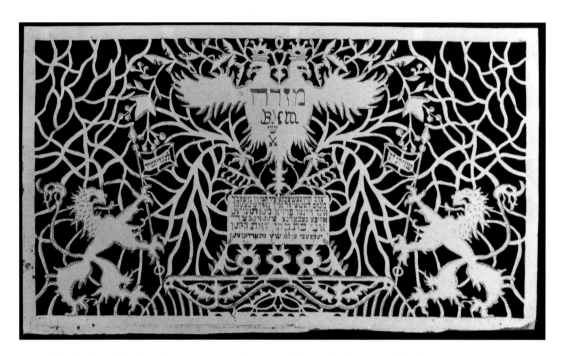

3.22. *Mizraḥ/Shiviti*. The lengthy inscription in the rectangle beneath the crowned double eagle in this *mizraḥ* starts off in Yiddish: "A gift for the home of Herr [Mr.] Moshe Ber Menaḥem Rotschild in Nordstetten (south of Horb-am-Neckar in Baden-Württemberg) and his wife Gitl Rotschilt [sic] née Ettwinger[?]," and continues in Hebrew: "I wrote this, the little Ya'aqov Tzvi the son of H. M. Schatz from Nordstetten." The Latin initials BHM, the little crown, and the crossed swords under the large word *mizraḥ* recall eighteenth-century German porcelain hallmarks. The lions are also very heraldic Germanic types — not at all the "Jewish species" we encounter so often in Jewish papercuts and other ritual art. 20 × 35 cm. (7⅞" × 13¾"). Gross Family Collection, Ramat Aviv.

(OPPOSITE PAGE) 3.23. Although there are probably more somewhere, we know of only two Jewish items of cut work made in England — one in parchment and one in paper. Both are clearly the work of Jews who emigrated to England from Eastern Europe and who carried on the tradition in their new homeland. Both are laudatory, perhaps even verging on sycophancy, addressed to the mighty and wealthy. It would be illuminating to see other papercuts created by these highly competent folk artists.

(a) Wedding Commemorative. Skillfully cut in a large piece of parchment, this very unusual work was made for the sumptuous wedding, in 1881, of Leopold de Rothschild and Marie Perugia at the Central Synagogue in Great Portland Street, London, in the presence of the Prince of Wales and many other dignitaries. It was probably presented to the couple. The text, entirely in Hebrew, is in effect a laudatory, acrostic, rhymed poem commending the advantages of marriage and wishing the newlyweds everything happy and good, to the end of their days. The composition is divided into two horizontal registers: in the upper one, the design, in which the verses of the poem are cut, forms a large letter מ *mem*, to which are added small letters ז *zayin* and ל *lamed*; in the lower register are a large letter ט *tet* and small letters ו *vav* and ב *beth* — all of which read מזל טוב *mazal tov* ("good luck"). The first letters of each line (but the last) of the poem, and the initials of the words in the last line make up (in Yiddish orthography): "LEOPOLD MARIE ROTSCHILD." The date and place are cut out within the smaller of the large letters in the upper and lower registers. Note the endless-knot configurations symbolizing everlasting love in the middle of each of the margins. We do not know who created this work, nor why and how it reached the collectors' market. 50.7 × 36.3 cm. (19¹⁵⁄₁₆" × 14⅝"). Bernice and Henry Tumen Collection, Judaica Division, Harvard College Library, Cambridge, Massachusetts.

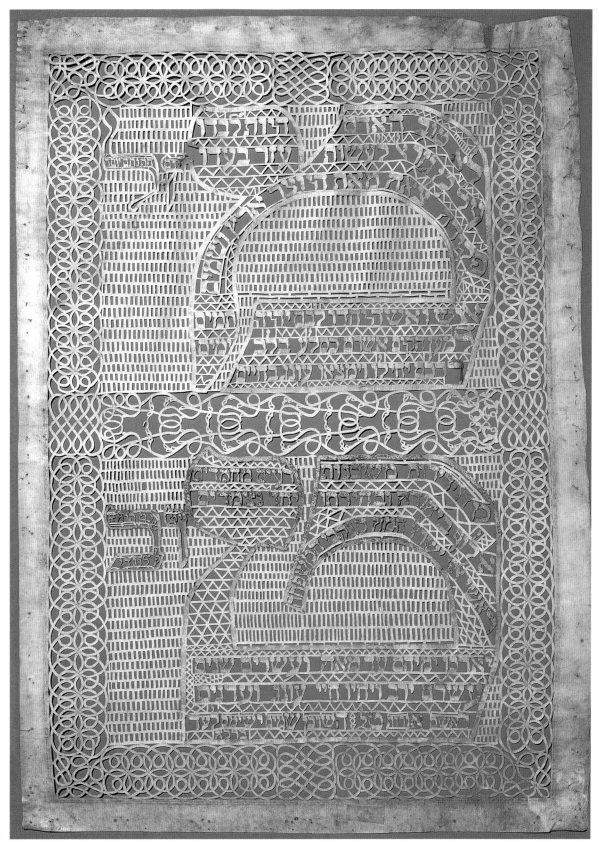

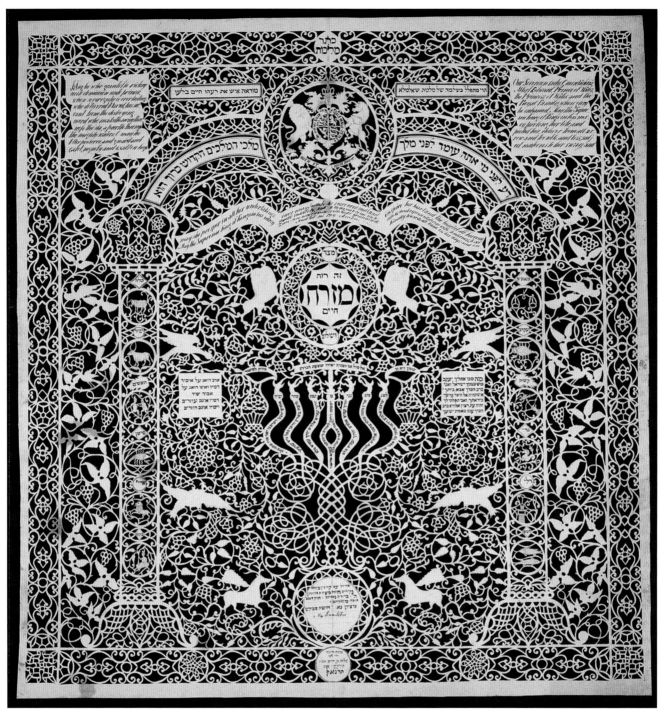

3.23b

(b) *Mizraḥ*/Laudative. Honoring Queen Victoria and the royal family, the inscriptions in the two roundels, bottom center, tell us that this splendid work was made in 1891 by Shalom the son of Ḥayyim HaLevi Horowitz [at the behest of a Mr. Munckton?]. The overall conception is entirely in the East-European tradition, very likely Galicia, from where the artist probably came to England. Shalom Horowitz was clearly a consummate, if not a professional, draftsman and calligrapher in both Hebrew and English. The main inscriptions, in square-letter Hebrew and an elegant cursive English, are the standard "Prayer for the Queen and the Royal Family" from the Sabbath and festivals morning liturgy, extolling the greatness of the sovereign and praying to the King of kings for her welfare, success, and prosperity of the realm, ". . . and [to] deal kindly and truly with all Israel. . . ." The central menorah, emerging from an intricate "endless-knot" base (see chapter 5), is inscribed with the sixty-seventh Psalm. It stands within an arched gateway, whose supporting columns contain the signs of the zodiac. The larger, upper roundel with the royal arms, is surmounted by a smaller shield: "Crown of Kingdom." The central roundel above the menorah bears the standard *mizraḥ* formula: "From this side the spirit of life," to which, however, the artist added the word *ve-shalom* ("and peace") as a personal touch, Shalom being his own name. 70 × 67 cm. (27⁹⁄₁₆″ × 26³⁄₈″). Gross Family Collection, Ramat Aviv.

Holidays and Festivals

Special papercuts were made on the occasion of different festivals to decorate the house, sukkah, or synagogue. Decorative paper-cut lanterns were sometimes hung in halls or homes for weddings or Purim celebrations, but also on memorial days for the dead.

Sukkoth/*ushpizin*

The first holiday of the Jewish year for which decorative papercut wall hangings were made is Sukkoth, the week-long Feast of Booths, or Tabernacles. These compositions would mention, and occasionally depict, the seven *ushpizin* (guests) of kabbalistic lore — Abraham, Isaac, Jacob, Joseph, Moses, Aaron, David, and sometimes also Solomon — who visit the *sukkah* during the seven days of the festival.[5] Each of these "guests" is invited and welcomed on a different day of the festival by a special prayer in the Sukkoth liturgy. Papercuts and other decorations for the sukkah often combine the *mizrah*, *menorah*, and/or *shiviti* formulas, for during the Sukkoth week, the family spends as much time as possible in the sukkah.

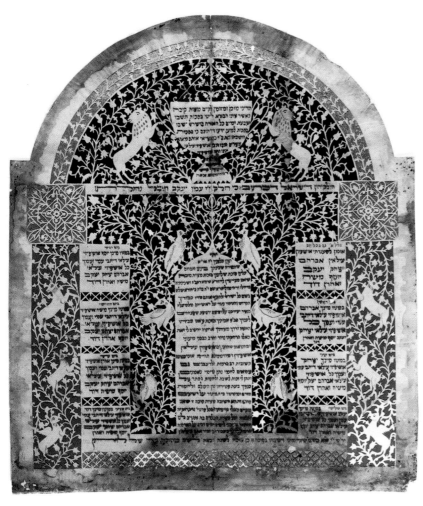

3.24. *Ushpizin* for the Sukkah. This work is signed Yitzḥaq Barukh ben Yeḥiel Mikhel along a fairly standard formula: "The work of my hands and not for my glorification," and dated 1856. The place is not indicated — perhaps western Poland or eastern Germany. The finely drawn and cut patterns and the fluid lines, not to mention the competent calligraphy, are the individual hallmark of the artist, who must have been a skilled scribe. Another papercut by the same man, in the same collection, shows similar artistic treatment. At the bottom of the papercut, made to be hung in the *sukkah*, he expressed his pious hope that next year, God willing, he would celebrate the Sukkoth festival in a *sukkah* made of the skin of Leviathan (implying the coming of the Messiah). 39 × 35 cm. (15⅜" × 13¾"). Gross Family Collection, Ramat Aviv.

3.24

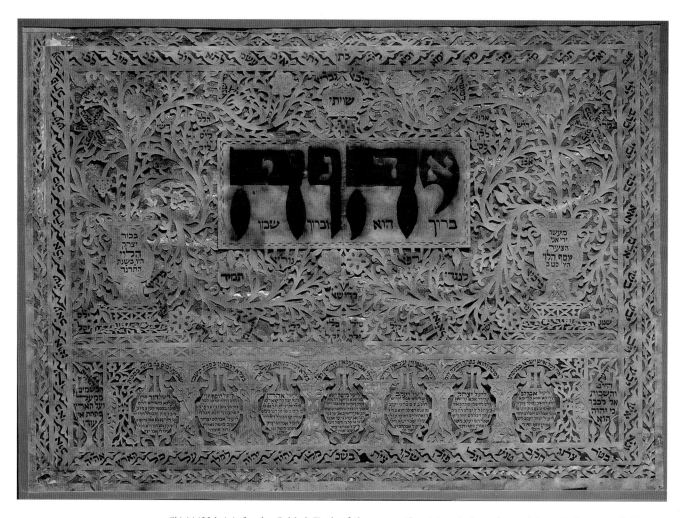

3.25. *Shiviti/Ushpizin* for the *Sukkah*. Each of the seven *ethrog* (citron)-shaped roundels at the bottom of this Sephardi papercut from Turkey invites one of the *ushpizin* (guests of kabbalistic lore) to visit the sukkah on consecutive days of the festival. The work, made in Izmir (Smyrna), is signed: "The work of my hands, the youth Yosef Halevi, may the Lord sustain and grant him favor, may his end be good, son of the honored rabbi, Yitzḥaq Halevi, may the Lord sustain and protect him, in the year 5654 (1894)." The central motif in the florid design is the Tetragrammaton in huge letters. The word *shiviti* is inscribed in the small crown above it, and the rest of the passage is written in smaller letters among the large ones of the Ineffable Name. The intricate vegetal patterns are dotted with magic formulas commonly found in Jewish amulets: names of angels, acronyms and cryptograms of biblical passages and prayers, and the like. The work was cut out of plain white or buff paper and mounted on fancy, gilt-embossed wrapping paper. Two similar works by the same artist are in the Israel Museum collection. 41 × 57 cm. (16⅛" × 22½"). Abraham Halpern, New York.

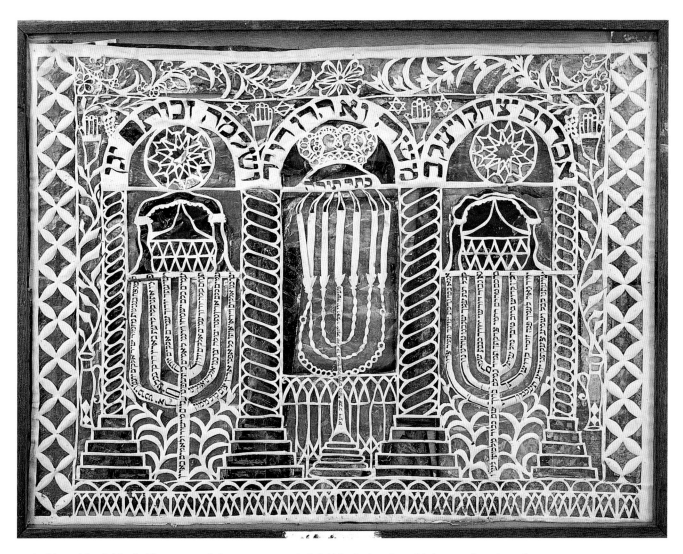

3.26. *Menorah* for Sukkoth. The names of the seven guests (*ushpizin*) invited to the *sukkah* are cut into the arches of this North African *menorah* papercut (cf. Fig. 2.43), which probably dates to the turn of the twentieth century. Each of the three *menorot* is inscribed. The one on the right bears the mystical *anna be-khoah* prayer from the liturgy, the left one has the usual Psalm 67, while in the middle stem of the central menorah are the words, "Made by the hands of the youth Yehudah ben Kalfa Zagbib. . . ." Note the grape clusters, *hamsa*s, *magen david*, and urns with vines growing out of them and around the central design. As with some other Jewish papercuts from North Africa, although the overall composition is symmetrical, it was not cut on a centerfold but in one unfolded sheet. Also characteristically, the main design is backed by colored metal foils, some of which have slipped out of place. 46.5 × 62 cm. (18¼" × 24½"). Musée d'art et d'histoire du Judaisme, Paris.

Simḥat Torah Flags

The Feast of Rejoicing in the Torah begins on the evening when Sukkoth ends, marking the day when the last portion of the Torah is read that year and the new cycle begins. All the Torah scrolls in the synagogue are carried around in joyful procession, accompanied by gleeful children carrying flags — which in past generations were often cut out of paper — with an apple stuck on top of the stick and a lit candle in the apple.

Ḥanukkah

Although Ḥanukkah menorahs appear in a few old Jewish papercuts, we know of none intended specifically for the Feast of Lights. Some have been made recently by contemporary Jewish papercut artists, usually featuring an eight-branched Ḥanukkah lamp with servitor, and appropriate texts.

3.27

3.27. Simḥat Torah Flag. No examples of old papercut Simḥat Torah flags are known to have survived. Giza Frankel mentioned having seen some before the War in Poland. The one reproduced here is the work of Yehudit Shadur, made in 1978 for an exhibit of contemporary designs for Simḥat Torah flags at the children's wing of the Israel Museum. 27.5 × 37.5 cm. (10¾" × 14¾"). Collection of the authors, Jerusalem.

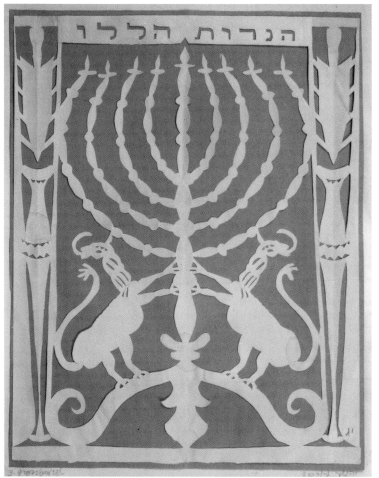

3.28

3.28. Ḥanukkah. The theme of the joyous Festival of Lights — Ḥanukkah — is not known to have been a subject of traditional Jewish papercuts. Only contemporary artists working in this medium have begun to use it — in this case, the late Yehoshua Grossbard, of Haifa (1974). 30 × 24 cm. (11¾" × 9½"). Collection of the authors, Jerusalem.

3.29a

3.29b

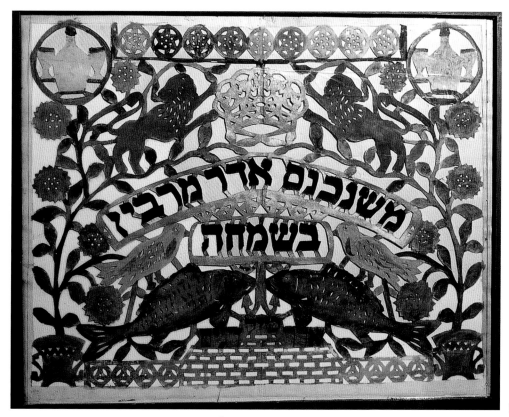

3.29c

3.29. *Mi-she-nikhnas Adar.* The three papercut Adar tablets known to us, spanning a long period, represent a genre that also exists in lithographed and printed form. All these three seemingly originate in the Carpathian Mountains region of Galicia and Slovakia. They show many similarities: "When Adar comes in there is much joy," read the bold inscriptions in the arched bands. There are the zodiacal fish of the month of Adar, chickens, and stags. The decanter and wine glasses evoke the pious enjoinder during the Purim festival to drink to the point where one cannot distinguish between "blessed be Mordecai" and "Haman be cursed." The photo (*a*) from the weekly paper of the Berlin Jewish community of 13 March 1938 (!) shows a papercut Adar wall-plaque reportedly made by Moshe Yehudah Adler in "1720" (but probably of later date), which was in the Berlin Jewish Museum at the time. The latest such item we have found (*c*) was made by the same hand as the *mizrah* in Fig. 7.17 in about 1930. It conforms entirely to the old style of such Adar papercuts and printed works. (*a*) After I. Schüler, 1938. (*b*) 34 × 41.5 cm. (13⅜" × 16³⁄₁₆"). Jüdisches Museum der Schweiz, Basel. (*c*) 42 × 53 cm. (16⁹⁄₁₆" × 20⅞"). Jewish Museum, Prešov, Slovakia.

Purim — *mi-she-nikhnas adar*

The beginning of the month of Adar, the month in which Purim is celebrated, is the occasion for hanging up a plaque with the phrase *mi-she-nikhnas adar marbin be-simḥa*: "when Adar comes in there is much joy."[6] According to the same Talmudic passage, during the month of Adar every single Jew is under a favorable star — the sign of Pisces of the Zodiac — when the Messiah is expected.

Purim — *megillat esther*

On Purim, the *megillat esther*, the "scroll of the Book of Esther," is read in the synagogue to the accompaniment of *groggers* (rotating ratchet rattles) every time the name Haman is mentioned. A few of the known old Italian *megillot* of the seventeenth and eighteenth centuries have cut-out border designs.

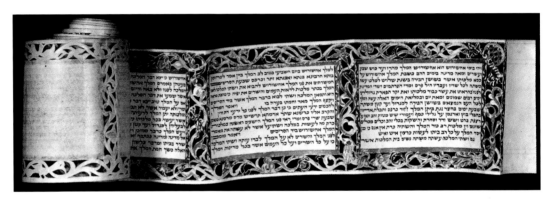

Sefirat ha-ʿomer Calendar

The forty-nine days (seven weeks) from the first day of Pessaḥ (Passover) is the solemn period of the Omer, anticipating Shavuoth, the day of giving the Torah on Mount Sinai. These days must be enumerated (*sefirah*, in Hebrew, means enumeration or counting) with special prayers said on each day. In several papercut Omer calendars, the days of the Omer are correlated with certain of the ten *sefirot* of the Kabbalah.

3.31. Omer Calendar. The tiny cut-out parchment frontispiece of a little leather-bound Omer calendar was made by, or belonged to, Rabbi Levi Yitzḥaq Shapira — or Shafra, whose name is inscribed inside the back cover. The inked inscription on the cut-out, *sefirat ha-ʿomer bi-zemano al tishkaḥ l-omar* — "Do not forget to count the *ʿomer* in time" — contains a spelling mistake in the word *al*: it should be *aleph lamed* ("do not") instead of *ʿayin lamed* ("on"). At the top are the words *tov meʾod* ("very good") in Rashi script. Provenance and date are unknown. 6.2 × 4.5 cm. (2⁷⁄₁₆" × 1¾"). Yitzḥaq Einhorn Collection, Tel Aviv.

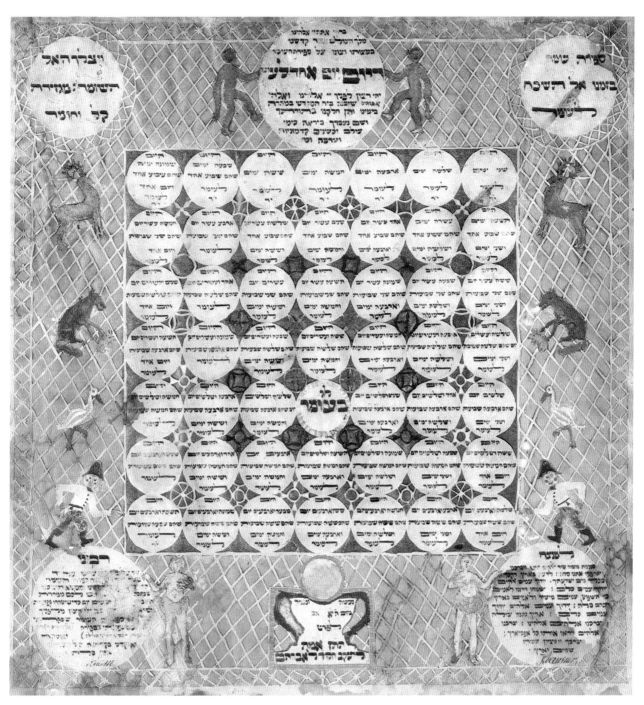

3.32. Omer Calendar. Made by Abraham Klausner in 1825 (if our reading is correct), this folksy papercut contains the prayers to be said on each of the forty-nine days of the Omer. The rhymed text in two small roundels at the top enjoins one not to forget enumerating the *'omer* so that God will protect from "גְּזֵירַת קַל־וָחֹמֶר" ("*gezeirat qal va-ḥomer*"), a figure of speech for [transgressing] "trivial as well as weighty precepts," but which here may also be an idiosyncratic manipulation by the folk artist of this Hebrew expression to suggest "cutting in a light material." All of Psalm 67 is inscribed in the lower right-hand roundel. The inscription in the left roundel at the bottom is almost illegible, but also relates to the counting of the Omer. What is interesting in this work are the amusing animal and human figures in the margins. Since such overt secular — not to say, irreverent — motifs are not known in the Jewish papercuts of the more eastern and northeastern regions, and particularly in Galicia, it suggests a Germanic or local Bohemian influence. 36.4 × 34.8 cm. (14⁵/₁₆" × 13¹¹/₁₆"). Židovské Muzeum Praha, Prague.

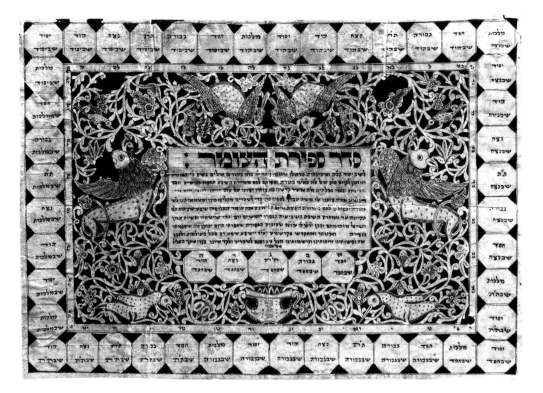

3.33. Omer Calendar. A fine papercut, of unknown date
and origin (but almost certainly from the general region of
Poland) that served to number the forty-nine days of the
Omer — from Pessah to Shavuoth. The Hebrew word
for counting, or numbering, *sefirah*, also evokes the ten
kabbalistic Sefirot (emanations), the seven lower ones of
which are each inscribed in one of the octagonal medallions
for each day. The text in the center panel contains the
prescribed prayers to be said on each day of the *'omer*.
25.5 × 36.7 cm. (10" × 14½"). Abraham Halpern, New York.

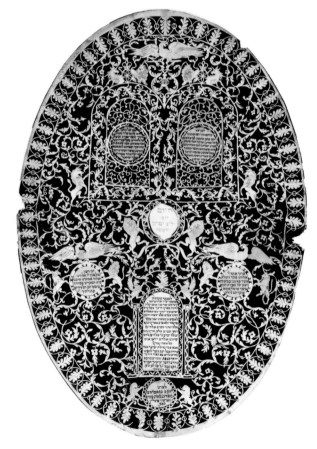

3.34. Omer Calendar. A most unusual item because of its oval shape. It
belonged to the present owner's grandfather, Rabbi Herman Shandel,
who was appointed minister to the Ramsgate Synagogue by Sir Moses
Montefiore in 1875. It then passed to his daughter, Mrs. Tilly Lipson and
her husband, the Rev. Solomon Lipson, Senior Chaplain to H. M.
Armed Forces in World War I. Each of the days of the Omer period of
seven weeks was to be inserted in turn in the central medallion held up
by two heraldic lions. The texts are prayers and scriptural passages
appropriate to the forty-nine-day interval between Pessah and Shavuoth.
The inscription in the medallion at the bottom tells us that this beautiful
papercut was made in 1841 as the pious work of Jacob, the son of
Abraham Madenberg of Warsaw. 69.7 × 49.1 cm. (27½" × 19½"). Ruth
Winston-Fox, London.

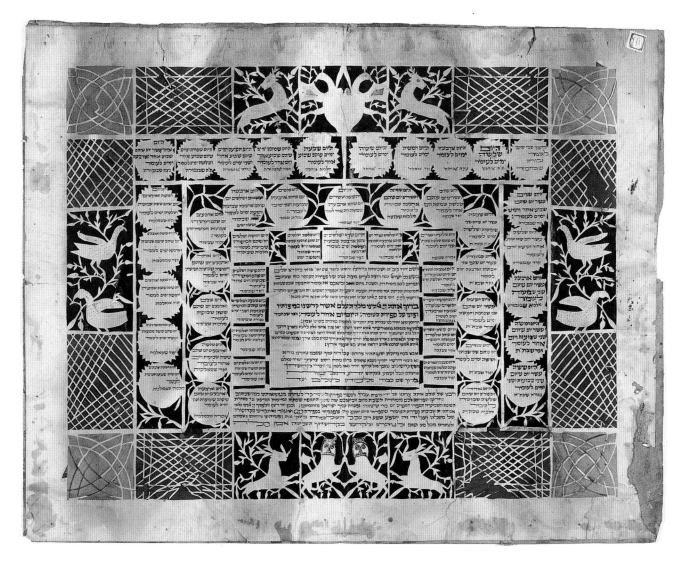

3.35. Omer Calendar. The forty-nine days of the Omer are numbered in the roundels and squares. The central panel contains the prescribed prayers of the *'omer* liturgy, including the mystical *anna be-khoah* text. Note the exceedingly fine lines and the stylized animals and birds — especially the "Jewish" lions. As always, some of the "Four Animals" are among them. 42.5 × 53.5 cm. (16¾" × 21¹⁄₁₆"). Jüdisches Museum Wien, Vienna.

Shavuoth

The joyous springtime festival of Shavuoth (Pentecost), the Feast of Weeks, was the occasion in the European shtetl for decorating windows of homes with papercut rosettes (*roizalakh*) or other small compositions, sometimes incorporating a few words appropriate to the holiday. Such little papercuts were generally known as *shavuoslakh*, with the Yiddish diminutive affix denoting endearment.

Symbols and Motifs

Most of the forms, figures, and decorative elements making up the world of the Jewish papercut are not unique to this art form but appear also on ritual objects, synagogue wall paintings, tombstones, book illustrations, and calligraphic and printed sheets. Almost all the inscriptions and the plants, animals, and objects depicted recur over and over again in a myriad combinations and variants, suggesting that they were expressions of a distinct iconographic language.

But what do they mean, and how did they come to acquire these meanings? Were these pictographs so universally understood that even the humblest papercut artist-craftsman incorporated them in his designs and compositions as a matter of course? Did he perhaps copy them without understanding? Did they reflect esoteric kabbalistic allegories? Were they intended as personal statements? Scholars and ethnographers trying to come to terms with the exuberance of motifs and forms have ranged from those regarding the various animal and vegetal motifs as purely decorative, to those who believe that everything is laden with significance. Jewish iconography poses many unresolved problems.[7]

If these pictures indeed have symbolic meaning, they are often difficult to understand because explanatory sources are lacking. One of the leading students of Jewish iconography, Rachel Wischnitzer-Bernstein (1885–1989), wrote in the 1930s:

> It is not as though we find what we call "Jewish symbolism" everywhere, but there exist ideograms and symbols stamped with the spirit of Judaism. An iconography of Jewish Art seems to us fully justified. It has lately been established that the widely circulated medieval treatise on natural history, the Greek *Physiologos*, is based on an early Jewish text from Syria, possibly of the fourth century — a time and place when the biblical sources were still close and real. Here were spun the legends of the animals mentioned in the books of Job, Psalms, and the Song of Songs. From here they spread to the western world. However, the Jews not only bypassed the literature and art of other peoples, but continued to evolve their own fables about these animals. So was created in the Midrash the Jewish phoenix, the Jewish pelican, the Jewish hart, the Jewish unicorn — all with their own meanings and traditions. These we encounter in Jewish art.[8]

The Jewish symbols of antiquity were probably carried on by a vivid folk memory, stimulated by intimate familiarity with the Scriptures and the great web of interpretative and mystic literature. And they must have absorbed demonologies and legends of gentile Diaspora milieus. The subjects were taken from the world of flora and fauna, the Bible and the Talmudic and Midrashic Aggadah, the literature of the Kabbalah, and from the rich folk fantasy.

We list the more common pictorial themes found in Jewish papercuts by category: emblems, architectural elements and furnishings, plants, animals, human forms, and an eclectic assortment of objects.

Emblems

Menorah

The seven-branched candelabrum, originally made at divine behest by Bezalel for the Tabernacle in Sinai, is the most ancient, exclusively Jewish symbol. In the post-exilic period, the menorah was endowed with spiritual connotations, mainly derived from Zechariah 4: the presence of the spirit of the God of Israel, bearing hope for redemption.[9] Although after the destruction of the Second Temple it was forbidden to make another menorah, its form could still be represented.[10] Among other attributes, the menorah stands for wisdom.[11] According to the commentary by Rashi, Midrash Tanḥuma on Exodus 25:37, "And thou shalt make the seven lamps thereof; that they may give light over against it," and also to the Babylonian Talmud tractate Menaḥot 98b, the flames must lean inward to the straight central branch that points to the Divine Presence:

> As for the six lamps atop the six branches that extend from the sides of the middle shaft, turn the mouths of those lamps toward the middle lamp so that, facing the mouth of the middle lamp, they may throw their light toward the middle shaft, the main part of the candelabrum.

In papercuts, the plant parts — *kaftor va-feraḥ* (knops and buds) — of the menorah often merge with vines and tendrils and take on a tree-like appearance, or its arms and base are intertwined to form complex patterns and endless-knot devices, which we discuss separately in chapter 5, below, along with the kabbalistic connotations of the menorah.

Crown

Sometimes all three crowns mentioned in Pirqei Avot, the "Sayings (Ethics) of the Fathers," are depicted: the crown of Torah, the crown of priesthood, and the crown of the royal house of David from which the Messiah will spring.[12] "But the crown of a good name excels them all," Rabbi Shime'on is quoted in the Sayings. *Keter torah* ("Crown of the Torah") probably inspired the literal crowning of the Torah scroll in the synagogue. "*Keter*" is also one of the leading kabbalistic concepts.[13]

Tablets of the Law

Jewish practice long discouraged representation of the Decalogue in any form. However, despite objections by the rabbis, from the seventeenth century on, the familiar double tablets rounded at the tops came into wide use among Jews, reflecting a distinct Christian influence in Jewish art.[14] Usually five lines with the beginning words of each of the Ten Commandments are inscribed on each tablet; or, if space did not permit, the Hebrew letters *aleph* א through *yod* י — the numerals one to ten, starting with the right-hand tablet — appear instead.

Magen david — Shield of David

The six-pointed star made up of two tête-bêche superimposed triangles is a relative newcomer as a distinctly Jewish symbol, although it does appear in ancient and medieval sources, usually in apotropaic contexts. The *magen david* was the emblem of the Prague Jewish community in

the late Middle Ages. Thereafter, its use spread throughout the Jewish world, mainly during the nineteenth century. With the growth of modern Jewish nationalism, it was officially adopted as the emblem of the Zionist movement, and later, together with the ancient menorah, as that of the State of Israel.

Ḥamsa

A different type of symbol, used extensively in North African and Middle Eastern Jewish communities but not in Ashkenazi ones, is the *ḥamsa* — "five" — the open palm of the hand warding off the evil eye. The "Hand of Fatima" is a favorite Muslim talisman that passed into Jewish practice. In practical kabbalistic lore, the number five (*heh*) ה, which stands for the Ineffable Name is considered a charm against evil.

Endless Knot

Intertwining, continuous variations and developments of the figure eight lying on its side and having no beginning and no end are worked into the designs of many Jewish papercuts of Central and Eastern Europe. An endless-knot device often appears as a development of the menorah, giving it a very peculiar form, or as part of the vine entanglements. Use of this element may represent a direct influence of German and French Christian religious and secular paper-

3.36. *Mizraḥ*. One of the papercut *mizraḥ*s from the folkloristic material collected by the An-Sky expedition in 1916 in the western Ukraine bordering on Galicia. The base of the "convoluted" menorah is an intertwining endless-knot development. Note also the standard depictions of the Leviathan framing the medallions inscribed with the letters of the word *mizraḥ* at the top, between the double-eagle/crown and the heraldic griffins.
ca. 40 × 47 cm.
(ca. 15½" × 18½").
After R. Wischnitzer-Bernstein, 1935.

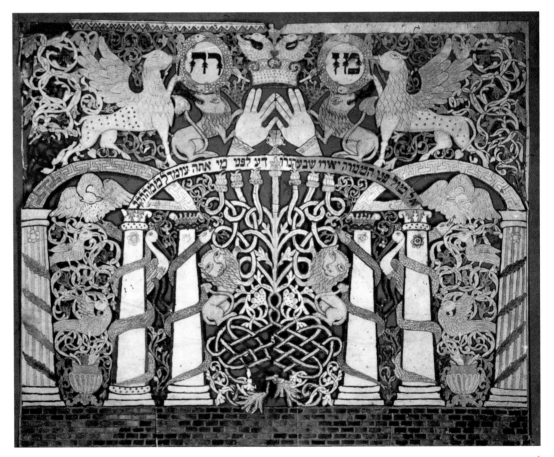

3.36

cuts, such as *Andachtsbilder*, where it commonly appears in analogous positions on the central axis, symbolizing constancy and everlasting love. We devote a detailed discussion to this configuration in chapter 5, below.

3.37. Endless Knot. Small *shavuosl* with an endless knot at the base of the menorah. 19 × 11 cm. (7½" × 4⁵⁄₁₆"). After G. Frankel, 1929.

Architectural Elements and Furnishings

Aron qodesh — Holy Ark, Torah Shrine

The abode of the Torah has been an important Jewish symbol since antiquity. The Shulḥan ʿArukh code of Jewish halakhah enjoins the accordance of great respect to the Torah scroll, giving it a special place of honor and beautifying that place in an exceptional manner.[15] The *aron qodesh* in the synagogue is usually raised on a podium, the steps leading up to it suggestive of the raised throne of Solomon.[16] Sometimes it is part of an elaborate structure rising to several tiers, always with two-winged doors, and is lavishly decorated with painted carvings of flanking, heraldic animals, and ritual appurtenances (pp. 47–49, 151–153).[17]

Columns

The two ornate columns flanking the entrance to the porch of Solomon's temple, known as Yakhin and Boaz, figure prominently in Jewish graphic architectural compositions, having come to symbolize the Temple as a whole.[18] Two columns supporting an arch — or even without an arch — may represent the concept of the heavenly gateway.[19] The twisted columns featured so frequently in Jewish ritual art of the last centuries were probably influenced by pictures of Bernini's spiral columns of the canopy under the dome of St. Peter's in Rome. These commonly appeared in printer's blocks used in title pages of Christian as well as of Jewish books of the seventeenth and eighteenth centuries in Italy and Holland (Figs. 2.44a–d).[20]

Arched Gateway

"This is the gate of the Lord into which the righteous shall enter" (Psalm 118:20) is but one of many metaphoric references to gates in the Bible, if by far the most common one. It was — and is — often inscribed over the entrance to the synagogue, or over the holy ark structure. In the ancient cities of the Middle East and as mentioned in the Bible, the gateway was where the judges held court, the place where justice was dispensed. In Jewish belief, gateways have important, multiple symbolic meanings, as in Gates of Justice, Gates of Heaven, Gate of Mercy, Gate of Tears, and similar figurative associations expressive of man's yearning for divine compassion.[21]

Bimah and Balustrades

The balustrade-enclosed, elevated *bimah* (reader's platform) in the center of the synagogue often had a baldachin or other decorative superstructure supported by four columns. It symbolizes the reading of the Torah, as related in Nehemia 8:4: "And Ezra the scribe stood upon a pulpit of wood . . . and . . . read in the book of the Law of God."

Lamps

"For the Commandment is a lamp and the Law is light," states Proverbs 6:23. Lighting fixtures and candles, symbolizing the Light of the Torah, are much in evidence in Jewish life. In a few of the known North African Jewish papercuts, lamps sometimes appear in arched niches, recalling the common lamp-in-the-niche motif of Islamic art, which derives from Sura 24:35 of the Qur'an:

> God is the light of the Heavens and the earth. His light is as a niche in which is a lamp and the lamp is in a glass, the glass is as though it were a glittering star.

The *ner tamid*—"eternal light"—became a standard fixture in synagogues from the seventeenth century on, symbolizing God's presence amid the people of Israel or the spiritual light emanating from the Temple.[22] Perhaps it was also inspired by the passage "quench not the light of Israel" in II Samuel 21:17.

Oil Pitchers

Stylized, usually long-beaked pitchers or ewers (containing olive oil) flanking the base of the menorah symbolize several biblical passages.[23] Some of these mention two olive trees on either side of the candlestick (e.g., Zechariah 4:3); but the main reference is Exodus 27:20: "And thou shalt command the children of Israel, that they bring thee pure olive oil beaten for the light, to cause the lamp to burn always." The Hebrew word for pitcher—*kad*—also has kabbalistic significance symbolizing the inexhaustible, mystical depth of the Torah.[24] The letters *khaf* כ and *dalet* ד that make up the word for pitcher, or jar, have a numerical value of twenty-four, the number of sacred books—*khaf-dalet sifrei ha-qodesh*—according to the Rabbinic register.

Musical Instruments

The Almighty's praises are sung in several of the Psalms (e.g., 33, 149, 150) to the accompaniment of harp, "psaltery of ten strings," timbrel, pipe, cymbals, and the "blast of the horn." Modern musical instruments such as violins, clarinets, trumpets, or drums, sometimes feature in old Jewish papercuts, as they did in synagogue wall decorations (Fig. 3.38).

Ḥanukkah Lamp, Candelabrum

Lamps or candelabra with eight flames and one servitor are used in the Festival of Lights. In modern times, Ḥanukkah has come to symbolize the struggles of the Jewish people for independence and freedom of worship. This motif appears in some of the new "revival" papercuts, but is almost unknown in old ones.

Jerusalem

Whereas some old Jewish papercuts have representations of holy places or pictorial allusions to the Holy City, stylized representations of Jerusalem have become a favorite motif in contemporary papercut compositions. Symbolic views of the walled city, representing the centrality of Zion and the spiritual and political focus of Judaism, are inspired or derived from nineteenth-century prints produced in Jerusalem, or are based on personal interpretations by the artist.

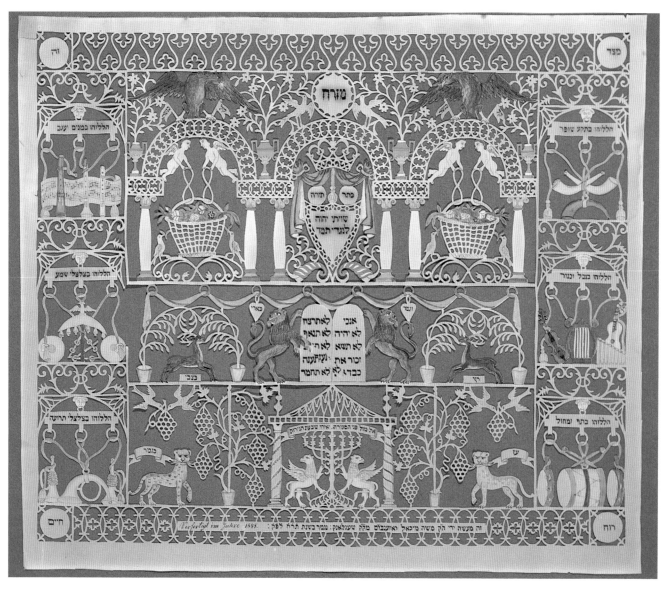

3.38. *Mizraḥ*. Dr. Alfred Salinger, an orthodox Jew who practiced medicine in Berlin in the 1920s, was given this beautiful papercut by one of his patients. The work is dated 1848 and signed by Moshe Michael Rosenboim of Schönlanke in Posen (West Prussia), today the Poznan province of Poland. The papercut shows considerable artistic ability and experience, perhaps even formal training in the graphic arts. As in some German folk art, there are representations of naked angels and garlands with baskets of fruit. Each of the Four Animals is there, notably the leopard, complete with spots and bushy mustachios. The able artist departed from symmetry in the lateral margins to depict the musical instruments from Psalm 150:3–5: "Praise Him with the blast of the horn; . . . the psaltery and harp; . . . the timbrel and dance; . . . stringed instruments and the pipe; . . . loud-sounding cymbals; . . . clanging cymbals." 33.5 × 39 cm. (13¼" × 15⁵⁄₁₆"). Sidie Weiskopf, New York.

Vegetal Motifs

Tree of Life

One of the most ancient symbols in the religions of the Middle East is the Tree of Life, most often represented as a palm, but also as the olive and other trees. In Jewish belief, two trees have great symbolic importance: *'etz ha-ḥayyim* — the Tree of Life — which represents the Torah, and

3.39. Jerusalem. Hardly any of the known old Jewish papercuts show representations of the heavenly Holy City. In the modern revival of the Jewish papercut, this motif was first used by Yehudit Shadur in the 1970s. Here, the domed "Temple" stands within the symbolic, walled city with its many gates. Three verses from the book of Psalms (137:6, 43:8, and 48:13–14) proclaim the exalted conception of Jerusalem. Crowning the composition is the *keter malkhut* — the Crown of Kingship in Zion. At the bottom is a fountain of life-giving waters (Psalm 36:10). 25.9 × 23 cm. (10³⁄₁₆" × 9¹⁄₁₆"). Collection of the authors, Jerusalem.

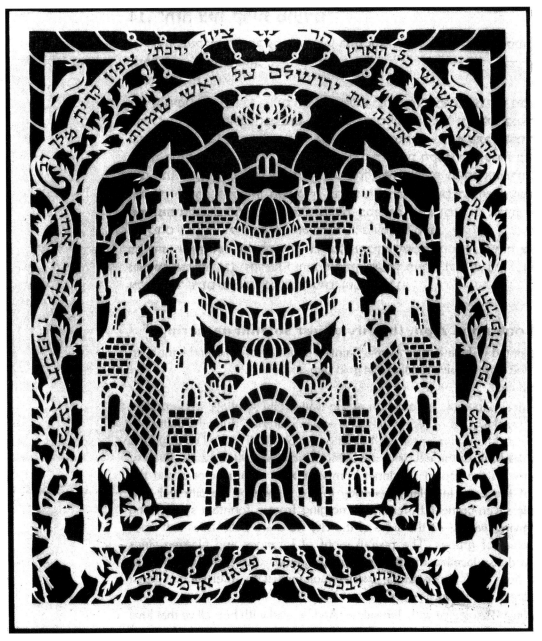

3.39

'etz ha-da'at — the Tree of Knowledge — standing for the spiritual and intellectual understanding of the Torah. These are often given the form of vines and tendrils growing out of urns, sometimes merging with the menorah (divine light = Torah) into one concept.[25] Ashkenazi terminology refers to the two wooden spindles on which the Torah scroll is wound as "Trees of Life," after Proverbs 3:18, "She [the Torah] is a tree of life to them that lay hold upon her."

Potted Plants, Vines, Tendrils

Variations on the Tree of Life symbol are smaller plants, buds, and flowers, growing out of urns and often incorporated in the border designs. The grapevine and clusters of grapes signify Israel, as in Isaiah 5:7: "For the vineyard of the Lord of Hosts is the house of Israel, and the men of Judah His pleasant plant." Many *midrashim* (textual interpretations) dwell on comparisons between the people of Israel and the grapevine in all its parts.[26] "Said Rabbi Shime'on ben Laqish: This nation may be compared to a grapevine: its branches — are the householders; its clusters — these are the scholars; its leaves — the ordinary (unlettered) people; the dry twigs — the empty, good-for-nothings of Israel . . . and the clusters will intercede for the leaves, for without the leaves there would be no life for the clusters."[27] A golden cluster of grapes hung over the portal of Herod's Temple; and, of course, wine is an important element in Jewish ritual.[28]

Bestiary

The "Four Animals"

As in Ashkenazi ritual art and synagogue decoration, the most common animal motifs in Jewish papercuts are the lion, vulture (eagle), leopard, and gazelle (deer). These are the Four Animals of the aphorism of Rabbi Judah ben Tema in Pirqei Avot — "Sayings (or, Ethics) of the Fathers" 5:23 — which is given in full on page 107 below, in the section on Hebrew inscriptions. The symbolism of these Four Animals — or often only two or three of them — was universally understood in European Jewish communities even when the text was not actually quoted. It is, however, not known in Sephardi iconography. These animals, which all belonged to the native fauna of the Holy Land, were unfamiliar to the Jews of Central and Eastern Europe. Hence they identified the majestic, soaring vulture (*nesher*) with the eagle of European heraldry; the delicate, quick gazelle (*tzvi*) with the heavier, antlered deer; and the leopard (*namer*) with the tiger of picture books.

Lion

Symbolizing power and majesty, lions have been widely used as royal and religious emblems from very remote times. They are often represented in symmetrical, confronting pairs. This is so in the earliest known synagogue art, where lions flank a central motif such as a menorah, and in later Jewish art, where they are shown rampant, usually facing either forward or backward, holding the tablets of the Law, a *magen david*, a crown, a shield with an inscription, or the like. The lion was the emblem of the tribe of Judah, from which the Messiah will spring.[29]

Gazelle

The gazelle (*tzvi*), the symbol of beauty and grace, stands also for the land and the people of Israel, as in *eretz ha-tzvi* — "Land of the Gazelle" the "beauteous land" (Daniel 11:16, 41); *ha-tzvi yisra'el* — "Thy beauty O Israel" (II Samuel 1:19); and other passages. The three Hebrew letters *tzadeh* צ, *bet* ב, *yod* י, that make up the word *tzvi* are also an acronym for *tzadiq be-emunato yihyeh* — "the righteous shall live by his faith" (Habakkuk 2:4).

Deer, Stag, Hart

The deer (*ayal*, in Hebrew; *hirsh* or *hersh*, in Yiddish) has often been confused with the gazelle (*tzvi*), which was not known in northern regions. Fallow and other deer did live in the Land of Israel in the past as they do in Europe, and so appear commonly as one of the "Four Animals" instead of the gazelle. The deer, as such, represents the craving for God's mercy: "As the hart panteth after the water brooks, so panteth my soul after thee, O Lord" (Psalm 42:2).

Eagle (Vulture)

The biblical *nesher*, translated as "eagle" into other languages and so reintroduced to Jewish lore, is most probably the griffon vulture. The modern Hebrew word for eagle is the biblical term *'ayit* (the Greek word is *aetos*). It is not the fault of the superb griffon vulture that it has come to evoke negative connotations. The eagle as symbolic of political power may have passed into Jewish iconography from the Roman empire (along with its identification as one of the "Four Animals"), and from its later use in the heraldry of the Middle East and Europe.

Double-headed Eagle

The double-headed eagle appears frequently in central and dominant positions in East-European Jewish papercuts and other ritual art. It has been interpreted as symbolizing the duality of Divine grace and mercy; but it undoubtedly also reflected the political allegiance of the community or artist to the Austrian or Russian empires, in whose coats of arms it appeared.[30] This was true for non-Jewish papercuts and folk art of the same regions as well. However, the symbol became so popular that it cannot always be taken as an indication of where a particular work was made. The Jewish double-headed eagles usually differ from the imperial ones: Whereas the latter hold an orb and a scepter or sword in their talons, the Jewish ones usually do not hold anything and are seldom crowned.

Griffin

Cherubs (*kruv, kruvim*, in Hebrew), encompassing the Ark of the Covenant and covering it with their wings are represented in ancient Jewish art as birds (Fig. 2.1).[31] It is not clear how they came to be depicted as bird-faced, winged lions — perhaps because the Greek word for griffin (*grips* or *grif*) is similar to *kruv* (Figs. 4.12a, 4.16, 4.17, 5.18, etc.).[32]

Birds

Birds have been identified with the human soul: "How say ye to my soul: 'Flee thou! to your mountain, ye birds'?" (Psalm 11:1). Birds among the foliage may also be evocative of Psalm 104:12: "the fowl of the heaven, From among the branches they sing." But they may serve purely decorative functions to enliven representations of vines and tendrils, as is common in baroque and folk art generally.

Stork

The Hebrew word for stork is *ḥassidah* — literally, "the good, charitable one." Since storks also eat snakes, which according to Genesis 3:14–15 are the accursed of God and enemies of man-

kind, the stork has come to symbolize good deeds. "Said Rav Yehudah: The stork — it is a white soaring bird, why is her name called *hassidah*? For she does righteousness with her fellows."[33]

Peacock

Symmetrical pairs of peacocks appear in synagogue decorations of the period of the Talmud, when they may well have been among the stock figures in pattern books of contemporary Roman and Byzantine artists. Midrash Tanḥuma (B.Lev.33) extols the peacock's beauty, and the head of the bird was considered a delicacy (Shabbat 130a). Legend has it that a golden peacock (*goldene pahve*, in Yiddish) confronted a golden eagle perched on the fourth step of Solomon's throne.[34] According to an ancient, non-Jewish tradition, the flesh of the peacock does not decay. In Christian iconography the bird symbolizes immortality.[35]

Fish

In the designs of "*mi-she-nikhnas adar*" papercuts (Figs. 3.29a–c), fish represent the month of Adar of the zodiac, when the Purim festival is celebrated and when the Messiah is expected to appear. Fish symbolize fertility because of their abundance, ". . . as the fish of the great sea, exceeding many" (Ezekiel 47:10). The Hebrew term *ve-yidgu*, meaning "to multiply like fish," appears in Genesis 48:16. According to a Jewish folk tradition, "As the fishes in the sea are covered by water . . . the evil eye has no power over them." (Berakhot 20a).[36]

Snakes

Snakes frequently appear in Jewish papercuts, twisting around columns or the Tree of Knowledge, being grasped in the beaks of storks, and sometimes in decorative configurations (e.g., Fig. 3.17).

Leviathan, *shor ha-bar*

The great, legendary sea monster of the Aggadah, upon which the righteous will feast in the hereafter, is commonly depicted in Jewish folk art as a long fish, forming a circle by biting its own tail, sometimes in conjunction with *shor ha-bar* — the "wild ox" or behemoth (Figs. 4.11, 5.12). It is very likely that fish-tailed lions, and possibly sea-lions, also represent Leviathan, as discussed at some length in chapter 5.

Fish-tailed Lion

This chimerical creature appears in Jewish folk art almost only on a few tombstones and even fewer carved Torah shrines, but more frequently in papercuts of Eastern Europe. It is probably another representation of Leviathan (Figs. 3.10b, 5.9a–b, 5.14, 5.16, and see detailed discussion in chapter 5).

Other Animals

Ram, rooster, elephant, squirrel, bear, and fabulous animals such as unicorns and griffins, taken either collectively or individually, may have a number of meanings. Thus, according to the Talmud, the rooster, cat, ant, and dove belong to those animals from which man can learn.[37]

The rooster symbolizes the righteous, for he ushers in the dawn of God's mercy from the east (*mizrah*).[38] Another Talmudic passage enjoins whoever sees an elephant, a monkey, or a long-tailed ape (?) to say a special blessing.[39] To dream of an elephant (*pil*) is a good omen if it is saddled, bad if it is not.[40] Rashi, in his commentary to Psalm 74:19, compares Israel to the variety of animal species. The bear (*dov*, in Hebrew; *ber*, in Yiddish) may stand for a common personal name, as is the case with other animals: Tzvi-Hersh (deer); Tzippora-Feigel (bird); Ze'ev-Wolf. But other animals and birds, such as camels, goats, sheep (*sheps*), geese (*gans*), turkeys (*indik*), and even parrots may simply have been familiar to the rural shtetl-dwellers from their everyday environment or commonly seen pictures. Sheps, Gans or Genser, and Indik were also fairly common Jewish family names in Eastern Europe.

Signs of the Zodiac

All twelve, or individual, signs of the *galgal ha-mazzalot* (zodiac) appearing in several papercuts may represent the cycle or time of year when the work was made, a festival falling during a particular month, a private anniversary or birthday, or a community commemoration. Although known in early synagogue mosaics, the zodiac is not referred to in the Mishnah, which states that "Israel is immune from planetary influence" (Shabbat 156a). Its first mention in Jewish sources is in the medieval kabbalistic *Sefer ha-yetzirah* — "Book of Formation" — and in the late fifteenth-century Midrashic anthology, *Yalqut Shim'oni* (Lev.148). Thereafter it becomes a fairly common motif in Jewish folk art.

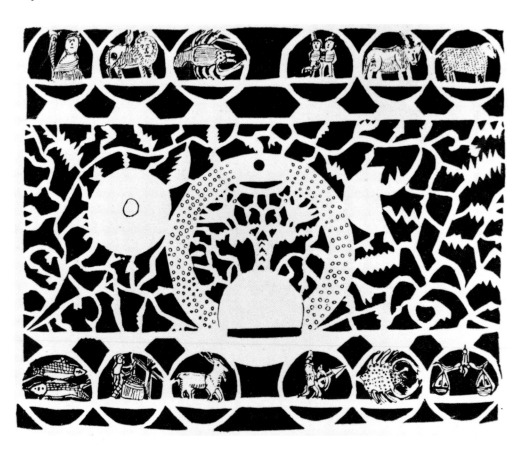

3.40. Signs of the Zodiac (*shavuosl*). No inscription or Jewish symbol appears on this rather crudely made papercut, except for the zodiac, and with a highly stylized Leviathan biting its tail. Compare the rendering here with that in Figs. 4.11 and 5.12. It is probably a *shavuosl* made by a young boy in Tomaszów-Lubelski (Poland) in the late nineteenth century. After R. Liliental, 1908.

Human Forms

Blessing Hands

The priestly blessing, in which four pairs of fingers are spread with the thumbs touching so as to form five voids, sometimes appears on papercuts.[41] Two arms holding up an open Torah

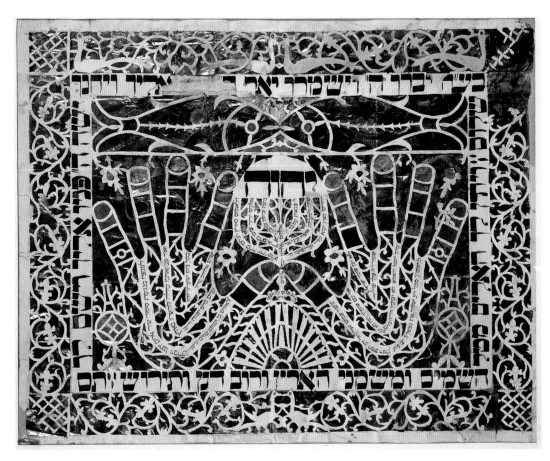

3.41. *Menorah*. The bold design of this Moroccan-Jewish papercut made by the same man who created the two monumental works in Figs. 5.26 and 5.27 is dominated by the blessing priest's hands, which hold a menorah-shaped medallion bearing the Tetragrammaton in large letters. In the register above, two confronting fish — harbingers of good fortune (immune to the evil eye) — touch mouth to mouth. The stylized elements, arabesques, and peacocks are like the ones in his two other works. Inscribed within the hand at the left, and extending to the left-hand branches of the menorah is the full text of Psalm 67. The right side of the menorah and the right hand are inscribed with Psalm 121. The inner border, lettered in square, Sephardi script, cites the three verses of the Priestly blessing (Numbers 6:24–26):

> The Lord bless thee and keep thee:
> The Lord make His face to shine upon thee and be gracious unto thee:
> The Lord turn His face unto thee and give thee peace.

To this is added the blessing that Isaac bestowed upon Jacob:

> So God give thee of the dew of heaven,
> And of the fat places of the earth,
> And plenty of corn and wine. (Genesis 27:28)

40 × 50 cm. (15¾" × 19¾"). The Sir Isaac and Lady Edith Wolfson Museum, Hechal Shlomo, Jerusalem.

scroll (Fig. 8.8b) illustrate Deuteronomy 4:44: "And this is the Law which Moses set before the children of Israel." — part of the liturgy of the reading of the Torah.

Adam and Eve

A few papercuts from regions of Germanic cultural influence show scenes from the Garden of Eden with the naked figures of Adam and Eve, the Tree of Knowledge, and the serpent (Genesis 3).

Angels

Winged angels, some of them blowing trumpets, clearly entered the Jewish papercut repertoire of symbols from western Christian iconography. Compare the ones in the Jewish works in Figs. 3.38 and 3.45 with the non-Jewish, Dutch papercuts in Figs. 1.17a–b.

Portraits

Cut-out, pasted-in portraits of famous rabbis occupy central positions in a few papercuts. In one case, the ruling Hapsburg emperor Ferdinand I is depicted (Fig. 3.42).

Biblical Scenes and Personages

Moses and Aaron, the *ushpizin*, the Binding of Isaac, Jacob's Dream, and other biblical scenes are featured in some papercuts, mainly on *shavuoslakh*, sukkah decorations, and ketubot.[42]

3.42. *Mizraḥ/* Commemorative. Naked Adam and Eve holding fruit from Trees of Knowledge around which wind snakes; a portrait of the "world-renowned" rabbi, Ya'aqov Kopel Altinkonstadt(?) from Verba? in Bohemia or Moravia?; a depiction of the reigning Hapsburg emperor, Ferdinand (1835–1848) in the upper right-hand corner (presumably, his wife, Maria Anna, figured in the now missing left-hand corner); naive, human-faced, red-cheeked and lipped lions flanking the standard *mizraḥ* formula; the sun and moon; a menorah inscribed with the incomplete words for "in memory"; and now partly illegible inscriptions in Hebrew and Gothic German apparently welcoming the royal couple (or the rabbi?) — are all featured in this eclectic papercut, probably dated to 1836 or so. 32 × 40.5 cm. (12⅝" × 15¹⁵⁄₁₆"). Jewish Museum, Prešov, Slovakia.

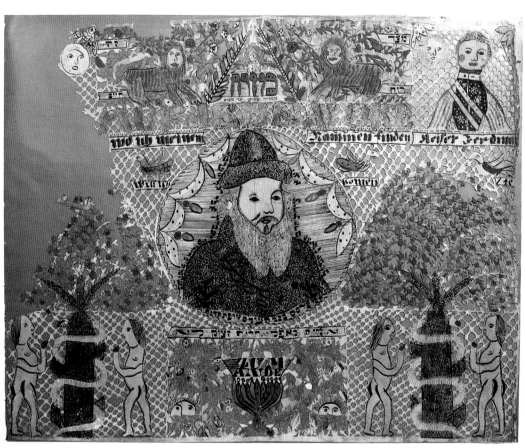

3.42

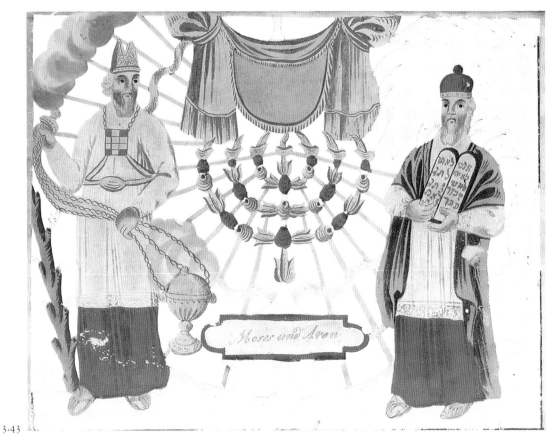

3.43. *Mizraḥ.* Although the word *mizraḥ* does not appear in this lithographed, cut-out, and water-colored work, its purpose was undoubtedly to indicate the direction of prayer to Jerusalem. Moses holds the Decalogue and Aaron swings the censer. The flames of the menorah point inward toward the middle light according to the iconographic practice, as explained on p. 91. This little work was reportedly made in Vienna in 1830. 20.5 × 26 cm. (8¹/₁₆" × 10¼"). Židovské Muzeum Praha, Prague.

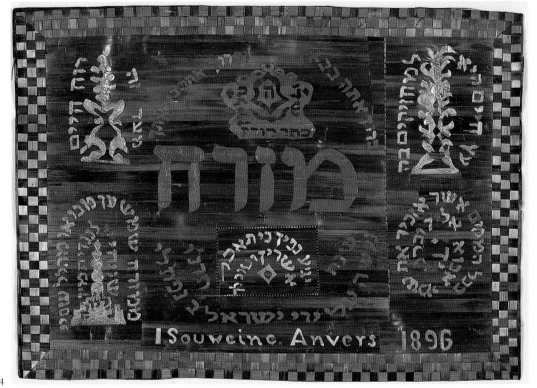

3.44. *Mizraḥ/Shiviti.* Not a papercut, this interesting Belgian-Jewish work was made of cut and inlaid straw by Yisrael the son of Naftali Souweine of Antwerp, in 1896. The arched inscription over the large word *mizrah* reads: "Be thou blessed in coming, and be thou blessed in departing" (Deuteronomy 28:6). The other inlaid inscriptions are standard texts appearing in many Jewish papercuts. 24 × 33.5 cm. (9⁷/₁₆" × 13³/₁₆"). Musée Juif de Belgique, Brussels.

Human Forms / **103**

Secular Scenes

Hunters, peasants, street scenes, buildings, carriages, soldiers in procession, and other figures appear on small *shavuoslakh*, obviously made by young boys impressed by things they had seen. To the extent that non-religious subjects appear in larger papercuts, they are, with very few exceptions, relegated to the border designs and never occupy central space. Such representations clearly reflect gentile — usually Germanic — cultural environments and the folk art of the peoples among whom Jews lived.

Odds and Ends

Ribbons, banners, pennants, heraldic shields, medallions, garlanded discs, buildings, and the like often form the backgrounds for inscriptions. Space is often filled in with lace-like geometrical patterns, which also serve the necessary function of holding the design together in one piece. Secular national emblems and flags and Masonic devices appear in some Jewish American papercuts (Figs. 1.24, 4.29, 4.30a–b, etc.). A Jewish papercut from the Ottoman empire (Fig. 4.23b) features panoplies of arms, crossed cannons or pistols, and the crescent and star emblem.

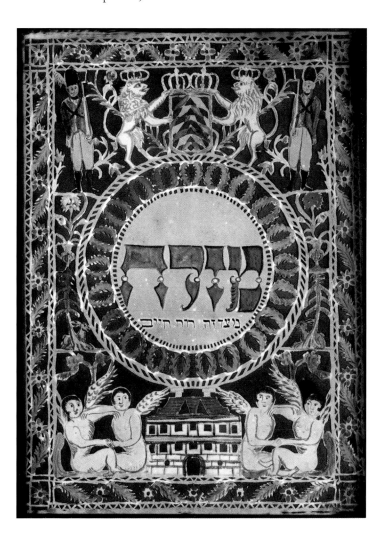

3.45. *Mizrah*. Only the large, Hebrew *mizrah* text in the central wreath identifies this decidedly Germanic-style papercut as Jewish. All the other configurations — especially the two pairs of naked angels — are secular. Exact provenance is unknown; the heraldic device may suggest Bavaria, but could indicate allegiance to some aristocratic German family or minor ducal state. The soldiers' uniforms suggest a late eighteenth- or early nineteenth-century dating. 28.6 × 21 cm. (11¼" × 8¼"). Jewish Museum, New York (JM 3-70).

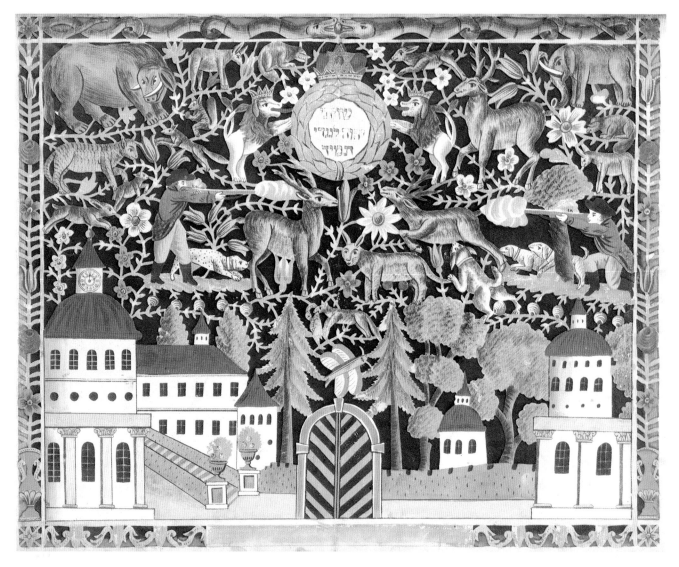

3.46. *Shiviti*. A very unusual Jewish papercut: The traditional, crowned roundel inscribed with the *shiviti* formula, flanked by two crowned lions, is the only specifically Jewish element in this otherwise entirely secular, eclectic composition. Note the two hunters firing their guns, and their dogs attacking the running deer — hardly Jewish motifs! The overall cultural influence is clearly Germanic, but what are the elephants doing there? And note the snakes in the top margin. We wish we could know more about this intriguing work, and by whom, when, and where it was made. 38.7 × 49 cm. (15¼" × 19⅝₆"). Židovské Muzeum Praha, Prague.

Hebrew Inscriptions, Acronyms, Anagrams, and Cryptograms

Since all traditional Jewish art is essentially a visual conceptualization of sacred texts, the written word is seldom absent in such creations. Inscriptions of many kinds abound, most of them with kabbalistic connotations and allusions. Although Yiddish texts, usually of a personal nature, are not uncommon in East-European Jewish papercuts, and sometimes a few words in other languages — mainly in German — may appear as well, the overwhelming majority of inscriptions are in Hebrew. Most are taken from the prayer book, the Bible, and from other devotional and mystical literature. Space does not permit us to list all the various inscriptions in the papercuts that we have seen. We give here some of the most common ones and a small sampling of others. Other inscriptions are treated in the captions to the appropriate illustrations.[43]

מִזְרָח – מִצַּד זֶה רוּחַ חַיִּים

mizraḥ; mi-tzad ze ru'aḥ ḥayyim: East; From this direction the spirit of life.

מִמִּזְרָח־שֶׁמֶשׁ עַד־מְבוֹאוֹ מְהֻלָּל שֵׁם יְהֹוָה

mi-mizraḥ-shemesh ad-mevo'o mehullal shem adonai: From the rising of the sun to its setting the name of the Lord is to be praised. (Psalm 113:3)

שִׁוִּיתִי יְהֹוָה (יְיָ) לְנֶגְדִּי תָמִיד
כִּי מִימִינִי בַּל־אֶמּוֹט

shiviti adonai le-negdi tamid [ki mi-yemini bal-'emot]: I have set the Lord always before me [Surely He is at my right hand, I shall not be moved]. (Psalm 16:8)

keter torah: Crown of the Torah. (Pirqei Avot 4:7, 4:13) כֶּתֶר תּוֹרָה

דַּע לִפְנֵי מִי אַתָּה עוֹמֵד לִפְנֵי מֶלֶךְ מַלְכֵי הַמְּלָכִים
הַקָּדוֹשׁ בָּרוּךְ הוּא [הַיּוֹדֵעַ כל מַצפּוּנֶיךָ]

da' lifnei mi ata omed, lifnei melekh malkei ha-melakhim ha-qadosh barukh hu [ha-yode'a kol matzpunekha]: Know before Whom you stand, before the King, King of Kings, the Holy One blessed be He [Who knows all your secrets]. (Berakhot 28b)

Shaddai: The Almighty. שַׁדַּי

le-mazal tov: For good luck (literally: "favorable star"). לְמַזָּל טוב

סמוי״ט – סוּר מֵרַע וַעֲשֵׂה טוֹב

SAMUT (soor mi-raʻ ve-ʻasseh tov): Depart from evil and do good. (Psalm 37:27)

אטלי״ס – אַךְ טוֹב לְיִשְׂרָאֵל סֶלָה

ATLAS (akh tov le-yisra'el selah): (God) is good to Israel, selah. (Psalm 73:1)

DAMASQ (daʻ mi she-hu qonekha): Know Who is your Maker. דמשי״ק – דַּע מִי שֶׁהוּא קוֹנֶךָ

דמלי״מ – דַּע מַה לְמַעְלָה מִמְּךָ

DAMLAM (daʻ ma le-maʻalah mi-mekha): Know What is above you. (Pirqei Avot 2:1)

The first three of the latter four Hebrew acronyms *SAMUT, ATLAS,* and *DAMASQ,* are the Yiddish words for velvet, silk, and damask cloth, respectively. In effect, they are really "inverse" acronyms, similar to the chronograms so beloved of Jews with a kabbalistic bent. These acronyms/words occasionally appear as part of the texts on the sumptuous embroidered *parokhot* (Torah shrine curtains) and *kaporot* (valances) hung in front of the holy ark in the synagogue, and indicate the textiles employed in making these hangings. As we explain in the caption to the papercut in Fig. 5.18, which bears the inscription "And these are the garments man shall make for his soul — *SAMUT, ATLAS, DAMASQ,*" the words are thus endowed with double and threefold meanings. These acronyms seldom, if at all, appear on ritual objects other than *parokhot,* papercuts, and devotional wall plaques, reinforcing the hypothesis advanced above, on pp. 47–49, that many East-European papercuts took their inspiration from synagogue Torah shrines, including also the curtains in front of the holy ark. Although the fourth acronym, *DAMLAM,* sometimes appears in conjunction with the others, we could not establish whether it too represents a textile, or has some added meaning.

יוֹם חַג הַשָּׁבוּעוֹת הַזֶּה

yom ḥag ha-shavu'ot ha-zeh: This feast day of Shavuoth. (From the prayer book)

ẓeman mattan toratenu: The season of the giving of our Torah. זְמַן מַתַּן תּוֹרָתֵנוּ

הֱוֵה עַז כַּנָּמֵר וְקַל כַּנֶּשֶׁר רָץ כַּצְּבִי וְגִבּוֹר כָּאֲרִי
לַעֲשׂוֹת רָצוֹן אָבִיךָ שֶׁבַּשָּׁמַיִם

hevei ʻaz ke-namer ve-qal ka-nesher ratẓ ke-tẓvi ve-gibor ka-ari la'assot ratzon avikha she-ba-shamayim:
 Be bold as the leopard and light (on the wing) as the vulture (eagle), swift as the gazelle,
 and powerful as the lion to do the will of your Father in heaven. (Pirqei Avot 5:23)

אֶל־מוּל פְּנֵי הַמְּנוֹרָה יָאִירוּ שִׁבְעַת הַנֵּרוֹת

el mool pnei ha-menorah ya'iru shiv'at ha-nerot: The seven lamps shall give light over against
 the menorah. (Numbers 8:2)

yevarekhekha adonai: May God bless you.

יְבָרֶכְךָ אֲדֹנָי (יְיָ)

זֶה־הַשַּׁעַר לַיהוָֹה צַדִּיקִים יָבֹאוּ בוֹ

zeh ha-sha‘ar l-adonai tzadiqim yavo'u bo: This is the gateway of the Lord into which the
 righteous shall enter. (Psalm 118:20)

נֵר יְהוָֹה נִשְׁמַת אָדָם

ner adonai nishmat adam: The spirit of man is the lamp of the Lord. (Proverbs 20:27)

אָדָם דּוֹאֵג עַל אוֹבֵד (אִיבּוּד) דָּמָיו
וְאֵינוֹ דוֹאֵג עַל אוֹבֵד (אִיבּוּד) יָמָיו
דָּמָיו אֵינָם עוֹזְרִים
וְיָמָיו אֵינָם חוֹזְרִים

adam do'eg 'al oved (or, *ibbud*) *damav*: Man worries about losing his money
ve-eino do'eg 'al oved (or, *ibbud*) *yamav*: And worries not about losing his days
damav einam 'ozrim: His money helps not
ve-yamav einam ḥozrim: And his days do not return.

(Sefer ha-Ḥayyim — Book of Life 10:1)

Other Common Inscriptions

• Prayers specific to the different holy days, the new moon, special religious occasions (after-
 meal blessing — *birkat ha-mazon* — circumcision ceremony, prayer for the dead, etc.).

• The two first words of each of the Ten Commandments, or the numerical letters *aleph-yod*
 א — י (Exodus 20:2–17)

•

בֶּן פֹּרָת יוֹסֵף בֵּן פֹּרָת עֲלֵי־עָיִן
בָּנוֹת צָעֲדָה עֲלֵי־שׁוּר

Ben porath yosef ben porath 'alei-'ayin [banot tza'adah 'alei-shur]: Joseph is a fruitful vine, A
fruitful vine by a fountain [Its branches run over the wall]. (Genesis 49:22, Berakhot 20a)

• The Ten Sefirot סְפִרוֹת — Emanations of the Ein Sof אֵין סוֹף — the kabbalistic funda-
 mentals of all existence: כֶּתֶר *keter* (Supreme Crown); חָכְמָה *ḥokhmah* (Wisdom); בִּנָה *binah*
 (Intelligence); חֶסֶד *ḥesed* (Lovingkindness, Greatness); גְּבוּרָה *gevurah* (Power, Judgment);
 תִּפְאֶרֶת *tif'eret* (Beauty, Mercy); נֶצַח *netzaḥ* (Eternity); הוֹד *hod* (Majesty); יְסוֹד *yesod* (Founda-
 tion, Righteousness); מַלְכוּת *malkhut* (Kingdom).

• A bewildering variety of baffling, esoteric acronyms and cryptograms composed of initial
 and/or final letters of biblical passages and prayers, of texts from kabbalistic writings, and
 words formed by rearranging the numerical values of letters or of certain magic formulas.

- Mysterious renderings of the Ineffable Name in various esoteric letter combinations of the Hebrew alphabet, some coded, for example, A = B, B = C, C = D, and/or A = Z, B = Y, C = X; cryptograms made up of the first and last letters of words in certain biblical passages; apparently senseless words resulting from the initial, final, and final-but-one letters of words of such passages, and the like. Thus the four-letter Name of the Almighty is evoked in eight, fourteen, twenty-two, forty-two, and seventy-two of such peculiar letter combinations from biblical verses, prayers, and special magic formulas, generally of apotropaic intent. They commonly appear in *kimpetbrivl* amulets and on *shiviti* and menorah papercuts, but also on *mizraḥim* and others. Some of these inscriptions are given in the relevant captions to the papercuts illustrated. The most important are:

- The introductory verse of Psalm 67 across the top of the menorah, and the seven verses of the Psalm on the seven branches:

לַמְנַצֵּחַ בִּנְגִינֹת מִזְמוֹר שִׁיר:

אֱלֹהִים יְחָנֵּנוּ וִיבָרְכֵנוּ יָאֵר פָּנָיו אִתָּנוּ סֶלָה:

לָדַעַת בָּאָרֶץ דַּרְכֶּךָ בְּכָל־גּוֹיִם יְשׁוּעָתֶךָ:

יוֹדוּךָ עַמִּים, אֱלֹהִים יוֹדוּךָ עַמִּים כֻּלָּם:

יִשְׂמְחוּ וִירַנְּנוּ לְאֻמִּים כִּי תִשְׁפֹּט עַמִּים מִישׁוֹר

וּלְאֻמִּים בָּאָרֶץ תַּנְחֵם סֶלָה:

יוֹדוּךָ עַמִּים, אֱלֹהִים יוֹדוּךָ עַמִּים כֻּלָּם:

אֶרֶץ נָתְנָה יְבוּלָהּ יְבָרְכֵנוּ אֱלֹהִים אֱלֹהֵינוּ:

יְבָרְכֵנוּ אֱלֹהִים וְיִירְאוּ אוֹתוֹ כָּל־אַפְסֵי־אָרֶץ:

For the Leader; with string-music. A Psalm, a Song./

God be gracious unto us, and bless us;
May He cause His face to shine toward us; Selah/

That Thy way may be known upon earth,
Thy salvation among all nations./

Let the peoples give thanks unto Thee, O God;
Let the peoples give thanks unto Thee, all of them./

O let the nations be glad and sing for joy;
For Thou wilt judge the peoples with equity,
And lead the nations upon earth. Selah/

Let the peoples give thanks unto Thee, O God;
Let the peoples give thanks unto Thee, all of them./

The earth hath yielded her increase;
May God, our own God, bless us./

And let all the ends of the earth fear Him./

- The "*anna be-khoaḥ*" prayer ascribed to Neḥunya ben ha-Qaneh (second century C.E.), but more probably part of kabbalistic prayers from thirteenth-century Spain that express hope for redemption from the Diaspora and implores the Almighty's protection. According to a long-established if obscure tradition, the initial letters of the words, in groups of three, supposedly incorporate the mystic, forty-two-letter Holy Name of God:

（תְּפִלַּת רַבִּי נְחוּנְיָא בֶּן הַקָּנֶה)

אָנָּא, בְּכֹחַ גְּדוּלַּת יְמִינְךָ, תַּתִּיר צְרוּרָה : קַבֵּל
רִנַּת עַמְּךָ, שַׂגְּבֵנוּ, טַהֲרֵנוּ, נוֹרָא : נָא גִבּוֹר, דּוֹרְשֵׁי
יִחוּדְךָ, כְּבָבַת שָׁמְרֵם : בָּרְכֵם, טַהֲרֵם, רַחֲמֵם,
צִדְקָתְךָ תָּמִיד גָּמְלֵם : חֲסִין קָדוֹשׁ, בְּרוֹב טוּבְךָ
נַהֵל עֲדָתֶךָ : יָחִיד, גֵּאֶה, לְעַמְּךָ פְּנֵה, זוֹכְרֵי
קְדֻשָּׁתֶךָ : שַׁוְעָתֵנוּ קַבֵּל, וּשְׁמַע צַעֲקָתֵנוּ, יוֹדֵעַ
תַּעֲלוּמוֹת : בָּרוּךְ שֵׁם כְּבוֹד מַלְכוּתוֹ לְעוֹלָם וָעֶד :

We beseech Thee, release Thy captive nation by the mighty strength of Thy right hand. Accept the joyful chant of Thy people, lift us and purify us, O revered God. O Thou mighty One, guard as the apple of Thine eye them that meditate upon Thy Unity. Bless them, purify them, have mercy upon them, ever bestow Thy charity unto them. O powerful and holy Being, in Thine abounding goodness lead Thy congregation. Turn, Thou who art the only and exalted God, unto Thy people, who are mindful of Thy holiness. Accept our prayer and hearken unto our cry, Thou who knowest all secrets. Blessed be His name, whose glorious kingdom is for ever and ever.

- מְכַשֵּׁפָה לֹא תְחַיֶּה

 makhashefa lo teḥayeh: Thou shalt not suffer a sorceress [witch] to live (in all possible permutations of the three words). (Exodus 22:17)

- שַׁדַּי קְרַע שָׂטָן

 shaddai qra' sattan: Almighty destroy (rend) Satan (but also the mystical initials of a sequence of six words in the *anna be-khoaḥ* prayer).

- סְנוֹי Sanvai (Sinav), סַנְסְנוֹי Sansanvai (Sinsinav), סְמַנְגְּלוֹף Semangalof: mystic names of protecting angels.

- *ARGAMAN*: An acronym that is the Hebrew word for "purple" made up of the initials of the angels אוֹרִיאֵל Uriel, רְפָאֵל Raphael, גַּבְרִיאֵל Gabriel, מִיכָאֵל Michael, נוּרִיאֵל Nuriel.

• *shir la-ma‘alot . . .*: Psalm 121 in its entirety:

שִׁיר לַמַּעֲלוֹת

אֶשָּׂא עֵינַי אֶל־הֶהָרִים מֵאַיִן יָבֹא עֶזְרִי׃

עֶזְרִי מֵעִם יְהוָה עֹשֵׂה שָׁמַיִם וָאָרֶץ׃

אַל־יִתֵּן לַמּוֹט רַגְלֶךָ אַל־יָנוּם שֹׁמְרֶךָ׃

הִנֵּה לֹא־יָנוּם וְלֹא יִישָׁן שׁוֹמֵר יִשְׂרָאֵל׃

יְהוָה שֹׁמְרֶךָ יְהוָה צִלְּךָ עַל־יַד יְמִינֶךָ׃

יוֹמָם הַשֶּׁמֶשׁ לֹא־יַכֶּכָּה וְיָרֵחַ בַּלָּיְלָה׃

יְהוָה יִשְׁמָרְךָ מִכָּל־רָע יִשְׁמֹר אֶת־נַפְשֶׁךָ׃

יְהוָה יִשְׁמָר־צֵאתְךָ וּבוֹאֶךָ מֵעַתָּה וְעַד־עוֹלָם׃

A Song of Ascents
 I will lift up mine eyes unto the mountains:
 From whence shall my help come?
 My help cometh from the Lord,
 Who made heaven and earth.
 He will not suffer thy foot to be moved;
 He that keepeth thee will not slumber.
 Behold, He that keepeth Israel
 Doth neither slumber nor sleep.
 The Lord is thy keeper;
 The Lord is thy shade upon thy right hand.
 The sun shall not smite thee by day,
 Nor the moon by night.
 The Lord shall keep thee from all evil;
 He shall keep thy soul.
 The Lord shall guard thy going out and thy coming in,
 From this time forth and for ever.

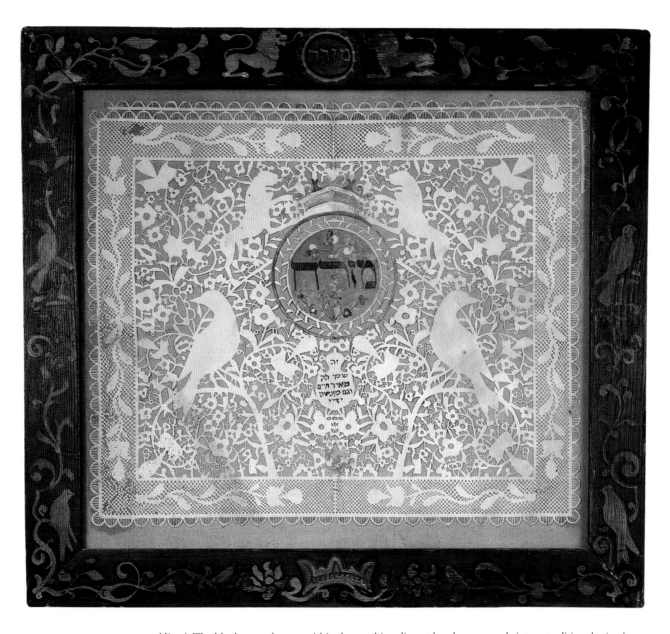

4.1. *Mizraḥ*. The blank central space within the machine die-cut border was made into a traditional *mizraḥ* papercut by Meir Ḥayyim, probably in the latter half of the nineteenth century in Vienna. 36 × 39 cm. (14¹⁄₁₆" × 15³⁄₈"). Mishkan le-Omanut, Museum of Art, ʿEin Ḥarod.

4

A CLOSER LOOK AT SOME JEWISH FOLK PAPERCUTS THROUGHOUT THE DIASPORA

Categorizing a folk tradition as old and widespread as the art of the Jewish papercut must take into account its various manifestations and aspects over a long period of time: from the latter half of the eighteenth century to the 1950s. In this chapter we supplement the examples illustrating the text by focusing on select types of such works in different parts of the Jewish world, presented more or less in chronological order for each cultural or geographic region. But let us begin with the effects of the machine age on this traditional craft.

Using Die-Cut and Machine-Embossed Papers

From around the mid-nineteenth century, a new technological development enabled the manufacture of decorative, die-cut stamped paper products, including gold- and other color-embossed

4.2a

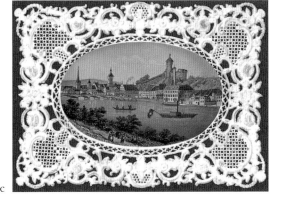
4.2c

4.2b

4.2. Blank Machine-cut Papers. (A printed Swiss landscape picture was pasted into one of these.)

113

designs and imitation lace patterns. Among these were blank sheets of paper with die-cut and/or embossed borders that were adapted by Christian makers of *Spitzenbilder* (lace pictures), and also by Jews, for their religious purposes in the manner of the traditional papercuts by complementing the machine-cut parts with hand-cut designs and inscribed texts. Although the center of this industry was in Germany and Bohemia, such products were also made in France. The popularity of machine-embossed papers extended to the lands of the Ottoman empire, including their use in Turkish-Jewish papercuts.

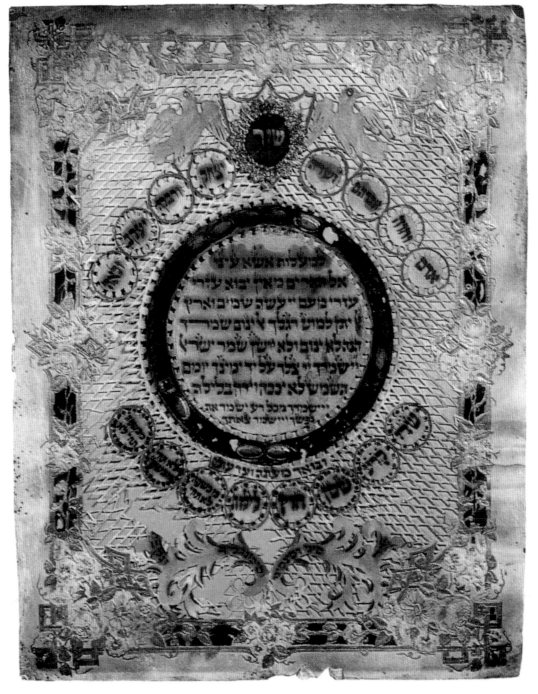

4.3. *Kimpetbrivl.* In the blank area within the ornate, machine-embossed, gilt frame is a delicately hand-cut symmetrical network with birds, small roundels, and baroque vegetal patterns (note the foldline down the middle). The embossed, gilt medallion at the top, and the large roundel in the center were pasted in. The inscriptions are the standard kabbalistic and magic formulas of such amulets in both Ashkenazi and Sephardi traditions (see p. 62 and Figs. 3.5–3.14). As usual, the entire text of Psalm 121 occupies center space. 28.5 × 22.5 cm. (11" × 8¹³⁄₁₆"). Archival collection of the authors, Jerusalem.

4.3

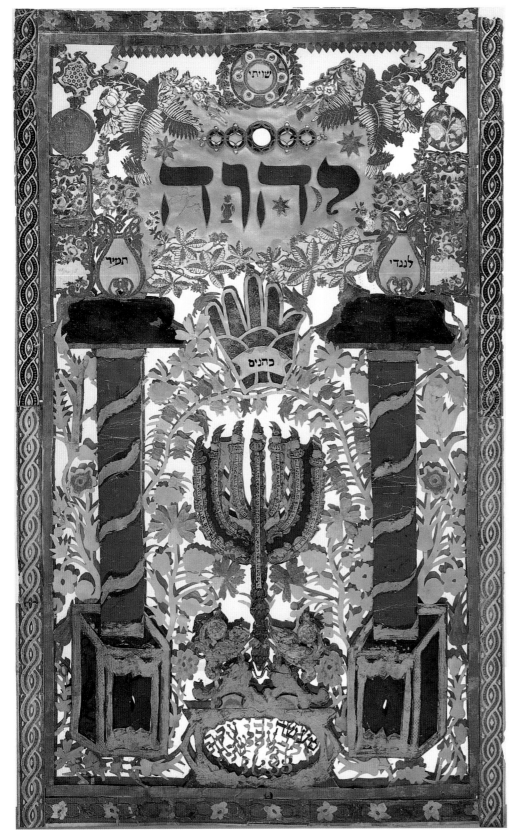

4.4. *Shiviti/Menorah.*
Decorative machine-
embossed and die-cut
elements were combined
in 1875 by Ya'aqov Alba'li
(in Turkey) in his hand-
colored and cut paper *shiviti-*
cum-amulet mounted on a
mirror. The central menorah,
inscribed with the sixty-
seventh Psalm, was apparently
cut out of a printed sheet and
pasted into the composition.
44 × 27 cm. (17¹/₁₆" × 10⁵/₈").
Israel Museum, Jerusalem.

4.4

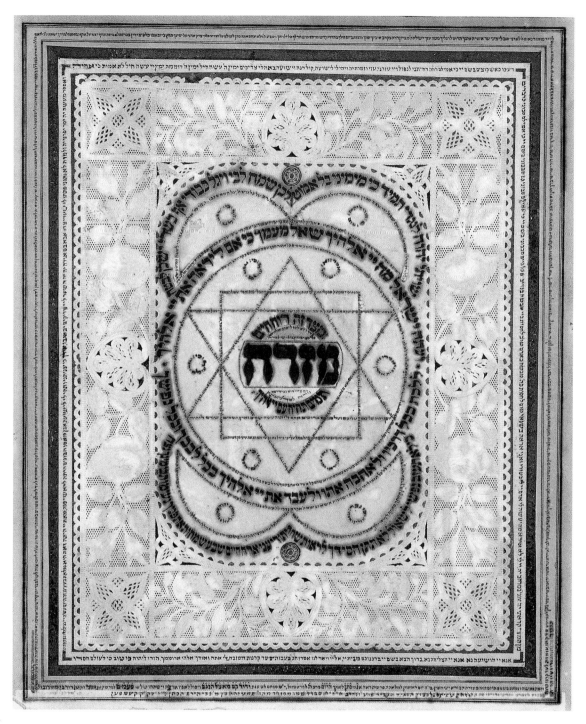

4.5a

(ABOVE AND OPPOSITE PAGE) 4.5. *Mizrah/Shiviti*. These mind-boggling micrographic, devotional — and quite similar — creations on sheets of paper with machine die-cut and embossed borders were made by two different men at different times and places: (*a*) by David ben Dov of Kempen near Breslau in 1851 in honor of Shmaryahu ben Tzvi-Hirsch HaCohen; and (*b*) about a half-century later, by David Davidson "Artist in Penmanship" from 18 Avenue C in Brooklyn, New York. Despite the many years between them, and even though (*b*) is about twice the size of (*a*), the marginal machine-cut designs are identical. Most of the minute inscriptions are from various Psalms. (*a*) 30.2 × 25.5 cm. (11⅞" × 10 1/16"). Jüdisches Museum Wien, Vienna. (*b*) 62 × 43 cm. (24⅜" × 16 15/16"). Mishkan le-Omanut, Museum of Art, 'Ein Ḥarod.

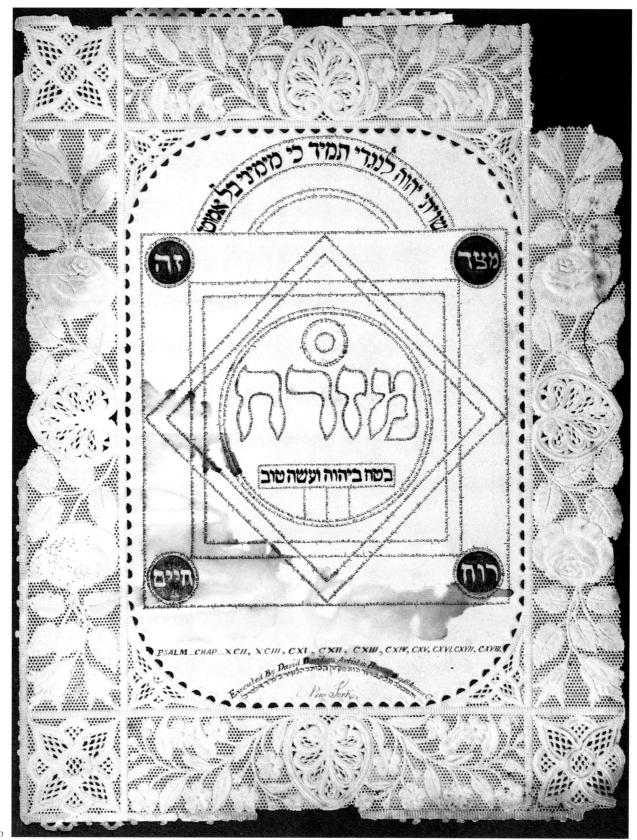

4.5b

Papercuts of Ashkenazim from Italy to Russia

Considering that, on the whole, all Jewish papercuts served the same ritual and religious purposes, the diversity of forms and artistic approaches are truly staggering. Can we detect any stylistic developments over the century and a half during which, for example, the seventeen Ashkenazi works in Figs. 4.6 to 4.18 were made? Except for the early, unique, fragmentary work (Fig. 4.7) found in the Luže synagogue genizah in eastern Bohemia,[1] all the others share many iconographic and textual components. But what stands out by looking at these, as all the other papercuts in these pages, is the intense individuality of those who created them — from Northern Italy to the Russian pale of Jewish settlement, and from Alsace and Copenhagen to Galicia and Moldavia.

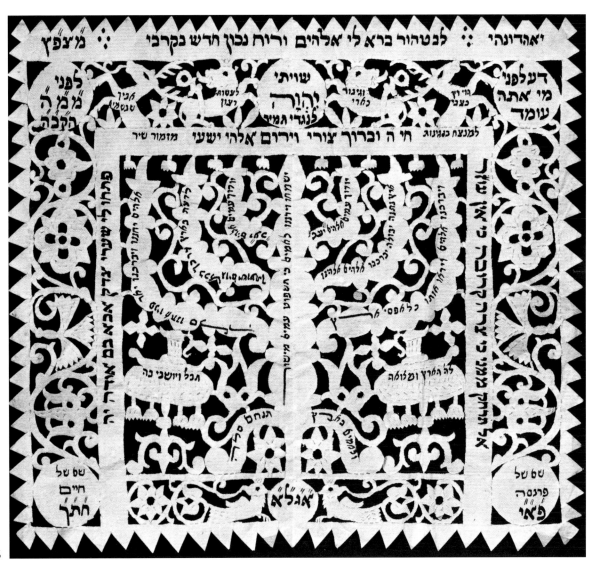

4.6

4.7. Sukkoth. Among a large variety of discarded Jewish religious and secular material discovered in the course of a survey in 1996 to 1999 by the Prague Jewish Museum of genizahs (repositories of sacred materials containing the name of God, which may not be destroyed), were also the three fragmentary remnants of this papercut. Although it was found in the attic of the Luže synagogue in eastern Bohemia, it may have been made elsewhere. From the remaining, inscribed parts we know that it was made for the Sukkoth festival in the Hebrew year 5534 (1773). Since in that year the first day of Sukkoth fell on a Sabbath, the texts in the central panel include the prescribed *havdalah* prayers for such occasions, along with the entire *qiddush* benediction for festivals and the Sabbath in the left-hand panel. The fragmentary panel, top right, mentions the *ushpizin*. Judging from the scant remains, and except for its *being* a papercut, it does not conform to the general genre of Jewish devotional papercuts. In this unique work we see none of the usual iconographic configurations, and the "slashing" cutting technique is also quite rare in Jewish work. As shown: 41.9 × 35.8 cm. (16½" × 14⅛"). Židovské Muzeum Praha, Prague.

4.7

(OPPOSITE PAGE) 4.6. *Shiviti/Menorah/*Amulet. Apart from ornate, baroque *ketubot* and scrolls of Esther with cut-out borders, this is one of only two Jewish papercuts from Italy we have ever seen. The good quality rag paper points to an early dating — at the least, not much later than the early nineteenth century, and more probably the eighteenth century. A menorah, inscribed as usual with the sixty-seventh Psalm, dominates the design. At each side are three-legged tables covered with heavy-tasseled cloths upon which stand ewers in deep dishes. The clearly delineated borders contain, at the top, crowned lions grasping a roundel inscribed with the *shiviti* passage. Two half-deer each hold roundels in the upper corners, and two eagles occupy the center of the lower margin, displaying another inscribed roundel. The texts in this most interesting work, combining passages from the Psalms with stereotypical kabbalistic cryptograms, indicate that it also served as an amulet. Especially noteworthy is the bold inscription at the top: "Create me a clean heart O God, And renew a steadfast spirit within me" (Psalm 51:12). Note also the added details and textural effects obtained by delicate knife slashes in the flowers, tablecloths, ewers, lions, and eagles — a technique that is commonplace in many Christian papercuts. This lovely little papercut was long kept among the pages of a printed Italian haggadah dated 1776. The family of its owner lived in the village of Finale-Emilia in the Modena-Cento province since at least 1680. The community ceased to exist during World War II. 15 × 17 cm. (5⅞" × 6⅝"). Itala Laba, Jerusalem.

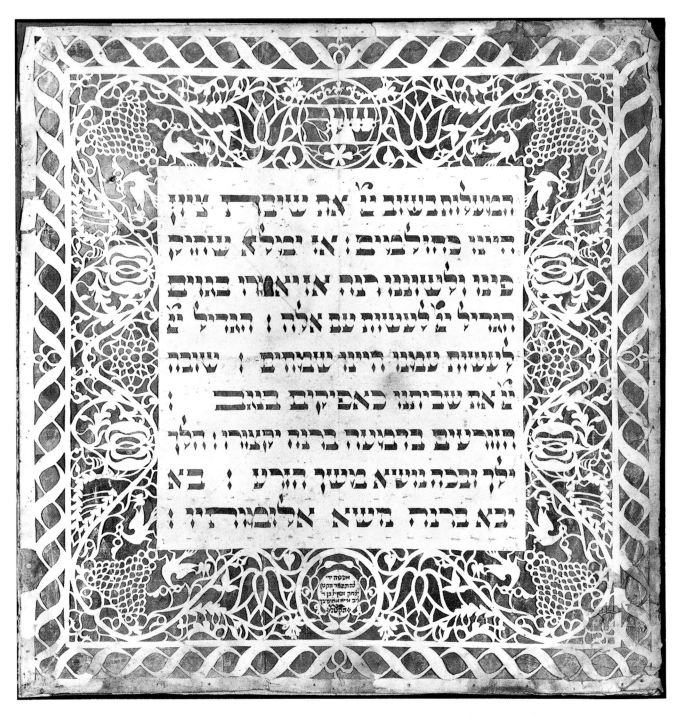

4.8. "Immaterial" Text. A rare example of a lengthy biblical passage entirely cut out in the style of "immaterial" books in which the letters are "non-existent" by being cut away. Psalm 126 is the central and only theme of this papercut. The inscription in the medallion, bottom center, tells us that it was made in 1779 by Yitzḥaq Zekil, son of Rabbi Leib May of Offenbach (next to Frankfurt a. M.). The richly ornate border contains grape clusters, pomegranates, ears of wheat, and birds. The symmetry of the border design is not only lateral but also vertical (note the fold lines crossing through the center). The square sheet of paper was folded into quarters and the four sides were cut together, only making allowance for the top and bottom medallions. This work was given to the Alsace-Lorraine Jewish Society by Leopold Levy of Wasselonne in 1909. 35 × 35 cm. (13¾" × 13¾"). Collection of the Société pour l'Histoire des Juifs d'Alsace-Lorraine, Musée Alsacien, Strasbourg.

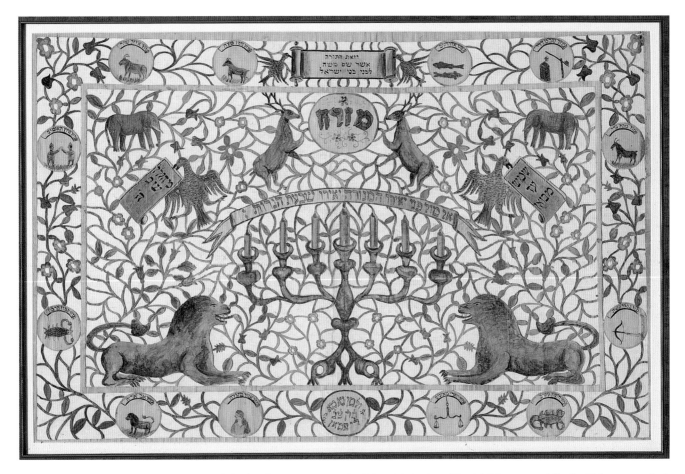

4.9. *Mizraḥ*. We seldom know how some of the fragile papercuts survived the vicissitudes of Jewish life — especially the Holocaust period. This large item, signed Zalman Natte Lipman, 1832, was reportedly acquired by the American collector of Judaica, Herman Davidowitz, from a Polish Jew who claimed that he saved it by sewing it in a piece of linen concealed in his clothing. The man brought it to London after the war, where Davidowitz agreed to buy it sight unseen and in unknown condition. Back in the United States, and loath to open the linen bag himself, he commissioned a restorer to do so. The work was found in fragmentary, dismembered condition, but was skillfully reconstructed to its present state. In addition to the lions, deer, and eagles representing the "Four Animals" aphorism, and other standard inscriptions, note the elephants, and the signs of the zodiac and the open Torah scroll in the upper margin. 61.6 × 93.3 cm. (24¼" × 36¾"). Dr. Fred and Cherry Joy Weinberg Collection, Toronto.

4.10. *Mizraḥ*. The delicate lines and elegant design, dated the last day of the year 5644 (Autumn 1884), bespeak a skilled craftsman-artist. The conception is bold: the wings of the double-headed eagle are inscribed with a highly contritious text, hinting at some deep personal crisis of faith in the man who made it — "Reuben the son of our teacher Rabbi Jacob Simon." The exact provenance is unknown, but this item is certainly from Eastern Europe. 29.2 × 40.6 cm. (11½" × 16"). Temple Anshe Ḥesed, Erie, Pennsylvania.

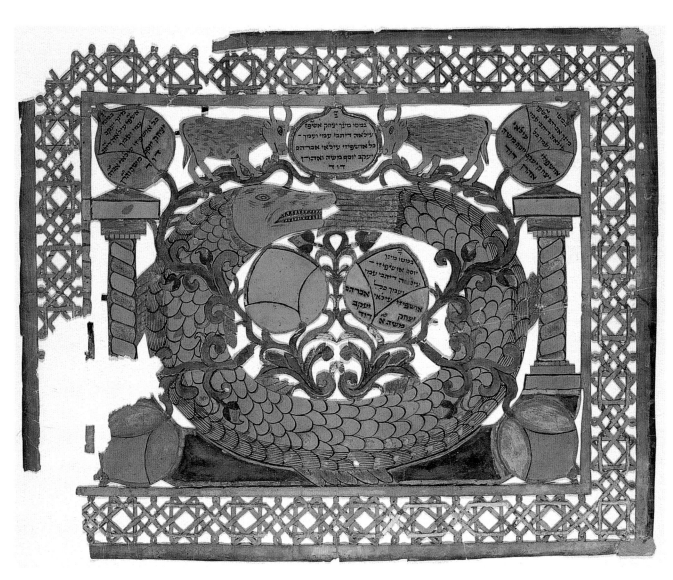

4.11. *Ushpizin* for Sukkoth. Fortunately, enough has remained of this beautiful work for us to admire. The great fish in the center and the two bovine animals above it represent Leviathan and *shor ha-bar* (the Wild Ox) — the mythical monsters of Jewish lore, who in days to come will battle to the death, and whose flesh will be served up at the banquet for the righteous when Messiah comes. The feast will take place in a *sukkah* covered with the skin of Leviathan. Of the seven pomegranate-shaped medallions, in which the prayers welcoming the traditional seven guests (*ushpizin*) were to be inscribed, only four were completed. The work thus remained unfinished (why?). Despite its small size, the bold, monumental conception and execution of this papercut attest a talented folk artist. The Hebrew lettering of the inscriptions is equally fine. According to the present owner, this and three other damaged and unfinished papercuts were probably made around the mid-nineteenth century by their ancestor, one Zev Leib Ḥazanof? (Chayes?), known as "Velvel der Kelmer *Shoiḥet*" (ritual slaughterer) in the community. Kelm was a shtetl in north-central Lithuania. Velvel was remembered in the family as having had "golden hands" — an artist who built and decorated *aronot qodesh* (Torah shrines) for synagogues. 28.5 × 35.5 cm. (11¼" × 14"). Freda Howitt, Jerusalem.

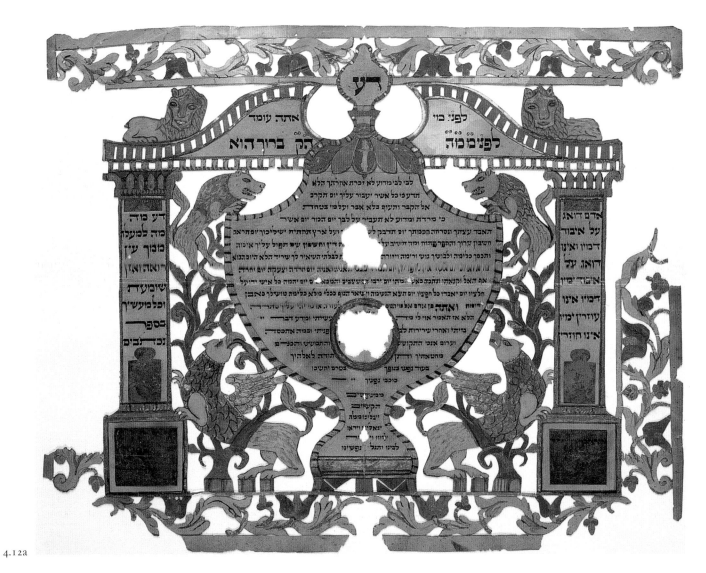

4.12a

4.12b

4.12. Memento Mori and an Unfinished Work. "Velvel der Kelmer Shoiḥet" of the "golden hands" who made the Sukkoth papercut depicted in Fig. 4.11 (Lithuania, mid-nineteenth century) also designed, cut-out, and inscribed (a) one of three similar, neo-classical, yet decidedly "Jewish baroque" designs, but of slightly different dimensions, which remained unfinished (b). The beautifully lettered inscriptions, especially the long, flowery poetic one in the center, enjoin humility and accountability before the Creator, and cognizance of man's mortal status. Unfortunately, all of Velvel's surviving works are damaged and fragmentary. The small, central roundel, which most probably contained his name, the place, and date, is entirely missing. This group of old papercuts came to Jerusalem after more than a century of migration by members of the family by way of Bialystok in Poland, Ireland, and England. (a) 34.5 × 43 cm. (13½" × 16⅞"). (b) 37.4 × 44.5 cm. (14⅝" × 17½"). Freda Howitt, Jerusalem.

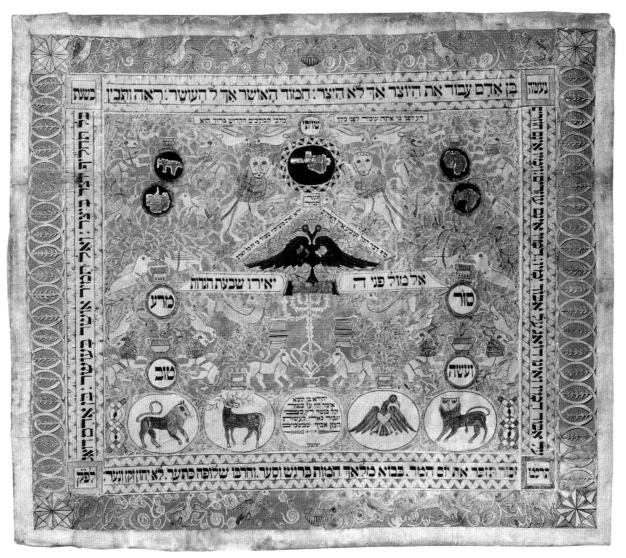

4.13. *Shiviti/Mizraḥ* (?). An interesting papercut made in 1869 in Bialystok (northeastern Poland) by a *sofer stam* (scribe of sacred texts) known as Reb Sussman, and brought to the United States by his daughter Masha in 1905. Use of poor materials caused a loss of some of the inscriptions. Unlike most traditional European Jewish papercuts cut from one sheet of paper, this one is made up of seven different pieces glued together with flour paste, partially underlaid with metallic material, and mounted on a backing board. The central motif is a menorah beneath a crowned, double-headed eagle under a gabled "roof" suggestive of an *aron qodesh*. As in most such works, a profusion of vegetation, inhabited by various animals and birds, grows out of urns — representative of the Tree of Life. The lower row of roundels depicts the Four Animals of the aphorism of Judah ben Tema (Pirqei Avot 5:230), which is lettered in full within the larger middle medallion. Above these are four roundels bearing the four words of the "*SAMUT*" text: "Depart from evil and do good." The text in the five upper roundels is now lost, but the central one held up by the large lions certainly contained the Ineffable Name of four letters — the missing word in the *shiviti* formula here. We can only speculate whether the other damaged four roundels contained the words of the *MIZRAḤ* acronym, "From this side the spirit of life" (which would define the work also as a *mizraḥ*), or, perhaps the four Hebrew words of the *ATLAS* acronym, "[God] is good to Israel, *selah*." The long text around the outer edges comprises conventional rhymed pithy sayings enjoining humility, right thinking, and reminding man of equality before the angel of death. The repeat patterns of the left- and right-hand marginal panels, which were made separately and pasted in place, were probably drawn and cut by using a coin as template. 47 × 55.5 cm. (18½" × 21⅞"). Hebrew Union College Skirball Culture Center, Museum Collection, Los Angeles. Gift of Mollie Sussman Shapiro (the artist's granddaughter).

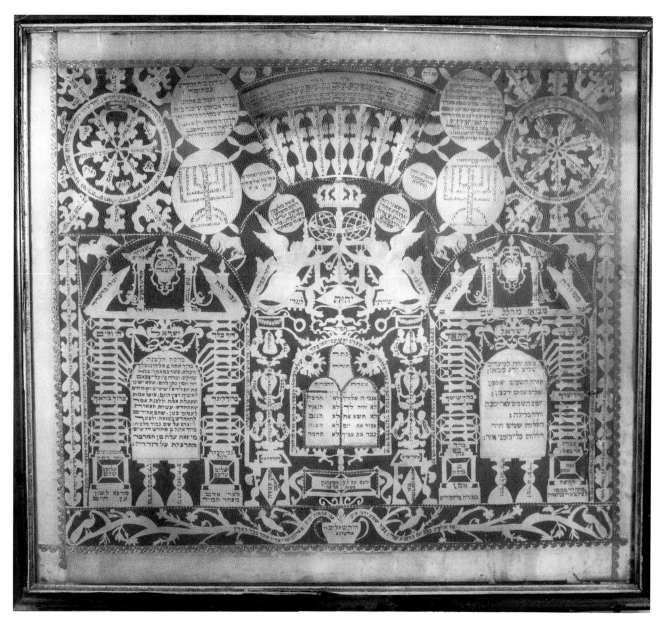

4.14. Liturgical Compendium/*shiviti*/*Mizraḥ*. A most unusual work "printed?" in Copenhagen in 1865 and signed, "Hirsh the son of Leib of Altona" (a suburb of Hamburg). An old written description appended to the poor photo (which is all we have to go by) tells us that it was cut out of white paper, had a blue linen background, and black-ink inscriptions; and that on the back of the framed work was a string with which the central, circular Omer calendar behind the curved window at the top could be rotated to "number the days of the Omer." And indeed, the flanking inscriptions in the upper ovals are the appropriate prayers from the Omer liturgy. The two circular "wheels" at the upper corners also have small "windows" on top — the one on the right for the seven days of the week, and on the left, the twelve months of the year. Among the many inscriptions that permeate the entire composition, the two micrography menorahs in the ovals are made up of Psalm 67 (right) and the mystical *anna be-khoaḥ* prayer (left). The inscriptions in the two baroque "gateways" topped with broken pediments are the *mizraḥ* formula (on the right) and verses from Psalms 121 and 148 alluding to the sun and the moon, and (on the left) the liturgy for the New Moon. The texts in the vertical outer margins, continuing around the tablets of the Decalogue, right to left, are Psalms 24 and 8. The central design with the crowned hemispheres held up by robed angels also incorporates the *shiviti* formula. Note that the outer margins consist of pasted-on paper strips with machine-embossed, beaded edges. Such very thinly cut, beaded edging is also affixed as outlines around important parts of the composition. 53 × 65 cm. (20⅞" × 25⁹⁄₁₆"). Photo: courtesy Giza Frankel Archival Collection, Jewish and Comparative Folklore Department, The Hebrew University of Jerusalem.

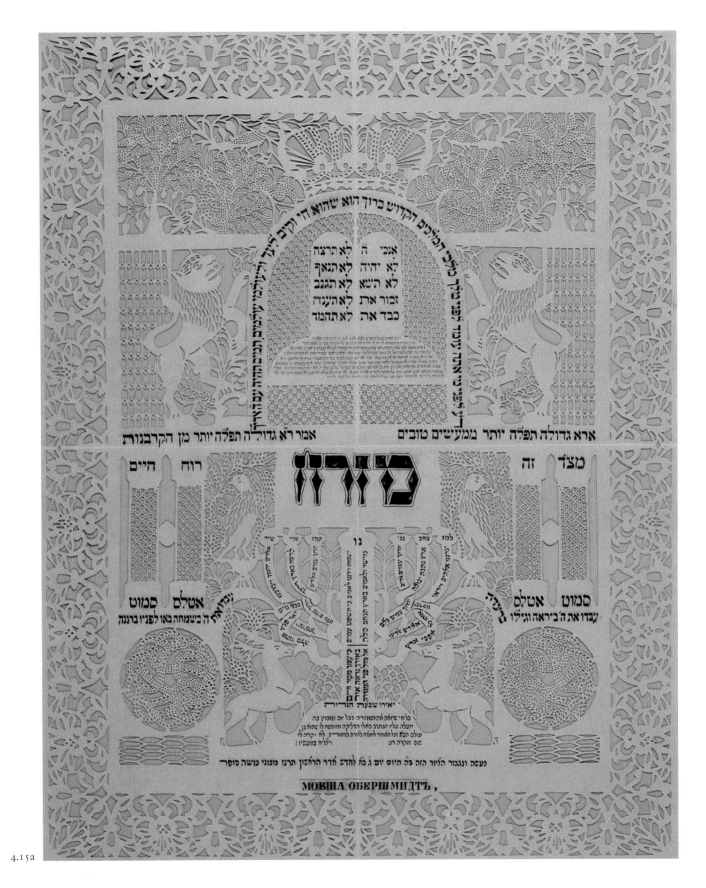

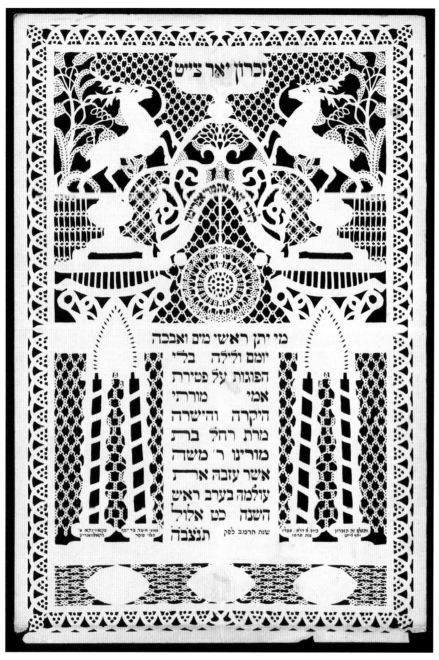

4.15b

(OPPOSITE PAGE AND ABOVE) 4.15. *Mizraḥ* and *Yortzait*. The man who made these two papercuts signed himself, in Hebrew, Moshe Bar (son of the rabbi) Yosef Halevi Sofer ("scribe"), and in Russian, Movscha Oberschmidt, probably from Nawinka near Kalwaria (southern Lithuania?). The polished style and professional workmanship attest an accomplished calligrapher and graphic artist, well-versed in the pious religious precepts, standard formulas, acronyms, and the inevitable sixty-seventh Psalm inscribed in the intertwining branches of the menorah. While the large work (*a*), dated 1897, incorporates the usual traditional Jewish iconographic elements and conforms to the generally architectural character of this "classic" genre, the effect is stiff and formal, unlike the more down-to-earth ebullience of most of these eclectic folk creations. The smaller papercut (*b*) by the same man, commemorates the memory of his mother, Rachel the daughter of Moshe, who died in 1882. Note the stylized memorial candles. (*a*) 46 × 37 cm. (18⅛" × 14⁹⁄₁₆"). Gross Family Collection, Ramat Aviv. (*b*) 31.5 × 21.4 cm. (12⅜" × 8⅜"). Spertus Museum, Spertus Institute of Jewish Studies, Chicago.

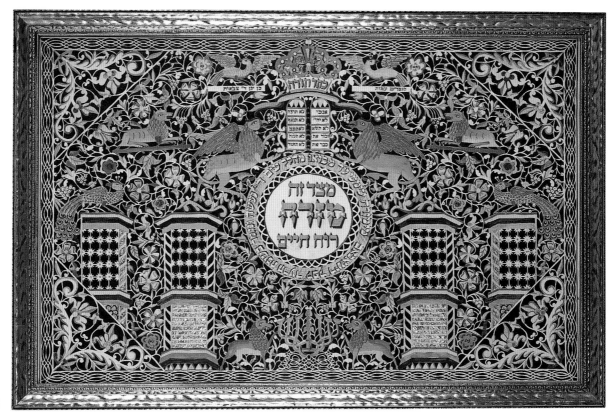

4.16

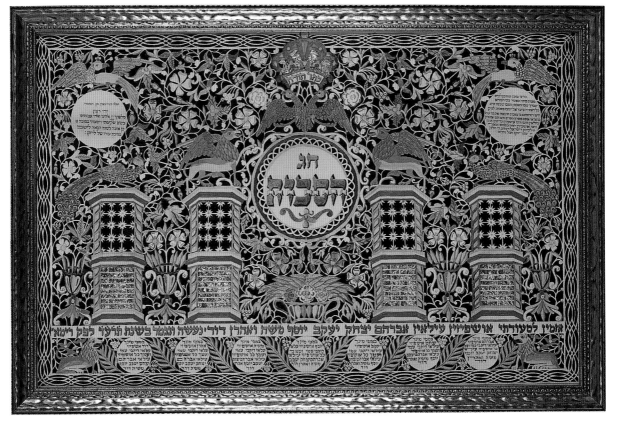

4.17

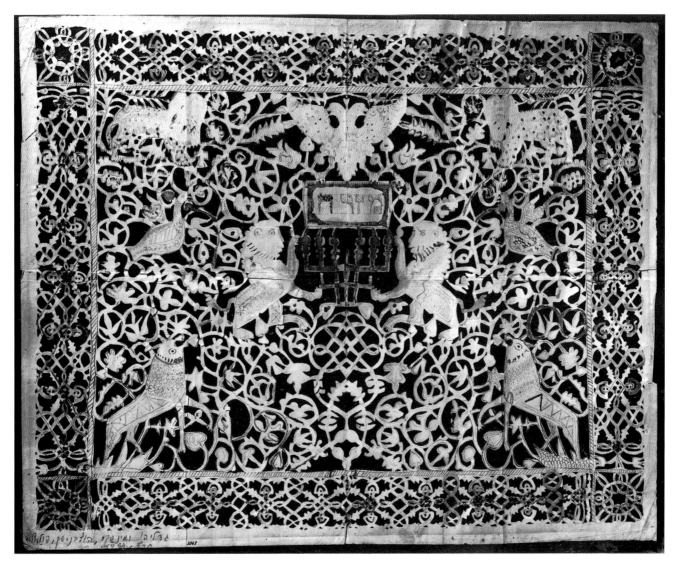

4.18. *Mizraḥ*. The penciled signature in the lower left-hand margin tells us that this intricate papercut was made by one Gedalyahu Naminsker from Holbenisk(?) (where?) in 1921. The animals and birds are naively drawn, yet the entire composition easily falls within the "classic" East-European Jewish papercutting genre. 38 × 44 cm. (14¹⁵⁄₁₆" × 17⁵⁄₁₆"). Israel Museum, Jerusalem.

(OPPOSITE PAGE) 4.16, 4.17. *Mizraḥ* and *Ushpizin* for Sukkoth. A mural painting made in about 1872 by two young yeshivah students for the synagogue of the Ḥassidic "Rymanover" Rebbe reportedly served as the model for three magnificent, large papercuts created four decades later (in 1913–1914) by one of them, Yisroel Cohen, in Rymanów, then in Austrian Galicia. Besides the *mizraḥ* (4.16), which he sent as a wedding present to his son Moishe in Brooklyn, Cohen made a similar papercut for Sukkoth (4.17) and another one for Shavuoth. The latter work apparently suffered from long neglect, and there is no record of it; the other two are the treasured possessions of Yisroel Cohen's descendants in New Jersey. Both works are of generally similar composition and apparently reflect structural elements of the Rymanów synagogue. The artistry and execution are highly competent. The *mizraḥ* features the standard elements and inscriptions, arranged hierarchically. Note the "convoluted" menorah and the "endless-knot" configuration at its foot (see chapter 5). The papercut for Sukkoth features the names of the revered guests ("*ushpizin*") — Abraham, Isaac, Jacob, Joseph, Moses, Aaron, and David — of kabbalistic tradition, with the appropriate daily prayer of the Sukkoth liturgy for each of them in the roundels at the bottom. Each 50.2 × 78.1 cm. (19¾" × 30¾"). (*4.16*) Barbara Cohen Pollak, East Brunswick, New Jersey. (*4.17*) Frieda Cohen, Cranbury, New Jersey.

Sephardi Papercuts from Ottoman Turkey and North Africa

Although located far apart at opposite ends of the Mediterranean basin, and exhibiting different stylistic charcteristics, the Jewish papercuts of Istanbul and Izmir (Smyrna) and of Morocco, Tangier, Algeria, and Tunisia reflect their respective Islamic regional cultural environments and artistic traditions. With notably rare exceptions, we look in vain here for animal — not to speak of human — forms, although birds do appear among the stylized, decorative vines and foliage. Nor are the commonplace *mizraḥ* inscriptions and related formulas of the Ashkenazi works to be seen. Along with the usual *menorah* and *shiviti* themes and texts, such as Psalm 67 and the *anna be-khoaḥ* prayer that also appear in Ashkenazi work, almost all Sephardi papercuts also served mystic apotropaic functions of a very personal nature: warding off the evil eye, soliciting material prosperity, health, fruitfulness, personal honor and advantage, and cursing all enemies. Islamic architectural and decorative forms and motifs predominate: horseshoe arches, lamps-in-niches, tulips and carnations in the Turkish works, and the like. Note also the commercially produced chromo-lithographed *menorah/shiviti* sheets from North Africa in which parts were cut out by hand and underlaid with metallic foils.

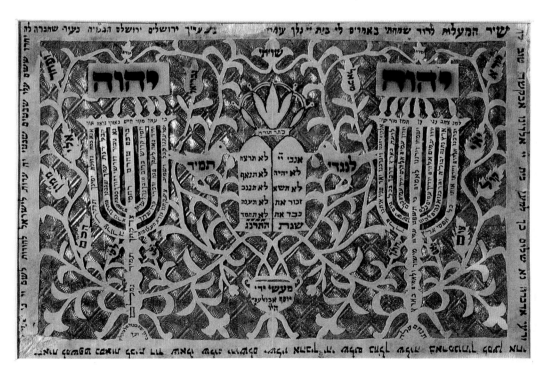

4.19. *Shiviti/Menorah.* Yosef Abulafia, who taught in a Jewish boys' school in Izmir, died in 1942. He was known for his artistic craft work, which included calligraphy, woodwork, carving of tombstones, and papercutting. Among his surviving work in paper are some interesting sukkah decorations, and several more-or-less complex *shiviti/menorah* compositions. In the one depicted here, dated 1893, the background underlay is a patterned, machine-embossed, gilt paper. The right-hand menorah is inscribed with the sixty-seventh Psalm; the left-hand one with the *anna be-khoaḥ* prayer. The running text around the outer margin is the entire one hundred and twenty-second Psalm ("... Pray for the peace of Jerusalem. ...") Other inscriptions are kabbalistic formulas and mystic cryptograms. 10 × 16 cm. (3¹⁵⁄₁₆" × 6⁵⁄₁₆"). Gross Family Collection, Ramat Aviv.

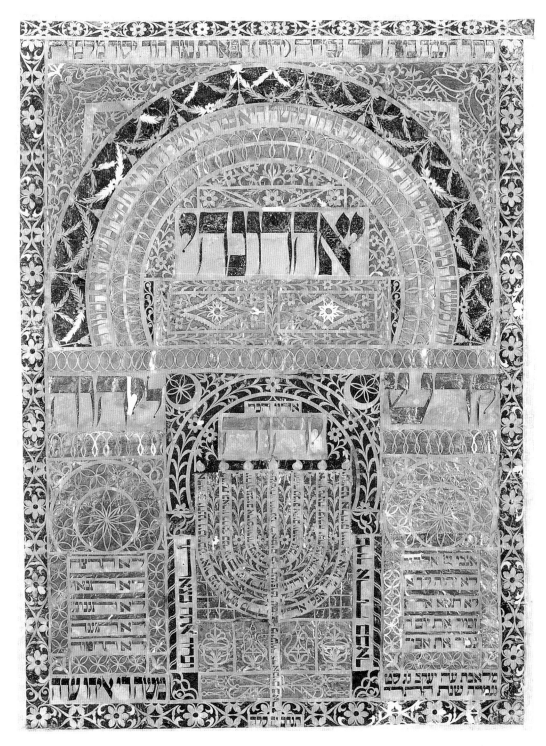

4.20. *Menorah*. Two names — Ya'aqov Djadj and Moshe di Eliyahu 'Edah? — appear at the bottom of this magnificent work from North Africa (Algeria or Tunisia?), which was completed in 1850. The Ineffable Name of the Almighty in large, bold letters makes up the central motif in the composition. Note the stylized crescents-and-stars at the upper corners of the lower central panel, and the great Moorish arch in the upper register. 88 × 69 cm. (34⅝" × 27⅛"). Gross Family Collection, Ramat Aviv.

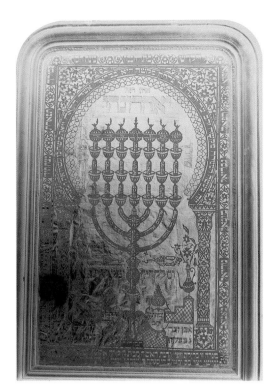

4.21a

4.21. *Shiviti/Menorah/*Amulets. The two old framed *menorah/shiviti* papercuts were photographed in situ — (*a*) dated 1870?, in the Ben Tuah synagogue in Algiers by the architect, the late Ya'aqov Pinkerfeld in the 1940s, and (*b*) by Bill Gross in Marrakesh in the late 1990s. Despite the poor quality of the photographs, we reproduce them here to further illustrate the genre of North-African Jewish papercuts. In each, the cut work is characteristically underlaid with thin metallic sheeting. (*a*) Photo: courtesy Giza Frankel Archival Collection, Jewish and Comparative Folklore Department, The Hebrew University of Jerusalem. (*b*) Photo: courtesy William L. Gross, Ramat Aviv.

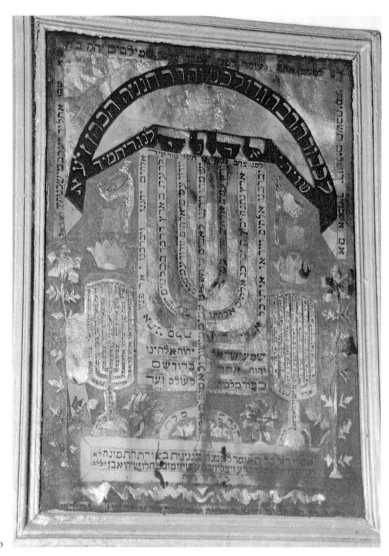

4.21b

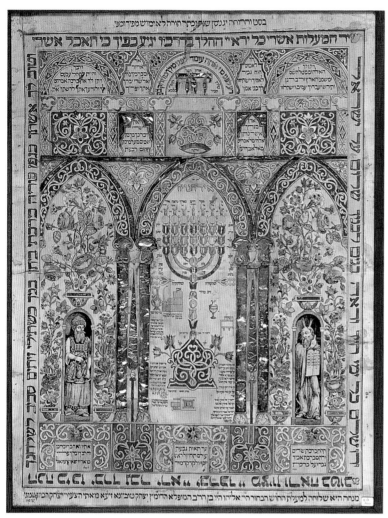

4.22a

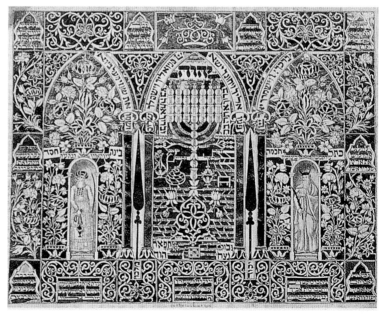

4.22b

4.22 *Shiviti/Menorah/*Amulets. These two large items represent a genre of large colored lithographed and printed devotional/apotropaic sheets in which various parts were cut out and backed with shiny metallic underlays. There is no mistaking the Islamic architectural and decorative character of the cultural environments in which these works were created. Menorah sheet (*a*) was apparently commissioned by a Tunisian rabbi, Yitzḥaq Cohen Tanoudji (Tubiana?) in 1846; sheet (*b*) was printed in Algiers, probably around the turn of the twentieth century. In both works, within three Moorish arches are a central menorah and cultic objects, flanked by Renaissance-type depictions of Moses and Aaron inspired by Christian sources, but common in Jewish ritual art in Germanic areas. The two spaces between the arches are occupied by slender cypress (cedar?) trees evocative of the Temple in Jerusalem. The profuse inscriptions comprise scriptural texts, kabbalistic formulas including the ten Sefirot, and magic apotropaic incantations. (*a*) 78.3 × 60.5 cm. (30¹³⁄₁₆" × 23¹³⁄₁₆"). Musée d'art et d'histoire du Judaisme, Paris. (*b*) 48 × 63 cm. (18⅞" × 24¹³⁄₁₆"). Photo: courtesy M. E. Szapiro, Paris; after Ader Picard Tajan Judaica auction catalog, 30 November 1988.

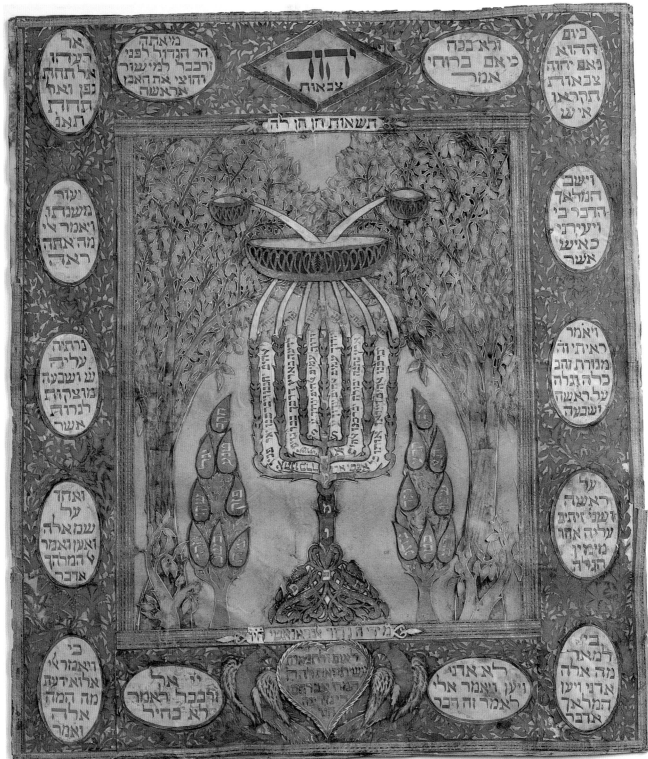

4.23a

The Algranati Papercuts

The collection of Turkish-Jewish Sephardi papercuts in the Israel Museum includes three remarkable works (Figs. 4.23a–c) by two men who were most probably related: Ḥayyim Ya'uda Algranati and David Algranati. We know nothing about them, or where and when they lived — perhaps in Istanbul, around the turn of the twentieth century. Very few Jewish papercuts from Turkey are known — no more than a dozen or so. Among them are groups of two or three items made by the same person. Therefore, although all these works bespeak a fully developed, sophisticated genre, we cannot know how widespread — if at all — was this particular Jewish art form in the Ottoman provinces, and whether the papercuts we have are at all representative, or simply the work of a few outstanding individuals. Despite a long tradition of papercutting in the Ottoman empire, the practice was apparently nowhere as common among the Sephardim in Turkey as with the Ashkenazim of Central and Eastern Europe. Nevertheless, it is well worth looking closely at the Algranatis' masterpieces in cut and applied paper, which served similar ritual purposes as the Ashkenazi papercuts, albeit reflecting a different iconographic conception and tradition.

(OPPOSITE PAGE) 4.23a. *Menorah*. The theme of this magnificent, jewel-like papercut is Zechariah 3:10–4:14. Part of the prophetic text of Zechariah 4:7, in cut-out letters, appears in the medallions of the encompassing margin (except in the central, heart-shaped one at the bottom, which contains Algranati's personal dedication to one Abraham DiMidina). The central menorah is inscribed with the sixty-seventh Psalm, and the paisley-shaped leaves of the cypress trees bear the initials in groups of threes of the *anna be-khoaḥ* prayer, which is one of the mystical forms of expressing the Ineffable Name. Both texts are endued with deep, arcane significance.

The two large, blue trees are the olive trees mentioned in Zechariah 4:2, but the entire pictorial representation, with the bowls "emptying the golden oil out of themselves" (Zechariah 4:12), illustrates and symbolizes the biblical text to the end of 4:14. Of particular kabbalistic import in this difficult passage is the verse: "'. . . these seven, which are the eyes of the Lord, that run to and fro through the whole earth'" (Zechariah 4:10). In the literature of the Kabbalah, the seven branches of the menorah symbolize the seven lower Sefirot — the Eyes of God that rule the world. The oil in the seven branches — the force of light in the menorah — is the inner soul of all the Sefirot, which are the emanations of the Ein Sof — the "Endless." The golden olive oil coming in abundance from above is the dynamic stream influenced by the Ein Sof. Somewhat differing mystic traditions also exist regarding this involved, hard-to-understand text.

David Algranati was clearly steeped in kabbalistic lore and was cognizant of the hidden esoteric meanings of the sacred scriptures. A consummate artist-craftsman, he displays complete mastery of the simple medium in which he worked: using papers of different colors in a multilayer technique, and achieving some depth through perspective in the composition. Note particularly how he allows the protruding gilt-paper underlay to finely outline the branches and leaves of the two blue olive trees, creating an effect of delicate cloisonné enamel work. Conditioned by the Muslim-Turkish esthetic of his cultural environment, David Algranati's artistic vision of an intense religious concept is a fascinating document of Sephardi Jewish folk art. 45 × 41 cm. (17¹¹⁄₁₆" × 16⅛"). Israel Museum, Jerusalem.

(PAGE 137) 4.23c. *Shiviti/Menorah/*Amulet. We know from the inscription in the garlanded medallion between the two birds in the bottom margin that David Algranati dedicated this beautiful papercut to his bosom friend, Ḥayyim Moshe Taranto. His own name is in the small roundel at the bottom left-hand corner, but the corresponding roundel at the right, which may have contained the date and place, is missing. This very large, complex, highly sophisticated work must have taken months to think out, plan, lay out, cut, paste, color, inscribe, and assemble. The overall sense is of an oriental carpet. It is replete with the usual ritual and kabbalistic acronyms, cryptograms, mystic letter combinations, and biblical passages. In the little, light-blue medallions in the upper, inner margin is the key passage from Leviticus 19:18: ". . . love thy neighbor as thyself: I am the Lord." 92 × 66.5 cm. (36¼" × 26³⁄₁₆"). Israel Museum, Jerusalem.

4.23b. *Shiviti/Ushpizin* for the Sukkah. Many Central and East-European Jewish papercuts incorporate national emblems, such as double-headed eagles, of the governments under which Jews lived. So also Ḥayyim Yaʾuda Algranati, who made this fine work at the end of the nineteenth century in Turkey, gave pride of place to the Ottoman crescent-and-star and a stylized panoply of military paraphernalia commonly emblazoned on Ottoman official and commercial documents, artifacts, and buildings. However, above the amalgam of Hebrew apotropaic inscriptions and cryptograms, and of Turkish-baroque weapons of war, he inscribed the ineffable name of the Almighty — the key word of the *shiviti* formula — in large, bold letters. Note the two *yadayim* (plural of *yad*; *ḥamsa*s) to ward off evil in the upper corners, inscribed with "[may He] bless you and protect you." *Yad* ("hand") symbols never appear in Ashkenazi compositions, only in Sephardic ones. As in Ashkenazi work, the kabbalistic inscriptions in the seven arches at the bottom refer to the seven guests (*ushpizin*) of kabbalistic tradition who are welcomed in the *sukkah* on consecutive days of the festival. In this, and several of the other known Turkish-Jewish papercuts, collages of commercial, machine-embossed gilt papers are combined with the hand-cut parts. 67 × 41 cm. (26½" × 16"). Israel Museum, Jerusalem.

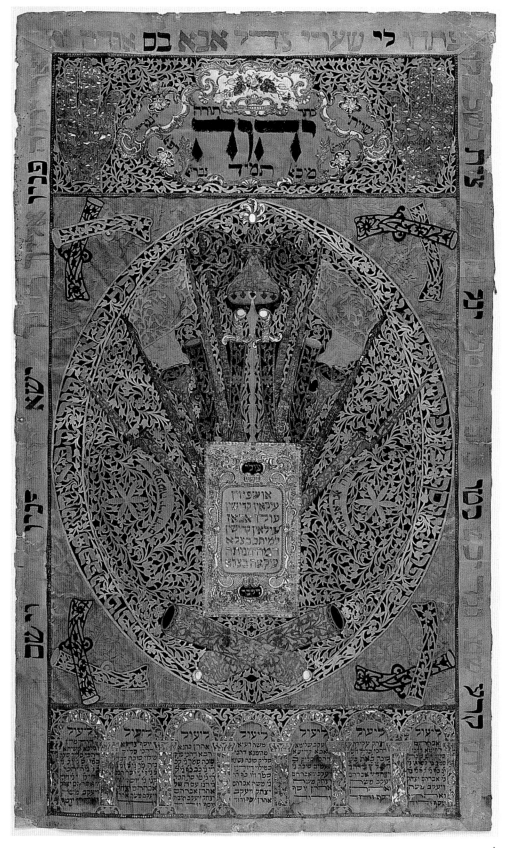

4.23b

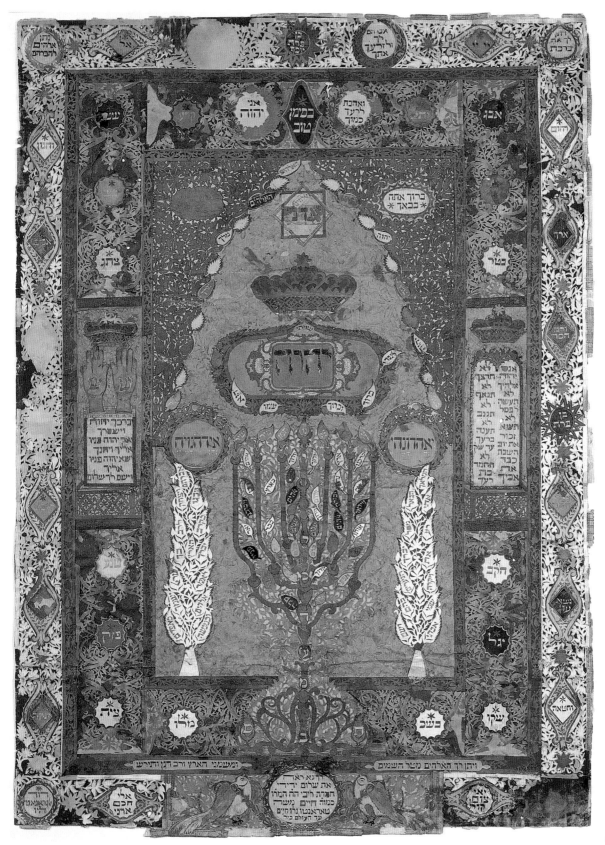

4.23c

An "Old Country" Tradition in the New World

It is not surprising that with the mass-immigration waves of Central and East-European Jews to America came also deeply ingrained customs and traditions, among them papercutting. Indeed, everything from simple little papercuts to intricate, highly sophisticated, masterful works were created in their new homeland by men (and some women) — from Brooklyn to Los Angeles, from Shreveport to Sioux City, and in other rather unexpected places. Although most of the Jews who made papercuts in the "Old Country" were devout men, many with decided Ḥassidic and kabbalistic affinities or leanings, the Jewish papercuts created in the United States from the mid-nineteenth to the mid-twentieth century introduce new ideological and thematic influences into this venerable folk art. Integrated into the maze of traditional Jewish symbols and inscriptions we now find American patriotic motifs, Masonic emblems, and modern architectural forms. Biblical texts of humanistic import are linked with democratic principles.

4.24. *Mizraḥ*. Found in an old English-language Jewish Bible, this attractive little *mizraḥ* was reportedly made in about 1870 by one Joseph A. Michael, probably somewhere in the United States. The simple, unpretentious design is quite effective, with some of the traditional symbolic elements: the lions and eagles evocative of the "Four Animals" aphorism of Judah ben Tema from Pirqei Avot 5:23; potted Trees of Life; columns suggesting the Temple in Jerusalem. Heart-shaped medallions inscribed with the word *mizraḥ* are also known from several European Jewish papercuts. Note, however, that the candelabrum at center-bottom is not a menorah but an eight-branched Ḥanukkah lamp. 18.4 × 24.1 cm. (7¼" × 9½"). Jewish Museum, New York (1987-140). Gift of Abraham J. and Deborah B. Karp.

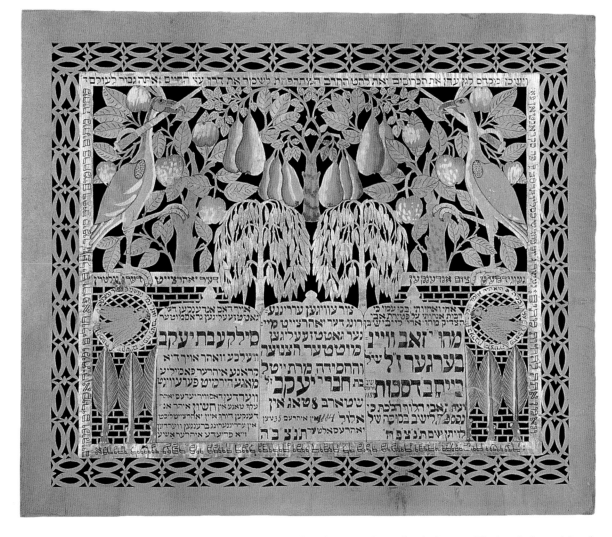

4.25. *Yortzait*. An interesting, unusual memorial papercut made in Scranton, Pennsylvania, in 1902. The inscriptions, giving dates of death of various members of the Weinberger family, are in Yiddish. The dominant motifs are different kinds of trees: The ones in the center are weeping willows — traditional "mourning" trees in many non-Jewish *memento mori* compositions and contexts, including papercuts (cf. Fig. 1.20). The trees in the lower corners are "ever-living" cypresses (*Cupressus sempervirens*), which in the Mediterranean world are planted at cemeteries to symbolize the eternal life of the soul. Their representation here against a stone wall is obviously derived from the productions of Jerusalem's Jewish printing shops in the mid-nineteenth and early twentieth centuries (cf. Figs 5.5–5.7) that were widely distributed throughout the Jewish world and where the trees evoke the Temple of Solomon built of cedars. The three fruit-bearing trees in the upper register represent the Tree of Knowledge and the Tree of Life in the Garden of Eden. The two symmetrical apple trees probably represent "*etz ha-da'at*" of which Eve and Adam ate; and the tree with the pears, "*etz ha-ḥayyim*" — the fruits of both these trees being forbidden to "the man." The two large, generic birds holding swords in their beaks symbolize the "*kruvim*," or (winged) cherubs, who with flaming swords prevented Adam and Eve from approaching the Tree of Life, lest eating of its fruit as well would give them immortality and make them Godlike.

All the symbolic configurations in the upper register illustrate the passage from Genesis 3:24, which is inscribed in Hebrew lettering at the top: ". . . and He placed at the east of the garden of Eden the cherubim, and the flaming sword which turned every way, to keep the way to the tree of life." The context for the theme of the upper register is Genesis 2:16 through all of Genesis 3. The man who conceived the theme and design of the papercut clearly had a deep understanding of the philosophic meanings of the biblical text and the commentaries. He contrasted the corporeal mortality of Man (prevented from eating of the fruit of the Tree of Life) with the immortality of the soul represented by the (*sempervirens* — ever-living) cypress trees. 50.5 × 61 cm. (20" × 24"). Hebrew Union College Skirball Culture Center, Museum Collection, Los Angeles. Gift of Rebecca and Leon Weinberger.

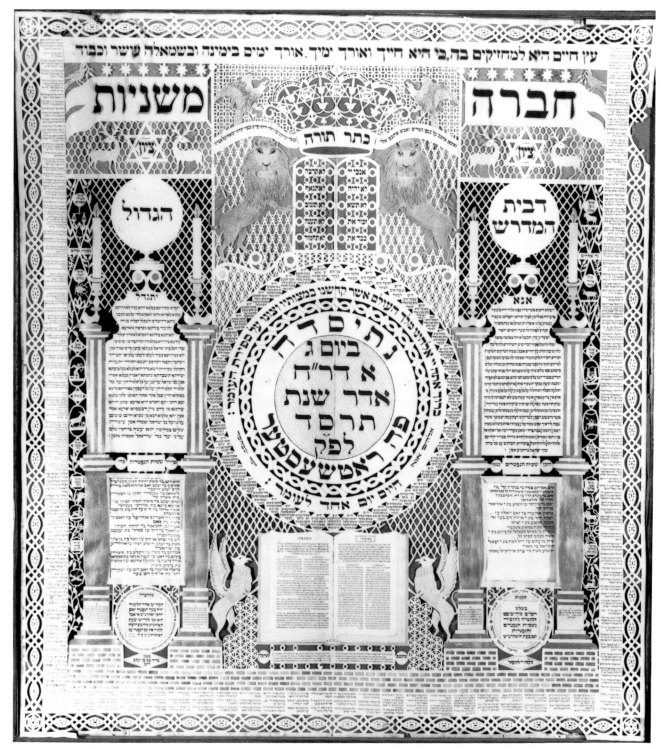

4.26

4.27

4.27. *Yortzait.* Indicating the date of his mother's death (in 1916), the person who devised and made this papercut (reportedly in Gardiner, Maine) added the typewritten English inscription, probably for those family members who could not read the Hebrew. The Hebrew texts are fairly standard commemorative and mortuary formulas. Note the stylized "convoluted" menorah with the endless-knot configuration at the foot — a direct carry-over from Eastern European papercuts, as is the double-eagle at the top. (But what do the buildings and birds within the arches at the bottom represent?) 42.5 × 33.8 cm. (16¾" × 13⁵⁄₁₆"). Jewish Museum, New York (1983-257). Museum purchase, Eva and Morris Feld Judaica Acquisition Fund.

(OPPOSITE PAGE) 4.26. Multipurpose, Dedicatory Commemorative. This huge, encyclopedic papercut, made by Barukh Zvi Ring in Rochester, New York, in 1904, is cut on a vertical centerfold and is all in one piece. The work served a number of purposes, all of them devotional. As proclaimed by the two words *ḥevrah mishnayot* in the large letters at the upper corners, it was primarily dedicated to a local group for studying the Mishnah (such associations were and still are common in pious Jewish circles). Because of its architectural character, and the standard sacred motifs, top-center (note the very American eagles flanking the Crown of Torah), it most probably also served as a *mizraḥ*, and was hung on an east-facing wall. The central roundel giving the date when the society was founded in Rochester, and the phrase: "Today the first day of the Omer," is surrounded by forty-eight small circles each inscribed with a consecutive day of the Omer, and so the papercut also served as an Omer calendar. Beneath, flanked by two griffins, is an open volume of the Mishnah. In addition, the names and commemorative days (*yortzait*) of deceased close relatives of the society's members are listed in the monumental structures at the sides. In the right, left, and bottom margins are the names of the society's members and their wives. Note also the signs of the zodiac in small ovals and lozenges alongside the vertical margins. The inscription across the top combines three passages: "She is a tree of life to them that lay hold upon her" (Proverbs 3:18); ". . . for that is thy life and the length of thy days" (Deuteronomy 30:20); and "Length of days is in her right hand/ In her left hand are riches and honour" (Proverbs 3:16).

Barukh (Bernard) Zvi Ring (ca. 1872–1927) apparently came to Rochester from Vishaya in southern Lithuania (or the Grodno district of northeastern Poland) at the age of 32 or 34. According to his grandson, Irving Ring, Barukh was descended from a long line of rabbis and himself studied for the rabbinate. On his arrival in Rochester, he found that there was no Hebrew calligrapher, and he became a *sofer stam*, writing Torah scrolls, *mezuzot*, and *tefillin*, and repairing them. He also made other ritual items and prepared boys for their Bar Mitzvah. Since Ring's wife died a day after she joined her husband in Rochester with their five children, he brought them up himself. 139.7 × 127 cm. (55" × 50"). Jewish Museum, New York (1983-229). Gift of Temple Beth Hamedresh–Beth Israel, Rochester, New York.

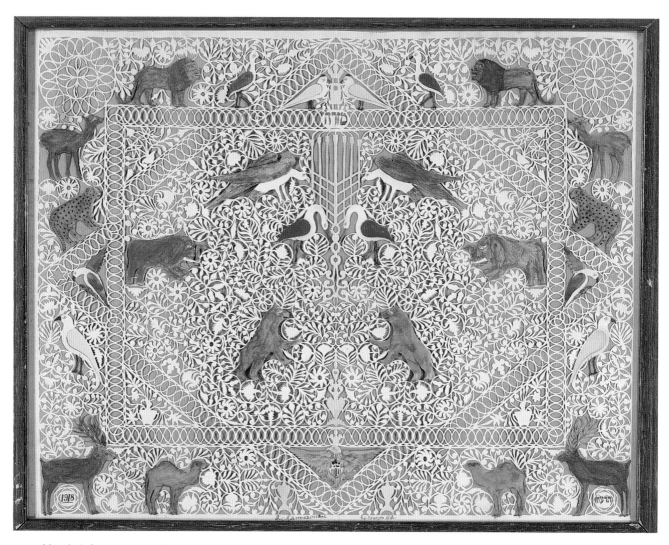

4.28. *Mizraḥ.* A fine specimen of Jewish Americana, this elegantly conceived, beautifully executed, delicate papercut was created by Israel Mannesovitch in 1918. Regrettably, we do not know where. The talented folk artist clearly understood the general iconographic language of Jewish ritual lore. Thus, the flames of the menorah face inward to the central one, as explained on p. 91. All the "Four Animals" — the leopard, the eagle, the deer (standing in for the gazelle), and the lion — are easily identified. The word *mizraḥ* is inscribed in the small oval above the menorah. And don't miss the small, crowned Torah scroll between the two yellow-winged birds, which may well have been intended as the cherubs shielding the Holy Ark of the Law. The interest of the graphic design is enhanced by the deflected lines of the central lozenge crossing the rectangle. The (crowned?) American eagle, bottom-center, expresses the patriotism of this Jew steeped in his people's heritage. 43.2 × 55.8 cm. (17" × 22"). Soclof Family Collection, Beachwood, Ohio.

(OPPOSITE PAGE) 4.29. *Mizraḥ/Shiviti.* Mordechai the son of Rabbi Yeḥiel Mikhel Reicher (1865–1927) of Brooklyn, New York, who created this work in 1922 as a gift to the fraternal "Ahavat Re'im" society, was unquestionably the outstanding Jewish papercutter of the early twentieth century in the United States. A superb draftsman, calligrapher, and with an intimate knowledge of the sacred texts and Jewish lore, his papercuts incorporate a wealth of traditional texts, iconographic symbols, and many cautionary inscriptions of the *memento mori* type. But note also the Zionist flags in the upper corners. The wings of the double-eagle are inscribed with: "and . . . I bore you on eagles' wings, and brought you unto Myself" (Exodus 19:4), implying the haven found by immigrants in the United States. Another of Reicher's papercuts features the American Stars-and-Stripes. His style is inimitable.

Reicher came to the United States in 1910 from his native shtetl, Olshan, near Kiev in the Ukraine. He made his living as a peddler until losing one of his legs in 1918. Thereafter, he became a teacher of Talmud and created his papercuts. 45.5 × 39 cm. (17⅞" × 15⅜"). Jewish Museum, New York (1993-181). Purchased with funds of the Phil and Norma Fine Foundation and the Judaica Endowment Fund.

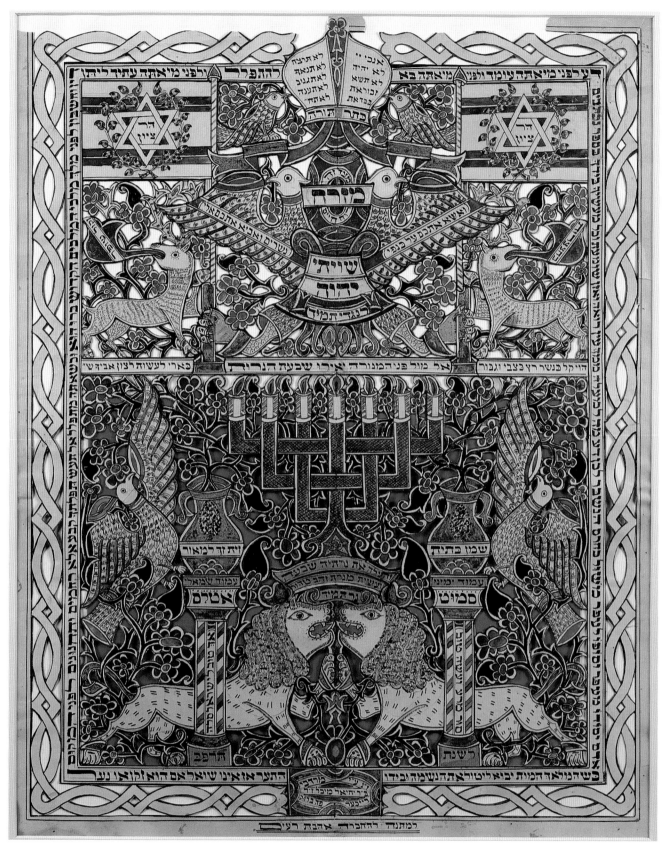

4.29

Aaron Katlinsky's Papercuts

When Aharon ben Eliezer Katlinsky (1816?–1909?) was pursuing rabbinical studies in Poland, he escaped conscription into the czar's army by emigrating to the United States (when?). Arriving in New Orleans, he peddled his way to Chicago, where he opened a hay and feed business only to see it burn down in the great fire of 1871. Discouraged, Katlinsky turned to the preoccupations of his youth and began making papercuts in the way he had learned as a yeshivah boy. We have seen two similar, large, intricate papercuts as in Fig. 4.30a, and three, identical photolithographic prints he made of another papercut (Fig. 4.30b).[2] They are remarkable for their delightful imagery and encyclopedic wealth of traditional Jewish motifs. But note the Masonic trysquare and compass at the bottom of each of his compositions, which as a dedicated Freemason Katlinsky added to the pious symbols of Judaism.

Some years before the turn of the twentieth century, Katlinsky must have created his *magnum opus*: a very large papercut — the prototype of Fig. 4.30b — that was an outpouring of all he wanted to express. Here is how a gentleman named H. Eliassof concluded his lengthy description of this work, which was raffled at a fair of the United Hebrew Charities in Chicago, in 1898:

> The figures and flowers of the picture appear on a dark red ground underlying the white surface. This produces a very delicate and pleasing effect. From a distance the lines and curves look like carved in ivory. Considering . . . that an old man traced and cut . . . this large picture, no one will deny Mr. Katlinsky the credit he deserves.
>
> It is a quaint and strange looking picture. It will remind the old people of the days of their childhood in the dear old home long, long ago. The younger people, born and raised among modern environments in this blessed land of rapid progress and religious reformation, will glance upon this reproduction of the ancient Jewish picture with curiosity. To them it is nothing but an archæological relic from times past and gone forever.

(OPPOSITE PAGE) 4.30a. *Shiviti/Mizraḥ*. Aaron Katlinsky created this large, symmetrical papercut in 1895, in Chicago. Like a somewhat smaller (58.5 × 45.7 cm., 23" × 18") papercut dated 1893, which was found among a heap of discarded objects in the basement of the old Anshe Ḥesed synagogue in the upper West Side of Manhattan and is now in a private collection in New York, it is replete with standard biblical quotations and moralizing rhymed precepts enjoining humility. The busy composition includes the traditional three crowns, blessing priestly hands, octagonal shields of David, columns of the Temple, a large menorah inscribed with the sixty-seventh Psalm, lions, deer, snakes, and birds. Details and shading are drawn in with pen and ink. The lettering of the inscriptions is not very skilled and fits the character of the charmingly naive animals and birds disporting themselves in the dense foliage of the Tree of Life growing out of ornate flower pots. The background underlay is gold foil. As in Katlinsky's other works, the outer columns are inscribed "Yakhin" and "Boaz" (2 Chronicles 3:15–17), which also evoke the Masonic concepts relating to the building of the Temple in Jerusalem. The rhymed inscription along the left-hand margin is the fairly common one, "Man worries about losing his money . . ." (p. 108); the one along the right-hand margin reads:

Remember the bitter day when the angel of death stands before you,
　His drawn sword like a [naked] blade in his hand,
And he asks not whether [you] are an old man or a youth.

71.1 × 49.5 cm. (28" × 19½"). Lee K. Vorisek Collection, Metairie, Louisiana.

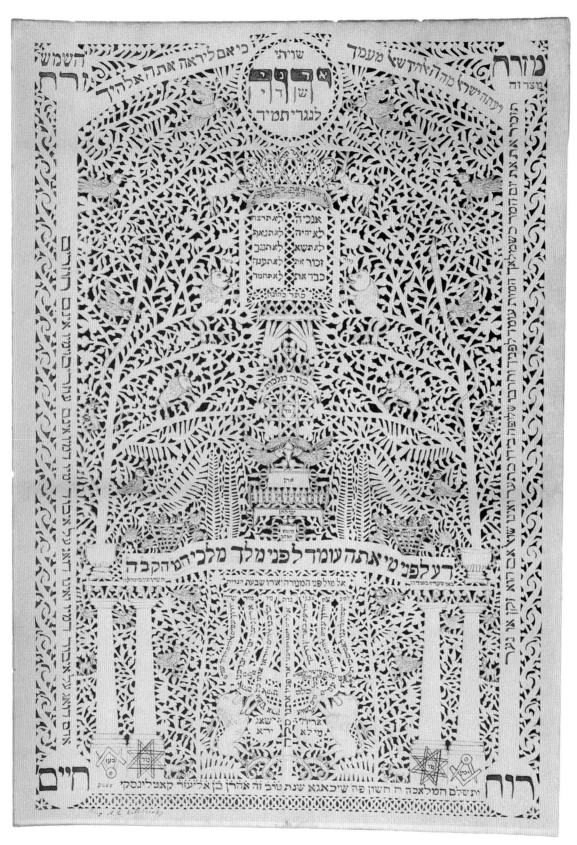

4.30a

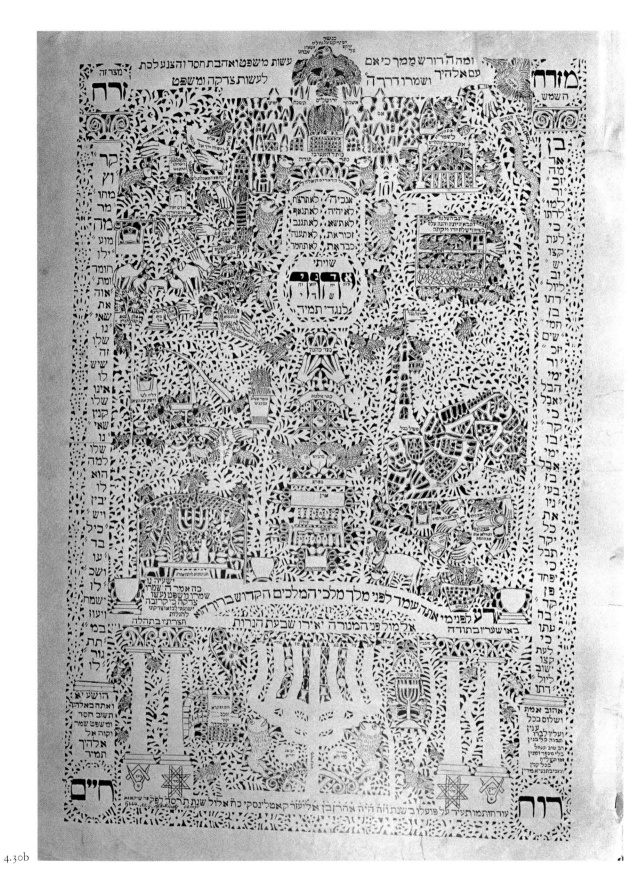

4.30b

Probably to meet demand in the Chicago Jewish community (and elsewhere?), or to present it to relatives, Katlinsky must have decided to create photo-lithographed multiples of this work. Although the original papercut apparently still exists somewhere, two of the lithographed prints are preserved in the Skirball Museum in Los Angeles, and a badly damaged one in the Israel Museum.

Katlinsky stands out among all the other named and anonymous Jewish papercutters of the past two or three centuries, whose work we know, by his emphasis on the ethical precepts of social justice as expressed by the prophets of Israel. While his use of traditional Jewish symbols attests his deep knowledge and understanding of the sacred texts and the religious customs of his people, unlike many of his fellow pious folk artists, he did not make his papercuts to keep away the evil eye or to solicit personal redemption, material prosperity, health, and fecundity. In keeping with Masonic principles regarding the brotherhood of man and with American democratic tenets, Katlinsky placed the universal humanistic ideals in the Bible at the head of his concerns. Thus, at the top of his masterpiece he inscribed: "And what the Lord doth require of thee: Only to do justly, and to love mercy, and to walk humbly with thy God" (Micah 6:8); and, "that they may keep the way of the Lord, to do righteousness and justice" (Genesis 18:19); and, again, lower down: "Thus said the Lord: Keep ye justice, and do righteousness; For My salvation is near to come, And My favour to be revealed" (Isaiah 56:1).

(OPPOSITE PAGE) 4.30b. Lithograph from Papercut. This work (dated 1904) reflects Katlinsky's characteristic style, and many elements resemble those in his two earlier papercuts. But there are also considerable differences. While the original work was also cut on a vertical centerfold, only the outer margins and the lower register are symmetrical. Katlinsky left large areas of uncut paper into which he proceeded to draw and cut an unparalleled wealth of charmingly naive illustrations of biblical passages and some traditional Jewish symbols. In this print, the menorah at bottom center was not inscribed and remained unfinished.

Rather than being invested with multi-layered, kabbalistic meanings and allusions, most of the composition is narrative and didactic, with each scene identified by an appropriate, brief biblical passage or quotation. To describe each little vignette in detail would require more space than we can devote to it, but wend your way through the maze of paper vegetation with a magnifying glass, and smile at the recognition of yet another familiar biblical episode.

Nevertheless, a few pointers: Beneath the eagle (or vulture) at top center is a symbolic representation of the Western Wall in Jerusalem topped by cypress (cedar) trees. To the right of the central Decalogue is Noah's ark, with Noah's hand receiving the dove with the olive branch in her beak. Further down is the Tower of Babel with the "flag of Babel," and down to the right, the chaos of Sodom and Gomorrah. Going down at the left, look for the Sacrifice of Isaac and Jacob's Ladder, the Tomb of the Patriarchs at Hebron, a shadoof with which Moses drew water for the flocks of the priest of Midian's daughters, a *sukkah* with tables and chairs. There is an eight-branched Ḥanukkah lamp, and much, much more. Note particularly the two wonderful bird-like creatures in the exact center of the composition: They are the "*kruvim*" — cherubs "screening the ark-cover with their wings, with their faces one to another" (Exodus 25:20). In all this there is not a human figure, and only hands represent divine or human action or intervention, on the *pars per toto* principle. 95.9 × 71.8 cm. (37¾" × 28¼"). Hebrew Union College Skirball Culture Center, Museum Collection, Los Angeles.

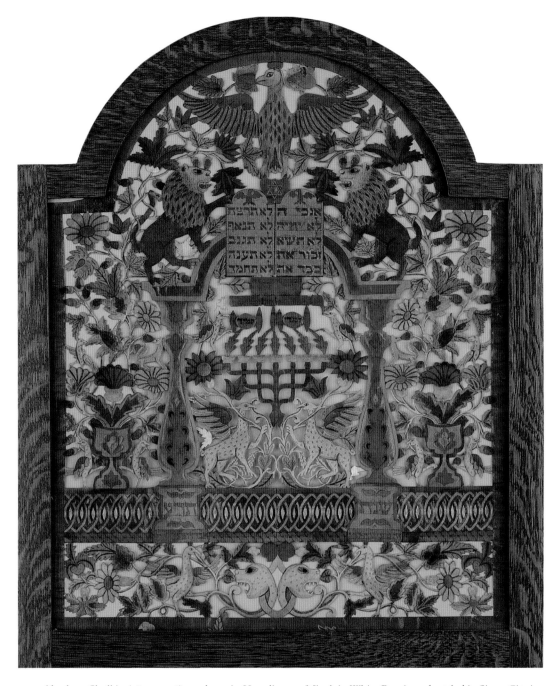

4.31. Abraham Shulkin (1852–1918) was born in Kapulie near Minsk in White Russia and settled in Sioux City in 1897, joining there the growing community of immigrants from his home *shtetl*. The soft-spoken, bearded, and deeply religious Shulkin supported his family of twelve children as a peddler and junk dealer. Hard work and the struggle to maintain his burgeoning family did not stifle his creative powers as a skilled designer and woodcarver of synagogue furnishings. This, the only known papercut by Shulkin, is dated 1910. The sculpturesque treatment of its various elements — the full columns, the chunky eagle facing sideways, chubby flowers and urns and the well-delineated central arch bearing the tablets of the Law — shows a decided affinity with his carved and turned woodwork. 45 × 38 cm. (17¾" × 15"). Jewish Community Center and Jewish Federation, Sioux City, Iowa.

5

STUDIES AND CONJECTURES
IN SOURCES, SYMBOLISMS, AND
TECHNIQUES

Having looked at Jewish papercuts and their extensive distribution in the lands of the Diaspora, we are left with a number of intriguing questions: Where, when, and by whom was this tradition begun? How, and in what direction, did it spread through the Jewish world? Did it move eastward from the German-speaking regions of western and central Europe where the papercutting arts can be traced to the late Middle Ages? Or did it reach Eastern Europe from the Ottoman lands to the south, with their rich tradition of papercutting, and where Sephardi Jews, as we have indicated (p. 9), were among the masterful shadow-theater performers? Could they have applied their cutting skills to Jewish religious and other folk usages?

What was in the minds of those who created these wonderful, intricate papercuts? Can any of the contents, techniques, and working methods be related to specific regions or communities? Were there any noticeable chronological developments? Can manifestations of the ideological streams in the Judaism of the past several centuries, such as Ḥassidism, formal traditionalism, or even rationalism and Reform Judaism, be detected in the contents of papercuts made in the different communities and congregations? Or conversely, can the style and/or contents of a given papercut provide clues as to where and when, or by whom it was made? These are relevant if difficult questions to answer, for many old Jewish papercuts bear no textual indication of their date and provenance, and, in any case, were highly individualized, eclectic creations, subject to diverse influences.

Apart from trying to understand the esoteric world of Jewish visual symbols and the use of, and allusions to, a variety of texts and popular mystic formulas, we have attempted to track down the circumstances under which some of these works were made. Hence, although we lack any solid, factual basis on which to reconstruct the early history of the Jewish papercutting tradition, we may venture some more-or-less plausible postulates and tentative answers to the above questions.

Decided Central-European influences, mainly Germanic but also Dutch, are evident in Jewish papercuts (and other Judaica) ranging from the Rhineland to western Poland in the north, and from Alsace to Bohemia, Moravia, Slovakia, and Austria-Hungary in the south. Thus we have peasant and hunting scenes, uniformed soldiers, naked, garlanded angels, figures of Adam and Eve, heraldic escutcheons, and certain characteristic Germanic stylistic motifs. If the Jewish practice of making devotional and apotropaic papercuts indeed moved eastward, such motifs were shed on the way, for they are almost entirely absent in Eastern European Jewish work, which, in addition to the standard symbols, shows a profusion of vegetation inhabited by a wide variety of animals, and birds — some of them bizarre, composite creatures.

Nor can we discount influences from the Ottoman lands — particularly, Turkey proper — where this art form was well known at least from the sixteenth century and earlier, as indicated in chapter 1, above. Jews moving between Christian Europe and the Ottoman provinces may well have introduced the technique and adapted it to their purposes. And perhaps the Jewish paper-cutting tradition drew from both geographic regions. Unless unequivocal evidence turns up, we shall probably never know the origins of papercutting among Jews.

As we stress elsewhere in this book, our interpretations and conclusions result from extensive, empirical observation and close scrutiny of known and recorded old Jewish papercuts, coupled with Yehudit's insights gained by her long personal experience in creating papercuts and mastering different techniques — and repairing old items. Again, we cannot understate the importance of a sufficient statistical basis for any generalizations regarding this peculiar folk art form. In the course of our research, we have seen "academic" papers by students of the subject whose descriptions and conclusions were derived from analyses of individual, published items and their descriptive captions, some of which are in effect erroneous, unrepresentative, and misleading — and even outright spurious, as we explain in chapter 8, below.

In this chapter we illustrate our approach and methodology in studying and probing Jewish papercuts by dealing in depth with certain specific aspects of this art.

Three Papercuts from Jerusalem

Of the two-hundred-or-so known and recorded "classic" Jewish papercuts stemming from Central and Eastern Europe, North Africa, and the Ottoman empire, very few can be ascribed with certainty to the Land of Israel, or to Jerusalem specifically.[1] The three papercuts we describe here in some detail, and which are today in Jerusalem, we believe to have been made locally about a century ago, showing that the tradition was also practiced by Jews in the Holy Land. Since they always maintained close connection with Diaspora communities, this is not at all unexpected.

One of these papercuts (Fig. 5.1), now in the Israel Museum collections, was ascribed by Giza Frankel to nineteenth-century Poland.[2] The work is cut out of embossed, brocade-type gilt paper that is laminated onto a faded brown paper backing. At the museum restoration department, it was remounted on a dark-blue background analogous to the original color.

There can be no doubt that a similar, privately owned, papercut (Fig. 5.2) was made by the same person. The gilt paper is identical, and the background, which in this case has not been replaced, is dark blue as well. There are also many resemblances in the overall conception and design.

A third work (Fig. 5.3), in the same gilt brocade paper, in another private collection in Jerusalem, was remounted on a white background before reframing. Nevertheless, the medallion inscribed with the Hebrew word *mizraḥ* (מזרח) is still backed by what was probably the original blue paper with which the cut work was underlaid when it was made. Here too, the decorative and artistic treatment points to this papercut being the work of the same hand that created the other two.

Besides being made of the same material, all three share the same central element of the composition — an *aron qodesh* rounded at the top with its two doors opened to the sides, flanked by a

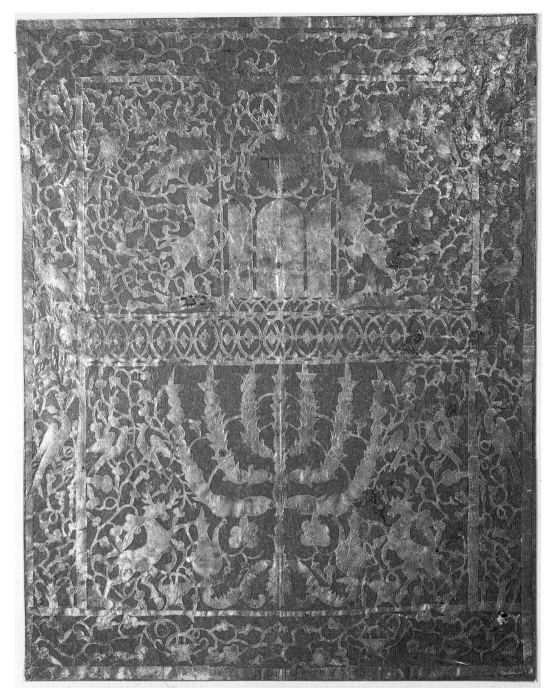

5.1

pair of heraldic animals (deer or lions), each of which holds a tall staff with a fluttering bande-role. Other elements are common to different combinations of two of the three works: round seal-type medallions inscribed with the word *mizraḥ* and surmounted by a crown; division of the entire composition into two equal, lateral registers, with the *aron qodesh* in the upper, and a seven-branched menorah in the lower one (5.1 and 5.2); identical decorative patterns in parts of the margins and dividing bands (5.1 and 5.2); treatment of the vines that fill the design (5.1 and 5.3).

5.2. *Mizraḥ* (?).
Papercut purchased in
the Me'ah She'arim
quarter in Jerusalem
in the 1950s. The gilt
paper is the same as
in Fig. 5.1, which is
thematically similar,
although no written
word appears on it.
49 × 39 cm. (19⁵⁄₁₆" ×
15⁵⁄₁₆"). Yitzḥak
Greenfield, Jerusalem.

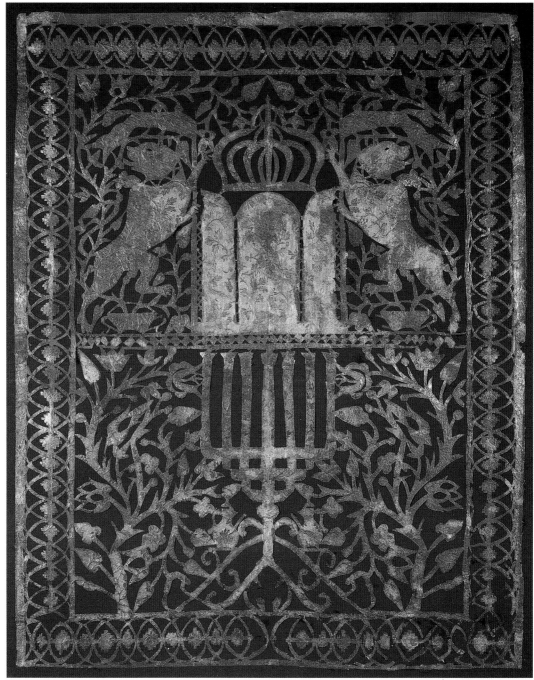

5.2

Rather than originating in Poland, it is far more likely that these papercuts were made in Jerusalem around the turn of the twentieth century, for they feature two characteristic motifs popular in the "Old Yishuv" of Jewish Jerusalem.[3] These are the Moses Montefiore coat of arms, and a device consisting of eight small, oval-shaped vignettes representing Jewish holy places around Jerusalem arranged so as to form a large oval.

The English-Jewish philanthropist, Sir Moses Montefiore, who visited Jerusalem seven times between 1827 and 1875 and greatly helped the impoverished Jews in the Holy City, left an indelible

5.3. *Mizraḥ*. Papercut acquired in Jerusalem's Me'ah She'arim quarter in the 1940s by the late Avraham Yaari.
The word *mizraḥ* appears in gilt letters within the blue roundel beneath the crown and above the open Torah ark.
Within the large oval made up of smaller ovals depicting revered sites of the Holy City is the large word
"Jerusalem." 45 × 38.5 cm. (17¹³⁄₁₆" × 15⅛"). Ḥava Yaari, Jerusalem.

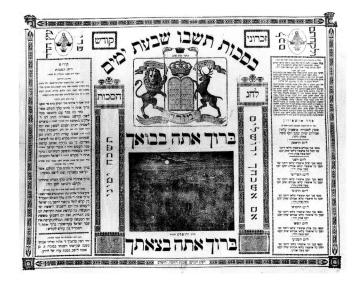

(LEFT) 5.4. Moses Montefiore family coat-of-arms.

(ABOVE) 5.5. *Ushpizin sukkah* decoration with adaptation of the Montefiore family arms, printed by Weingarten, Jerusalem (1890s). 46.3 × 61.7 cm. (18¼" × 24⁵⁄₁₆"). Yitzḥaq Einhorn Collection, Tel Aviv.

impression on the people — Sephardim as well as Ashkenazim — of the Old Yishuv. The Montefiore family arms incorporate a crowned, composite heraldic device and motto, flanked by a lion and a deer, each holding a lance with a fluttering pennant inscribed with the Hebrew word *Yerushalem* ירושלם (Fig. 5.4).[4] In the productions of Jerusalem's Jewish printing shops in the latter part of the nineteenth century, the crown, lion and deer, and the banderoles of the Montefiore coat of arms were borrowed and adapted to various designs of printed *mizraḥ* sheets, *sukkah* decorations, and similar items (Fig. 5.5).[5]

In each of these three papercuts, the lion-and-deer device was modified by the dictates of the usual technique employed in making papercuts: cutting the design in a vertically folded sheet to obtain lateral symmetry when opening it out. Thus we have either a pair of deer (Figs. 5.1 and 5.3) or a pair of lions (Fig. 5.2). The banderoles, which in the Montefiore arms flutter to the left, point symmetrically outward in the cut design.

Papercut 5.3 features as its central motif an oval made up of a chain of eight small, printed vignettes of holy places, probably cut out of a printed Jerusalem *mizraḥ* sheet and pasted into the papercut composition (Figs. 5.6–5.7).[6]

Moreover, at least two of these papercuts (5.2 and 5.3) are known to have been acquired in the Me'ah She'arim quarter of Jerusalem in the 1940s and 1950s. The circumstantial evidence for their having been made in Jerusalem is thus very strong.

When and by whom were they made? No information regarding that person's identity can be gleaned from the papercuts themselves. A possible clue for dating these works may lie in the embossed gilt paper from which all three are cut. In some Jewish papercuts dated 1894 from Izmir in western Turkey, in the Israel Museum and the ones in Figs. 3.25 and 4.19 in these pages, the white paper of the papercut is backed by very similar embossed gilt paper.[7] While this does

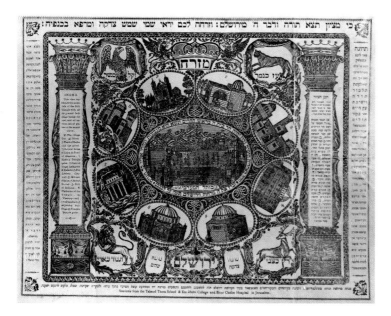

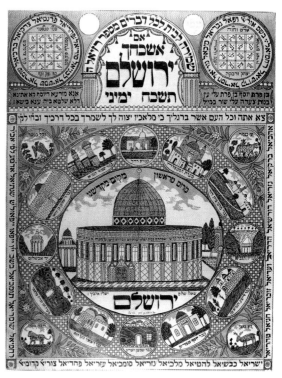

(ABOVE) 5.6. Printed *mizraḥ* sheet from Jerusalem with oval vignettes of holy places in the Land of Israel (1890s). 41 × 53.2 cm. (16⅛" × 20¹⁵⁄₁₆"). Yitzḥaq Einhorn Collection, Tel Aviv.

(RIGHT) 5.7. Colored Jerusalem lithograph amulet based on the Book of Raziel for the protection of the home, featuring, among other depictions, oval vignettes of Jewish holy places. Produced by Moshe Mizraḥi?, Jerusalem (1890s). 56.7 × 43.5 cm. (22⁵⁄₁₆" × 17⅛"). Musée Juif de Belgique, Brussels.

not necessarily mean that paper of this sort was not used before or after 1894, or elsewhere, it does give an indication of materials available in the Ottoman empire around the turn of the century. In this case, the date would be compatible with the use of the Montefiore coat of arms and the vignettes of holy places.

It is therefore reasonable to ascribe these three Jewish papercuts to someone from the Old Yishuv in Jerusalem, where conditions forced Sephardi and Ashkenazi Jews to live and function in close contact with each other. Whoever made these works drew his inspiration and models from the papercutting traditions in both Ashkenazi and Sephardi communities of the Diaspora, and from the iconography of printed *mizraḥ* sheets, amulets, and other popular items produced for both communities by Jerusalem's Jewish printing shops. The two double-headed eagles in the Israel Museum papercut (Fig. 5.1), may hint at an Ashkenazi rather than a Sephardi affinity of the folk-artist, for many of the European Jews living in Palestine at the time were under Russian or Austro-Hungarian consular protection.

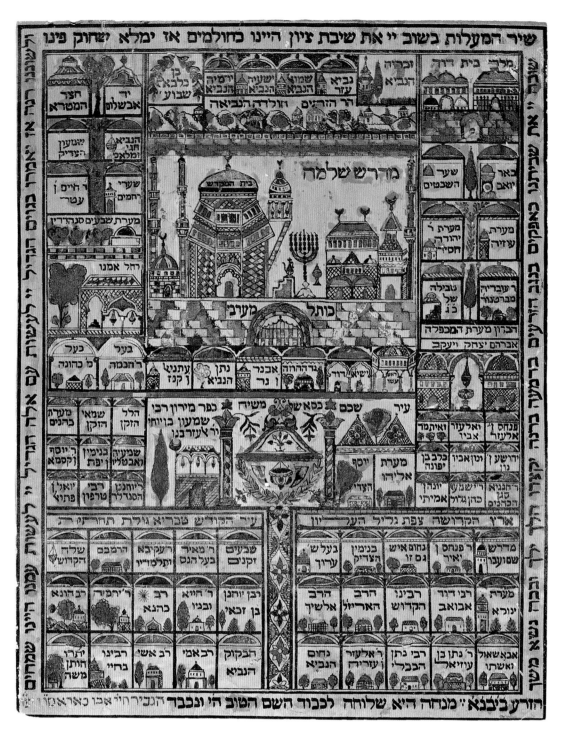

5.8. Presentation souvenir sheets depicting Jewish pilgrimage and other venerated sites in the Holy Land were lithographed and printed in Jerusalem around the turn of the twentieth century. Such memorials were commonly presented to benefactors of yeshivahs and religious institutions in the Holy Land. Here, as in some printed *menorah* sheets from North Africa (Figs. 4.22a–b), many of the vignettes and decorative elements were cut out and underlaid with shiny metallic sheets (cf. Figs. 2.4, 3.2, 3.41, 5.27, etc.), in the manner of North African and Turkish Jewish papercuts. "The [wealthy] dignitary, Ḥayyim Abu Karasso, may He [the Almighty] protect his going out and his coming in" is inscribed in the blank space at the end of the standard printed ingratiating dedicatory text along the bottom margin. This work was formerly in the collection of Dahn Ben Amotz in Tel Aviv. 48 × 37.7 cm. (18⅞" × 14¹³⁄₁₆"). Collection Gabriela Brown, Tel Aviv.

The Fish-Tailed Lion, the Convoluted Menorah, and the Endless Knot in the Iconography of East-European Jewish Papercuts

Close study, detailed scrutiny, and comparisons of known old Jewish papercuts, both original works and photographs, revealed several configurations that never — or very rarely — appear among the rich array of traditional iconographic symbols (the menorah, lions, gazelles, eagles, crowns, ornate columns, the Tree of Life, the *magen david*, etc.) found in other Jewish ritual and folk art. Consequently, these particular configurations have not been given the consideration they seem to deserve. To the extent that they may be typified and interpreted, they can broaden our understanding of Jewish iconography of the last several centuries. Specifically, we refer to peculiarly shaped menorahs incorporating variations of "endless-knot" motifs; the endless knot proper; composite lion-and-fish motifs; and perhaps the unicorn.

Fish-tailed Lions

Representations of composite, fantastic animals (and humans) are common in Medieval — particularly in Romanesque — and Renaissance art. Such grotesque figures have also found their way into Jewish illuminated manuscripts and ritual art of those periods, as well as into later

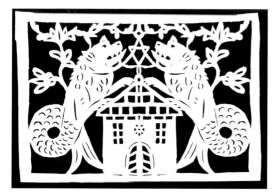

5.9a

5.9. Fish tailed Lions (*shavuoslakh*). Just as endless-knot motifs in Jewish ritual art seem to be found almost exclusively in papercuts and some tombstones, so too the fish-tailed lion. We have no conclusive explanation for this. The configuration is most probably a representation of Leviathan. The two *shavuoslakh* featuring this composite creature may have come from Yabrow in Galicia, probably around the turn of the twentieth century. (*a*) 14 × 20 cm. (5 ½" × 7⅞"). (*b*) 17 × 21 cm. (6¹¹⁄₁₆" × 8¼"). Reizes Collection, Ethnography and Folklore Pavilion, Eretz Israel Museum, Ramat Aviv.

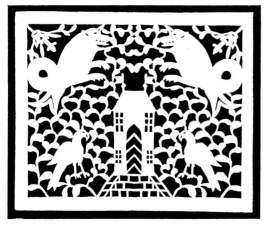

5.9b

works: synagogue wall paintings, carved Torah shrines, and the like. By far the most common of these is the griffin, which in Jewish folklore represents the *kruvim* (cherubs) flanking the Ark of the Covenant as described in Exodus 25:19 and 37:8 (e.g., Figs. 3.36, 5.12).

However, composite beasts with the head, mane, torso, and front legs of a lion, and the scaly tail of a fish seem to appear almost only on several Jewish papercuts (e.g., Fig. 3.10b) and on some carved tombstones of Eastern Europe.[8] Do fish-tailed lions have special meaning, and if so, what do they represent? In a brief caption to reproductions of *shavuoslakh* (the small papercuts made by *ḥeder* boys to be pasted on windows during the Shavuoth festival in Eastern Europe) featuring this monster, Giza Frankel stated it to be Leviathan, but did not elaborate (Figs. 5.9a–b).[9] The common Jewish iconographic image of Leviathan, from the Middle Ages until modern times, is of a gigantic, long fish, its body usually encircling an inscription, a bovine

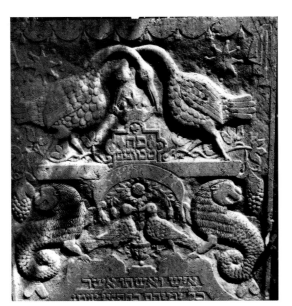

ולויתן ושור הבר

animal (the "wild ox"), a town, or some other picture, and often biting its own tail (Figs. 5.11, 5.12). If the fish-tailed lion (or, lion-headed fish) is indeed another way of representing Leviathan, how can this be explained? And why does it appear almost exclusively on papercuts and some tombstones?

The Leviathan motif on papercuts made specifically for the Shavuoth festival is entirely apposite to the ninety verses of the Aramaic *aqdamut millin* that are sung as part of the Shavuoth liturgy and vividly describe the great reward in store for the righteous in the Messianic afterlife: the feast prepared from the flesh of Leviathan and Behemoth (*shor ha-bar*) following their struggle to the death.[10] The Yiddish word for lion is *leib* or *leiv;* leviathan is pronounced *levyossn.* Could this phonetic similarity (the Hebrew and Yiddish orthographies differ) have led to Leviathan — a mystical marine monster — being given a lion's head and forequarters in Eastern European Jewish folk imagery?

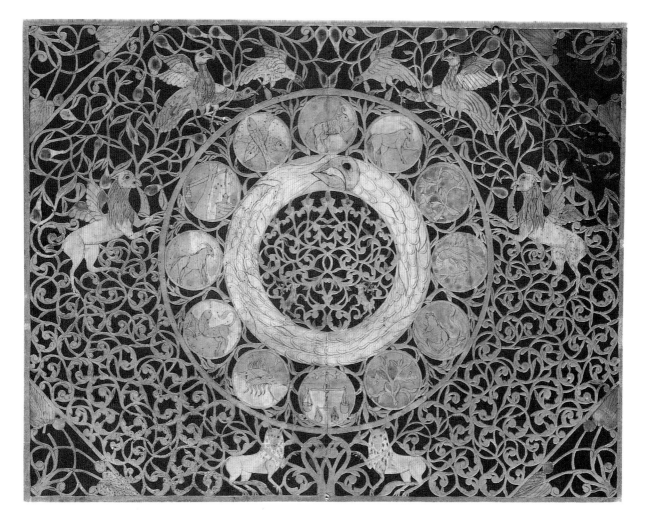

5.12. Leviathan, Zodiac. Although not one Hebrew letter appears in this beautiful papercut, there can be no question of its Jewishness. The central design is a highly stylized, ornate menorah, its flames pointing inward. The signs of the zodiac have no human figures. But the most remarkable Jewish symbol is the fish drawn around the inner circle, its tail in its mouth. This is the most common representation of Leviathan in Jewish folk art of the past two or three centuries. (See also the *shavuosl* with stylized Leviathan and analogous zodiac in Fig. 3.40). This papercut was never framed but was pasted onto a cardboard backing with eyelets punched into it for hanging on a wall. That it must have been displayed in this way for a long time is attested by the many fly specks. We do not know where and when the papercut was made; to hazard a guess, we would put it in the latter decades of the nineteenth century, perhaps from Bohemia or Slovakia. 31.5 × 40.5 cm. (12¼" × 16"). Abraham Halpern, New York.

 The case for the fish-tailed lion representing Leviathan is strengthened by its appearance as the main motif on some carved tombstones in Poland, the Ukraine, Moldavia, and elsewhere, probably as attributes of meritorious deeds by the deceased (Figs. 5.10, 5.13).[11] Here again this would be in accordance with Talmudic and Midrashic *aggadah* telling of the feasts for the righteous in the world to come, where they are to be served up the flesh of Leviathan which they will eat in a large *sukkah* covered with the skin of the monster.[12] The text incised in the stone beneath a carved relief of a crowned (why?) fish-tailed lion in Fig. 5.13 is in keeping with the stereotypical, laudatory Hebrew formulas of Jewish funerary inscriptions, such as:

An old, respected and revered man, whose righteousness grew with his years, who had clean hands and a pure heart from his youth, gave his bread to the hungry, his house was open wide, supported students of the Torah, his memory is blessed, walked honestly and did righteous deeds, his name is glorious, benefactor and leader, shepherd of holy sheep, gracious to all creatures and also beloved in heaven and thus will he be blessed by the people, may his soul be tied in the knot [or bundle] of life, our teacher Rabbi Tovia son of Yeḥiel of blessed memory, died on 25 Adar A' in the year 5589 (1829).[13]

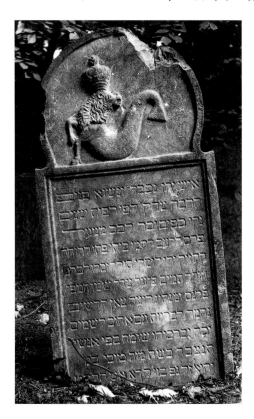

(RIGHT) 5.13. Crowned fish-tailed lion on tombstone in Warsaw. Photo: courtesy Monika Krajewska, Warsaw.

(FAR RIGHT) 5.14. Fish-tailed lions flank a florid menorah. Detail from a larger East-European(?) papercut of unknown provenance and date measuring 56.5 × 50 cm. (22¼" × 19¾"). Courtesy: Rare Book Department, The Free Library of Philadelphia.

In the context of Leviathan and the righteous dead, the papercut depicted in Fig. 5.15 is noteworthy. In addition to its being a *mizraḥ*, it was also made to serve as a *yortzait* or *ner zikaron* (memorial tablet). In the lower part of the papercut are three mortuary monuments with eulogizing inscriptions and the dates of death of several persons. Unfortunately, these inked texts have just about faded beyond legibility. Among the realistic, finely drawn animals that attest to the ability and knowledge of the artist, are a symmetrical pair of sea-lions flanking the central memorial stone at the bottom. Unlike in many old Jewish papercuts in which animals are so naively drawn as to be hard to identify, here they are unmistakable. The artist must at least have seen such animals depicted and described in a printed picture, and his choice of sea-lions was more probably deliberate than random. If, as we suggest above, Leviathan with its eschatological associations came to be represented as a fish-tailed lion, its mutation to a sea-lion is quite conceivable and the German word for sea-lion, *Seelöwe*, would easily fit this composite, imaginary creature.[14] It would seem therefore that sea-lions/fish-tailed lions (= Leviathan) deserve recognition in the venerable iconographic bestiary of Jewish art of the recent centuries.

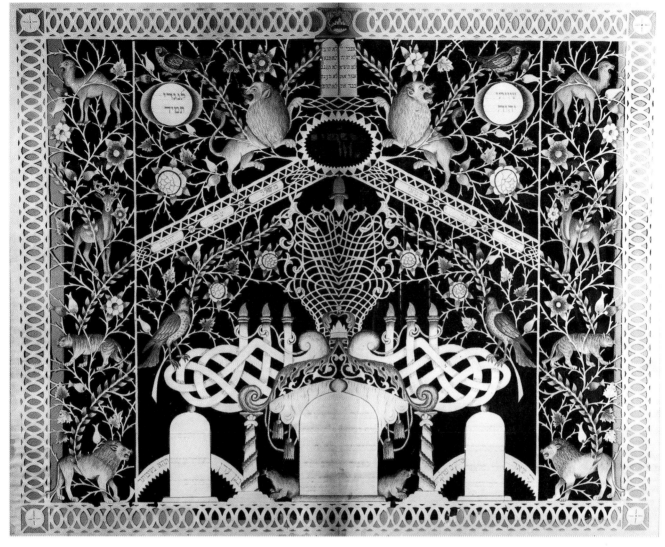

5.15. *Yortzait/Mizrah/Shiviti.* Memorial papercut from Mezhevizh, Ukraine, of the nineteenth century, from the collection of Rabbi Yitzḥaq Meir Heshil, Haifa. Note the pair of sea-lions on either side of the funerary monument at bottom center. The menorah is of the "convoluted" type incorporating endless-knot developments. 60 × 76 cm. (23⅝" × 29¹⁵⁄₁₆"). Photo: courtesy Giza Frankel Archival Collection, Jewish and Comparative Folklore Department, The Hebrew University of Jerusalem.

In this connection, we point to a most interesting configuration appearing in the remarkable Russian-Jewish papercut made in the mid-nineteenth century in Moscow by the grandfather of the American sculptor Jo Davidson (Fig. 5.16). Here, two superbly drawn fish-tailed lions (Leviathans?) are literally locked in combat with elegant unicorns, evoking the struggle to the death between Leviathan and Behemoth, or *shor ha-bar* — the "Wild Ox," also identified as the *re'em* that, in turn, has been interpreted as the "unicorn" of Scripture and the Midrashim.[15] Unicorns

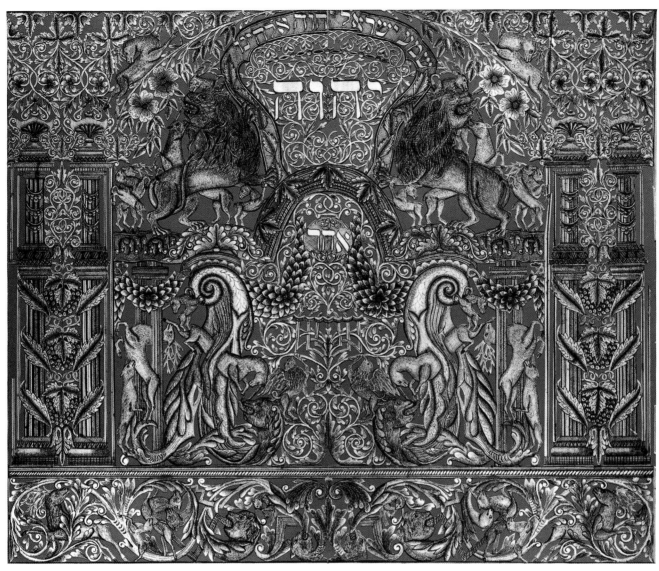

5.16. The *shema' yisrael*, the Jewish declaration of faith, "HEAR, O ISRAEL: THE LORD OUR GOD, THE LORD IS ONE" (Deuteronomy 6:4) is the only inscription in this magnificent papercut. The superb draftsmanship and pen-and-ink shading and the neo-classical Renaissance treatment of traditional motifs give reason to believe that the artist was a skilled engraver. The complex designs recall banknotes or bonds. Note particularly the fish-tailed lions and unicorns in the lower part. In Jewish folk imagery, there is a certain confusion in the depiction of the biblical *shor ha-bar* (Wild Ox), *behemoth*, and *re'em*, which is sometimes given the form of a unicorn. The artist may have intended showing the apocalyptic struggle to the death between Leviathan and Behemoth by intertwining these mystical animals. This papercut was made in Moscow in the mid-nineteenth century by the grandfather of the sculptor Jo Davidson. As a skilled graphic artist, he must have qualified for special permission to reside outside the Russian pale of Jewish settlement. The cheap wood-pulp paper he used has unfortunately yellowed and become brittle with age. 34.5 × 42 cm. (13½" × 16½"). Michael and Esther Davidson, New York.

by themselves or together with lions — sometimes in violent confrontation with one another — do appear on Jewish tombstones and synagogue wall-paintings, as well as in papercuts (e.g., Fig. 3.13).[16] That unicorns are represented here together with fish-tailed lions may thus be another corroboration of the latter's identity with Leviathan.

Convoluted Menorahs and Endless Knots

Traditional Jewish papercuts from Eastern Europe feature the menorah in a variety and complexity of forms unmatched by any other branch of Jewish ritual and folk art. The full range of the visual configurations of the menorah can only be appreciated by studying many Jewish papercuts (and perhaps other *mizrah*, *shiviti*, and similar printed or hand-made works on paper). Systematic examination of old papercuts revealed menorahs ranging from the simplest schematic forms, through realistic depictions replete with "knops and buds" as detailed in Exodus 25: 31–40 and 37: 17–24, to the convoluted types discussed below.

Out of a random sampling of 120 large and small Jewish papercuts from Central and Eastern Europe (but not including *ketubot* and *megillot esther* with cut out decorative borders, to the extent that these exist in the region; nor any of the Sephardi papercuts, which are quite different), we found that about half of them feature a menorah in a prominent central position of the composition. Most of the menorahs have a very peculiar appearance, which we have chosen to call "convoluted," for they have intertwining upper branches and ribbon-like endless-knot configurations at the foot, in many variants. Some, such as the one in Fig. 5.12, are very strange indeed: To someone not attuned to the centrality of the menorah motif, it would easily escape notice. What gives it away are the little flames at the top, pointing inward from the sides in keeping with Rashi, Midrash Tanḥuma, and Babylonian Talmud, Menaḥot 98b commentaries on Exodus 25: 31–40: "And thou shalt make the seven lamps thereof . . . that they may give light over against it" (p. 91).

Many of the menorahs appearing on papercuts are so intricately convoluted as to bear hardly any resemblance to the essential form of the menorah (e.g., Figs. 5.15, 5.17, 5.23, 5.25, etc.). In some East-European Jewish papercuts, the arms of the menorah take on the appearance of intertwining vegetal branches in a merging with the Tree of Life motif, while the base of the menorah becomes a development of an endless knot, sometimes carried to implausible permutations.

5.17. *Shavuosl.* Note the menorah with an "endless-knot" base flanked by long-necked deer. The storks in the side panels symbolize divine mercy. 21 × 17 cm. (8¼" × 6¾"). Reizes Collection, Ethnology and Folklore Pavilion, Eretz Israel Museum, Ramat Aviv.

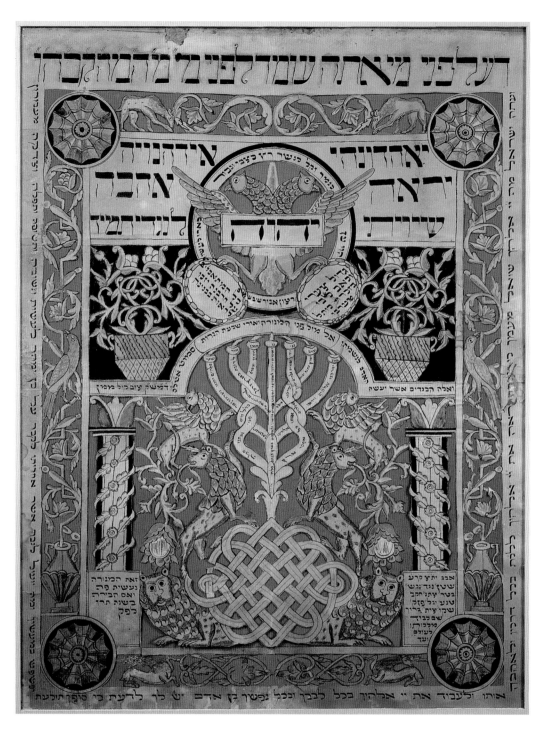

5.18. *Shiviti*. This imposing papercut from Yassi in Romania, dated 1846, presents many interesting features. The overall composition and decorative treatment are neoclassical in spirit. The central menorah, flanked by lions and griffins, is especially noteworthy: The massive base in the form of a complex endless knot supports snakelike, intertwining branches, inscribed as usual with Psalm 67. The upper register, with the double-eagle surrounded by the "Four Animals" aphorism, rests upon the inscribed arch supported by two columns of the Temple portal. The text in the arched band dividing the upper from the lower register reads: "And these are the garments man shall make for his soul — *SAMUT, ATLAS, DAMASQ*." The three latter are the Yiddish words for velvet, silk, and damask fabric, respectively, which in Hebrew are acronyms for pious precepts, as explained on p. 107. The calligraphic texts in the margins combine pithy sayings, prayers, and mystical formulas. 54 × 42 cm. (21¼" × 16½"). Mishkan Le-omanut, Museum of Art, 'Ein Ḥarod.

Out of a relatively large sampling of fifty-five, mainly East-European Jewish papercuts featuring central menorahs, we found only fourteen to be of "classic" form. Three-quarters of all the menorahs were "convoluted" types.

The classical menorah of antiquity is well known from many excavations and architectural fragments in the Mediterranean region — mosaic floors, lintels, columns, funerary steles, oil-lamps, gilt glass — dating from the Second Temple period through the time of the Talmud and the Mishnah, the Roman-Byzantine, and possibly into the Early Arab periods (Fig. 5.19). It is a simple, bold, esthetically satisfying, often stylized symbol. It can be linear, or more ornate to reflect the description in the book of Exodus of the menorah made by Bezalel (p. 91). Throughout the Medieval and Renaissance periods the menorah maintained its essential, "classical" form. In Sephardi Jewish papercuts, as in all other Jewish ritual and national contexts, this is how the menorah is represented to this day. Many of the menorahs in East-European Jewish papercuts thus diverge greatly in appearance from the essential forms.

How can such liberties with the basic symbol of Judaism be accounted for? One explanation is that the convoluted configurations are decorative treatments, stemming from the nature of the material and the techniques of papercutting. Just as a folk fiddler or clarinetist improvises trills and embellishments to show off his virtuosity on the instrument, so the folk artist making the papercut could manifest his consummate skill and mastery of his simple tools and materials by creating mind-boggling, intricate, cut-out designs (again, imagine yourself doing this!). Or, perhaps more in keeping with his religious motivation, the Jewish scribe/artist exercised his skill to the utmost in glorification of the Almighty. This, however, may at best only partially explain these curious menorahs, for the prominent, central position of these designs in the overall composition of the papercut strongly suggests that they also have some symbolic significance that has eluded us.

Early on in our studies, we noted the hierarchical arrangement of the symbols appearing in East-European Jewish papercuts.[17] Unlike in Greek-Orthodox ecclesiastical art, such as church murals and icons, with its strictly prescribed hierarchical positioning of conventional thematic representations, we know of no code of written rules governing Jewish religious art (except perhaps the Talmudic passage regarding the inward-facing flames of the menorah as indicated on p. 91). And in any case, Jewish papercuts were not an institutionalized art but very highly individualized folk creations made within a self-contained cultural framework.

Although, on the whole, the men who made papercuts followed their whims, they did so within a generally accepted and understood iconographic language. By giving endless-knot-*cum*-menorah configurations a central place in their compositions, they attest the importance of this motif in their iconographic repertoire. With even many secondary and marginal figures having deeply rooted, recognizable symbolic meanings, it is hardly conceivable that the prominent, centrally positioned menorah in its convoluted variants is not laden with symbolic significance as well. In view of the rich expressiveness of Jewish iconography with its multi-layered meanings, it seems most unlikely that these peculiar forms of the menorah were determined by esthetic or technical considerations alone.

All these convoluted menorahs incorporate, or are developments of, the endless knot; and if there is indeed a special significance to the endless-knot motif, we can begin to understand

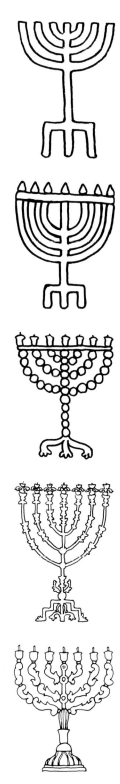

5.19. Standard menorah configurations from antiquity to the modern period.

Convoluted Menorahs and Endless Knots / **165**

5.20. *Mizraḥ?* A yeshivah student in Pressburg (today, Bratislava), who signed himself Moshe Dov Katz (the acronym for *kohen tzedeq* = righteous priest) Miller, created this delicate, meticulously cut work with repeating endless-knot patterns in 1866. The central medallion of the composition, which may have contained the word *mizraḥ* and was probably damaged, was replaced in more recent years with a pasted-in printed reproduction of a color photograph of a synagogue holy ark that evoked the same idea. The well-lettered inscription around the margins relates to the building of Solomon's Temple, starting with Ezekiel 43:12: "This is the law of the house: upon the top of the mountain the whole limit thereof round about shall be most holy. . . .," and continues with 1 Kings 8:18–19, 1 Kings 8:13, and ends with Psalm 92:14: "Planted in the house of the Lord, They shall flourish in the courts of our God." Unlike most traditional Jewish papercuts, the design is essentially mechanical and rather unimaginative: The young man who made this expressed his fulfillment of the *hiddur mitzvah* precept primarily through the virtuosity of his cutting skill. 51 × 51 cm. (20¹/₁₆" × 20¹/₁₆"). Múzeum židovskej kultúry, Bratislava.

its widespread appearance in the papercuts. In the parchment-cut in Fig. 5.21, for example, an inscribed endless-knot design occupies the place where we would expect to see a menorah, a large *mizraḥ* or *shiviti* inscription in a medallion, the tablets of the Decalogue, or other major cultic symbols — certainly not a purely decorative device! (And see also Fig. 3.14, where an "endless knot" forms the "Crown of a Good Name.")

Where does the idea of the endless-knot symbol come from? There can be no doubt of its Christian inspiration. In German, French, Swiss, Austrian, and other European folk art — both profane and sacred — the "infinity" or "endlessness" motif of the *Liebesknoten* or *lacs d'amour* — the love-knot — is exceedingly common (Figs. 5.22a–c). In *Spitzenbilder* and *Andachtsbilder*, the

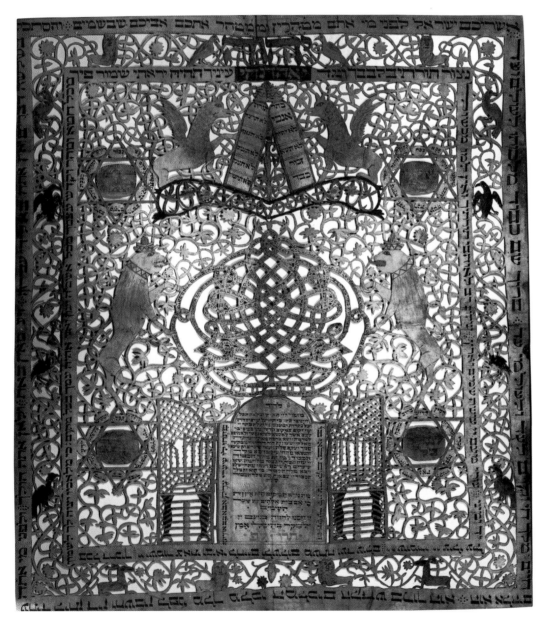

5.21. *Shiviti.* Cut in parchment by Simon Simel in 1845/46, somewhere in Galicia, this unusual, intricate *shiviti* is both cautionary and apotropaic in intent, with many texts from the Bible — mainly Psalms, Mishnaic passages, and mystic formulas. Many of these are epitomized by the aphorism from Pirqei Avot 3:1 (in the outer margin): "Reflect upon three things, and thou wilt not come within the power of sin; know whence thou camest, and whither thou art going, and before Whom thou wilt in future have to give account and reckoning. . . ." The central focus in this composition is on the prominent endless-knot design inscribed with Deuteronomy 10:12–22 and several Psalms. 35.5 × 31.8 cm. (14" × 12½"). Jewish Museum, New York (JM 51-51). Gift of Mr. and Mrs. George Sagan, New York City.

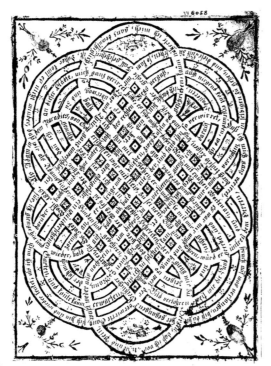

5.22a

5.22b

5.22c

5.22. Endless Knot. Complex entanglements
challenging the proficiency of the folk artist are fairly
common in East-European Jewish papercuts. They
probably found their way into Jewish devotional
works from religious and secular Christian European
folk art, where intricate endless-knot formations and
permutations embodying the reclining figure eight —
the symbol of infinity — and sometimes forming a
heart, represent everlasting love. The endless-knot
(*Liebesknoten*) designs (*a*) and (*b*) are secular rhymed
love messages. In the devotional Catholic parchment
Spitzenbild/Andachtsbild from Germany (*c*), with
representation of a saint, endless-knot developments
at top and bottom symbolize Christian love and
eternal faith. Museum der Kulturen (Abteilung
Europa), Basel.

small devotional or secular Christian paper and parchment cut-outs that, as has been seen, also
have parallels in the Jewish papercut repertoire, this device occupies central positions (Figs. 1.5,
1.6b). In this sense, it was apparently adopted in Jewish marriage contracts (*ketubot*), where it is
frequently labeled *tzeror ha-mor* (Song of Songs 1:13), usually translated as "bundle of myrrh,"
but also meaning "knot" or "tie" of myrrh. Indeed, small, marginal endless-knot designs do

5.23. *Mizraḥ*. An old photograph from the collection of the renowned artist-craftsman Ilya Schor (1904–1961), who came to New York in 1941 from Galicia, is all we have of this beautiful work made by Yitzḥaq the son of Rabbi Aaron in 1880, probably somewhere in Poland, the Ukraine, or Galicia. Note especially the central, convoluted menorah and the intricate "endless-knot" design of its stem and base. The menorah is flanked by a pair of unicorns and two lions rampant. The double eagle at the top has the words *qal ka-nesher* ("light [on the wing] as the eagle [vulture?]") evoking the aphorism of Judah ben Tema (Pirqei Avot 5:23). Beneath the Tablets of the Law are storks grasping snakes in their beaks. As in many of these compositions, ramified Trees of Life grow out of ornate urns in the lower corners. ca. 38 × 45 cm. (ca. 15" × 18"). Archival collection of the authors, Jerusalem.

5.24. Tombstone with endless-knot convoluted menorah, in the Czernowitz Jewish cemetery (Bukovina). Apart from their use in Jewish papercuts, such menorah motifs appear almost exclusively on some Eastern European Jewish tombstones. After M. Diamant, 1937.

5.25. *Mizraḥ.* This marvelous papercut *mizraḥ*, dated 1876, was among the folkloristic material collected by the An-Sky expedition in 1916 in the western Ukraine bordering on Galicia. The base of the "convoluted" menorah is an amazing, intertwining endless-knot development. The crowned, double-headed eagle bears the words *"qal ka-nesher"* ("light [on the wing] as the eagle") of the Four Animals aphorism. ca. 40 × 47 cm. (ca. 15½" × 18½"). After R. Wischnitzer-Bernstein, 1935.

5.25

appear in Jewish papercuts, in some calligraphic sheets, and occasionally in wood carvings.[18] But these are of a very different order from the bizarre developments of the menorah, or where they are the dominant, central elements of the composition.

We have searched libraries, museum exhibits, private collections, books, and many other sources on Jewish ritual art for "convoluted" configurations of the menorah and the endless knot, but have found very few outside of papercuts — with one exception: Again, as in the case of the fish-tailed lion, they appear on some East-European Jewish tombstones of the same regions (Fig. 5.24).[19]

As far as we could ascertain, neither the convoluted menorah configurations nor the endless-knot motif have ever been considered as distinct visual symbols in Jewish iconography. And yet, they are so common and figure so prominently in East-European Jewish papercuts that they can hardly be regarded as mere decorative motifs.

The earliest known, datable Jewish folk papercuts that show convoluted developments of the basic menorah design and the endless-knot motif, *in central positions*, were made before the end of the eighteenth century. The origins of these peculiar configurations should therefore be sought a good many years before that time. Thus, the metamorphosis of the traditional menorah of

antiquity and the Middle Ages into the convoluted, endless-knot configurations appearing in the papercuts coincides with the spread and growing popularization of messianic mysticism and the Kabbalah throughout the Jewish communities of Eastern Europe from the early eighteenth century on — along with the development of the entire papercutting practice itself.

As can be seen from many of the works illustrated in these pages, unequivocal kabbalistic affinities are much in evidence in traditional Jewish papercuts. A number of East-European as well as some of the recorded Sephardi Jewish papercuts prominently feature actual inscriptions of the Sefirot, usually within medallions or cartouches (e.g., Figs. 3.33, 4.22a–b, etc.), and often in conjunction with the numbering (*sefirah*, in Hebrew) of the *'omer*. Not being competent in this field, we do not hazard interpretations of kabbalistic lore. But even a superficial knowledge, gained from general reading on kabbalistic thought and systems, seems to suggest that this is where an understanding of the convoluted menorah may perhaps be sought.

Already in the earliest kabbalistic writings, the Tree of Life and the menorah are closely linked in their symbolic meanings. The menorah appears as a symbol of the seven lower Sefirot — the seven eyes of God, according to Zechariah 4:10 — that rule the world. They are products of the third of the three upper Sefirot that emanate from the "*Ein Sof*" — the "Endless" — the infinite, pure essence of the Creator. Thus, the oil in the branches of the menorah is the force for light in the menorah, symbolizing the dynamic stream influenced by the *Ein Sof*.[20] Might the centrally placed endless-knot configurations, having no beginning and no end (*beli reshit beli takhlit*, as in the Adon 'Olam hymn), which merge into the menorah, suggest a graphic rendering of the kabbalistic concept of the *Ein Sof*?

The particular figures discussed above, which we suspect to be highly charged symbolic devices, and which seem to be virtually specific to Jewish papercuts and carved tombstones of Eastern Europe, may thus perhaps afford new insights into the Jewish iconography of the latter centuries, as distinct from the Jewish symbols of antiquity and the Middle Ages that were also carried on into the Renaissance and later periods. Whether these are indeed the sources of the convoluted menorah and the endless-knot configurations in Jewish papercuts, and whether they were intended as graphic expressions of mystic religious concepts, must remain an intriguing question until more satisfactory explanations are forthcoming.

Anatomy of a North African Jewish Papercut

As we indicated in chapter 2, among the several hundred known and recorded old "classic" Jewish papercuts, only about a dozen or fifteen come from western North Africa — the Maghreb (among them, Figs. 2.4, 3.2, 3.26, 3.41, 4.20, 4.21a–b, 4.22a–b). Such a small number of items is insufficient to permit generalizations regarding this particular branch of Jewish folk art in the lands of the Maghreb, the more so since several of these papercuts are the work of the same person. We cannot know just how representative they are, if at all. Giza Frankel's descriptions focused mainly on the thematic aspects and on some of the symbols and inscriptions of the

works depicted. She also wrote that all these papercuts are backed with brightly colored, very thin, metallic foils that she took to be "candy wrappers." As to the exact provenance and periodization of the works, except for one dated 1850 and another 1892, and the names of two or three of the folk-artists, we have no further information, although we estimate that most were made around the turn of the twentieth century in Morocco, Algeria, and Tunisia.

A number of years ago, I (Yehudit) was able to gain unique insights into the materials and techniques used in creating one such papercut work: Rabbi Shlomo Pappenheim, founder and director of the Museum of Jewish Art in Jerusalem, entrusted me with the preservation and reconditioning of a large "*menorah*" papercut wall amulet that he had reportedly acquired from a peddler. The work, which was originally about 46 cm. high by 97 cm. wide (18 in. × 38 in.), was given over to me in a dismembered state. Years of negligent storage had partially destroyed this rare remnant of the North African Jewish papercutting tradition. Parts of the cut areas had disappeared. Most of the underlaid, paper-thin, stiff, copper sheets that formed the background to the cut-out paper parts had shifted out of place, and a few seemed to be missing. Their original pink, red, violet, and emerald-green painted-on, lacquered metallic coloration had faded and almost totally flaked away.

Working at reassembling the papercut (Fig. 5.26) in my studio, I understood what a singular opportunity had been given me to acquaint myself intimately with this painstaking labor of love made by a devout *sofer stam* (scribe) or Torah scholar, years ago, in Meknes, Fez, or some other center of Jewish learning. As I worked at fitting the fragments in place, I found that, unlike the traditional European Jewish papercuts that were usually cut from one piece of folded paper, this work was made up of three separate panels of intricately cut repeat-patterns plus inscribed paper strips. The panels were arranged according to an overall symmetrical plan. Pieces of lacquered metal foil of various colors were then glued to the reverse sides of the panels, so that each subsection of the panels had its own background color. The joints between the panels were overlaid with glued-on strips of paper inscribed with biblical and other passages in large, square Hebrew letters. This method of assembling a repeat pattern of several designs recalled ornamental Islamic wooden screens and cabinets popular in Middle Eastern and North African decor.

To keep all the elements of this large, fragile composition in place, the panels with their colored foil underlay were mounted on a rigid backing made up of glued-together sheets of lined pages, all covered with fine cursive "*ma'aravi*" Hebrew script, which once may have been part of a notebook belonging to a yeshivah student or perhaps of a communal ledger of sorts. The pen-and-ink writing could be seen clearly on what was left of the original 7 to 8 centimeter- (3 inch-) -wide margins that surrounded the cut composition, and that were not intended to be visible; cut-out decorative border strips were probably glued over them. These protruding "underlay" margins had initially been overpainted with a diluted lacquer or shellac that had by now flaked in part and had discolored to a grey-green. Perhaps this same shellacking process had also been applied to the metal-foil sheets that had lost most of their original color.

Almost one-half of the outer border had disappeared, but the two calligraphic inscriptions lettered in black ink in bold, classical Sephardi square script surrounding the two panels of the papercut were complete. They were inscribed on several long strips of cheap white paper that had yellowed from exposure to light more than had the cut areas. The paper on which this

5.26a

5.26b

5.26. *Menorah.* The ledger or notebook paper used as the foundation onto which were glued the component parts of this complex Moroccan *menorah* papercut composition can be clearly seen around the edges. The central menorah was left unfinished, without the usual inscription of Psalm 67 (see detail). The text inscribed in square letters in the strips is (right panel) Isaac's blessing to Jacob from Genesis 27:28–29:

> So God give thee of the dew of heaven, And of the fat places of the earth, And plenty of corn and wine, Let peoples serve thee, And nations bow down to thee. Be lord over thy brethren, And let thy mother's sons bow down to thee. Cursed be every one that curseth thee.

and (left panel) Deuteronomy 7:14–15:

> Thou shalt be blessed above all peoples; there shall not be male or female barren among you, or among your cattle. And the Lord will take away from thee all sickness; and He will put none of the evil diseases of Egypt, which thou knowest, upon thee, but will lay them upon all that hate thee.

43.5 × 81.5 cm. (17⅛" × 32 1/16"). Jewish Museum, New York.

inscription had been lettered, possibly by a different hand, differed in quality from that of the papercut panels. These strips were the last element of the entire composition to be added, for they served to help keep the completed work together by covering the joints between the panels.

At that point, the overall conception of the design, the cut-out paper panels, and the inscribed strips looked somehow familiar. They turned out to be almost the same, and even in part identical, to another, even larger, Moroccan papercut in the Sir Isaac and Lady Wolfson Museum at the Hekhal Shlomo in Jerusalem (Fig. 5.27). Another, companion, Moroccan papercut in the same collection features some parallel elements and similar inscribed border strips (Fig. 3.41). Both these works were acquired by the Wolfson Museum from the Heshil and Rivka Golnitzky collection. Golnitzky, a Haifa collector of Judaica, had reportedly bought the two "good" papercuts from Moroccan immigrants in the early 1950s in one of the new *moshavim* (agricultural settlements) in southern Israel. The "poor" one I was working on was acquired separately by someone else. But clearly, these three papercuts were the work of the same person!

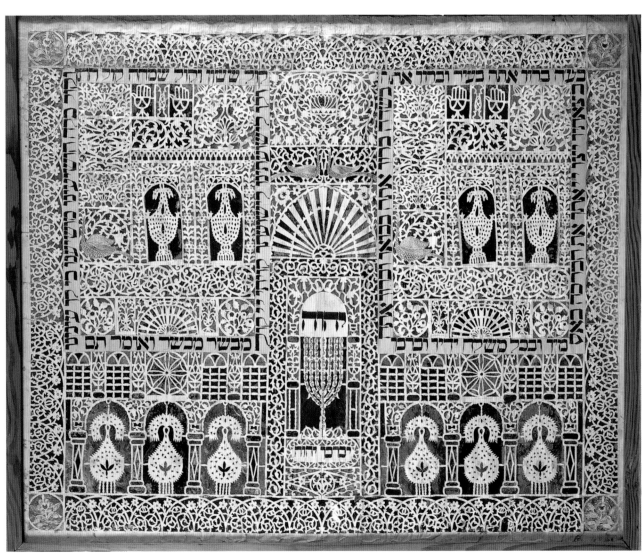

5.27

Now that I had some guidelines and points of reference for piecing the puzzle together, I laid the various component parts carefully in place on a large cardboard. I was relieved to find that at least all the foil sheets (not "candy wrappers") of the background were accounted for, some of them having slipped out of sight among the dismembered cut-paper elements.

Closely inspecting the intricate, cut panels, I realized that they had not been done freehand, but had been cut along a (sheet-metal?) template clamped over a number of layered sheets of light-weight newsprint-quality paper, not unlike the Chinese technique of papercutting through stacks of many sheets. This conclusion was reinforced when I compared all the *hamsa*s, "lamps-in-niche," peacocks, floral motifs, Moorish and fan-like arches, stylized vegetal arabesques, and repeat border designs of flowering plants that made up the composition. Each complex design was identical to its opposite companion piece, even down to the slight erratic and rigid character of the cutting, indicating that they had been incised in layers by direct, vertical pressure guided by the same template.

The cut-paper panels making up this work being identical to some of the panels in the larger, composite Moroccan papercut in the Wolfson Museum, the panels for both works were apparently cut at the same time — or, at least along the same templates. In "my" papercut, the identical, template-cut elements had been mounted front-to-back opposite each other so as to achieve mirror symmetry of the panels in the overall composition, as can be seen, for example, in the

(OPPOSITE PAGE) 5.27. *Menorah*/Amulet. Among the relatively few known Jewish papercuts from Sephardi and Oriental communities, most have a central menorah inscribed with Psalm 67, and other characteristic texts that are also found in Ashkenazi work. However, the architectural and decorative motifs are typically Islamic, with only an occasional bird among the arabesques. In this very large papercut from Morocco of the late nineteenth or early twentieth century, there are lamps-in-niches, crescent-and-star, and *hamsa*s to ward off the evil eye. The intricate, repetitive patterns and other elements were achieved by cutting along templates, and the component parts were assembled to obtain the entire, complex composition. The papercut was mounted on a large base-sheet made up of glued-together pages from notebooks or ledgers covered with finely hand-written Hebrew cursive script. As in other such North African papercuts, the contrasting colored background to the actual papercut consists of shiny, colored metal foils that, in effect, form an intermediate layer between the base-sheet and the papercut. The pink, green, purple, scarlet, gold, and other colors of this layer recall Islamic colored glass windows. Unfortunately, much of the colored paints have flaked away with age. Note that, here, the two squarish panels, left and right, were apparently cut out at one time and held in place by pasted-on strips of paper that were later inscribed. Both panels face in the same direction and do not conform to the overall symmetry of the entire composition (in error?).

The inscription in large square letters around the right-hand panel is from Deuteronomy 28:3, 6, and 8, respectively:

Blessed shalt thou be in the city, and blessed shalt thou be in the field.
Blessed shalt thou be when thou comest in, and blessed shalt thou be when thou goest out.
The Lord will command the blessing with thee in thy barns, and in all that thou puttest thy hand unto.

The text around the left-hand panel begins with Jeremiah 16:9 (and several other passages):

The voice of mirth and the voice of gladness, The voice of the bridegroom and the voice of the bride

and continues with a rhymed invocation:

Savior save us, for to Thee our eyes are turned;
And to Thee and Thy succor I hoped O God,
To the voice of the bearer of tidings proclaims and completes.

78 × 97 cm. (30¹¹⁄₁₆" × 38³⁄₁₆"). The Sir Isaac and Lady Edith Wolfson Museum, Hechal Shlomo, Jerusalem.

thumbs of the *ḥamsa*s and the facing peacocks. However, the left-hand panel in the Wolfson Museum papercut had not been inverted, and therefore faces in the same direction as the right-hand panel — obviously by mistake.

Apart from the Hebrew calligraphic inscriptions on the pasted-on border strips, only the central portion of the papercut incorporates Jewish motifs: an elongated menorah and a boldly lettered Tetragrammaton. Unlike the two identical but reversed side panels, these central elements with the monumental arch form and Islamic crescent-and-stars in the upper corners had also been cut along templates in the folded paper (the original fold creases are clearly visible). Comparison with the Wolfson Museum papercut showed that the one I worked on had never been finished. It lacked the addition of inked-in detailing, for example, in the peacocks' feathers and bodies. The menorah, usually containing the seven verses of Psalm 67 inked-in in microscript on the seven branches, was here left blank, as was the rectangular uncut area below the menorah, the appropriate place for an inscription.

After many hours of concentrated work, I succeeded in returning all the surviving backing sheets, pieces of copper foil, and cut designs to their original positions. Before assembling and gluing the papercut together again, and mounting it on a sheet of heavy, hand-made, acid-free Japanese paper, I had to make a crucial decision: should I attempt to fill in the missing elements and renew the faded and flaked foil to its original brilliant colors? I decided to repaint some of the copper foil backing sheets that had almost totally lost their lacquer, in order to renew, in part, the vibrant colors so characteristic of North African Jewish — and other — folk art. But I thought best to leave the irregular, rather tattered shape, and areas of missing cut paper that revealed more of the underlying foil and notebook paper than its creator had originally intended, as testimony to the working process behind this interesting item of Jewish folk art. The restored papercut was framed between two panes of glass so that its method and construction techniques can be seen, front and back. Today the work is in the New York Jewish Museum collection (Fig. 5.26).

This papercut, examined down to its detailed component parts and construction, raises a number of intriguing questions. Did the man who made these compound papercut compositions on a "mass-production" system create others as well — perhaps for sale as effective amulets? Did he employ assistants or relatives to cut the standard components along templates? Who designed and made the templates? Were they made of metal to last a long time, or of cardboard? Were such templates generally used by Muslim North African craftsmen working in paper or other materials? Were these works typical of other papercuts in the community? Why, after so many exacting hours invested in cutting, coloring, and assembling, had the artist/craftsman neglected to add the finishing touches to his monumental work? Why had it been stored so carelessly over the decades, suffering decay and disintegration, when its more elaborate and fortunate "big brother" had enjoyed good care to survive in almost pristine condition? Would that we could answer these questions.

Four Papercuts from the Prague Jewish Museum

Among the wealth of Jewish ritual artifacts gathered in 1942 to 1943 at Nazi orders for a projected museum of the "defunct Jewish people" to be established in Prague by Jewish experts (all of whom were later killed), were also a number of papercuts. One of these (Fig. 5.28) was described in detail in 1966, albeit in part erroneously, by Elias Katz, the then-Chief Rabbi of Slovakia.[21] Close examination of the papercuts in the Prague Jewish Museum revealed certain similarities and affinities in different pairs of four of these works, suggesting that they were created by the same man. Thus, Figs. 5.28 and 5.29 share several of the same inscriptions and elements of the composition; Figs. 5.28 and 5.30 have the same central biblical quotation: "This is the table that is before the Lord" (Ezekiel 41:22), with some resemblance in the style of the lettering; and other inscriptions on Figs. 5.30 and 5.31 may provide clues to the man who made them, and where and when they were made. Interestingly, a fragment of a beautifully lettered work on paper found in the Luže synagogue genizah (see caption to Fig. 4.7), and dated to the end of the eighteenth century, bears the same words along with small heraldic emblems of a double-headed eagle and a lion, all within a circular inscription from the Mishna, Pirqei Avot 3:4: "... (if) three have eaten at a table and have spoken there words of Torah, it is as if they had eaten at the table of the All-Present, of which it is said, 'And he said unto me, This is the table that is before the Lord.'"

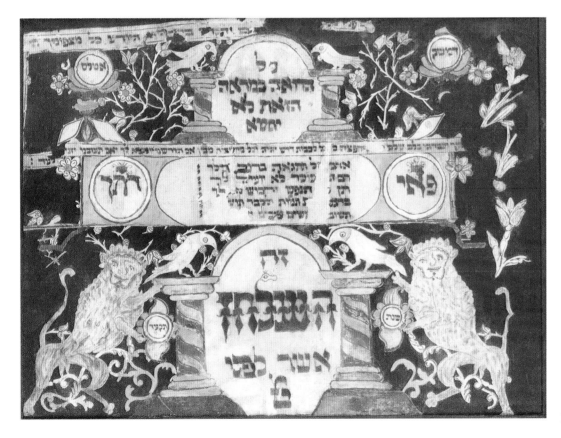

5.28. Caption on next page.

(PREVIOUS PAGE) 5.28. Cautionary Admonition. Although the word *mizrah* does not actually appear on this monumental, but unfortunately, badly damaged work, it may have served the same traditional purpose by being hung on an eastern wall in the home. Or, more probably, it was affixed in front of the reader's desk in the synagogue. As was pointed out by Elias Katz, the purport of the texts is to enjoin deepfelt faith and purposeful observance of prescribed ritual practices in order to keep from punishable transgressions: "Those who see this sight [the picture] will not sin" is proclaimed in bold letters in the central upper, arched space.

The text across the top, which is here mostly missing, can be reconstructed from the analogous inscription in Fig. 5.29 by the same folk artist: "Know before Whom you stand, before the King, King of Kings, the Holy One blessed be He, Who knows all your secrets" (Berakhot 28:1). In the same spirit, the next band down is inscribed with a passage from I Chronicles 28:9: "And thou . . . know . . . the God of thy father, and serve Him with a whole heart, and with a willing mind; for the Lord searcheth all hearts, and understandeth all the imaginations of the thoughts; if thou seek Him, He will be found of thee; but if thou forsake Him, He will cast thee off forever." The two roundels at the top bear the standard acronyms *DAMASQ* and *ATLAS* for: "Know Who is your Maker," and "(God) is good to Israel, *selah*" (Psalm 73:1), as explained on p. 107.

In the large central oval, the rhymed cautionary text in five lines from an unknown source, as reconstructed by Elias Katz, reads:

> Man, do not exalt yourself in your pride; Even if your wealth is great, it will not be of use; Give me the soul and what is yours, what remains to you; At any moment you will die and be sent to the grave; Repent, good deeds will save you.

The two large roundels on either side contain the cryptograms for "Thou openest Thy hand" (Psalm 145:16), made up of the first and last letters of the three Hebrew words of the passage. The very large inscription in the lower register is from Ezekiel 41:22: "This is the table that is before the Lord." The two small roundels at the sides, between the lions' paws, give the year: 1814. The text from Ezekiel equates the wooden "table" with the sacrificial altar of the sanctuary. When, after the destruction of the Temple, blood sacrifice was replaced with prayer, the designation "the table that is before the Lord" was applied to the officiating reader's lectern facing the *aron qodesh* in the synagogue — upon which a *shiviti, menorah*, or similar plaque was often placed.

The symbolic meanings of the lions and birds are explained elsewhere in these pages, but the two recurring arched portals supported by solid columns deserve some comment. As Gates of Heaven, Gate of Mercy, Gate of Tears, and similar metaphorical associations, they evoke divine mercy and compassion — and so are entirely in line with the import of the written texts in this devotional papercut. ca. 30 × 39.5 cm. (11¹³⁄₁₆" × 15⁹⁄₁₆"). Židovské Muzeum Praha, Prague.

(OPPOSITE PAGE) 5.29. *Shiviti/Menorah*. Another, quite beautiful, later work by the man who made the cautionary papercut (Fig. 5.28) is dated 1821 in the analogous small roundels between the lions' paws. Note the very similar arch supported by two massive columns with neo-classic decoration and the two birds pecking at berries perched upon the columns. Here the large inscription is the common *shiviti* text: "I have set the Lord always before me" from Psalm 16:8, and the acronyms in the upper roundels are *SAMUT* and *ATLAS*, for "Depart from evil and do good" (Psalm 37:27), and "(God) is good to Israel, *selah*" (Psalm 73:1). The texts in the three horizontal bands are identical to the ones in the two bands of Fig. 5.28. The letter combinations in the five roundels in the narrow, middle register are again, hard to explain kabbalistic cryptograms. The large menorah is inscribed, as usual, with Psalm 67.

But note the very small, unobtrusive inscription in the two little oval cartouches above the blue birds in the lower register: "For a bird of the air/ shall carry the voice." Here, along with the standard, pious precepts, we have some earthy, practical wisdom on how to get on in a world ruled by the high and mighty: The full text of this passage from Ecclesiastes 10:20 counsels: "Curse not the king, not in thy thought, And curse not the rich in thy bedchamber; For a bird of the air shall carry the voice, And that which hath wings shall tell the matter." 45 × 37.4 cm. (17¾" × 14¾"). Židovské Muzeum Praha, Prague.

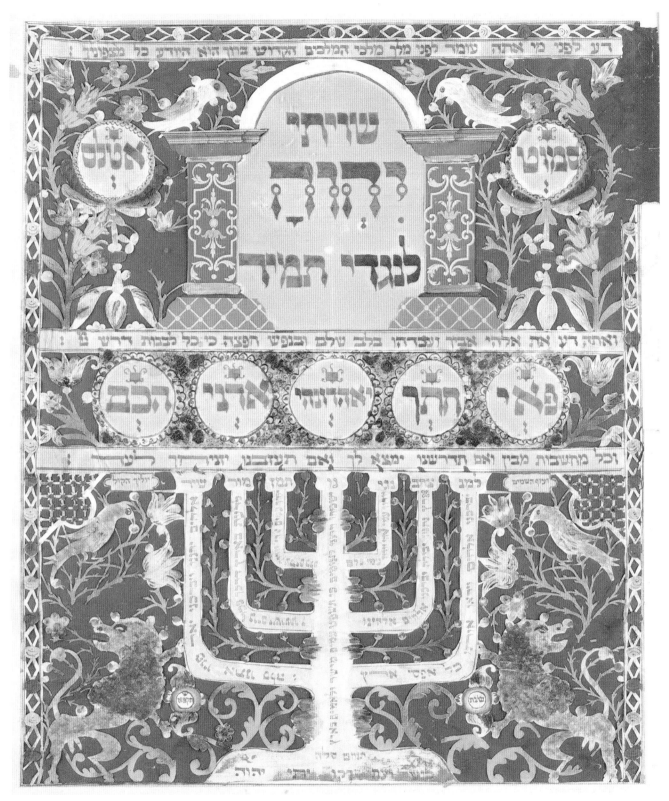

5.29

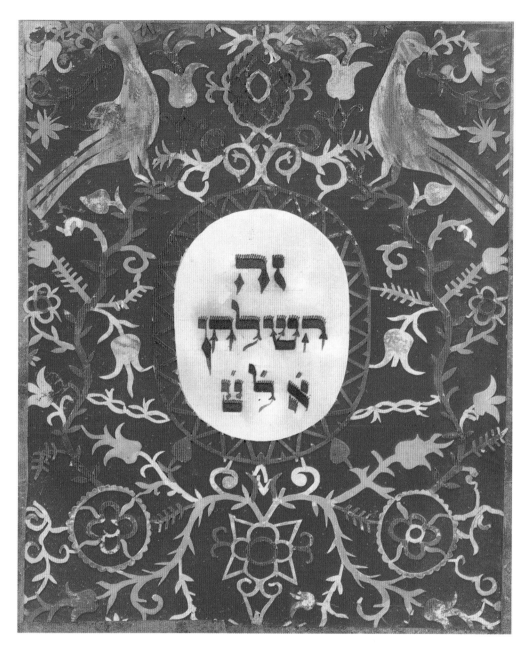

5.30. *Ze ha-shulḥan.* But for the (partly abbreviated) Hebrew text, "This is the table that is before the Lord" (Ezekiel 41:22), there is nothing in the design of this folksy papercut to identify it as Jewish. Since besides Fig. 2.31 we know of no other Jewish papercut with this particular text except Fig. 5.28, which also ended up in the Prague Jewish Museum, it may not be unrelated to (or influenced by?) the two others shown here that were made by the same man. More recently, the same text on a paper fragment (Fig. 4.7) was also found in the Luže genizah, in the Czech Republic. A hand-written inscription on the reverse side of this attractive work tells us that it is "Dedicated to Bernard Kosiner, in Ješín [in northern Bohemia], 1859, teacher Popper." Another added inscription is in the margin at the lower right-hand corner: "Františka Blochová, born Kosinerová," and one written vertically in the left margin states that "the undersigned, Josef Kosiner from Ješín, born in 1869, confirms the remembrance of his teacher." What can we make of all this? Although the papercut is apparently dated 1859, there is some similarity in the style of the large, ornate Hebrew letters with those of the same text in Fig. 5.28. And who was "teacher Popper"? Perhaps the following papercut (Fig. 5.31) can provide a clue. 23 × 19.5 cm. (9¹/₁₆" × 7¹³/₁₆"). Židovské Muzeum Praha, Prague.

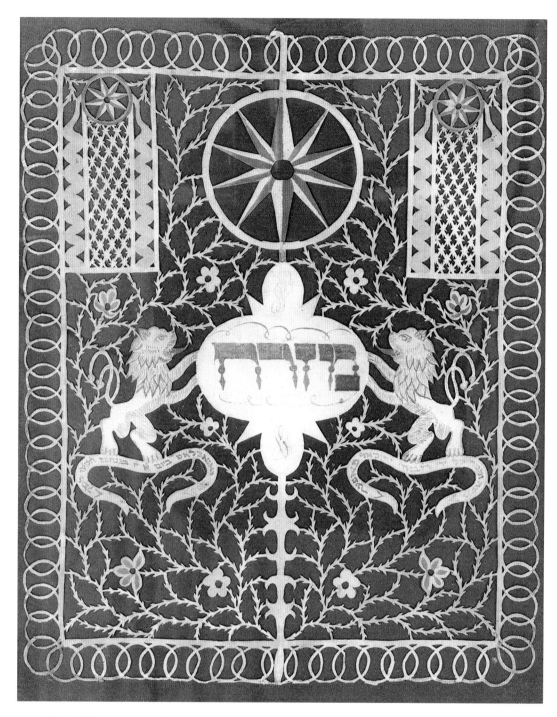

5.31. *Mizraḥ*. The "compass" design implies a geographic direction — "*mizraḥ*" — east, toward which one prays. The inscriptions in the ribbons beneath the lions holding up the central shield read: "Designed and executed by the youth, Yeḥesq'el Popper, Wonoklas [Vonoklasy, southwest of Prague], 1816." If this man was the same "teacher Popper" remembered in Fig. 5.30, could he have been the creator of Figs. 5.28 and 5.29? The date, 1816, is certainly compatible with the dates on the first two, 1814 and 1821. 32.2 × 26 cm. (12¹¹/₁₆" × 10¼"). Židovské Muzeum Praha, Prague.

6.0 Michael Levy, Monticello, Virginia, ca. 1820. Collection of the authors, Jerusalem.

JEWS IN SILHOUETTE

The art of cutting silhouettes out of black (and occasionally of white) paper reached the height of fashion in Europe and America from the mid-eighteenth century until the introduction of photography in the 1860s. Among the tens of thousands of portrait silhouettes cut by famous and lesser-known artists, it is only to be expected that Jews figured as well. Some of the silhouettists were themselves Jews: we know of one Minna Brandes who was born in 1765 in Berlin, of Beerman in Kassel, and of Ludwig Richter and Adam Rosenzweig both from the same region of Hessen, who cut and sold portrait silhouettes.[1] There must have been many more.

The Zürich philosopher and theologian, Johan Casper Lavater (1741–1801), expounded the theory that essential human character can be discerned through the systematic analysis of silhouette profiles. His voluminous, illustrated treatise, *Essays on Physiognomy; Calculated to Extend the Knowledge and Love of Mankind*, first published in 1775, gained wide popularity and appeared in many subsequent editions in all the major European languages. It did much to propagate the

Kasseler Porträtsilhouetten
von Beermann 1827.

6.1. Jews of Kassel in Hessen in the year 1827 are immortalized in these silhouette portraits cut by one of their fellow coreligionists. After R. Hallo, 1928.

183

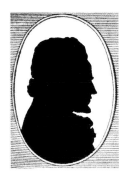

6.2. Silhouette portrait of Moses Mendelssohn. After J. C. Lavater, 1794.

fashion of cutting silhouette portraits. Here is what Lavater detected in the silhouette profile of the Jewish philosopher Moses Mendelssohn:

> I feast my eyes on these outlines. My glance rolls from this magnificent curve of the forehead to the sharp bones over the eye! The determined nose; the marvelous transition from the nose to the upper lip — the symmetry of both lips, neither protruding beyond the other. Oh, how it all fits together to reveal and make one feel the Godly truth of the physiognomy. Yes, I see him, the son of Abraham, who will yet, with Plato and Moses, recognize and worship the crucified Lord of Glory.[2]

Silhouettes of leading lights in the early American Jewish community — a Jewish aristocracy with many gentile intermarriages — were sought out and published in 1941 by Hannah London in a book entitled *Shades of My Forefathers*. She enlivened the charming silhouettes with family backgrounds and pedigrees of the subjects and relates quaint little anecdotes of their social graces.

Many of these black scissor-cut portraits were the work of the Frenchman Augustin Edouart (1789–1861), the acknowledged master of the art, who had settled in England after the Napoleonic wars and visited America in the 1840s. Among the Jewish sitters whose likenesses he cut in

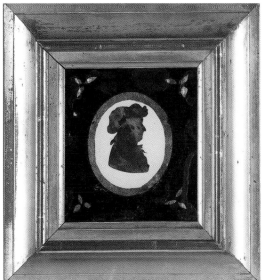
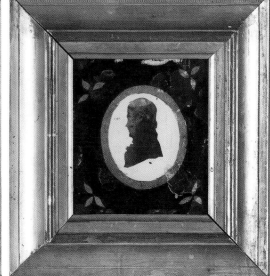

6.3. Portrait Silhouettes. These lovely portrait silhouettes of Simon Nathan (1746–1822) and his wife, Grace Mendes Seixas Nathan (1752–1831), were cut in "negative" in white paper and laid over backings of scrap engraved paper to achieve a textured, dark image. They were made by a member of the famous Peale family of artists of Philadelphia. Simon Nathan was born in England and came to the Colonies in 1773, where he became involved in the American Revolution, with close connections to Jefferson. He married Grace Mendes Seixas in 1780. Subsequently, he served for many years as President of the Shearith Yisrael congregation — the Spanish and Portuguese synagogue. Simon Nathan's great-great-grandson, Edgar Joshua Nathan III, today fills the very same position in the same historic synagogue. The silhouettes are incorporated in a handsome underglass gold-leaf composition. 6 cm. high (2⅜"). Edgar J. Nathan III and Ruth Nathan, New York.

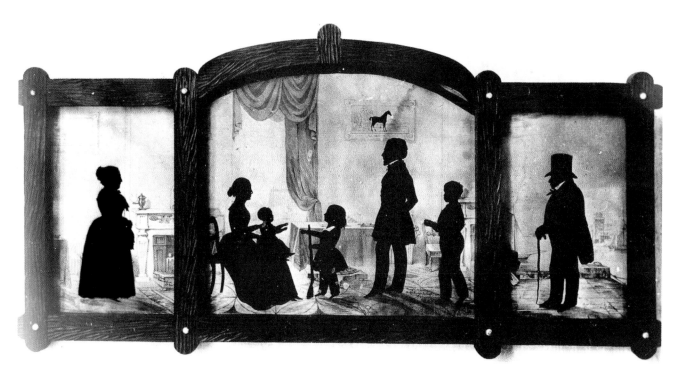

6.4. Silhouettes. Although not a part of the Jewish devotional papercutting tradition, the fashion of silhouette cutting was popular in Jewish circles in Europe and the United States. Some Jews excelled as cutters; others were portrayed by silhouettists. Such, for example, was the family of Samuel and Isabelle Lyons Moss of New Orleans, who appear together with their Black slave boy in this group portrait cut in 1844 by master silhouettist Augustin Edouart. American Jewish Historical Society, Waltham, Massachusetts and New York, New York.

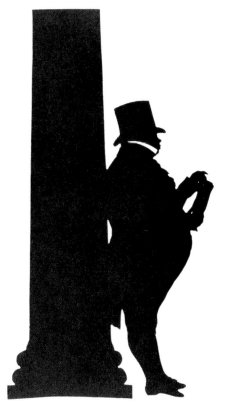

6.5. Nathan Mayer Rothschild at the London Stock Exchange. After N. E. Jackson, 1938.

England's fashionable watering places was one "J. Abraham, Optician of Bath & Cheltenham." A famous, full-length silhouette portrait (Edouart always did the complete person as most expressive of the subject's character) is that of Nathan Rothschild leaning against "his" pillar of the London Stock Exchange.

Closer to our time, Jerusalem Bezalel Academy artists Michael Filmus (1892–1965) in 1911 to 1916, and Meir Gur-Arie (1891–1951) cut silhouette scenes and different types of people — many of them of *ḥalutzim* (Zionist pioneer settlers) — in Palestine of the 1920s and 1930s.

"הוֹרָה".

(ABOVE AND RIGHT) 6.6. The life of Zionist pioneers in Palestine in the 1920s depicted in a series of silhouettes. After M. Gur-Arie, 1925.

6.7

6.7. Poster advertising an exhibit of Meir Gur-Arie's silhouettes on the theme of the book of Genesis (1930s). Central Zionist Archives, Jerusalem.

6.8. Shadow stencil portraits by Meir Gur-Arie of Herbert Samuel, high commissioner for Palestine, and of Meir Dizengoff, mayor of Tel Aviv (1920s). 15 × 10 cm. (5 ¹³⁄₁₆" × 3 ¹⁵⁄₁₆"). Yitzḥaq Einhorn Collection, Tel Aviv.

6.8a

6.8b

Meir Gur-Arie's Work / **187**

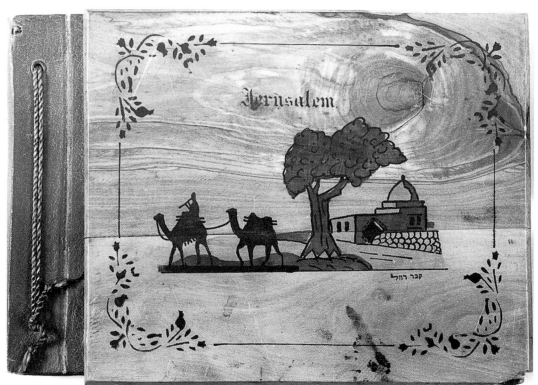

(THIS PAGE) 6.9.
Stencilled silhouette
decorations for olive-
wood covers of tourist
souvenir albums and
prayerbooks designed
by the Bezalel School
in Jerusalem, 1920s
to 1940s. Yitzḥaq
Einhorn Collection,
Tel Aviv.

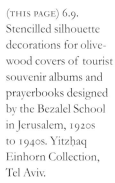

6.10a

6.10 (*a, b*) Book cover and silhouette illustration for a Purim shadow play by Alex and Lotte Baerwald on the Esther story published in 1920 in Berlin. (*c*) Silhouette by Irma Cohn from a rhymed *purimshpil* text for children, Hamburg, 1931. Gross Family Collection, Ramat Aviv.

Haman.
Dies ist der Mann, den der König ehrt!
Sereth gießt ihm's Töpfchen auf den Kopf.

6.10b

Seht hier wird Mordechai Euch vorgeführt
Mit aller Ehre, wie sie ihm gebührt."

Der Haman, geht gar traurig hinterher
Und ist wütend, denn er ärgert sich so sehr. —

6.10c

6.11. Advertisement for four sets of sixteen silhouette illustrations of stories for Jewish children for discussion in the school room: "A Story of Boots," "The Cat's House Burns Down," "The Children and the Rope," and "The War of the Roosters." Achiewer, Warsaw (1930s).

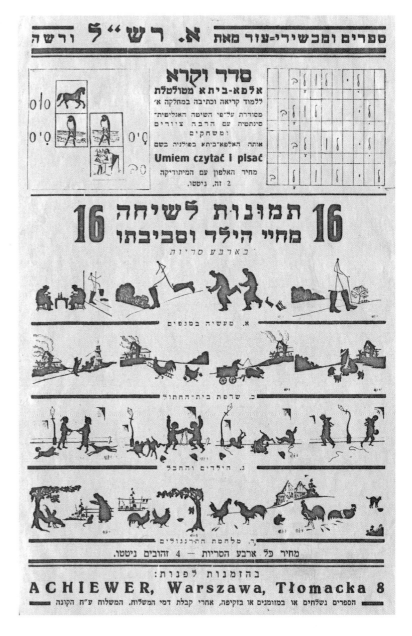

These and others of their lively, expressive silhouette cuts were used to illustrate several books of poems and children's verses, and to decorate olive-wood boxes and other crafted objects sold in tourist shops.[3] In the tradition of the "Chinese shadows" or *ombres chinoises* puppet theater, two fanciful *purimshpils* (Purim plays) for children were published in Germany in 1920 and 1931, featuring prints of humorous silhouettes illustrative of the Esther story.[4]

Occasionally, at fairs and other festive occasions, an itinerant "profilist" (yes, they still exist!) sets up shop in the form of a folding chair and displays this once-so-fashionable skill with a pair of scissors and sheets of black paper. One could do worse than to patronize him or her for a nostalgic personal memento. And if you or the artist is Jewish, you'll have an instant collector's item of Judaica!

7 | DOCUMENTING A TRADITION

The Pioneering Studies of Giza Frankel

Dr. Giza Frankel died in Haifa in the spring of 1984, aged ninety. She was the first ethnographer to make a study of Jewish papercutting traditions in her native Poland at a time when the art, although dying out, was still practiced there. Her first article on the subject was published in 1929, and she continued to gather material and source information on Jewish papercuts throughout her life (see the Selective Bibliography, below).

During the Holocaust, Giza Frankel suffered personal tragedy and escaped to Russia. Returning to Poland after the war, she was appointed director of the Warsaw Jewish Historical Institute. In 1950, she emigrated to Israel, where she joined the staff of the Haifa Museum of Ethnography and Folklore in 1956. Although she worked in other fields of Jewish ethnography, Giza Frankel always maintained her interest in papercuts. She initiated exhibitions, wrote introductions to catalogs, lectured, published articles, and encouraged artists working in this medium.

Dr. GIZA FRÄNKLOWA

WYCINANKA ŻYDOWSKA W POLSCE
(PAPIERSCHNITTE BEI DEN JUDEN IN POLEN)

Z 16 ILUSTRACJAMI.

LWÓW 1929
NAKŁADEM TOWARZYSTWA LUDOZNAWCZEGO

(FAR LEFT) 7.1. Giza Frankel (1895–1984).

(LEFT) 7.2. Autograph title page of Giza Frankel's first publication on Jewish papercuts.

It is largely the efforts of Giza Frankel that gave impetus to the current revival of Jewish papercutting. She contributed the article on the subject for the *Encyclopædia Judaica* (1971/1973), and a year before her death saw the publication of her album-book in Hebrew, *Migzarot n'yar —omanut yehudit 'ammamit* ("Paper-cuts — A Jewish Folk Art"), with reproductions of nearly 150 Jewish cut-paper items. The book was reissued posthumously in 1996 in a bilingual Hebrew-English edition, but minus some of the original illustrations. Unfortunately, more recent information and closer analyses of five or six papercuts depicted in this important work have shown these to be spurious, late copies made for the Judaica collectors' market from published pictures of old originals — something the author was not aware of at the time she included them in her book (we discuss the problem of such fraudulent practices in chapter 8, below). Similarly, some of her geographic attributions and dating require revision.

Few other scholars or collectors of Judaica paid much attention to the lowly papercut. Thus, Boris Schatz, the founder of the Bezalel Academy of Arts and Design in Jerusalem, did not see fit to include papercutting among the twenty-nine craft arts in his 1917 home-production arts program for the Academy.[1] And the authors of an anthropological study of the East-European Jewish shtetl, published in 1952, asserted unabashedly that:

> the balebosteh [housewife] . . . in decorating her home . . . will draw chiefly from peasant art. . . . Jewish folk art is chiefly verbal. There is a rich lore of stories, sayings, proverbs, but very little Jewish handicraft, aside from ritual objects. . . . there is no specifically Jewish art. There is no equivalent of the peasant embroideries, or the elaborate papercuts made by the Poles.[2]

Early Documentation and Collections: 1908 to the Holocaust, and After

The first serious mention and illustration of Jewish papercuts as a distinct folk art form appeared in a booklet on Jewish-Polish festival customs, published in 1908 in Krakow by Regina Liliental (d. 1927).[3] Four years later, an expedition of the Jewish Historical and Ethnographic Society in St. Petersburg was organized by Shlomo An-Sky (1863–1920) to tour towns and villages in the Kiev, Podolia, and Volhynia provinces of western Ukraine. The group, comprised mainly of students at the Jewish Academy of St. Petersburg University, visited about seventy shtetls and systematically collected a vast amount of Jewish folkloristic, cultural, and religious material. Among the hundreds of objects they assembled was a large number of paper cut-outs.[4] Eventually, all this material was reputedly stored at the State Ethnographic Museum of the Peoples of the U.S.S.R. in Leningrad. While attending an international ethnographic conference in the Soviet Union in 1964, Giza Frankel was able, after much difficulty, to hurriedly see some papercuts "at the top of a stack" of such works.[5] But several years later, upon being queried, the Museum authorities denied having them. An inventory of Jewish folk art in the Russian provinces, drawn up by Yehezq'el Dobrushin a few years after the Revolution for the Yiddish *kultur-lige* (Cultural League) in Kiev, also included papercuts.[6]

After the demise of the Soviet Union, renewed efforts were made to locate and study the Jewish items in the St. Petersburg Russian Ethnographic Museum. At the initiative of the Amsterdam Jewish Historic Museum and with its active cooperation, select items from St. Petersburg were exhibited in Amsterdam, Frankfurt, New York, and at the Israel Museum in Jerusalem. Among the exhibits were a few papercuts that had already been published in the 1920s, but no such other "new" old material.[7] The whereabouts of the "stack" of old papercuts reportedly seen by Giza Frankel in 1964 remain an unresolved mystery; our repeated attempts — direct and through intermediaries — to trace these works have so far come up against unanswered letters and evasive reactions.

At the beginning of the twentieth century, a local architect, Prof. Julian Zacharjewicz, donated his private collection of over two hundred, mostly small Jewish folk papercuts of the late nineteenth century to the Lvov Municipal Museum.[8] In the period between the two World Wars, an important collector of Judaica was Maksymiljan Goldstein (1880–1942) of Lvov (Lemberg) in Polish Galicia, now Lviv, in the Ukraine. He was particularly interested in ethnographic material and owned a number of papercuts. Goldstein saw it as his mission to encourage the perpetuation

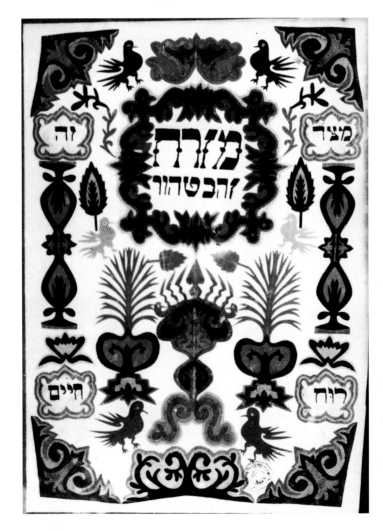

7.3. *Mizrah*. Apparently commissioned by Maksymiljan Goldstein of Lvov for his collection in the 1920s or 1930s, this cut-out and collage composition by "Kiwe" Hass is in the local peasant style, very different from the traditional Jewish work — notwithstanding the Hebrew inscriptions. Photo: courtesy Giza Frankel Archival Collection, Jewish and Comparative Folklore Department, The Hebrew University of Jerusalem.

of Jewish folk art and commissioned some papercuts specially, as he did other items in his collection. Among the folk artists, most of them poor, "simple workmen with skilled hands," who also made such papercuts in more-or-less traditional style for Goldstein were Dawid Rosengarten, Jakob Dreisin, W. Taubert, Mordche Laszower, and Akiva "Kiwe" (Karl) Hass, whose work, however, shows decided stylistic affinities with Ukrainian folk art rather than traditional Jewish forms.[9] Although some of their works generally conformed to the traditional genres, these papercuts (except perhaps Rosengarten's) did not really serve actual, devotional functions, and may thus be considered the forerunners of the conscious, contemporary, modern revival of this folk art.

Goldstein, who at first worked under the Soviet and later German occupation as the curator of his own "nationalized" collection, reportedly died in December 1942 in a German forced-labor camp in Lvov. Much of his collection was saved by being stored in the local Municipal Artistic Crafts Museum throughout the war years, and remained there later during the Soviet period, when official policy negated the existence of a distinct Jewish culture. A number of papercuts, mainly from Zacharjewicz's and Goldstein's collections, were included in exhibits of Jewish art mounted in Lvov (Lviv, in Ukrainian) and Krakow in 1990 and 1993, and in 1994, in an important exhibit, "From the Treasures of the Heritage of Galician Jewry," at the Diaspora Museum on the Tel Aviv University campus.[10]

One early collector of Jewish papercuts was a Viennese doctor named Josef Reizes, who later settled in Tel Aviv. In a brief article published in 1924, he deplored the passing of the endearing practice of pasting scissor-cut paper rosettes (*roizalakh*) made by *ḥeder* boys on house windows for the Shavuoth festival.[11] His large, important collection of these small papercuts, most of them without inscriptions, was presented by his heirs to the Ha-Aretz Museum in Tel Aviv, and is now kept in the Eretz Israel Museum (Jewish) Folklore Pavilion, together with some other fine papercuts.[12] Dr. Heinrich Feuchtwanger (1898–1963) of Munich, and later Jerusalem, acquired a number of important old papercuts among his extensive collection of Judaica, which is now part of the Israel Museum holdings.[13]

In Central Europe, an important collection of Jewish papercuts is kept at the Prague Jewish Museum. Most of these items and other synagogue and religious objects were assembled under Nazi orders in 1942 for a projected museum of the "extinct" Jewish people of Bohemia and Moravia. Twelve papercuts which survived the war in Prešov, in northeastern Slovakia, are today stored in the local synagogue museum that was founded in 1928; two items are in the Museum of Jewish Culture in Bratislava. The Vienna Jewish Museum collection boasts a number of unusual, important old papercuts, and two or three are in the Budapest Jewish Museum.[14] We do not know what happened to the papercuts that were still in the Berlin Jewish Museum in 1938.

Both before and after World War II, Jewish papercuts were acquired by most Jewish museums in Western Europe and North America, and by several private collectors. Odd pieces have been preserved here and there. One lovely papercut, made in the late nineteenth century, hung for years together with some unremarkable pictures in the vestibule of the old synagogue in Erie, Pennsylvania. Others, kept by families over the years, still turn up once in a while, and are sometimes given over to museums by public-spirited owners. There must be still others, in both likely and unlikely places.

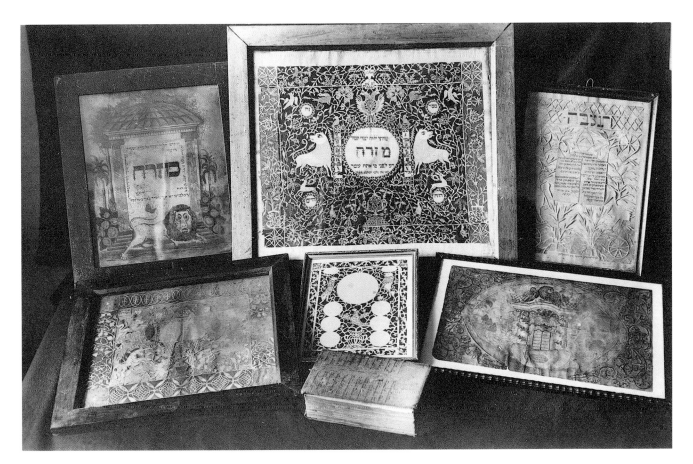

7.4. Souvenir postcard of papercuts and other Jewish wall-plaques from an exhibition at the Jewish Museum of Prešov in Slovakia held shortly after World War II (1946–1947). Archival collection of the authors, Jerusalem.

Perpetuating a Waning Tradition

During the first decades of the twentieth century, individual Jews in Diaspora communities and in Palestine were still making papercuts for traditional purposes. Some of their work is depicted elsewhere in these pages with appropriate captions (e.g., Figs. 3.29c, 4.18, 4.28, 7.17). In the United States, two immigrants from the "old country," whose work is now well known and treasured, created highly sophisticated, technically masterful papercut compositions incorporating the vast gamut of traditional symbols and inscriptions. They were Mordechai Reicher (1865–1927) of Brooklyn (Fig. 4.29), and Baruch Zvi Ring (1870–1927) of Rochester, New York (Figs. 2.46, 3.16, 4.29). Both produced different works for a variety of personal and community purposes. One rather simple papercut was made in Boston around 1950 by Kate Ring Rosenthal — apparently Baruch Ring's daughter.[15] Probably the last person to practice the old Jewish papercutting tradition was David Koretsky (1886–1960) of Pittsburgh and later of Los Angeles, whose sole surviving papercut was left unfinished in 1958, and to whom we devote a special section, below.

As those who kept up the venerable, old tradition died out, the essence of this Jewish art form

was carried on only through its technique. One representative of this development was Arieh Skolnick (1880–1964) of the Bronx, who came to America as a young man from Antopol in western Lithuania and worked as a cutter in the millinery trade. He made unsophisticated, small papercuts of the *shavuosl* type, usually without inscriptions, for his family's anniversaries and some of the holidays, including Israel's Independence Day. Many of his charming, simple compositions were cut out of smoothed tin or aluminum foils and pasted on blue, red, or green cardboard. When asked by his grandchildren how he could make such intricate cutouts, he would reply, "I have a factory with ten workers" (his fingers). After his death in 1964, the papercuts remaining in his possession were sent to his daughter in Israel, where they are now kept in the Shephela Educational Museum at Kibbutz Kfar Menaḥem.[16]

Another papercut artist was Yosef Wisnitzer (1889–1942) of Tel Aviv. Born in Woshkowitz in the Bukovina, he emigrated in 1930 to Palestine where he worked as a bookkeeper. Wisnitzer made papercuts from early youth and continued until his death at the age of 53. His work was shown in Tel Aviv in 1936, and posthumously in 1943 at the Mishkan le-Omanut at Ein Ḥarod. A collection of his papercuts was presented to the Ginza Circle for Jewish Art in Tel Aviv and exhibited at the old Tel Aviv Museum in 1960.[17]

These men represent a carry-over from the papercutters of the shtetl milieu of their childhood to the new Diaspora and Israel. They drew upon their personal memories, and perhaps family traditions, but their creations no longer conformed to the "classic" compositions. Much of Wisnitzer's work depicts secular subjects, and both he and Skolnick cut out purely decorative designs, departing from the traditional forms and purposes of the traditional Jewish papercut.

7.5

7.6a

7.6b

(ABOVE LEFT) 7.5. Ḥanukkah. With the increasing secularization of Jewish life and the gradual decline of religious folk art, traditional Jewish arts and crafts were adapted to modern educational programs in Jewish schools and clubs. In 1922, a series of teachers' manuals in Hebrew were published in Frankfurt, Moscow, and Odessa. Among them was also a volume on papercutting techniques. The Ḥanukkah decoration depicted here is one of the suggested designs. After M. A. Beigel, 1922.

(ABOVE CENTER AND RIGHT) 7.6. Small papercut and appliqué compositions made by Arieh Skolnick (1880–1964) of the Bronx in 1951 and 1958, for the birthdays of his grandchildren in Israel. Hashefelah Museum, Kibbutz Kfar Menaḥem.

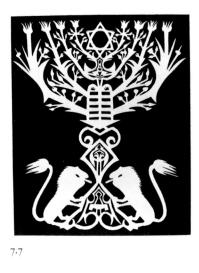

7.7

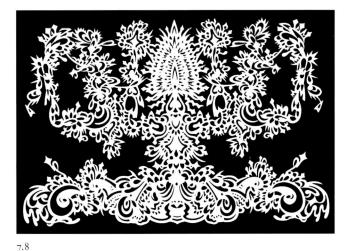

7.8

7.9b

7.7. Papercut by Yosef Wisnitzer (1889–1942), Tel Aviv.

7.8. Menorah papercut by Moshe Reifer (1907–1984), Kibbutz Yagur.

7.9. The artist Yehoshua Grossbard (1902–1992) of Haifa used scissors to cut his charming compositions. Note the children in procession carrying Simḥat Torah flags.

7.9a

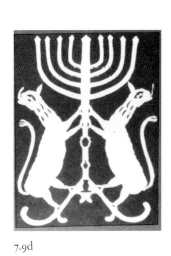

7.9d

7.9c

Exhibitions: Papercuts as a Distinct Jewish Art Form

The first showing of traditional old Jewish papercuts was mounted in the Tel Aviv Museum in 1955 by the Ginza Circle and arranged by Giza Frankel.[18] The organizers were amazed by the rich and varied amount of material they were able to gather from private homes and collections in Israel, and were stimulated by this to devote further attention to the art. The collecting, research, and exhibition of Jewish papercuts subsequently centered in the Haifa Ethnological Museum and Folklore Archives, which opened in 1956 under the directorship of Prof. Dov Noy,

with Dr. Giza Frankel as staff ethnologist and librarian. At her initiative, two Israeli artists working in this medium — Yehoshua Grossbard (1902–1992) of Haifa and Moshe Reifer (1907–1984) of Kibbutz Yagur — exhibited their work there in 1959 and 1969, respectively.[19]

An important comprehensive exhibit of Jewish papercuts, organized in the fall of 1976 at the Haifa Ethnological Museum, assembled for the first time representative types of old Jewish papercuts from various collections in Israel together with the work of three contemporary artists — Yehoshua Grossbard, Moshe Reifer, and Yehudit Shadur. The detailed catalog of this show was prepared by Liora Bronstein, the Museum's acting curator.[20] Together with articles in the American Jewish press describing the work of Yehudit Shadur, it marked a starting point in the conscious revival of the Jewish papercut, and the recognition of this all but forgotten branch of Jewish folklore as a respectable and important branch of Jewish art.[21]

Following the Haifa show, interest spread rapidly to Jewish communities all over the world. Other Jewish artists began to try their hand at papercutting, each developing his or her individual style: Tsirl Waletzky in New York, whose work was shown at the Yeshiva University Museum in 1977;[22] Joann Benjamin-Farran and Martin Farran in Boston; and Jacob Neeman (1908–1994) in Haifa. A one-person show of Yehudit Shadur's papercuts was mounted at the Judah L. Magnes Museum in Berkeley in 1978. Two major, comprehensive exhibits of both old and contemporary Jewish papercuts were held in 1980: in the summer, a large, beautifully arranged exhibit curated by Sarah Harel at the Jerusalem City Museum in the historic "Tower of David" (Citadel);[23] and that winter, at the Goldman Fine Arts Gallery in Greater Washington, D.C., organized and arranged by Susan Morgenstern. Since then, the number of Jewish papercutters — of uneven talent and taste — has proliferated to the point where it is no longer practicable to keep track of them.

7.10. Dr. Giza Frankel (1895–1984), who pioneered the study of Jewish papercuts, at the opening exhibition of old and modern Jewish papercuts at the Haifa Museum of Ethnology and Folklore, 1976.

7.11. Old and new Jewish papercuts at the
Jerusalem City Museum — The Citadel
(David's Tower) — in 1980, and the poster
of the exhibition by Yehudit Shadur.
Note also her large papercut in the
medieval window, Fig. 7.11a.

jewish
papercuts
old and new

jerusalem
city museum
the citadel
(david's tower)

ה' בתמוז תש״מ 19.6.80 · ז' באלול תש״מ 19.8.80

7.12. Poster of the exhibition "World Papercuts," at the Haifa Museum of Music and Ethnology, 1986/1987. The large papercut (159.8 × 106 cm.; 63" × 41¾") reproduced on the poster is a *shiviti* of unknown provenance, dated 1930, which was donated to the Museum in memory of Giza Frankel by the Jewish community of Messina, New York.

7.13. Children making papercuts at the Israel Museum Youth Wing, Jerusalem.

In the winter of 1986/1987, the new Haifa Museum of Music and Ethnology opened an exhibit entitled "World Papercuts." The fine, didactic presentation, curated by Yael Hoz, included a representative selection of old and contemporary Jewish work.[24] Today, the study and documentation of Jewish papercuts, including current manifestations of the art, are centered at the Jewish and Comparative Folklore Department of the Hebrew University of Jerusalem on Mount Scopus, where Giza Frankel's archival materials are kept. The moving spirit behind the establishment and development of the center and its current director is Prof. Olga Goldberg-Mulkiewicz. Important groups of old papercuts are part of private Judaica collections—notably, of the Gross family in Ramat Aviv, and of Abraham Halpern in New York.

A most regrettable, if perhaps unavoidable, development of recent years has been the proliferation of "antiqued" modern papercuts offered as genuine, old pieces in order to profit from the growing demand by (inexpert) collectors. Some such spurious items have found their way into serious museum collections through gifts, and even by outright purchase. We discuss this phenomenon at some length in chapter 8, below.

The contemporary, self-conscious revival of this art form after the mid-1970s sparked growing interest in papercutting throughout the contemporary Jewish world. However the entire character and approach is today generally far removed from the deep, almost intuitive, understanding of the traditional symbolism with which this intensely religious folk-art was always endued. Much of the new Jewish papercutting work is essentially decorative. It lacks the warmth and unaffected vibrancy of the traditional works, and is often contrived. But even if it has lost many of its inner meanings, exhibitions, demonstrations, seminars, teacher-training programs, and practical classwork in schools and community centers throughout the Jewish world have to some extent reinstated the Jewish papercut as a popular art form. This lovely old folk tradition thus lives on outside the ghetto or the *mellāḥ* as a distinctive branch of the flourishing Jewish creative (and commercial) art scene.

The Missing Link: The Papercut Work of David Koretsky

A chance meeting with Molly and Manuel Steinberg of Los Angeles acquainted us with a *mizraḥ* papercut made in the 1950s by Molly's father, David Koretsky (1886–1960). Together with his nearly completed but still unfinished *mizraḥ*, Koretsky left preliminary sketches, Hebrew inscriptions on printers' blocks, tentative layouts, and a hand-written statement and explanation of his ideas. This material is of incalculable importance for filling a significant gap in tracing the perpetuation of this traditional Jewish folk craft, and in understanding the thinking and meticulous planning behind such works.

David Koretsky was born in 1886 in the small Ukrainian shtetl of Sudlikov, west of Kiev. He lived there until the age of nineteen, when he emigrated to the United States early in 1905 and settled in Pittsburgh, Pennsylvania. He worked for several years to help bring over the rest of his family — father, mother, sister, and two brothers. In 1914, he married Esther Greenberg, from Russia, and they had four children, of which Molly is the youngest.

In the Ukraine, Koretsky learned the bookbinder's trade, but in America worked as a wallpaper hanger until his retirement in 1950 due to heart trouble. He never had time or money for any formal art training.

David Koretsky, who was well-versed in Hebrew and Yiddish, and in Talmudic studies, had throughout his childhood and youth seen papercuttings in yeshivas and synagogues, and probably

7.14. David Koretsky (1886–1960).

7.15. *Mizraḥ/Shiviti.* Unfinished papercut by David Koretsky, 1959, Los Angeles. Note the Four Animals — leopard, eagle (attacking a fox), deer (gazelle), and lion (flanking a Torah scroll). The usual *shiviti* and *mizraḥ* inscriptions are at the top center, with the rays of the rising sun between the *mizraḥ* panel and the menorah. Koretsky made it a point to indicate the biblical sources in English. But what do the houses with the paths(?) leading up to them mean? And what about the hatted men at the foot of the large trees? 48.2 × 61 cm. (19" × 24"). Molly Koretsky Steinberg, Los Angeles.

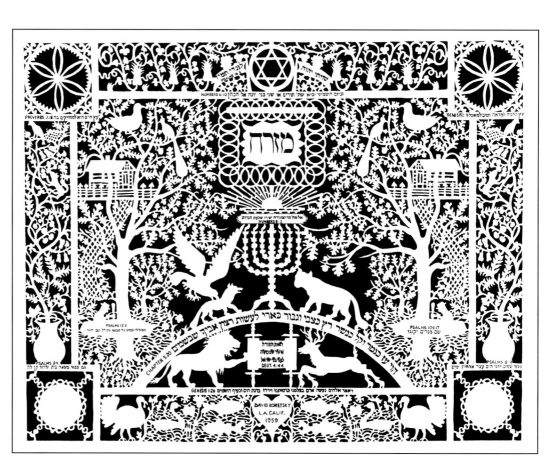

in private homes. His first papercut, begun sometime in the late 1930s, was lost during a move. The burden of supporting a growing family through the depression and the war economy left little time for his craft, and it wasn't until the late 1940s that he could begin to recreate his lost papercut.

Using a little pen-knife he kept sharpening on a small whetstone, and a vertically folded sheet of paper placed on a wooden board, Koretsky started work on the first of six identical papercuts for his immediate family members. He called it "The Creation of the Universe," and planned two additional designs: "Adam and Eve in the Garden of Eden" and "Jacob's Dream." After painstakingly laying out and lettering the Hebrew texts, he had these set in type and printed, so that they could be cut out and pasted in place on each of the cut-out designs.

Here is what David Koretsky wrote in December 1958 about his papercut and ideas (rendered here verbatim):

An Introduction to the Picture

This religious Eastern-Wall 17x22 picture represents "The Creation of the Universe." It has no comparison to it and it is priceless. It has biblical history and its used highly in European countries in hebrew orthodox synagogues & in private houses. Its hung up on the Eastern wall of the room, to let strange people know which the Eastern of the room is so they can face to the East while worshiping to God. but they use a small printed picture & not a cut out design like this one.

 It is designed, cut & painted by
 David Koretsky L.A. 46 Calif.

Dec. 1958
The next pictures
will be
Adam & Eve in the
garden of Eden.

———

Our ancestor Jacob's
dream & wrestle with
an angel the whole night.

———

But he did not manage to finish even "The Creation of the Universe" before his death in 1960. Some of the inscriptions remained incomplete, and he had intended to put contrasting colored paper behind the cutting.

What is so remarkable about Koretsky's unfinished papercuts? As we have stated in the introductory chapters, and Koretsky confirms as a matter of fact, papercutting had already begun to die out as a traditional Jewish folk craft before the Holocaust, with the spread of cheap printed colored wall plaques serving the same religious functions. The latest entirely "traditional" Jewish papercuts that we knew of was the very large one dated 1930 (Fig. 7.12), as it was reproduced on

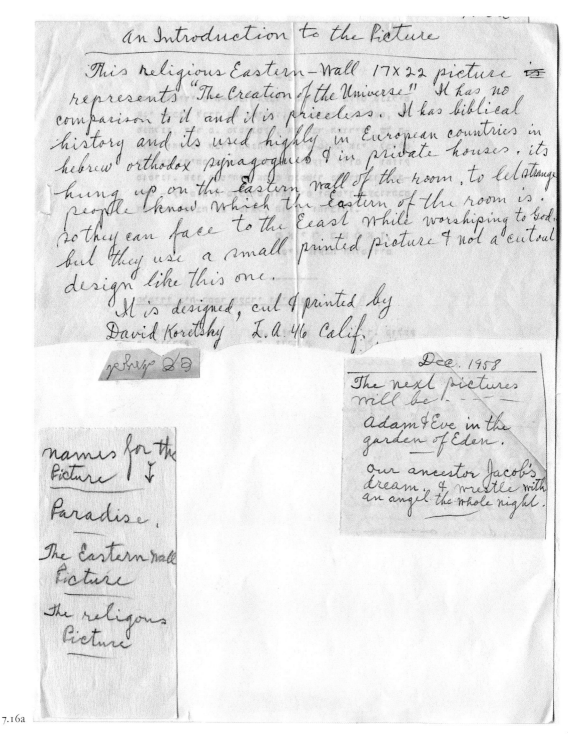

An Introduction to the Picture

This religious Eastern-Wall 17x22 picture is represents "The Creation of the Universe". It has no comparison to it and it is priceless. It has biblical history and its used highly in European countries in hebrew orthodox synagogues & in private houses. its hung up on the Eastern wall of the room, to let strange people know which the Eastern of the room is, so they can face to the Eeast while worshiping to God. but they use a small printed picture & not a cutout design like this one.

It is designed, cut & printed by
David Koretsky L.A. 46 Calif.

Dec. 1958
The next pictures will be:---
Adam & Eve in the garden of Eden.
Our ancestor Jacob's dream. & wrestle with an angel the whole night.

names for the Picture ↓
Paradise.
The Eastern wall Picture
The religous Picture

7.16a

(PAGES 204–207) 7.16. Written statement, preliminary sketches, inscriptions, and layout plans for a *mizrah* papercut by David Koretsky, 1950s, Los Angeles. Molly Koretsky Steinberg, Los Angeles.

7.16b

Genesis ———
Exodus ———
Leviticus ———
Numbers ———
Deuteronomy ———

Psalms 16.8
numbers 8.2
Psalms 13.3
Proverbs 3.18
numbers 6.10
Gen. 1.26
Gen. 2.9
Deut. 4.44
Psalms 8.9
Psalms 84.4
Psalms 1.3
Psalms 104.17

DAVID KORETSKY L.A.CALIF.

DAVID KORETSKY L.A.CALIF. 1/8 of an inch

THIS FINE ART completed

the "World Papercuts" poster of the Haifa Museum of Music and Ethnology exhibit in 1986/1987; and two of the works from Prešov in Slovakia dated 1930/1931 (Figs. 3.29c and 7.17).

Jews who still made papercuts after that, such as Yosef Wisnitzer, Moshe Reifer, and Yehoshua Grossbard in Israel, and Arieh Skolnick in the Bronx, preserved memories of the shtetl where traditional religious papercuts were to be found in many a home. But, as we have indicated, their creations in this medium diverged from the traditional forms and content to become personal artistic expressions, sometimes with only the most tenuous Jewish subject-matter. These works therefore do not really represent a continuity of the traditional Ashkenazi and Sephardi papercuts.

To our knowledge, Koretsky's *mizrah*, as it remained at his death in 1960, is at present the latest authentic, recorded example of this centuries-old Jewish ritual folk art, made by a man who personally absorbed it in the shtetl milieu of his childhood and youth and never forgot it. He was intimately familiar with the appropriate Hebrew texts and understood as a self-evident matter of

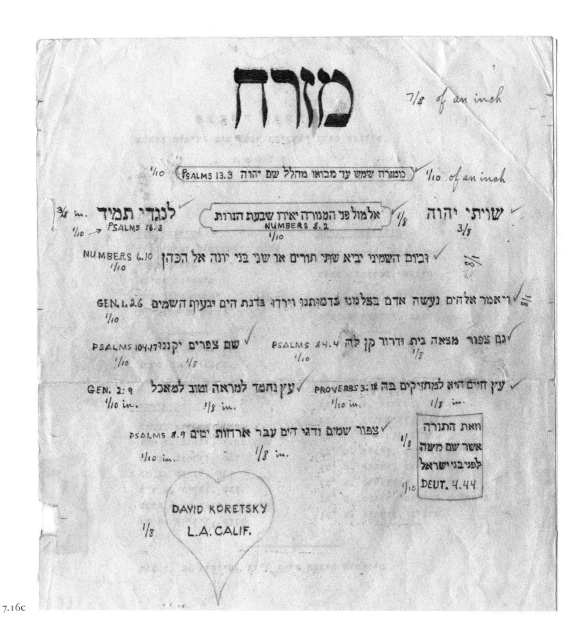

מזרח

7/8 of an inch

1/10 (PSALMS 13.3) מזרח שמש עד מבואו מהלל שם יהוה 1/10 of an inch

3/8 in. לנגדי תמיד 1/8 אלמול פני המנורה יאירו שבעת הנרות שויתי יהוה 3/8
1/10→ PSALMS 16.8 NUMBERS 8.2
1/10

NUMBERS 6.10 ובים השמיני יביא שתי תרים או שני בני יונה אל הכהן
1/10

GEN. 1.26 ויאמר אלהים נעשה אדם בצלמנו כדמותנו וירדו בדגת הים ובעוף השמים
1/10

PSALMS 104.17 שם צפרים יקננו PSALMS 84.4 גם צפור מצאה בית ודרור קן לה
1/10 1/8 1/10 1/8

GEN. 2:9 עץ נחמד למראה וטוב למאכל PROVERBS 3: 18 עץ חיים היא למחזיקים בה
1/10 in. 1/8 in. 1/10 in. 1/8 in.

PSALMS 8.9 צפור שמים ודגי הים עבר ארחות ימים
1/10 in. 1/8 in.

וזאת התורה 1/8
אשר שם מעשה
לפני בני ישראל
1/10 DEUT. 4.44

DAVID KORETSKY
1/8 L.A. CALIF.

7.16c

course the use of the ancient symbols. His preliminary sketches and layout plans, as well as his short note and mention of his projected works, which he did not live to create, are therefore of unusual, touching interest. We have never come across any other direct evidence for the meticulous preparation in the creation of these complex compositions.

Koretsky's work clearly shows the forethought and planning that preceded the actual layout and cutting work, as well as his full awareness of — as he put it — the "priceless" nature of his creation, and his deep identification with this sacred work. "Classic" Jewish papercuts were never spontaneous creations; they were taken very seriously, every detail and inscription were carefully worked out, and their makers showed great pride in their achievement. But as in many of the signatures on traditional papercuts — in Europe as in western North Africa and in Ottoman Turkey — the folk artist was careful not to boast of his achievement, for it was holy

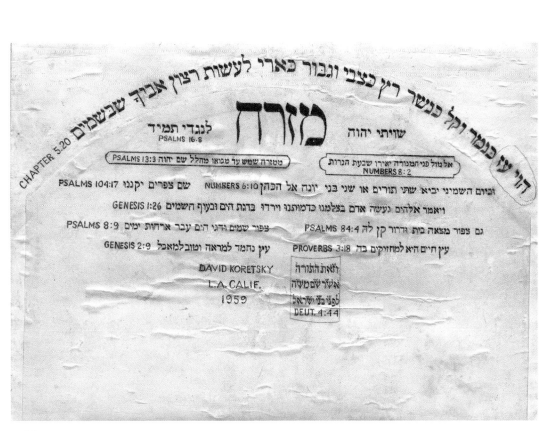

שויתי יהוה

מזרח

לנגדי תמיד
PSALMS 16·8

CHAPTER 5·20

ממזרח שמש עד מבואו מהלל שם יהוה PSALMS 13:3

אל מול פני המנורה יאירו שבעת הנרות
NUMBERS 8:2

PSALMS 104:17 שם צפרים יקננו ובים השמיני יביא שתי תורים או שני בני יונה אל הכהן NUMBERS 6:10

GENESIS 1:26 ויאמר אלהים נעשה אדם בצלמנו וירדו בדגת הים ובעוף השמים

PSALMS 8:9 צפור שמים ודגי הים עבר ארחות ימים גם צפור מצאה בית ודרור קן לה PSALMS 84:4

GENESIS 2:9 עץ נחמד למראה וטוב למאכל עץ חיים היא למחזיקים בה PROVERBS 3:18

DAVID KORETSKY

L.A. CALIF.

1959

וזאת התורה
אשר שם משה
לפני בני ישראל
DEUT. 4:44

7.16d

7.16e-1

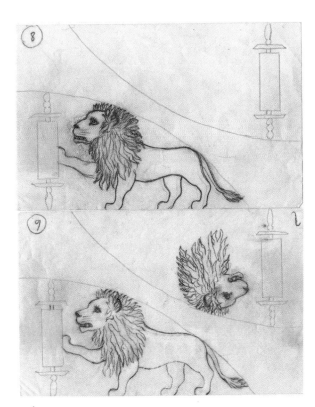

7.16e-2

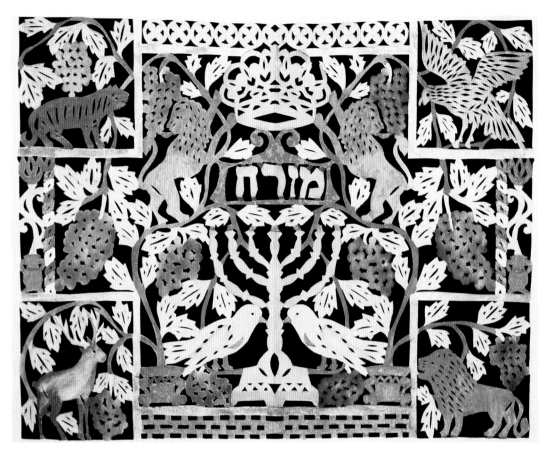

7.17. *Mizraḥ*. The last fully traditional Jewish papercut we know of, preceding Koretsky's masterpiece, is this *mizraḥ* from Slovakia. Although rather more chunky and sturdier than the delicate papercuts of earlier years, a hand-written inscription on the back, in Hungarian, tells us that it was either made by or given to someone by "Erna Schwartz in 1931 in memory of Gezaiknak(?)." The design and composition are beautiful and forceful. Note the Four Animals — tiger (leopard), eagle, antlered deer (gazelle), and lion in the corners. No written text was necessary to explain and identify these ubiquitous symbols. The material is a heavy construction-type paper, and the work looks decidedly modern, even though it is well within the established tradition. Note particularly, that unlike in most of the older papercuts where texture (manes of lions, feathers of birds, fruit, vegetal detailing, clothing, etc.) is drawn in by shading or in other ways, here it is indicated by the cutting technique itself. 44.2 × 53 cm. (17⁷/₁₆" × 20⁷/₈"). Jewish Museum, Prešov, Slovakia.

work: "the work of my hands and not for my glorification," as some of them made it a point to inscribe at the bottom of their marvelously intricate compositions.

The documented record of Koretsky's approach and planning provides a rare insight into the actual process of creating this inadvertently sophisticated, religious folk art. We may reasonably extrapolate from it to gain a glimpse into the way that all the many Jews who made devotional and apotropaic papercuts through the ages, in hundreds of communities, conceived and created their masterpieces.

Molly Steinberg wrote to us that "This papercut Mizrach is my father's legacy to our family. We feel extremely proud to have been present when he created his dream." Others like her must still treasure such family heirlooms, and can provide invaluable information about the nearly forgotten Jewish papercutting tradition.

MULTIPLES, IMITATIONS, AND FRAUDS
FOLK ART AND THE COLLECTORS' MARKET

In our times, when collectors of Judaica are prepared to pay far more for possessing an object than its intrinsic value, there is a decided incentive to make and pass off imitations of old items as the genuine article.[1] This, of course, has been true for a long time regarding all antiques, everywhere, and the detection of frauds of this type is a distinct field of expertise among art historians and museologists. Unfortunately, Jewish papercuts are no exception, and many an innocent or wishful collector — experienced as well as amateur, and occasionally even a museum curator — has fallen prey to expensive deceptions, some even depicted and "described" in reputable auction catalogs. Since they are made by hand from the cheapest of materials, papercuts present strong temptation to unscrupulous counterfeiters. So, if you are offered an "old" Jewish papercut at a hefty price, beware!

In the course of our searches and studies of traditional Jewish papercuts, we have increasingly come across items that were obviously copies or "reinterpretations" of original, old works. Some of these even date back to the early decades of the twentieth century, when a demand for "Judaica" was already growing. In the hope that we ourselves have not been taken in by such early deceptions, we will try here to suggest some guidelines regarding "finds" of this kind.

In this connection, as we mentioned in our introductory remarks to chapters 2 and 5, we must sound a note of caution to others intrigued by Jewish papercuts: A critical approach is essential. We have seen a number of serious papers written by students of Jewish folklore that purport to analyze and offer generalizations regarding old, traditional Jewish papercuts. Almost always, such studies are based on published reproductions and a few museum exhibits. In the course of our researches, we have found such material to be not always authentic or correctly identified and labeled (including in some auction catalogs). Obviously, when fraudulent items made for the Judaica collectors' market are treated unknowingly as representative examples of old Jewish papercut work, such studies are questionable and the conclusions unwarranted, if not misleading.

Inspired Copies

As we have seen in the discussion of the three papercuts from Jerusalem and the four from Prague in chapter 5, in the work of Shmuel Eliezer Singer from Slovakia (Figs, 2.22a–b), Aaron Katlinsky in America (Figs. 4.30a–b), the Algranatis in Turkey (Figs. 4.23a–c), and others, some of the old papercuts can be shown with certainty to have been made by the same person. This is

not at all unexpected: It is only natural for an imaginative individual to develop an idea and continue to apply successful techniques and design forms in creating new compositions. Although, as we have shown, the particular works by the same man inevitably differ from one another, many of the motifs and decorative elements reappear in each one, constituting, so to speak, the folk artist's personal, identifiable, stylistic hallmark. We do know from the inscriptions on a few of such works, and from written references, that devotional and amulet papercuts that met a common demand for such ritual objects were also made for sale, and so an economic incentive would have existed for the same person to make additional papercuts — multiples.[2]

We have also come across multiples of a given work — that is, more than one papercut of exactly the same design, with perhaps only some changes in the hand-lettered texts, detailing, and the coloration applied later (Figs. 3.11a–b). Almost all the examples we have seen of such multiples are of *kimpetbrivlakh* — amulets made to safeguard the nursing mother and her baby from the witch Lilith. This fits what we know about the custom of hanging such amulets on the four walls of the room to secure mother and child from evil influences coming from any direction (Fig. 3.8). It corroborates the oral evidence provided by the late Israeli sculptor Tzvi Aldouby (1904–1996) in describing the amulet papercut in Fig. 3.7, which he stated to be the only surviving one of four identical ones, albeit in different coloration, that were hung in his family home next to each of the windows and door of the nursery room after the birth of his baby brother.

Technically, such multiples were more often not cut from a folded sheet of paper but were traced from an original design onto a sheet placed on top of a number of other sheets and cut out together. The thickness of the stack depended on the ability of the papercutter to cut through all the sheets with his knife — probably no more than four or five at a time. One of them was then kept for tracing the design and cutting an additional batch. All such multiples of old papercuts reflect the same motivation for creating religious and devotional items for the home, and therefore are as authentic as the general run of other functional Jewish ritual objects.

But a popular folk art form is inevitably affected by its environment and by earlier creations,

(OPPOSITE PAGE, TOP) 8.1. (a) *Mizraḥ/Shiviti*. The drawing of this papercut, made in 1876 by Jacob Feiveshson (in Galicia?), is charmingly naive. Yet its thoroughly thought-out composition reveals a sophistication entirely within the "classic" tradition of Eastern European symmetrical Jewish papercuts. As usual, there is a strong hierarchical structure, in this case reminiscent of the Holy Ark in the synagogue. At the bottom, the menorah, in the form of a convoluted endless knot, is flanked by "Jewish" lions. Peculiar long-tailed beasts (griffins?) rise up against sturdy, vine-covered columns. These in turn support the upper register, with tablets of the Law inscribed with the word *mizraḥ* and the *shiviti* formula, and surmounted with a double-headed eagle. Each column is topped with a disc on which are lettered the acronyms *SAMUT* and *ATLAS* (p. 107) and the artist's name, and on these are perched delightful, parrot-like birds. The papercut was pasted on heavy cardboard and fitted with two metal eyelets at the upper edge for hanging. 33.5 × 42 cm. (13¼" × 16½"). Abraham Halpern, New York.

(OPPOSITE PAGE, BOTTOM) (b) *Mizraḥ/Shiviti*. Compare this work, dated 1882, with Feiveshson's work (a) of 1876. Here, the two columns and their bases are inscribed in competent lettering: "By the worker engaging in his craft/Yisrael Mordekhai Milman year 5642." Milman must have seen the earlier papercut and copied it, albeit in somewhat cruder form, but with changes and additions and more vivid coloration. Or, at least, he was inspired by it and sought to emulate it. Thus, folk art genres are perpetuated by copying and developing styles and ideas, while manifestly reflecting sincere individual emotions and feelings. 34 × 41 cm. (12³⁄₁₆" × 16⅛"). Israel Museum, Jerusalem.

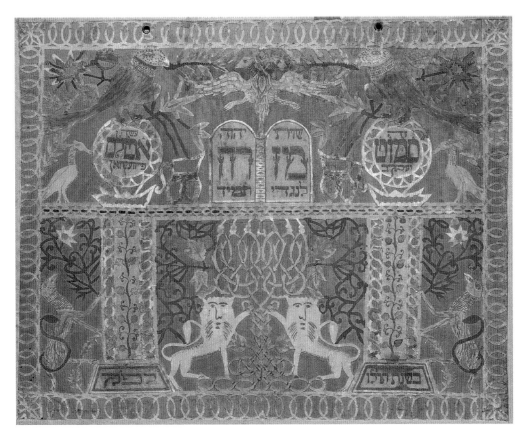

8.1a

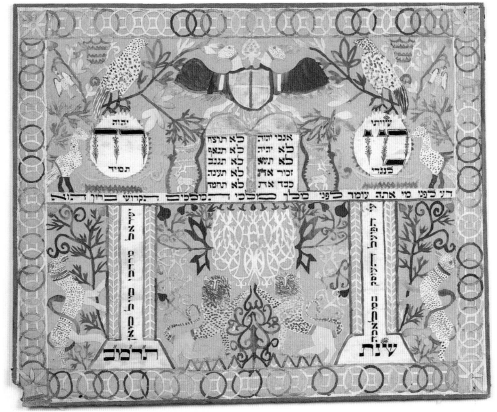

8.1b

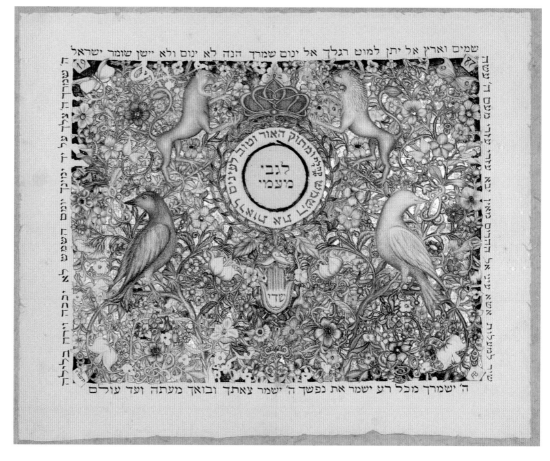

8.2. Personal
Memento. This small,
wonderfully fine work
was frankly inspired
by and reinterpreted
from the papercut
with machine-cut
borders in the ʿEin
Ḥarod Museum
shown in Fig. 4.1.
It was made by the
artist, Batya Apollo,
of Kibbutz Gonen
in 1987 as a personal
token for close friends.
15 × 18.8 cm. (5⅞″ ×
7⁷⁄₁₆″). Collection
Gabriela Brown,
Tel Aviv.

and traditions are also passed on by copying, modifying, and adding. Here too, we have a few Jewish papercuts that were more or less directly influenced by previously existing ones. A good example are the two papercuts in Figs. 8.1a–b. The later one, by Mordechai Milman, dated 1882, was fairly obviously inspired by the one made by Jacob Feiveshson in 1876. There is no apparent reason to doubt the genuineness of either. The later work, probably by a man in the same community who saw and admired the work of Feiveshson (who, for all we know, may also have seen and copied a similar, earlier papercut), but who himself may not have felt up to the task of creating an entirely new conception, followed Feiveshson's basic design and forms. His drawing is less skilled and self-assured, as can be seen in the clumsier double-headed eagle, the griffins, the central, "convoluted" menorah, and the columns. But his Hebrew calligraphy and sense of color are not less competent, and he was certainly well versed in the Hebrew texts. We consider this work "genuine" because it was obviously made for its basic purpose — a *mizraḥ*. So what, if he copied something he admired, as long as it met the objective? There were no "copyrights." Mordechai Milman owed no one any justification or explanation, and was clearly as proud of his work as if he had invented the design himself, for he inscribed in the right-hand column "By a worker doing his craft." Thus is a collective esthetic handed on and down through the generations. So much for credible, authentic works.

Suspect Copies

We now come to a much more intricate problem in unravelling the true from the false, the genuine article from papercuts made for the Judaica market to pass as antiques. Just as now, Jewish ritual artifacts, including papercuts, were in the past also commissioned from artist-craftsmen (more recently, also women) skilled in making them, sometimes with personalized inscriptions and special symbols. Can we differentiate between such works made to serve their ritual or apotropaic purpose from those made for collectors? Is the one more genuine than the other? The answer is simple: As long as they are declared to be what they are, and are not sold by deceiving anyone as to their "genuineness" or antiquity, such works are certainly authentic and original — even if this stretches a strict definition of unselfconscious folk art. And in any case, the term "folk art" is open to a wide range of interpretations that we cannot go into here. An example of a Jewish papercut apparently commissioned by a collector seems to be the one dated ca. 1900? in Fig. 8.6B made by Dawid Rosengarten, a humble working man from Galicia.

How to distinguish such works by looking at them? It is not always possible to offer clear guidelines. For example, take the three papercuts depicted in Figs. 8.3a–c. Already our first acquaintance with an almost identical one at the Haifa show of old and contemporary Jewish papercuts in 1976 aroused some suspicions. It somehow seemed too "slick" and perfect, although it was undoubtedly the work of a skilled Jewish draftsman or scribe. The colors were very fresh and it looked quite new.[3] Some years later, we saw a blank papercut (Fig. 8.3c) in the National Jewish Museum in Washington, D.C., that looked familiar, and still later, we came upon other blanks like it, elsewhere. When we compared a photograph of this blank papercut with the above one, the design was obviously the same, and the dimensions were the same as well. Then, a cut work in vellum of, yet again, the same design was sold at auction in New York in 1988 (Fig. 8.3b). The provenance of none of these three works could be established until we found, in the Giza Frankel Archival Collection in the Jewish and Comparative Folklore Department at the Hebrew University of Jerusalem, a small, poor, old photograph taken in Warsaw in 1948/49 of what was obviously the damaged original work (Fig. 8.3a). The photo shows the right-hand margin of the papercut to be missing and the top covered up or cut off by the frame. Since this, as other such works, was essentially symmetrical by being cut on a vertical fold, the later versions could be reconstructed from it, some remaining in a blank state and never finished (and there may still be others we don't know about). The Hebrew inscriptions in the copies attest to their having been made by a skilled calligrapher. Who did this, and to what purpose? Although we cannot help suspecting the motivation behind these copies, the mystery must remain unresolved until new information is forthcoming.

We might add here that vellum and parchment do not lend themselves readily to being folded like paper. Over the past decades, other obviously traced copies (probably from enlarged photocopies) of published old Jewish papercuts, skillfully executed in vellum, have appeared on the collectors' market. They were described in auction catalogs as ". . . in Polish style . . . twentieth century" — not untruthfully, but also not candidly.

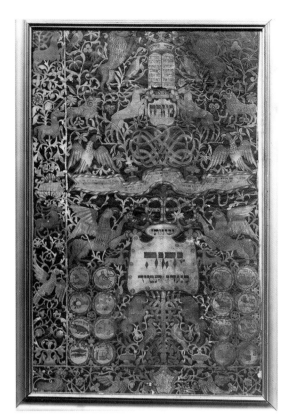

8.3a

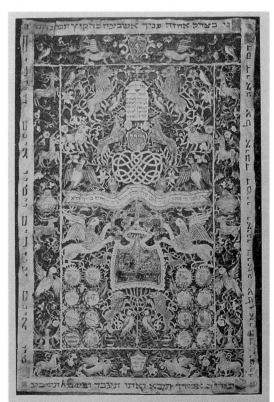

8.3b

8.3. *Mizraḥ/Shiviti*. Photograph (*a*), dated 1948/1949 on the reverse, from the Giza Frankel Archival Collection in the Jewish and Comparative Folklore Department at the Hebrew University of Jerusalem, shows the greater part of an intricate papercut from Warsaw. There is no indication of its dimensions or coloration.

Papercut (*b*) was apparently traced onto a piece of vellum, possibly from the original working drawings, and cut out. The details, with minor changes, were drawn in and colored in the traditional manner. We know of at least one other, similar copy, in paper. Since in the old photograph parts of the papercut composition and inscribed margins are missing and/or are covered by the heavy frame, whoever (the same man?) copied this work must have had access to the complete design. In any case, both these later versions are clearly the work of a Jew well-versed in traditional lore. Although the workmanship of these two completed imitations is competent and the calligraphy very good, a discerning eye will detect that neither is as accomplished and free-flowing as the original (*a*).

The outlines in the identical blank unfinished copies (*c*) are even less succinct. One of these is in the National Jewish Museum, Washington, D.C., and another in the Eretz-Israel Museum Folklore Pavilion, Tel Aviv.
a) dimensions unknown. b) ca. 57 × 39 cm. (22⁷⁄₁₆″ × 15⅜″). c) ca. 60.5 × 42.5 cm. (23¹³⁄₁₆″ × 16¾″).

8.3c

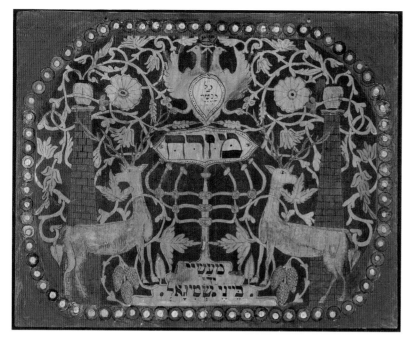

8.4. *Mizraḥ.* This item is one of several known papercuts (or compositions made from parts of papercuts) that appeared on the collectors' market in the 1970s or 1980s — possibly from the region of Slovakia or the Carpathians. They were pasted on a stiff cardboard backing and lacquered or varnished, and provided with metal eyelets for tacking on a wall. Here, the central elements were most probably cut from a larger design that may have been damaged, and surrounded with the blue and yellow cut-out dots to frame it. While the overall conception and iconography conform to what we know of traditional East-European works, we cannot be sure that it was not "doctored" and that the inscriptions were not added at a later date by someone else in order to enhance its interest for modern collectors of Judaica: there is a blatant spelling mistake in the medallion on the double-eagle, and the "signature" at the bottom is rather strange and unusually large. As we noted elsewhere, the men who made such works generally tended to sign their work modestly in small letters. 34.5 × 43.5 cm. (13⁹⁄₁₆″ × 17⅛″). Yitzḥaq Einhorn Collection, Tel Aviv.

8.4

8.5a

8.5b

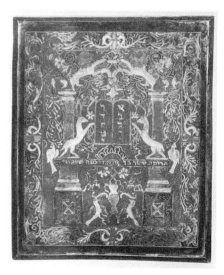

8.5c

8.5. *Mizraḥ/Shiviti.* The large work (*a*), from Wieliczka near Krakow in western Galicia, and reportedly owned by Giza Frankel in 1925, was reproduced in very small format in her 1929 publication on Jewish papercuts. It subsequently served as the model for copies, of which we have seen a small one in paper (*b*) with lively, fresh coloration, and another in brass inlaid with silver (*c*), that were almost certainly created for the Judaica collectors' market. Curiously, the "original?" (*a*) contains a number of bad spelling mistakes in the devotional texts in large Hebrew letters — something that cannot but raise questions regarding the genuineness of this work. The drawing, too, does not look fresh and may well itself be a copy made for the collectors' market from an earlier prototype — even in the 1920s. (*a*) 68 × 51 cm. (26¾″ × 20¹⁄₁₆″). After G. Frankel, 1929. (*b*) 14.3 × 11.5 cm. (5⅝″ × 4½″). The Sir Isaac and Lady Edith Wolfson Museum, Hechal Shlomo, Jerusalem. (*c*) 26 × 21.5 cm. (10¼″ × 8⁷⁄₁₆″). After J. Weinstein, 1985.

Frauds

Outright fakes, made to profit from the lucrative Judaica collectors' market, can usually be detected by an experienced eye. One or another detail invariably rings false enough to arouse suspicion about the whole thing (Figs. 8.5a–c). Thus also, several papercuts obviously made by the same hand, from a private collection in Tel Aviv and exhibited at the Israel Museum some decades ago, can be traced as copies of papercuts by Dawid Rosengarten and other works reproduced before World War II as small black-and-white illustrations in Goldstein and Dresdner's book.[4] Unlike in a few other fraudulent copies, the person who made or was commissioned to make these copies — probably intended as outright forgeries — was proficient at Hebrew calligraphy. But the drawing is crude — what is known in professional terminology as a "stupid" or "dumb" imitative, uncreative line — and the dull coloration is the same in all of them (see detailed discussion for the eight items in Figs. 8.6A-d).

Another, even more blatant case of a recent faked old Jewish papercut is an even "dumber" copy of a work from Drohobycz in Galicia dated to 1875 (Fig. 8.7a) that was reproduced in black-and-white (we do not know the coloration of the original) by Giza Frankel in 1929, in her article in the *Encyclopaedia Judaica* (1972/75), and on page 133 of her book, *The Art of the Jewish Paper-Cut*, in 1983. One papercut made from a photocopy of these published photos was "discovered" several years ago in a used furniture shop in Prague, and acquired at a relatively high price by an unsuspecting American Judaica enthusiast. In this case, the picture from which the papercut was made was "improved upon" by better drawing and addition of details and coloration. The work was "aged" with water-stains and "flyspecks," and encased in a tattered old frame under soiled glass. But what really gives the hoax away is the pseudo-Hebrew lettering — again, "stupid" copies of the very clearly legible inscriptions in the photo of the original. Whoever produced this spurious "old" Jewish papercut did not know Hebrew: The letters are wrongly executed, and the hallowed, sacred texts are hopelessly, absurdly muddled. Since then, another duly water-stained and fly-specked hand-made copy of the same original turned up in an important museum collection (Fig. 8.7c). Another example of a clearly spurious work is shown in Fig. 8.8a, along with the original old papercuts (Figs. 8.8b and 8.8c) from which large parts of the faked work were copied.

(PAGES 217–218) 8.6. The four small black-and-white photographs (*A*), (*B*), (*C*), and (*D*) in Maksymiljan Goldstein and Karol Dresdner's book on Polish-Jewish folk art and culture, published in Lvov in 1935, served as models for three basic designs (*a* and *aa*), (*b*), and (*c*) of papercuts made in recent decades for the collectors' market. Since part of Goldstein's extensive collection was lost during World War II, the dimensions and coloration of the originals are unknown. Some of these late "interpretations" (fakes, in plain language) have been erroneously described and dated in serious publications and auction catalogs. Such items were offered — and bought! — at high, not to say exorbitant, prices by unsuspecting collectors and museum curators, when even an untrained but critical eye and a basic knowledge of Hebrew should have been enough to detect the rather crudely drawn and lettered deceptions. Some of the worked-over designs incorporate various elements from two or more of the photographs in Goldstein and Dresdner's book, of which one, (*D*), is not of a papercut but of a repoussé sheet-brass album cover commissioned by Maksymiljan Goldstein for a family memorial volume. In some of the concocted copies, the Hebrew letters are so hopelessly bungled as to (inadvertently, to be sure) form sacrilegious meanings. But take a close look at the details:

a) Papercut for Shavuoth. In the original (*A*), the inscription in the wide band reads, "This day the Feast of Weeks." The letters *zayin* ז, *mem* מ, *tav* ת in the roundel at the bottom center stand for *zeman mattan toratenu* — "The time of the giving of our Torah." Compare the

8.6A

8.6a

8.6aa

crude renditions of the animals and vegetal elements in copies (*a*) and (*aa*) with the fine drawing in (*A*). The coloration of (*a*) is similar in its watery, monochromatic quality and hues to that of papercuts (*b*) and (*c*), which incorporate elements coarsely copied — at least in part, or entirely — from (*B*), (*C*), and (*D*), attesting the copies to be the work of the same hand. We know of at least four different papercuts of this design (*A*), of uneven competence and dimensions. Some were clearly lettered by Jews; others are apparently copies of the copies, with dumb tracings of Hebrew letters by someone who did not know the language.

b) Papercut *mizraḥ*. Here, yet again, the same hand made a bad copy of photo (*B*), of a papercut dated ca. 1900, by Dawid Rosengarten of Lvov, and applied the same coloration as in (*a*) and (*b*). Note the senseless, deformed copies of the *magen david*s from (*B*) and the very poor drawing of the animals and heraldic creatures. Not having been thought out and planned in advance, the inscriptions are partly incomplete.

c) Papercut for Shavuoth. Apart from being an obvious pastiche of elements from photos (*B*), (*C*), and (*D*), the slovenly, cursory drawing of the animals and birds, and, again, the flat coloration, all point to an item made to deceive. Moreover, the "shavuoth"-related texts in this design are contrived. A very similar *mizraḥ* papercut, copied and worked-over from the same sources by the same hand, fetched a high price at auction in 1989.

All these spurious "old" Judaica works are entirely devoid of inspiration or dedication; they bespeak hurried, slipshod workmanship. The Jews who made their papercuts as holy work throughout the ages devoted careful thought to planning their designs and inscriptions, and took great pains in cutting and coloring them.

(*a*) 31 × 49 cm. (12³⁄₁₆" × 19¼"). Yitzḥaq Einhorn Collection, Tel Aviv. (*aa*) 29.5 × 37 cm. (11⅝" × 14⁹⁄₁₆"). Jüdisches Museum Wien, Vienna. (*b*) 51 × 32.5 cm. (20¹⁄₁₆" × 12⁹⁄₁₆"). Yitzḥaq Einhorn Collection, Tel Aviv. (*c*) 40 × 29.7 cm. (19⅝" × 11¹¹⁄₁₆"). Yitzḥaq Einhorn Collection, Tel Aviv.

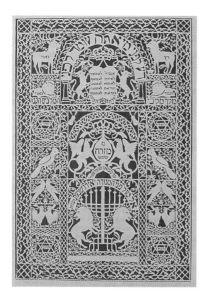

8.6B

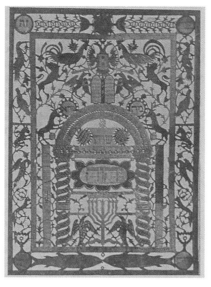

8.6C

8.6D

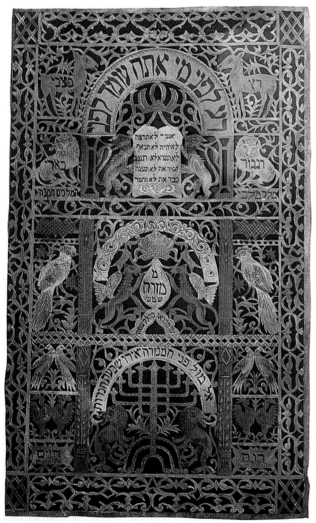

8.6b

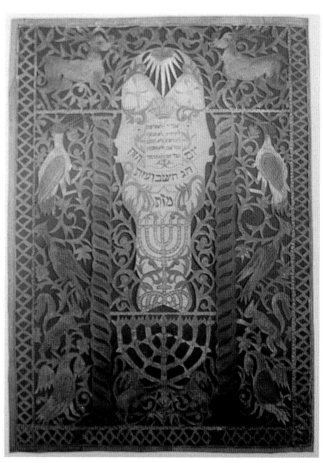

8.6c

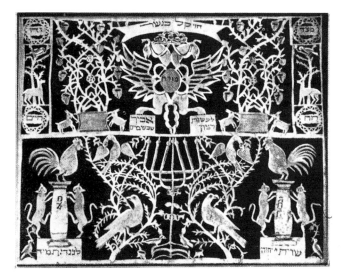

8.7a

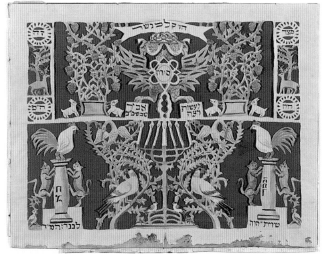

8.7c

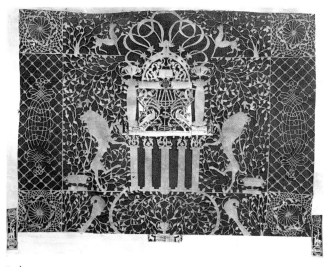

8.7b

8.7. *Mizrah/Shiviti.* A photograph of this papercut *mizrah/shiviti* (*a*) reportedly made in 1875 in Drohobycz in Galicia, by the father of one Lipa Schutzman of Lvov, was first reproduced in Giza Frankel's publication on Jewish papercuts (in Polish) in 1929. The fate of the original is unknown. At some point, the published photograph was enlarged and parts of it integrated in a damaged, beautiful old papercut (*b*) last owned by the late Dr. Atlas of Prešov (Slovakia), and eventually of Jerusalem. Central elements and some other parts of (*a*) were cut out of the enlarged photograph and pasted into the composition of (*b*), probably to replace damaged or missing parts. Who did this and why must remain unanswered, but it was probably not done to deceive anyone — perhaps for his own satisfaction by the owner of this work?

In recent years, rough copies, obviously made from enlarged photocopies of the old photograph of (*a*), were traced on half a vertically folded sheet of paper, cut out, and colored. The workmanship is crude and the lines are "dumbly" copied from the original picture. One such dishonest copy was "discovered" in an old-furniture shop in Prague and bought for several hundred dollars. Another (*c*), found its way into the Vienna Jewish museum as part of a private Judaica collection. What gives these works completely away as outright fakes is the tortured, stupidly traced Hebrew lettering — obviously by someone who did not know the language — resulting in preposterous textual errors. The two such items we have seen were "antiqued" with water-stains and fly-specks, and framed in dirty old frames to make them look convincing to gullible collectors. (*a*) 28 × 36 cm. (11" × 14"). After G. Frankel, 1929. (*b*) 31 × 40 cm. (12³/₁₆" × 15¾"). Atlas Collection, Jerusalem. (*c*) 39 × 50.5 cm. (15⅜" × 19⅞"). Jüdisches Museum Wien, Vienna.

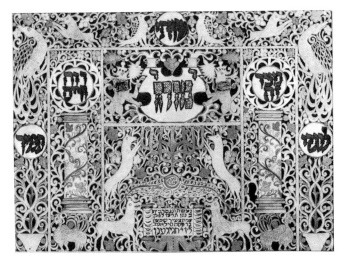

8.8a

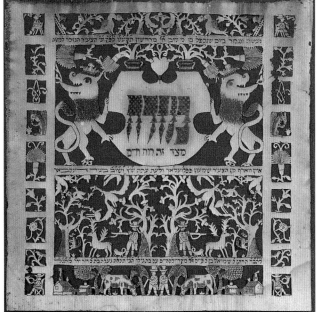

8.8c

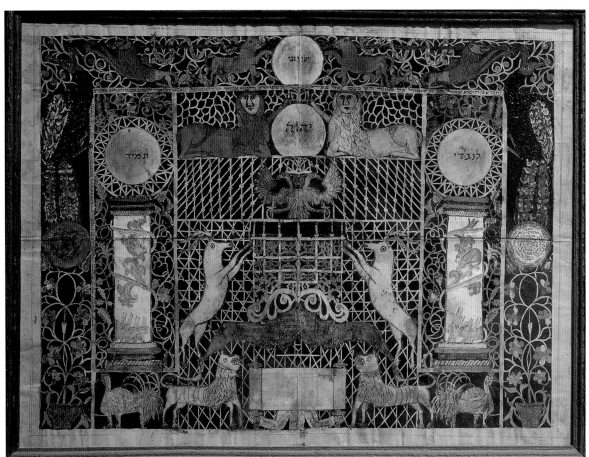

8.8b

We could go on and on with more such items, but the point should be clear by now. One might well take to heart what the Neoplatonic Roman philosopher, Plotinus, wrote in the third century: "Remember that there are parts of what it most concerns you to know which I cannot describe to you; you must come with me and see for yourselves. The vision is for him who will see it."[5] As in other art, that is precisely the key here. If you do not have the discerning eye of a creative artist or connoisseur, trained to principles of good design, and with enough practical experience to exercise suspicion, it is best to take qualified counsel before paying good money for a phony "old" work.

As we have stated elsewhere in these pages, traditional Jewish papercuts, and some other works on paper or parchment, were always considered "holy work" — 'avodat qodesh. The men (and very few women) who made them put much thought into planning, laying out the complex designs, deciding upon and lettering the inscriptions, and exercising painstaking care in cutting their work. Even when the maker of the papercut was less skilled technically, he did his very best. He never treated his creation lightly, or worked in a hurried, slap-dash manner.

The corollary to all this is, of course, that potential forgers will now take even greater pains to make their deceptions as convincing as possible. Already, artificial concoctions, which in the past tended to be rather crudely executed, now attest increasing skill in producing fairly credible forgeries. By raising doubts and uncertainties among collectors and museums, this trend may well put an end to further acquisitions of genuine, rare, authentic works, for what prospective buyer will want to risk acquiring worthless fakes?

8.8. (a) *Mizraḥ/Shiviti*. Apparently made for the collectors' market, this papercut was contrived by crudely and stupidly copying the central elements of the fine *shiviti* papercut from Galicia (b) and combining these with the central parts of the much earlier *mizraḥ* from Germany (c). Since the latter was only first published in the 1970s, the nineteenth- or early twentieth-century dating indicated on this fraudulent item (a) is absurd, as is the entire bogus personal signature *within the open Torah scroll*!

(b) *Shiviti*. An utterly charming work, this papercut reveals the consummate skill and patience of the folk artist in cutting fine lines. Note the very human "Jewish" lions with the awkwardly held paws in the upper register, the amusing roosters at the bottom, and the comical rabbits at the bottom of the two columns — presumably, Yakhin and Bo'az. At center-bottom, a Torah scroll is held up by two human arms inscribed with the text from the liturgy of the reading of the Torah: "She is a tree of life to them that lay hold upon her. . . ." (Proverbs 3:18). Only the two first (Hebrew) words of Deuteronomy 10:12: "And now, Israel, [what doth the Lord thy God require of thee, but to fear the Lord thy God, to walk in all His ways, and to love Him, and to serve the Lord thy God with all thy soul, . . .]" are lettered on the open scroll. The roundel in the right-hand margin is inscribed with the entire "*anna be-khoaḥ*" prayer. The partly illegible inscription in the green ribbon beneath the central menorah states that this is the "work of Ya'aqov Benyamin [son of the honored rabbi?] the prominent Avraham, may the Merciful One protect [or, save] him and bless him." The date seems to be 1857; the place-name cannot be made out, but this work is almost certainly from Galicia. Some of the coloration may have been "doctored" in more recent times.

(c) *Mizraḥ*. This papercut, dated 1819, was made as a wedding present by one Simon Papflauenbach of Dinsbach? for a friend in the town of Kreilsheim (in the Rhineland). Cut on a fold to obtain a symmetrical image, the composition is divided into two distinct registers and a decorative border design. Were it not for the bold upper device of two "Jewish" heraldic lions holding a shield with the word *mizraḥ* emblazoned on it, and the Hebrew dedicatory inscriptions in the horizontal dividing bands, there would be nothing to distinguish this papercut from German peasant work — from which it may well have been copied or adapted.

(a) ca. 43 × 57 cm. (ca. 16¹⁵⁄₁₆" × 22⁷⁄₁₆"). Anonymous owner. (b) 43 × 56.2 cm. (16¹⁵⁄₁₆" × 22¼"). Yitzḥaq Einhorn Collection, Tel Aviv. (c) 30.6 × 30.5 cm. (12" × 12"). Feuchtwanger Collection, purchased and donated to the Israel Museum, Jerusalem by Baruch and Ruth Rappaport of Geneva.

9.0. Yehudit Shadur repairing and restoring a damaged old papercut from the former Atlas Collection, Jerusalem. The work is a *mizraḥ*, probably from the region of Prešov in Slovakia where the late Dr. Atlas lived before the Holocaust. Apart from the word *mizraḥ* in the central roundel, the main inscriptions are the common "Four Animals" passage (p. 107), but also "The spirit of man is the lamp of the Lord" from Proverbs 20:27 (p. 108) in the two roundels flanking the upper part of the menorah. Archival collection of the authors, Jerusalem.

9

SO YOU'VE FOUND AN
OLD JEWISH PAPERCUT!

Since the current revival of Jewish papercutting started in earnest in the late 1970s and began to arouse awareness of this art form, more and more old Jewish papercuts have been emerging from attics, synagogue basements, between the pages of old books, and other forgotten places. Growing concern for tracing our past has also helped to restore respect and serious consideration for these unique expressions of our cultural heritage. Some of the works reproduced in this book were and are the prized possessions of the children, grandchildren, and great-grandchildren of the folk artists who made them.

What should you do if you have the good fortune to discover an old papercut? The advice that follows applies to all papercuts, not only Jewish ones. Papercuts were not always framed or displayed, but were sometimes kept flat or folded between the pages of a book, to be taken out, admired, and then returned to their storage place. Some of them show the effects of excessive handling. Others were poorly mounted and framed, suffering deterioration from exposure to light, dampness, and careless storage. Most papercuts made after the 1840s, when cheap wood pulp paper came into common usage, have become extremely brittle with age and tend to disintegrate on touch. Trying to smooth or uncrease them will almost certainly cause more damage.

Never attempt to repair such a piece on your own. Instead, package it carefully without disturbing its existing state, so that it can be handed or sent to an expert on paper restoration. If it is in a flat, unfolded condition, do not try to repair, replace, or cut away any worn or weak parts. If at all possible, never glue the papercut to a backing — or to anything else! Many old papercuts subjected to such drastic methods of inexpert "preservation" have lost their unique cut quality and ended up looking more like prints. Some have been remounted on a black or other dark-colored background for greater contrast. Old Jewish papercuts were rarely, if ever, mounted on black; deep blue was the traditional color for backgrounds in Ashkenazi work.

Attempts at gluing or patching torn or cut areas should always be left to an experienced art restorer. Only acid-free, non-staining materials should be used. Even if an old papercut has been relatively well framed and treated, chances are that some dirt and dampness have penetrated over the years, so that opening, cleaning, and resealing of the old frame may be required. All too often, old papercuts have been matted and framed so as to cover up part of the external margin — supposedly to give them a "neat" look. This is extremely bad practice, for the margins are integral parts of the entire composition, and even if damaged or torn (as they often are), they should be fully visible. Moreover, on removing old papercuts from their antique frames, we sometimes discovered hidden, hand-written signatures, dedicatory inscriptions, or even dates along the margins. The glass of the frame should not actually touch the cut paper work through

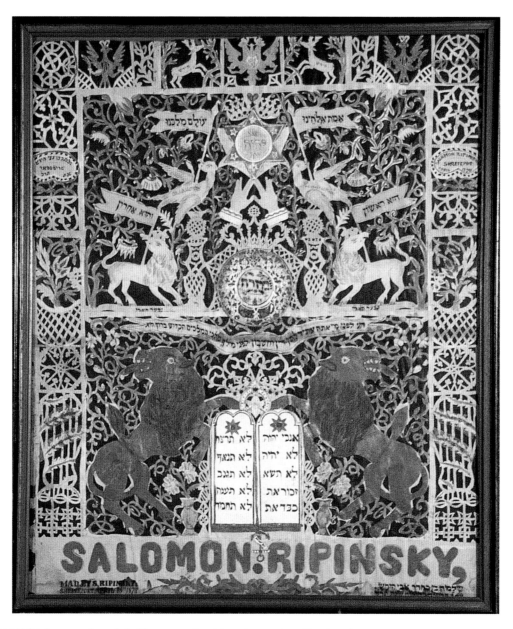

9.1. *Mizraḥ/Shiviti.* This large work made in Shreveport, Louisiana, in 1870 is well within the architectural, strongly hierarchic manner of "classic" Eastern European Jewish papercuts. The profuse, flowering vines of the Tree of Life grow out of small urns next to the tablets of the Decalogue. Further up the central axis are the Three Crowns; blessing priests' hands; a *magen david* inscribed with the Ineffable Name, suggesting that this is also a *shiviti*; and the word *mizraḥ* in the central roundel. Besides the fairly standard text in the ribbon at the top of the lower register, the inscriptions in the flags, "Our God is Truth/ Forever our King/ He is First/ And He is Last," are unusual in papercuts. Out of character is the very large "SALOMON.RIPINSKY," signature across the lower margin (and why the small anchor between the *N* and the *R* of his names?). As indicated in Hebrew and English in small lettering in the lower corners, Salomon/Shelomo was the son of Barukh Tzvi-Hirsch Ripinsky. Tzvi-Hirsch being Hebrew and Yiddish for "Gazelle-Deer" (see pp. 97–98), each of these names is inscribed in the two small deer flanking the central double-headed eagle in the top margin. Together with the large heraldic lions, eagles, and the rather strange, not quite lion-like creatures holding the flags, and labeled "bold as the leopard" and "powerful as the lion," they represent the ubiquitous Four Animals aphorism of Judah ben Tema.

It is a pity that the heavy, old frame detracts from the completeness of this bold — even monumental — composition. 72.4 × 62.2 cm. (28½" × 24½"), framed. Hebrew Union College Skirball Culture Center, Museum Collection, Los Angeles. Gift of Helen B. and Arthur C. Roe.

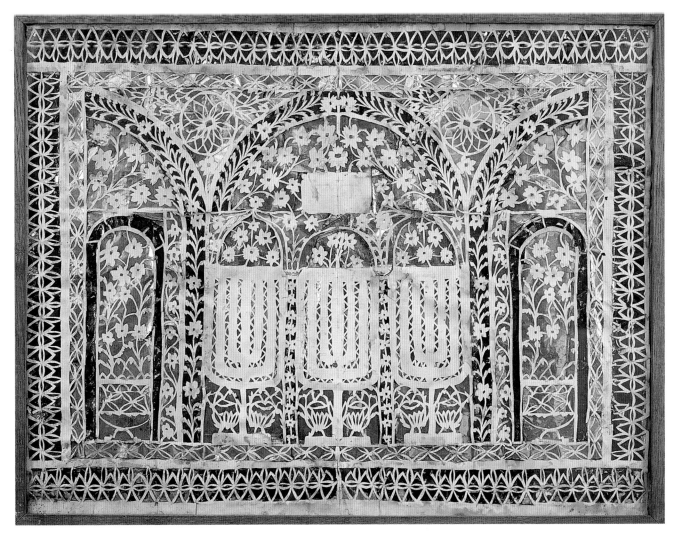

9.2. *Menorah*. Most of the few North African Jewish papercuts known to us are of similar architectural character, with columns, Moorish arches, and monumental *menorot* (cf. Fig. 2.43). Almost all have colored metal foil backing underlaying the cut-out composition. Several are made up of pasted-together sections traced or cut along stencils to achieve repeat motifs. Here, as in most European Jewish papercuts, the entire composition was cut on a centerfold. In the rectangle at the upper center, the faded Tetragrammaton can still be made out. No other inscriptions are visible, having faded completely, or because the work was left unfinished. The work probably dates to the turn of the twentieth century.

 Although the old frame hides most of the natural margins of this fine work, like most similar items, the museum restoration experts feared to disturb its very fragile, delicate condition, and decided to leave it as found. 47 × 60.5 cm. (18½" × 23¾"). Musée d'art et d'histoire du Judaisme, Paris.

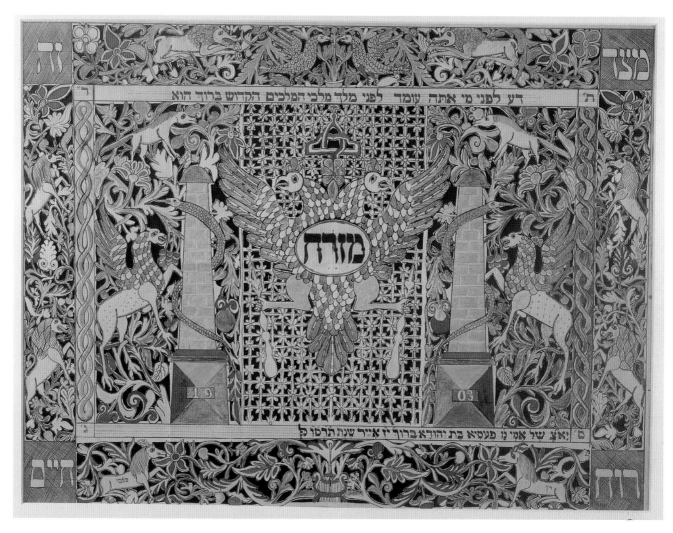

9.3. *Mizrah/Yortzait.* Wolf Kurtzman (1865–1945), a watchmaker from Mekhalpolia in Podolia made this fine *mizrah* in 1903, and later added the name of his deceased mother, Pessya, and the day of her death in 1906 to serve as a reminder of her *yortzait*. In the central oval medallion on the large double-eagle the word *mizrah* appears in large letters; the four words of the inverse acronym "From this side the spirit of life" are inscribed in the corners. The two deer-like animals in the lower margin each have one of the two Hebrew words for "fleet as the gazelle" of the ubiquitous "Four Animals" aphorism of Judah ben Tema. Note that the two upper, maned creatures in the outer margins are unicorns. As is common in Eastern European Jewish papercuts, snakes wind around the stately columns — probably representing Yakhin and Boaz of the Temple sanctuary in Jerusalem. Kurtzman came to America in the 1920s with his five children.

Sadly, this fine work serves here as an example of how *not* to frame and photograph such works: the outer margins, which hold all the work together in one piece, were covered up by a mat that is too wide, "cutting off" part of the actual composition — all for the sake of "neatness." ca. 33 × 43 cm. (13" × 16¹⁵⁄₁₆"). Jewish Museum, New York (1982-125). Gift of Celia Goldstein.

9.4. *Mizrah/Shiviti.* This papercut, almost certainly from Eastern Europe, was found among the effects left by an old, very religious Jew, in Philadelphia. It was never mounted on a backing, and was folded up and stuffed in a used business-size envelope. Made of cheap, thin newsprint paper, it became so brittle with age that it disintegrated at the slightest handling. To save what remained, we worked for hours, carefully reassembling the many fragments as best we could. In this case, there was no choice but to glue the pieces down completely on acid-free backing paper. Even in its poor state, it is entirely in the venerable tradition of such works: The menorah is inscribed with the sixty-seventh Psalm, and the lions and deer evoke the "Four Animals" aphorism of Judah ben Tema. The birds, with the standard *mizrah* and *shiviti* formulas boldly lettered between them and topped by the Crown of the Torah, are probably the cherubs (*kruvim*) of the sanctuary. ca. 39 × 39 cm. (15⅜" × 15⅜"). Collection of the authors, Jerusalem.

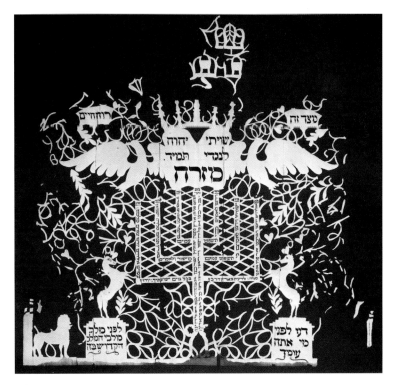

9.4

use of a suitable mat cut so as to reveal as much margin as possible. Works that are too brittle should be preserved within a cardboard folder and kept flat: Not every old papercut is suitable for display on the wall!

It is therefore highly important that under all circumstances you show your papercut to an expert — not only to gain knowledge about the work and receive suggestions for its restoration and preservation, but also to make its existence known to art historians, thus adding to the corpus of recorded information about Jewish papercuts. It should also be photographed and all that is known about it — exact dimensions, history, a description of where and when it was found — should be written up. In many larger communities throughout the United States, Canada, Europe, and Israel, there are museums and collections of Judaic art whose staff can be approached for advice. We ourselves welcome all such queries, preferably accompanied by good prints or color slides and whatever you might know about it and the person who made it.

If you wish to photograph your papercut (or any other flat picture, for that matter), unless you are a professional photographer it is best *not* to do so while it hangs on a wall. Since the camera must be perfectly parallel to the work, the best way for an amateur to obtain good results is to place the picture flat on a horizontal surface (the floor is fine), in good unshaded light. Use a stable tripod with the camera facing down, carefully levelled and focused, and use a wire shutter release. If at all possible, the papercut should be removed from its frame to avoid glassy reflections in the photograph.

Above all, remember that although your papercut is your personal property, in owning it you have become a responsible custodian for the Jewish people as a whole of an important historical and cultural relic.

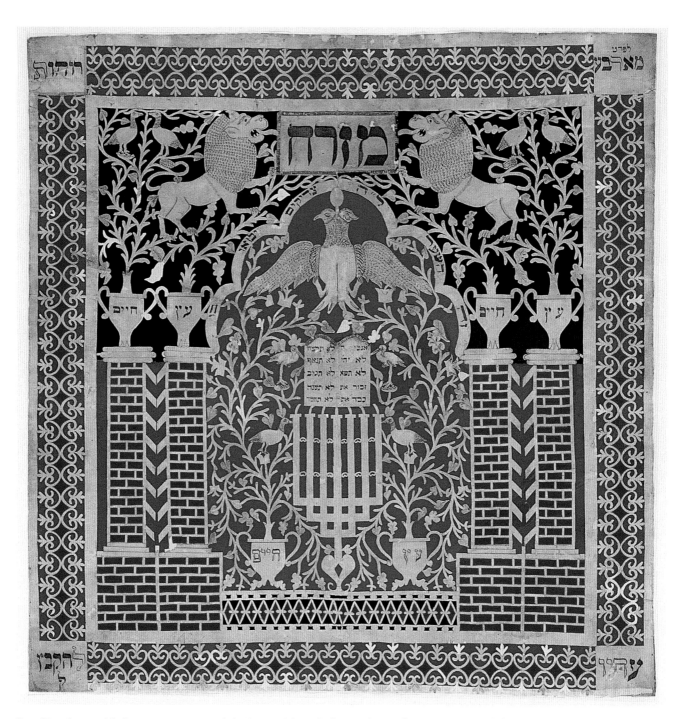

R-0. Dated 1891, this fine papercut was made in Ostrów-Mazowiecka, northeast of Warsaw, apparently by the same man who made the work shown in Fig. I-1. Its rigid, static quality with its formal border and brick masonry is tempered by the free florid motifs growing out of six urns, which their inscriptions tell us represent the Tree of Life. Among the fowls inhabiting the vines and foliage are storks (pp. 98–99). The heavy-maned heraldic lions holding a panel with the word *mizrah* are perched precariously on the delicate twigs. Above the central, angular menorah are tablets of the Law topped by double-headed eagles (p. 98) within a ribbon-like arch inscribed with "This is the gate of the Lord into which the righteous shall enter" (p. 93). 53 × 52 cm. (21" × 20½"). Gross family collection, Ramat Aviv.

I n summing up, we must repeat what we have said earlier: Our views and conclusions are based entirely on first-hand study and intimate familiarity with Jewish papercuts, and on extensive personal experience and experimentation with the techniques of making them. We estimate that out of perhaps four to five hundred old Jewish papercuts of all types known today, about half are what may be termed "classic" traditional ones. In the wake of Giza Frankel and other students of Jewish ritual and folk art, we have attempted to detect unifying characteristics in these works. But often, just when we thought we had hit upon acceptable generalizations, we came upon "new" old Jewish papercuts that upset all such apparent certainties.

The papercutters of the *mellāḥ*, ghetto, or shtetl did not share our obsession for categorizing, classifying, and defining their work. Despite what we may have said, some of them made papercuts that were asymmetrical, with unexpected human figures and peculiar decorative devices. If the spirit so moved them, they thought nothing of pasting figures cut out of illustrated journals or children's picture books into their "classic" devotional compositions. In short, they did what they felt like doing, blithely switched their working techniques as whimsy dictated, and did not have to account to anyone. They were unaware of any fixed rules governing their efforts. And yet, as we have already pointed out, there is no mistaking a Jewish papercut for anything but that.

An Inner World Revealed:
Synthesis of Ideology, Faith, and Craft through Symbols

Examining these complex creations at length and in detail inevitably led us to the conclusion that the iconographic language of many Jewish papercuts reflects the kabbalistic concept that sees everything in the world replete with symbolic significance, and that the essence of the Torah lies in hidden meanings. Although many ordinary Jews made papercuts, most of them — unconsciously, to be sure — represented an undefined, mystic fraternity, possessing the intuitive artistic eye and manual skill of the calligrapher and a deep acquaintance with the Kabbalah and its literature, folklore, and mental imagery. In this, the *ḥeder* undoubtedly exercised a far-reaching influence on the development of the rising Jewish generations, not only in implanting knowledge, but in forming a particular worldview: "In the *ḥeder* the boys became familiar . . . with

countless folk sayings, legends, and all the national traditions." Or, as Shlomo An-Sky, who lived and breathed Jewish folklore, wrote in 1909:

> While the child is in its mother's womb, an angel comes and teaches it the entire Torah, but just before the birth, he gives it a tap on the nose and the child forgets it all. . . . But there are these exceptional Jewish souls, who either do not forget everything or quickly summon up what has been forgotten."[1]

Ordinary or exceptional, it would be illuminating to know more about the men who, from generation to generation, made these papercuts throughout the Jewish world.

That Jewish papercuts were closely related to the sacred craft of the Jewish scribe, the *sofer stam*, was pointed out by the late David Davidovitch (1905–1993), one of the leading modern authorities on Jewish folk art:

> From the Hebrew letter, which by its very nature embodies the first principle of graphic art — precision — grew up a [Jewish] decorative art which is but one of the stages leading from graphics to monumental painting. To us Jews, the art of the line — the sacred letter, the book — was in many ways closer to the heart and to Jewish thought, serving our spiritual needs far more than monumental painting.
>
> The papercut is a particularly important branch of Jewish graphics . . . free of the higher culture and professionalism. These papercuts . . . reveal the soul of their creators far more than any other branch of popular and folkloristic art or craft. The Jewish papercut did not stand out only by its graphic character, expressed by the integration of delicate lines, but also by the wealth of colorful motifs. What originality and sense of beauty have been breathed into the motifs of our paper cut-outs — especially those made for holy purposes![2]

There indeed do seem to be motifs commonly featured in Jewish papercuts that are specific to this art form, or at least restricted to very few other types of ritual objects. Again, we draw attention to the "endless-knot" motif merging with and developing out of the menorah. Besides appearing fairly frequently on East-European papercuts, it is occasionally seen on carved tombstones and calligraphic works, as in *pinqassim* (communal ledgers), and in a very few ritual objects of the same regions. Perhaps such intricate designs challenged the virtuosity of the papercutter or stonecarver. Or did they, as we suspect, have an established meaning that we do not yet understand?

How can we assess these papercuts as works of art? Unlike some works in cut paper of other cultures, which were often made for pleasure, as a hobby, as art for its own sake, and kept in books or stored away flat, most of the Jewish ones were made for display on the wall (or window pane) and for a specific, functional purpose. They were usually mounted on a stiff backing cardboard, and/or framed.

The primary concern of those Jews who made papercuts was content: the purpose, or purposes — all of them religious — that their work was to serve. Having decided on the content, the devout folk artist formed a mental image of what he intended to create, and the texts he wanted to include. In this he must have modeled himself on other such works he had seen, and probably admired. And he undoubtedly drew on common designs, forms, and configurations

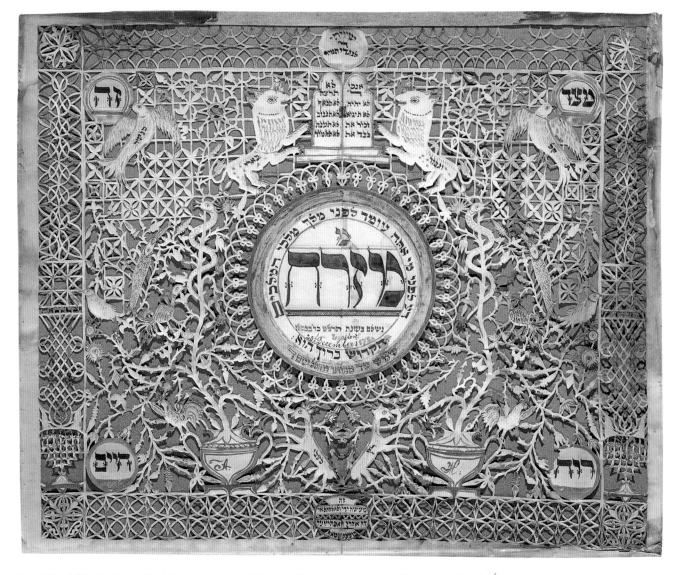

R-1. *Mizraḥ/Shiviti.* Aaron Hochhaiser completed his magnificent papercut on 20 December 1878, in Żegestów in Galicia. Clustered around a large central medallion are many animals, among them three of the "Four Animals": lion, gazelle (deer), and vulture (eagle). There are also various birds, including roosters; snakes twisting around Trees of Knowledge that grow out of vases, each bearing one of the artist's initials in Latin letters (*A* and *H*). The big fish swallowing a little fish is obviously imagery derived from the Talmudic tractate Avodah Zarah 4a. The workmanship is delicate throughout. To achieve regularity in the repeating border pattern made up of circles and half-circles, the artist probably used coins as templates to guide his pencil. Note that in each of the outside borders there are stylized menorahs. Those at the bottom are clearly seen. But it takes a discerning eye to realize that the threefold endless-knot design just above these culminates at the top in another menorah, its flames inclining toward the center according to the iconographic requirements. 31.2 x 38.2 cm. (12¼" × 15¹⁄₁₆"). Allen Field, Larchmont, New York.

of his environment; particularly, in his synagogue. Along with the simple tools he employed, he had a mental store of traditional symbols, emblems, and texts from which he could choose to enhance his idea and express his vision of the sacred work he planned.

In most papercuts of other peoples, including those that influenced the Jewish form of this medium, the motifs and ideas behind them are straightforward, and the symbolic repertoire comparatively simple. What you see is what there is: a landscape, flowers, family coat of arms, saints of the church and their attributes, a biblical scene, purely decorative designs, a love letter, and the like. Not so, the Jewish papercuts.

Almost every symbol is endowed with double if not triple, or multiple meanings. The impression one gains from looking at a large sampling of these works is that they somehow — most probably, unconsciously — reflect the Jewish theological concept of *PARDES* (פַּרְדֵּס), literally, "orchard" in Hebrew. The word is related to "paradise," the beautiful enclosed garden of ancient Middle-Eastern mythology — the Garden of Eden. The four consonants making up the Hebrew word have become an inverse acronym so characteristic of Jewish mystical lore: the initials of *peshat* (plain, literal meaning); *remez* (hint, or allegory); *derash* (interpretation); *sod* (hidden, esoteric and mystical) stand for the traditional method of understanding the different levels of the Torah, especially by the small number of initiates into the mysteries of Divine Creation.

Most Jewish papercuts, with their flowing vegetation symbolizing the Tree of Life, pretty birds, and engaging animals among the foliage, all within a delimiting enclosure, indeed evoke a vision of the *PARDES* set apart from the mundane realities of the shtetl or *mellāḥ*. Dominating this pleasant setting are the fundamental symbols of Jewish belief: the large central menorah, the Crown of the Torah, the Decalogue, the architectural elements of the Temple sanctuary, the heraldic lions and griffins, the Four Animals, the sacred inscriptions — all with layers of meanings of the *PARDES* method. Minor emblems and configurations enhance the composition and reveal the folk-artist's personal touch. The whole thing suggests a graphic portrayal of deep faith, an organization of a thought system.

Moreover, as we mentioned at the outset, Jewish papercuts were generally designed and cut so as to remain in one piece and keep their shape without "slumping" when held from the upper corners. The biblical texts describing the original menorah fashioned at divine instruction to Moses in Sinai include the Hebrew phrase *"miqshah aḥat"* — "of one piece" (Exodus 25:36, 37:22), which has come to be identified with a philosophic concept of completeness and wholeness — "the absolute unity of the Divine powers."[3] Being of one piece, Jewish papercut work seemingly reflects such spiritual associations.

The quality of the actual execution of an idea by the papercutting technique varied with the ability, experience, skill, and artistic talent of the men who made the papercuts. Some of these works are small, simple, and rather crude, poignant in their aspiration to spiritual expression; others are mind-boggling, complex marvels of virtuosity and sophistication, with every possible variant in between. Almost without exception, these works are monumental in character and satisfying to the eye: cutting on a fold creates instant symmetry and lateral stability, and balance of the composition. Two-dimensionality conveys a sense of abstract space. In short, they "work" artistically. And they work well!

Most of the Jews who created these works in the traditional manner did not think of them-

selves as artists; certainly not "folk artists." They were not concerned with innovating, and used the same old symbols and constructions over and over in delineating their own, idiosyncratic, visual conceptions of holy work. The spiritual quality behind these papercuts transcends formalistic criteria for judging them as works of art.

Can we draw any conclusions regarding the geographic spread of Jewish papercutting? Judging from the presently known, recorded material, it appears that almost all the earlier works of the latter eighteenth century and the first decades of the nineteenth come from areas of Germanic cultural influence: from Alsace and the Rhineland, across Bohemia and Moravia, into Hungarian urban centers, where — unlike in Slavic Eastern Europe — the papercutting arts were well-established and popular. Most of the known East-European Jewish papercuts date from the mid-nineteenth century on; and almost all the Sephardi work is of the late nineteenth to early twentieth century. Perhaps, in German-speaking regions, some educated, intellectual Jews collected Jewish artifacts — including an occasional papercut — before such interest arose in Eastern Europe. Moreover, during the Holocaust period, large numbers of Judaica items were confiscated at Nazi-German orders from doomed Jewish communities and individuals in the German protectorate of Bohemia-Moravia, and brought to Prague for a projected museum of the "extinct Jewish people." In this way, an important corpus of ten or so old Jewish papercuts has been preserved, in addition to about fifteen other papercuts that survived the war in Czechoslovakia — most of them in Slovakia, which during the war was a pseudo-independent German puppet state. Twenty-five items are ten percent of *all* known traditional Jewish papercuts: Without this body of generally Germanic-influenced works the picture would be quite different. Thus, if it seems that in Europe the tradition spread from west to east, with a concomitant transfiguration of iconographic elements, this may well be misleading: The earliest, clearly dated, known East-European Jewish papercut is of 1810, and there must have been more.[4] As we have indicated, a large assemblage of Jewish folk papercuts collected in White Russia and the Ukrainian provinces of Volhynia and Podolia by the An-Sky expedition in 1916, and subsequently under the early Soviet regime, has never been studied or opened to public view. No doubt, such remaining material in Poland and the Soviet Union was also lost during the war years. We do not know, therefore, whether any of these works were already made in the eighteenth or early nineteenth centuries.

And so, again, it is a matter of sufficient statistical data, and all our attempts at fathoming this inspired inner world are really only impressions and speculations. After all the years we have devoted to search and study of Jewish papercuts, the basic questions still remain unanswered: How and where did it all start? What impelled so many to create these marvelously intricate works? How did they master and pass on the technique of making the papercuts? How did the Jews making papercuts learn and absorb the involved and sophisticated language of visual symbols they integrated into their creations?

Awareness of this art form in Jewish communities world-wide may yet bring to light additional clues and unrecorded items that may add to our understanding. Further study of the subject requires the development of a central photographic file and a relevant index of information, open to the concerned public, on every known, genuine, old Jewish papercut in order to provide an optimal database.

R-2a R-2b

R-2. Two of three unfinished, small papercuts, probably intended as *kimpetbrivlakh*, given to Giza Frankel by Rabbi Ḥayyim Katz Silbiger shortly before he died in Israel in the 1950s(?). He had begun them in 1892 when he was a young yeshivah student in his hometown of Oświecim (Auschwitz, in German). Note the holes in the margins made by the tacks that fixed the folded paper to the cutting board. 25 × 19 cm. (9¾" × 7½").
(*a*) Giza Frankel Archival Collection, Jewish and Comparative Folklore Department, The Hebrew University of Jerusalem. (*b*) The Sir Isaac and Lady Edith Wolfson Museum, Hechal Shlomo, Jerusalem.

Finally, we cannot end this book without stressing again the great debt that we, and all those captivated by Jewish papercuts, owe to Giza Frankel. Much of what we have learned, the additional source material we have found, the way we look at and study this wonderful folk art of our people — all derives ultimately from her research, writing, and the conversations we had with her. Who would otherwise have found the rare, early descriptions of Jewish papercuts in Polish? Who would have known to reread long forgotten, obscure publications or seek out the books and articles listed in her bibliographies, had she not shown us where to look? But for Giza Frankel, the art of the papercut might well have remained a quaint and curious, scarcely noted backwater of the Jewish cultural tradition. May this book help to keep her memory alive.

NOTES

Articles and books listed in the bibliographical sections, pp. 247–254, are given in abbreviated form in the notes.

I. PAPER, PAPERCUTTING ARTS, AND SHADOW THEATER FIGURES

1. Although this book is about Jewish papercuts, such works were not created in a cultural vacuum and can be better understood from a more general perspective. Rather than give precise references for the statements we make in the first chapter, we discuss here the relevant works of the vast source material upon which we have drawn, more or less in the order of the points we make.

Books on the history of paper, on the various papercutting traditions, and on the related arts of the silhouette and the shadow theater are legion. Material on the history and manufacturing processes of paper are on hand in most general libraries. A very detailed account of the early Spanish paper industry, and of the role played in it by Jews, is given in the introductory chapters of Oriol Vallis y Subira, *Paper and Watermarks in Catalonia,* vol. 1 (Amsterdam: Paper Publications Society, 1970).

Many of the studies of papercutting and related arts were published in Munich. A comprehensive general work on the subject in English remains to be produced. Some of the more important German books are: Martin Knapp, *Deutsche Schatten und Scherenbilder aus Drei Jahrhunderten* (Dachau: Gelber Verlag, 1916); Adolf Spamer, *Das Kleine Andachtsbild vom XIV bis zum XX Jahrhundert* (München: Bruckman, 1930 [reprinted in 1980]); Georg Jacob, *Die Herkunft der Silhouettenkunst aus Persien* (Berlin: Meyer u. Müller, 1913), and other works by the same author. All of these attempt to trace the sources and development of papercutting traditions in Europe. Probably the best summaries are to be found in Max Bucherer, ed., *Spitzenbilder, Papierschnitte, Porträtsilhouetten* (Dachau, 1920); and still from Munich, in more recent, profusely illustrated and thoroughly researched works: Sigrid Metken, *Geschnittenes Papier: Eine Geschichte des Ausschneidens in Europa von 1500 bis Heute* (München: Callwey, 1978); in Marianne Bernhard, ed., *Schattenrisse, Silhouetten und Scherenschnitte in Deutschland im 18. und 19. Jahrhundert* (München: Staackmann, 1977); and Fritz Bernhard & Fritz Glotzmann, *Spitzenbilder* (Dortmund: Harenberg, 1979).

For a brief survey of incised leather bookbinding, see Richard Ettinghausen, "Near Eastern Book Covers and their Influence on European Bindings," *Ars Orientalis* 3 (1959): 113–31; and Evgin Özdeniz, "Turkish Bookbinding," *Sanat Dünyamiz* 8, no. 21 (1981): 13–25. Studies of Medieval and later papercut work of the Turkish peoples are mainly published in Turkish. A glimpse into this marvelous world has been provided for English readers in a brief summary article by Filiz Çagman, "The Art of Paper Filigree," *Sanat Dünyamiz* 3, no. 8 (1976): 22–27. A good, short summary of the current state of knowledge about Islamic papercuts is J. M. Rogers, "Paper-Cuts," in *Islamic Art and Design 1500–1700* (London: British Museum, 1983), pp. 18–25. "Immaterial" books are described in Metken, *Geschnittenes Papier,* pp. 12–14, 26–27, which provides background material to Prof. Otto Kurz's article, "Libri cum characteribus ex nulla materia compositis," *Israel Oriental Studies* 2 (1972): 240–47 (despite the Latin title, this interesting article is written in good English). The general literature cited above, which contains much material on the papercutting traditions of many, various peoples, barely mentions Jewish papercuts.

One of the best sources on Chinese papercuts is a little book: Jutta Bewig, *Chinesische Papierschnitte* (Hamburg: Hamburgisches Museum für Völkerkunde, 1978); and an excellent work in English is Florence Temko, *Chinese Papercuts, Their History . . . How to Use Them . . . How to Make Them* (San Francisco: China Books, 1982). Egyptian shadow figures are dealt with in Paul Kahle, *Geschichte des Arabischen Schattentheaters in Aegypten* (Leipzig, 1908); and in several of his other works, one of which is a short article in English, "The Arabic Shadow Play in Egypt," *Journal of the Royal Asiatic Society* (Jan. 1940): 21–34. A small book by Metin And, *Karaköz,*

Turkish Shadow Theatre (Istanbul: Dost, 1979), is a good summary that also mentions the Jew as a stock figure in the repertoire, and Jewish artists in this popular folk entertainment. An article by Jacob M. Landau, "Shadow Plays in the Near East," *Edoth* 3 (1947–48): xxiii–lxiv and bibliography, pp. 70–72, deals mainly with Arabic shadow plays, including those in Palestine of the 1940s when the art was giving way to the cinema. For a general overview of the shadow theater arts, see Olive Blackham, *Shadow Puppets* (London: Barrie & Rockliff, 1960).

Central European — German, Swiss, Austrian, French, and Dutch — and some English papercuts and silhouettes are amply discussed in the German works mentioned above and in a few English ones. Concise information on ornamental and lace-like machine die-cut paper work is provided in two exhibition catalogs on the subject: Wolfgang Brückner, *Papier-Ornamentik: Prägedrucke und Standsspitzen des 19. Jahrhunderts* (Würzburg: Städtischen Galerie, 1977); and Theo Gantner et al., *Papier-Ornamentik: Prägedruck, Glanzbilder, Oblaten, Scraps im 19. Jahrhundert* (Basel: Schweizerisches Museum für Volkskunde, 1979). Papercutting in the Netherlands is discussed in a most informative booklet with a good bibliography, in Dutch, by Joke Verhave & Jan-Peter Verhave, *Schaarkunst* (Arnhem: Vrienden van het Nederlands Openluchtmuseum, 1983). The same authors also produced a beautifully illustrated, important monograph on the naive work on biblical themes by Jan de Knipper I: *Jan de Prentenknipper (1798–1870) Zeeuwse Volkskunst langs 's Heeren wegen* (JS Goes: De Koperen Tuin, 1993). Polish *wycinanki* are described in detail in Jozef Grabowski, *Wycinanka Ludowa* (Warszawa: Sztuka, 1955); and American papercuts in the German (Pennsylvania Dutch) tradition by Claudia Hopf, *Scherenschnitte, Traditional Papercutting* (Lebanon, Pa.: Applied Arts, 1972). A book on Mexican papercuts is Alan R. Sandstrom and Pamela Effrein Sandstrom, *Traditional Papermaking and Paper Cult Figures of Mexico* (Norman: University of Oklahoma Press, 1986).

2. JEWISH PAPERCUTTING TRADITIONS IN ASHKENAZI AND SEPHARDI COMMUNITIES

1. Rabbi Shem-Tov Ardutiel's humorous fourteenth-century *"Milḥemet ha-et ve-ha-misparayim"* was reprinted in Hebrew Rashi type in: Ashkenazi, *Sefer divrei ḥakhamim*. A more recent edition is: Shepard, *"Shem Tov, His World and His Words."* And see also: Kurz, "Libri."

2. Narkiss, *"Ḥittuv n'yar yehudi,"* pp. 29–30, mentions one Moses Goldschmidt-Friedstadt, a converted Jew from Frankfurt, who in 1647 was adept at cutting paper. Unfortunately, Narkiss does not indicate his sources. Johanna Koerten, a Dutch papercutter in 1736(?), wrote about two brothers — Jacobus and Leonor Gadella, or Gadelha — members of the Amsterdam Portuguese Jewish community, who were famous calligraphers and also did cut-paper work. See also J. S. Da Silva Rosa, *Geschiedenis der Portugeesche Joden te Amsterdam 1593–1925* (Amsterdam: Hertzberger, 1925), pp. 102–3, which refers to Leonor Gadella as "she." The story of 1853 is mentioned in R. B. Evenhuis, *Ook datt was Amsterdam* 4 (Baarn: Ten Have b.v., 1978), p. 233. We are indebted to Joke and Dr. Jan Peter Verhave for extensive information on Dutch papercuts, including Jewish involvement in this art form. Surprisingly, no "classic"-type Jewish papercuts are known from the Netherlands.

3. See listing of articles and books by Shalom Sabar on *ketubot*, including with cut-out decorative elements, in the Selective Bibliography at the end of this book. Sabar also contributed the informative introductory chapter to Marach et al., *Ebrei a Lugo. I contratti matrimoniali.*

4. The main earlier English texts on Jewish papercuts are almost exclusively by Giza Frankel, the two most important ones being her articles "Paper Cuts" in the *Encyclopædia Judaica* (1971), and "Paper-cuts Throughout the World and in Jewish Tradition" (1976). Her Hebrew book, *Migzarot n'yar* (1983) and its posthumously published, slightly diminished 1996 edition, also with English texts, *The Art of the Jewish Paper-cut*, with its many color and other reproductions make it an indispensable work. The text essentially repeats her earlier writings (but see our remarks on p. 192).

Giza Frankel's basic writing on the subject is found in the two articles in Polish listed in the Bibliography. An important article, from which Giza Frankel also drew, was published in a small periodical for educators by Mordekhai Narkiss, the director of the Bezalel School of Arts and Crafts in Jerusalem (see note 2 to this chapter). Narkiss purported to trace the history and types of Jewish papercuts in various parts of the Diaspora, writing among other things:

There is no doubt that this craft [papercutting] originated with Oriental Jews. The best testimony of this is that the motifs of Western and Eastern European Jewish papercuts are also the favorite designs of the Oriental Jews — in Baghdad and North Africa. In both these distant regions the white areas constitute the picture and not the black ones! This is how we found the *shiviti* cut out of parchment or paper in Poland or all of Germany, as it is found in quantities in Baghdad. In Baghdad it is known as "menorah" because the central motif is a seven-branched menorah, with the usual *shiviti* inscription above it. These menorahs in Baghdad were made as special presents for the Jewish boy, being given him by his teacher for Ḥanukkah. Here too, the menorah is white with flanking gazelles and the like, just as it is in Poland.

For comprehensive, illustrated material on Sephardi Jewish papercuts in the Ottoman Empire see Juhasz, "Paper Cuts," pp. 238–53; and see also a condensed version by her, under Yohas, "Battles Between Pen and Scissors."

5. The purposes for which papercuts were made and their Hebrew and Yiddish appellations are listed and explained in chapter 3.

6. The incidental mention of this practice by Narkiss in "*Hittuv niyyar yehudi*," p. 31, has since been much amplified in Hoz, "The Heart and Its Variations on Jewish Bookbindings." Yael Hoz's meticulous research has shown how widespread the custom was in both Ashkenazi and Sephardi communities.

7. G. Frankel and other authorities state that Jewish papercuts were exclusively the work of men and boys. Kleeblatt & Wertkin, "Jewish Folk Art in America," p. 27 and note 23, draw attention to a woman who made papercuts. See also Item 123, p. 115 in the same work. And see Piercy, "Snowflakes, my mother called them." According to Marge Piercy (personal communication of 31 May 2000), her grandmother (born Levy), the daughter of a rabbi in a small Lithuanian shtetl, who apparently went to Philadelphia in about 1900, used small scissors and a small scalpel-like knife to make her papercuts.

8. Lilientalowa, *Świeta Żydowskie*, p. 60.

9. G. Frankel, "Wycinanka Żydowska," p. 8.

10. Narkiss, "*Hittuv n'yar yehudi*," p. 30.

11. Weyl et al., *L'imagerie populaire juive,* second (unnumbered) page of text.

12. Olga Goldberg-Mulkiewicz, "Przenikanie Elementów," pp. 105–12, and abstract on p. 141. In her article, the author mentions the work of two Polish scholars, Aleksander Błachowski and Stefan Czarnowski, who touched upon this question.

13. See Kampf, quoting Dobrushin, "In Quest of the Jewish Style," p. 61.

14. On the "Jewish Baroque," also in the text following, see Wischnitzer, "Judaism and Art," pp. 1338, 1345 and note 48; and Kayser's introduction to *Jewish Ceremonial Art*. Kampf, "In Quest of the Jewish Style," pp. 48–75, discusses, among other things, the symbolism, spirituality, and abstract character of the legendary creatures depicted in the Jewish folk art of Eastern Europe. Metzger, "Style in Jewish Art," pp. 181–93 and separate introduction, does not relate to nineteenth-century Eastern Europe.

15. Lissitzky, "*Vegen der mohilever shul*," pp. 9–13.

16. Ibid., pp. 12–13 (my translation from the Yiddish, J.S.).

17. Wischnitzer, "Judaism and Art," pp. 1336–37. Relevant remarks on the baroque quality of Jewish synagogue wall painting in Poland are also provided by Davidovitch, *Tziyurei qir*, pp. 20–24.

18. See Wischnitzer, "Judaism and Art," p. 1345 and note 48, for additional sources.

19. Greenwald, "The Masonic *Mizrah*," pp. 87–101; and see also Kleeblatt et al., *The Jewish Heritage*, Item 46, p. 57, and Item 98, pp. 100–101.

3. USES, SYMBOLS, AND INSCRIPTIONS

1. See, for example, Greenwald, "The *Mizrah* — Compass of the Heart," pp. 12–13.

2. See, for example, Juhasz, "The Amuletic Menorah."

3. Schrire, *Hebrew Amulets*, pp. 18, 116–18, ascribes the first mention of these angels to Sefer (the Book of) Raziel 43b. And see D. Goldstein, *Jewish Mythology*, pp. 28–30.

4. See note 3 to chapter 2.

5. Zohar Emor 5, 103b–104a.

6. Ta'anit 29:71 (29a–b).

7. Considering the vast amount of research and writing on Jewish art, it is surprising that no definitive work on Jewish iconography exists. A pioneer work in this field was Wischnitzer-Bernstein,

Gestalten und Symbole der Jüdischen Kunst (1935). Good-enough's monumental thirteen volume *Jewish Symbols in the Greco-Roman Period* (1954–1968) provides important clues but does not deal with the iconography of Jewish religious art in more recent centuries, some of which is touched upon in Huberman, *Living Symbols* (1988). Other useful contributions to the subject are: Kanof, *Jewish Symbolic Art* (1990); E. Frankel & Teutsch, *Encyclopedia of Jewish Symbols* (1992); Hubka, "Gwozdziec Synagogue" (1996); Klagsbald, *A l'ombre de Dieu* (1997); Israeli, *In the Light of the Menorah* (1999). But many questions still remain.

8. Wischnitzer, *Gestalten und Symbole*, pp. vi–vii (my translation from the German, J.S.)

9. Exodus 25:31–40; 37:17–24; on Zechariah 4, see particularly Klagsbald, *A l'ombre de Dieu*, pp. 1–2; Idel, "*Binah*, the Eighth *Sefirah*."

10. Menahot 28b; Avodah Zara 43a; Rosh Hashana 24b.

11. Gutmann, *The Jewish Sanctuary*, pp. 18–20 and notes 14 and 15.

12. Pirqei Avot 4:17.

13. We draw attention to Prof. Daniel Sperber's important point regarding deeper, added meaning of the concept "*keter*" in his Foreword to this book.

14. Mellinkoff, "The Round-Topped Tablets," pp. 28–43.

15. Shabbat 133b.

16. I Chronicles 29:23.

17. This perhaps reflects the legend of the gates of Nikanor in the Tosefta Yoma 2:4 and the Babylonian Talmud, Yoma 38a.

18. I Kings 7:15–22; II Chronicles 3:15–17.

19. Yaniv, "The Origins of the 'Two-Column Motif' in European Parokhot," purports to show that representations of free-standing columns derive originally from an entire "gateway," symbolizing the Torah shrine behind the *parokhet*. While this may be so regarding *parokhot*, in some of the papercuts (e.g., Figs. 4.30a–b; and see also the lithographed *mizrah* no.60, p. 79 in Kleeblatt & Wertkin, *The Jewish Heritage*) such columns are clearly inscribed "Yakhin" and "Boaz." In any case, both the curtain (*parokhet*) in front of the Holy of Holies and the two columns were posited near each other.

20. See, for example, Gutmann, *Beauty in Holiness*, pp. 149–51.

21. For example, Genesis 28:17; Psalms 24:9, 100:4, 118:19–20; Bereshit 32b. And see E. Frankel & Teutsch, "Gates," *Encyclopedia of Jewish Symbols*, pp. 129–30, "Portal."

22. Gutmann, *The Jewish Sanctuary*, pp. 13–14; Shabbat 22b; Shemot Rabbah 36:1.

23. Exodus 27:20, 35:14, 39:37; Numbers 4:16; Zechariah 4:3, 11, 12, 14; and see also the Hebrew Union College catalog, *Mizrah: Compass for the Heart*, p. 6, explanation to no. 10.

24. See Scholem, *On the Kabbala*, p. 60.

25. For a concise discussion of the interrelationship of the Tree of Life and the menorah in the Kabbalah, see Huberman, *Living Symbols*, pp. 33–34; and Frankel & Teutsch, *Encyclopedia of Jewish Symbols*, pp. 181–82.

26. For example, Shemot Rabbah 44; Vayiqra Rabbah 36; Midrash Shemuel 16; and others.

27. Ḥullin 92a.

28. Middot 3:28.

29. Genesis 49:9.

30. Huberman, "The Double-Headed Eagle," pp. 45–51.

31. Exodus 25:19, 37:8.

32. Landsberger, "Old Time Torah Curtains," p. 158.

33. Ḥullin 63a.

34. Ginzberg, *The Legends of the Jews*, vol. 4, pp. 157–58.

35. Ferguson, *Signs and Symbols*, p. 23.

36. See, for example, Belinfante & Dubov, *Tracing An-Sky*, p. 111; Frankel & Teutsch, *Encyclopedia of Jewish Symbols*, p. 55 ("Fish").

37. Eruvin 100b.

38. Berakhot 60b. In the Kabbala, night is the time of Divine judgment, and day the time of grace.

39. Berakhot 58b.

40. Berakhot 56b, 57a.

41. Shulḥan, Arukh, Orekh Ḥayyim 128:12.

42. Although the representation of human figures was generally considered taboo, it was done occasionally as a prank. The collector Josef Reizes, in "Jüdische Volkskunst," p. 51, tells of acquiring a *shavuosl* depicting Moses and Aaron at Mount Sinai from an elderly Jew who had just finished cutting it. The man had a peculiar look — a mixture of fear at having committed a transgression and of childish pleasure at the joke (see Fig. 2.18). The much-discussed problem of the human figure in Jewish ritual art cannot be pursued here.

43. For detailed renderings and some elucidation of the esoteric formulas, acronyms, anagrams, and other word and letter combinations so common in Jewish mystic folk practice, see Shachar's Hebrew and English catalogs of the Feuchtwanger Collec-

tion, particularly the chapter on "Amulets," pp. 236–317, and the bibliography on p. 332, of the English version.

4. A CLOSER LOOK AT SOME JEWISH FOLK PAPERCUTS THROUGHOUT THE DIASPORA

1. We particularly thank Olga Sixtová, of the Prague Jewish Museum, for her efforts and helpfulness in providing the photographic material and information about this rare, very early papercut.

2. The other one, owned by Michael Strassfeld of New York, is depicted in Shadur & Shadur, *Jewish Papercuts*, p. 41, Fig. 69. We are much indebted to Lee K. Vorisek of Metairie, Louisiana, for providing most of the information and documentation about his great-grandfather, Aaron Katlinsky.

5. STUDIES AND CONJECTURES IN SOURCES, SYMBOLISMS, AND TECHNIQUES

1. This section is a revised version of our article by the same title in *Jewish Art* 16/17 (1990/91): 6–11.

2. G. Frankel, *The Art of the Jewish Paper-cut*, pp. 22–23.

3. "Old Yishuv" refers to the traditional Jewish communities of the nineteenth and early twentieth centuries in the Land of Israel, as distinct from "New Yishuv," which represents the beginnings of modern Zionist settlement from the 1880s.

4. *Encyclopaedia Judaica*, vol. 8, col. 337, fig. 5.

5. Fisher, *Omanut ve-umanut be-eretz-yisra'el*, fig. 156.

6. Ibid., pp. 173–209, figs. 153, 154, 159, 160.

7. See, for example, Juhasz, "*Migzarot n'yar*," pp. 246–47.

8. A few such configurations are known from non-Jewish decorative contexts, such as on the facade of the Church of San Miniato al Monte in Florence, in the Cappelina del Perdono in the ducal palace of Urbino, and in some Victorian neo-Renaissance cast-iron balustrades.

9. G. Frankel, *Papercuts for Shavuoth*, illustration no. 9, p. 24.

10. See Gutmann, "Leviathan, Behemoth and Zis;" Vayiqra Rabbah 13:3; Yalqut Shim'oni Vayiqra §535.

11. For example, Goberman, *Jewish Tombstones in Ukraine and Moldova*, figs. 31, 32, 158.

12. For example, Baba Bathra 74b–75a, and elsewhere.

13. Krajewska, *Time of Stones*, pp. 44, 45, 69. We are grateful to the author for providing us with her photographs, including a previously unpublished one. (We cannot resist here the Yiddish story about the small boy wandering through the old cemetery on the ninth of Av with his father and reading the sententious epitaphs about the "righteous man" this, and the "guileless and upright man" that. After a while he asked: "*Tattenyu* [Daddy], don't thieves ever die?")

14. According to Zusia Efron of Jerusalem, a knowledgeable authority on Jewish folk art and founder of the Mishkan LeOmanut Museum at 'Ein Harod, the sea-lion was indeed one of the configurations representing Leviathan (personal communication). We are grateful for having been allowed to see his manuscript article on the Leviathan in Jewish art.

15. The complexities of the unicorn/*shor ha-bar*/*re'em*/Behemoth in Jewish folklore have been treated in Jewish encyclopedias, compendiums such as Ginzberg, *Legends of the Jews*, and monographs, among them: Cohen, *Geschichte des Einhorns*. And see also: Schreiber, *Enhörningen*.

16. See, for example, Goberman, *Jewish Tombstones in Ukraine and Moldova*, figs. 35 (fish-tailed unicorn), 41, 68, 75, 103, 104, 172, 188, 228.

17. At about the same time (the late 1970s), our own conclusions were reinforced and confirmed by Brakha Yaniv's paper, "*Migzeret ha-mizrah*," in which she analyzed the hierarchic arrangement of the symbols in some East-European Jewish *mizrah* papercuts and other work.

18. For "endless-knot" (*tashliv*, in Hebrew), often labeled *tzeror ha-mor*, motifs that are part of the decorative repertoire in Italian *ketubot* of the late seventeenth to the mid-nineteenth centuries, see, for example, Sabar, *Ketubah*, pp. 74–75, 164–165, 170–171, 182, 231, 259; Sabar, *Mazal Tov*, pp. 38–39, 58–59, 60–61, and others. Calligraphic title pages of East-European Jewish community and congregational *pinqassim* (minutes books, ledgers) with endless-knot designs are illustrated in Rakitin & Sarabianov, *An-Sky*, pp. 83, 86, 92, 96, 111, and elsewhere.

19. See Goberman, *Jewish Tombstones in Ukraine*

and Moldova, figs. 107–108, 110, 120–121, 130, 134, 143, 171, 216, 221.

20. See, for example, articles on "Kabbala," "Tree of Life," "Ein Sof," and the like in the *Encyclopædia Judaica*. For recent, concise discussions of the interrelationships of the Menorah and Tree of Life in the Kabbala, see Huberman, *Living Symbols*, pp. 33–34; Klagsbald, "La Menorah et le vêtement de Dieu," Idel, "*Binah*, the Eighth *Sefirah*."

21. Katz, "Eine Misrachtafel."

6. JEWS IN SILHOUETTE

1. Jackson, *History of Silhouettes*, p. 90; Hallo, *Jüdische Volkskunst*, p. 41.

2. Quoted in Rowidowicz, *Moses Mendelssohn*, pp. l–li.

3. We are indebted to Ori Soltes, the former Director of the B'nai B'rith Klutznik National Jewish Museum, Washington, D.C., for this and other important remarks expressed in his review of our previous book, *Jewish Papercuts: A History and Guide*, in *Moment* magazine of October 1994, p. 99.

4. Baerwald & Baerwald, *Esther*; Goldschmidt, *Megillat Esther*.

7. DOCUMENTING A TRADITION

1. See note 3 to chapter 6.

2. Zobrowski & Herzog, *Life is with People*, p. 364.

3. Lilientalowa, *Świeta Żydowskie*.

4. Kampf, "In Quest of the Jewish Style," p. 49ff; Belinfante & Dubov, *Tracing An-Sky*, pp. 16–23.

5. Personal communication from Giza Frankel. In 1969, Ziasewa & Shangina wrote an article, "*Yiddishe kolektzies*," in the Yiddish periodical *Sovetish Heimland* 1:147–48, about papercuts as an important category among the Jewish Collections in the Leningrad Ethnographic Museum.

6. Kampf, "In Quest of the Jewish Style," pp. 61–62; Belinfante & Dubov, *Tracing An-Sky*, p. 47.

7. Belinfante & Dubov, *Tracing An-Sky*, pp. 52, 75, 84.

8. Harel-Hoshen, *Treasures of Jewish Galicia*, pp. 8, 71 (note 28), 75.

9. Goldstein & Dresdner, *Kultura i Sztuka Ludu*, pp. 80–82, 186.

10. Harel-Hoshen, *Treasures of Jewish Galicia*, pp. 10, 62–63, 67, 79–80, 179.

11. Reizes, "Jüdische Volkskunst."

12. Museum Ha-Aretz, *Paper Cuts for Shavuoth*.

13. Shachar, *Jewish Tradition in Art*, figs. 110, 112, 114, 783.

14. Doleželová, "Mizrahs from the Collection," pp. 14–28; and see Pařík, "Die Bildersammlung," pp. 75–78, and Petrášová, "Collections of the Central Jewish Museum," p. 29. We are particularly grateful to Michaela Hájková and Olga Sixtová of the curatoria of the Prague Jewish Museum; to Prof. Pavol Mešťan, the director of the Museum of Jewish Culture in Bratislava, and to Katarína Kušanová; to Imrich Kónya of the Prešov Jewish Museum; and to Gabriele Kohlbauer-Fritz and Christa Prokisch of the Vienna Jewish Museum, for the important information and photographic material on the papercuts in their collections.

15. Kleeblatt & Wertkin, *The Jewish Heritage*, pp. 62, 74, 88, 90–91, 98–99, 100–103, 115.

16. Personal communication from Penina Halevy, Kibbutz Ḥatzor-Ashdod.

17. Wisnitzer, *Migzarot*.

18. Tel Aviv Museum, *Ta'arukhat migzarot*.

19. Haifa Municipality, *Migzeret n'yar yehudit*; Haifa Municipality, *Migzarot n'yar shel ha-tzayar yehoshua' grossbard*.

20. Haifa Municipality, *The Papercut*.

21. Gingold, "Revival of a Jewish Folk Art," pp. 38–39 and cover; Kahane, "Folk-Art of Paper-Cutting."

22. Yeshiva University Museum, *Papercuts: A Contemporary Interpretation*. See also "'The Story of Ruth' — Papercuts by Tsirl Waletzky at the Yeshiva University Museum," *World Over* 38, no. 16 (1977): 11.

23. Ronnen, "Cutting Out Judaica."

24. Hoz, *World Papercuts*.

8. MULTIPLES, IMITATIONS, AND FRAUDS

1. On such practices in the field of Judaica, see Cecil Roth (1967), "Caveat Emptor Judaeus," *Commentary* 43, no. 3 (1967): 84–86; Shachar, *Osef Feuchtwanger* in Hebrew, p. 12, and the English edition, *Jewish Tradition in Art*, pp. 7–8; Eli Davis & Elise Davis (1977) *Jewish Folk Art over the Ages*, Jerusalem, pp. 14–15; Jay Weinstein (1985), "Fakes and Forgeries," in *A Collector's Guide to Judaica* (New York & London: Thames & Hudson, 1985), pp. 226–33; Bernard Josephs & David Rudge (1987), "They are

Beautiful, Costly — and Fake," *Jerusalem Post*, 13 Feb. 1987, 5 and *Jewish Chronicle*, 6 March 1987, 27; Shalom Sabar (1989), "Fakes and Forgeries of Jewish Marriage Contracts, Then and Now," *Jewish Art* 15 (1989): 44–60; Alfred Moldovan (1993), "Foolishness, Fakes and Forgeries in Jewish Art," in Clare Moore, ed., *The Visual Dimension: Aspects of Jewish Art* (Boulder: Westview), pp. 105–19. Except for a few words by Eli and Elise Davis on Persian-Jewish cut-out amulets, none of these writers deal with Jewish papercuts.

2. Weyl et al., *L'imagerie populaire juive*, second (unnumbered) page of text, and Figs. 2.19, 3.7, 3.8, etc.

3. This item was subsequently reproduced in Frankel, *The Art of the Jewish Paper-Cut*, p. 19.

4. Goldstein & Dresdner, *Kultura i Sztuka Ludu*, pp. 46, 53, 162, 166. And compare G. Frankel, *The Art of the Jewish Paper-cut*, p. 45 with Goldstein & Dresdner, p. 162; G. Frankel, p. 73, with Goldstein & Dresdner, p. 46. G. Frankel, p. 71 is largely

copied, albeit with some changes, from a memorial-book cover design commissioned by Goldstein from an artist named Sz. Sack and depicted in Goldstein & Dresdner, p. 166.

5. Quoted from W. M. Ivins, *How Prints Look* (Boston: Beacon Press, 1958), title page.

RETROSPECT: THE ART OF THE JEWISH PAPERCUT

1. Quoted by A. Kantsedikas in Rakitin & Sarabianov, *An-Sky, Semyon*, pp. 47 and 17, respectively.

2. From the introduction to the memorial booklet by Wisnitzer, *Migzarot*.

3. Idel, "*Binah*, The Eighth *Sefirah*," p. 144ff, touches upon this mystic concept and cites several literary references.

4. See G. Frankel, *The Art of the Jewish Paper-Cut*, p. 29; Shadur & Shadur, *Jewish Papercuts*, Plate 15 (and perhaps also Plate 6).

GLOSSARY

Aggadah: Non-legal (non-*halakhic*) passages in the Talmud and the Midrash comprising Biblical tales, fables, folklore, anecdotes, stories about sages, philosophical, medical, and other material.

Andachtsbilder: Literally, "devotional pictures," often cut in paper or parchment, popular in Catholic Germanic regions at least from the seventeenth century on. (See also *Spitzenbilder*.)

Apotropaic: Designed to avert or turn aside evil through magic, ritual, or incantatory formulas.

Ark; Holy Ark: Chest or other receptacle, usually a decorated wall closet at the east-facing wall of the synagogue, in which Torah scrolls and other sacred objects are kept.

Aron(ot) qodesh: Hebrew for "holy ark(s)" — the Torah shrine in the synagogue.

Ashkenazi(m): "German"; Yiddish-speaking Jewish communities or individuals of Central and Eastern European origin, having different customs, liturgy, and institutions than those of Sephardi and other Jewish communities.

Baroque: Style of art popular in sixteenth to eighteenth century Europe, characterized by highly ornamental, mainly curved lines, sometimes fantastically overdecorated.

Belfer(s): "Helper" in Yiddish, young assistant teacher in a *heder*.

Bimah: Raised podium in the synagogue from which the Torah is read.

Birkat ha-mazon: Hebrew for the "blessing over food" said after meals.

B'rith milah: Ritual circumcision ceremony of entering into the Covenant of Abraham, performed by a *mohel* on the eighth day after the birth of the baby boy.

Dreidel: Small top with which children play on Hanukkah.

Gemara: The second, supplementary part of the Talmud, providing commentaries on the first part, the Mishna; the term "Gemara" is often used interchangeably with "Talmud."

Genizah: Repository, often in attics or annexes to synagogues, for worn and discarded Hebrew texts and ritual objects containing the name of God, which may not be destroyed.

Göstermelik: Decorative, cut-out device hung between acts on the lit screen of the Turkish Karagöz shadow theater.

Grogger: Yiddish word for noisy rotary rattle twirled during the reading of the Scroll of Esther in the Purim liturgy every time the despised name of Haman is mentioned.

Haggadah: Literally, "narrative"; a book, often illustrated, that contains the home service for the Passover seder.

Hiddur mitzvah: Literally, Hebrew for "glorification, or 'making splendid' the commands (for worship)."

Horror vacui: Aversion to empty space in decorative art.

Hallah: Twisted loaf of white bread eaten at the Sabbath and holiday meals.

Hamsa: Arabic for "five"; refers to depiction of the palm of the five-fingered hand in a gesture of warding off the evil eye.

Hanukkah: Hebrew for "dedication"; the eight day-long Feast of Lights, usually falling in December, commemorating the rededication of the Temple in the second century BCE.

Hazzan: Cantor who sings the liturgy in the synagogue.

Heder: Hebrew for "room"; in Yiddish it refers to a place of study or school room where very young boys learn the sacred texts.

Hummash(im): From the Hebrew word *hamesh* (five); any one or all of the five books of the Torah.

Kabbalah: Literally, Hebrew for "reception"; a mystic movement in Judaism, mainly developed since the Middle Ages, with a complex system of interpretations and beliefs seeking hidden meanings in the Scriptural texts.

Kaporet: Valence hung at the top in front of the *parokhet* of the Torah shrine (holy ark) in the synagogue.

Karagöz: Eponymous hero of the Turkish shadow theater, also in Greek and Arabic versions.

Keter (pl. ketarim): Hebrew for "crown."

Ketubah (pl. ketubot): Literally, Hebrew for "the written one"; the written contract of marriage given to the bride at the wedding.

Kimpetbrivl (pl. kimpetbrivlakh): Yiddish diminutive for the German *Kindbettbrief*— "childbed letter"; an amulet hung over the baby's crib to ward off evil influences (see *Shir hamalosl*).

Liebesbrief: German for "love letter"; a popular type of written and decorated, often paper-cut message of affection popular in German-speaking regions from the seventeenth century on.

Lilith: In medieval and later Jewish folk demonology, Adam's first wife before Eve was created; a nocturnal witch who harms and snatches newborn babies.

Lulav: Palm branch bound together with myrtle and willow twigs used in the Sukkoth liturgy and in the *sukkah*.

Maghreb: Arabic for "west"; the term designates the western North African Muslim countries.

Megillat (pl. megillot) esther: Scroll(s) of the Book of Esther read publicly in the synagogue during Purim.

Mellāḥ: Jewish quarter of North African towns.

Menorah (Hebrew pl. menorot): Seven-branched candelabrum; the oldest and most important symbol of Judaism; the term indicates a type of wall plaque having a menorah as its central motif.

Midrash(im): Literally, Hebrew for "study, or interpretation"; the vast corpus of literature explaining the essence of various biblical passages, largely dealing with details of observance.

Mishnah: Literally, "repetition, teaching, study"; the collection of oral legal traditions that is the basis of the Talmud. It consists of six "Orders" divided into sixty-three Tractates.

Mizraḥ: Hebrew for "east," literally, the "place of shining (of the sun)"; indicates the direction of prayer, toward the Temple site in Jerusalem.

Ner zikaron (pl. nerot zikaron): Literally, Hebrew for "fire (candle) of remembrance"; lit on anniversaries of death of family members or on national days of mourning.

Omer: Literally, "sheaf of grain"; the period of seven weeks from the second night of Passover to Shavuoth; "counting of the Omer" — *sefirat ha-'omer* — entails a prayer for each day, with special wall calendars often used to keep track of these days.

Parokhet (pl. parokhot): Ornamental curtain hung in front of the doors of the holy ark in the synagogue.

Pessaḥ: Literally, "passing over"; Passover, one of the main Jewish festivals usually falling in March or April, which commemorates the liberation from bondage in Egypt.

Pinqas(im): Notebook(s) or ledger(s) of benevolent society and other community social organization and/or study group of religious texts, usually with calligraphic and hand-decorated title page and/or cover.

Pirqei Avot: Literally, "Chapters of the Fathers"; parts of the Mishnah that were given special place in the liturgy, rich in aphorisms and moral sayings by revered rabbis.

Purim: Joyous minor festival, usually falling in February, commemorating the providential deliverance of Jews in Persia from destruction by Haman as related in the Book of Esther.

Purimshpil: Yiddish for "Purim play," based on the Book of Esther and performed during the festival.

Qiddush (also sp. kiddush): Literally, "sanctification"; the benediction over wine said before the Sabbath and festival evening meal and after the morning service the following day.

Rashi: Acronym of "Rabbi Shelomo ben Yitzḥaq" (1040–1105), a major commentator on the Scriptures and Talmud; "Rashi script" is a distinct way of forming Hebrew letters.

Register: A horizontal or vertical spatial division of a pictorial composition.

Roizalakh: Yiddish diminutive for "rosettes"; small papercut decorations pasted on window panes in honor of the Shavuoth festival (see *Shavuosl*).

Scherenschnitt: German for "scissors cut" or papercut.

Scroll of the Law; Torah scroll: Handlettered text of the Pentateuch (the five Books of Moses) on a sewn parchment scroll wound on two wooden spindles having turned handles.

Seder: Literally, "order"; the festive ritual Passover meal and its liturgy.

Sephardi: Oriental, North-African, and Ladino-speaking Jewish communities or individuals, initially of medieval Spanish and Portuguese origin, having traditions, liturgy, and customs different from Ashkenazi and other communities.

Servitor: The ninth light (candle or oil container)

of a Ḥanukkah lamp; the light of the eight regular lights may only be looked at, not used, hence an extra one is provided with which the others are lit.

Shavuosl(akh): Yiddish diminutive, meaning "little Shavuoth"; small papercut decorations pasted on window panes in honor of the festival (see *Roizalakh*).

Shavuoth: Hebrew for "weeks"; the solemn Feast of Weeks (Pentecost) at the end of the Omer period of forty-nine days after Passover, commemorating the giving of the Torah on Mount Sinai.

Shir hamalosl(akh): Yiddish diminutive meaning "little Song of Ascents" (the beginning words of Psalm 121), used as an amulet to protect newborn babies and nursing mothers (see *Kimpetbrivl*).

Shiviti: Hebrew for "I have set," the opening word of the verse from Psalm 16:8 ("I have set the Lord always before me"); indicates a type of wall plaque having much the same function as a *mizraḥ*.

Shofar: Ram's horn trumpet sounded in the Rosh Hashana (New Year) liturgy and on specially festive and solemn occasions.

Shtetl(akh): Yiddish for "little town(s)"; refers to Jewish townlets in Eastern Europe before the Holocaust.

Shul: Yiddish for synagogue; from the German *Schule* — school.

Shulḥan 'Arukh: Literally, "set table"; a comprehensive codification of Jewish law compiled in the sixteenth century.

Simḥat Torah: Literally, "rejoicing in the Torah"; the happy festival that concludes the Sukkoth week to celebrate the conclusion and the new start of the annual Torah-reading cycle in the synagogue.

Sofer stam (pl. sofrei stam): Traditional scribe who copies *sefarim* (books = Torah scrolls), *tefillin* (phylacteries), and *mezuzot* (the declaration of faith written on parchment and affixed to doorposts of Jewish houses).

Spitzenbilder: German for "lace pictures"; small, mainly devotional papercuts with finely cut, pricked, or punched lace-like designs, popular in Central Europe from at least the seventeenth century on. (See also *Andachtshilder*.)

Sukkah: Hebrew for "booth"; specially constructed and decorated for Sukkoth where the family is enjoined to spend most of its time during the festival.

Sukkoth: "Booths"; the Feast of Booths (Tabernacles) commemorating the sojourn in the desert after the exodus from Egypt and the end of the harvest season at the end of fall.

Talmud: Literally, "study, or learning"; the great corpus of Jewish law and tradition comprising the Mishnah and the Gemara. Two versions exist: the shorter Palestinian or Jerusalem Talmud, and the Babylonian Talmud.

Tetragrammaton: The four Hebrew letters *yod*, *heh*, *vav*, *heh*, that make up the ancient ineffable name of the Almighty.

Torah: Literally, "teaching, guidance, instruction"; the Pentateuch or the first five books of the Bible; the Law.

Torah mantle: Specially tailored and often finely embroidered slip-cover for the entire Torah scroll and the spindles on which it is rolled.

Tzitzit (pl. tzitziyot): Literally, "fringe," or "tassel" of devotional significance at the four corners of a special small shawl worn by men and boys under their upper garments; also at the four corners of the *tallith* (prayer shawl).

Ushpizin: Aramaic for "guests" traditionally welcomed in the *sukkah*.

Wycinanki: Polish for "cut-outs."

Yad (pl. yadayim): Hebrew for "hand"; like the *hamsa*, serves as an amulet to ward off the evil eye and to bring luck among Sephardi and Oriental Jewries.

Yeshivah (pl. yeshivot): Literally, "sitting, session"; a higher school for study of the Talmud.

Yortzait: Yiddish, from the German *Jahrzeit*; refers to the day of remembrance of deceased family members when a memorial candle (*ner zikaron*) is lit and the prayer for the dead is recited.

Zohar: Literally, "splendor"; the Book of Splendor (Zohar) is the most important kabbalistic work, containing many mystical interpretations and speculations on Scriptural and Messianic themes.

BIBLIOGRAPHY

SELECTIVE BIBLIOGRAPHY OF
JEWISH PAPERCUTS

American Cultural Center (1981). *Paper Cuts: Yehudit Shadur.* Exhibition catalog edited by Tova Tsuriel; 12 Dec. 1981–22 Jan. 1982, with introduction by Yehudit and Joseph Shadur. Tel Aviv: U.S. Cultural Center.

Ardutiel, Shem-Tov bar Yitzhak (1849). *"Ma'asseh ha-rav don shem-tov bar yitzhaq ardutiel"* (The Feat of the Rabbi Don Shem-Tov bar Yitzhak Ardutiel), in *Sefer divrei hakhamim* (Book of the Sayings [Acts] of the Sages), ed. Eliezer Ashkenazi (of Poland). Metz: J. Mayer Samuel. Vol. 70, pp. 47–55. (Hebrew).

Avrin, Leila (1995). "Jewish Papercuts, A History and Guide" (book review). *Hadassah Magazine* (February): 45–48.

Baerwald, Alex, and Lotte Baerwald (1920). *Esther. Ein Schattenspiel für Jung und Alt.* Berlin: Welt-Verlag.

Bar-Or, Galia (1980). *Migzeret ha-n'yar ha-yehudit, masoret 'ammamit nimshekhet* (The Jewish Papercut, A Continuing Popular Tradition). Explanatory leaflet for exhibition of Jewish papercuts at the Mishkan le-Omanut, En Harod, Shavuoth 5740. (Hebrew).

Beck, Mordechai (1996). "Jewish Papercuts: A History and Guide" (book review). *Letter Arts Review* 13, no. 3: 52–53.

Behrouzi, Nitza (1995/96). *Jerusalem from Generation to Generation: Papercuts by Yehudit Shadur.* Catalog of Exhibition of the Ethnography and Folklore Pavilion. Tel Aviv: Eretz Israel Museum.

Beigel, M. A. (1922). *Gezirah bi-n'yar. omanut ve-umanut be-veit ha-sefer* (Cutting in Paper. Art and Craft in the School). Frankfurt am Main, Moskva; Odessa: Omonuth. (Hebrew).

Belinfante, Judith C. E., and Igor Dubov, eds. (1992–94). *Tracing An-Sky: Jewish Collections from the State Ethnographic Museum in St. Petersburg.* Amsterdam Joods Historisch Museum and St. Petersburg State Ethnographic Museum. Zwolle: Waanders, pp. 47, 52, 75, 84 (#6413-7).

Ben-David, Caleb (1994). "Jewish Papercuts: A History and Guide" (book review). *The Jerusalem Report* (December 29): 49.

Benoschofsky, Ilona, and Alexander Schreiber, eds. (1987). *The Jewish Museum of Budapest.* Budapest: Corvina, p. 219.

Bialer, Yehuda L., and Estelle Fink (1976). *Jewish Life in Art and Tradition.* London: Weidenfeld and Nicolson, Hechal Shlomo, pp. 58, 74.

Bondoni, Simonetta M., and Giolio Busi (1987). *Cultura Ebraica in Emilia-Romagna.* Luisé: Instituto Per i Beni Culturali della Regione Emilia-Romagna, pp. 409, 410–11, 413, 627, 629.

Davidovitch, David (1943). *Migzarot, ma'asseh yedei yosef visnitzer* (Cutouts, the Handwork of Yosef Wisnitzer), with introduction by David Davidovitch. Tel Aviv: Printing Workers Union, four introductory pages. (Hebrew).

——— (1955). *"Ta'arukhat migzarot"* (Exhibition of [Paper]cuts). Tel Aviv: Tel Aviv Museum, Ginza Circle for Popular Jewish Art. (Hebrew).

——— (1960). *"Shavu'ot be-omanut 'ammamit"* (Shavuoth in Folk Art). *Mahanayim* 39: 73–80. (Hebrew).

——— (1972). *Paper Cuts for Shavuoth from the Estate of Dr. Josef Reizes.* Catalog of exhibition, with introductions by David Davidovitch and Giza Frankel. Tel Aviv: Museum Ha-Aretz — Museum of Ethnography and Culture, pp. 6–7; 39–42. (Hebrew and English).

"Decorative Papercuts" (1978). *Ariel* 47: 80–81, 118, and cover. Jerusalem: Cultural and Scientific Relations Division, Ministry of Foreign Affairs.

Doleželová, Jana (1975). "Mizrahs from the Collection of the State Jewish Museum in Prague." *Judaica Bohemiæ* 9, no. 1: 14–28 and photo on back cover.

Eis, Ruth, ed. (1978). *Paper-Cuts by Yehudit Shadur.* Berkeley: Judah L. Magnes Museum of Judaica.

Erella and Azaria Alon (n.d., ca. 1983). *Aleph-beit shel kibbutz* (ABC of Kibbutz), Illustrated with papercuts by Erella, text by Azaria Alon. Tel Aviv: Hakibbutz Hameuhad. (Hebrew).

Frankel, Giza (1929). "Wycinanka żydowska w Polsce" (Papierschnitte bei den Juden in Polen). *Lud* 28. (Polish, German summary).

——— (1955). Introduction to *Ta'arukhat migzarot* (Exhibition of [Paper]cuts). Tel Aviv: Tel Aviv Museum, Ginza Circle for Popular Jewish Art. (Hebrew).

——— (1964). "Jewish Papercuts Rediscovered." *Jewish Chronicle* (Dec. 11): 9; and *Canadian Jewish Chronicle* (Dec. 18).

——— (1965). "Wycinanka żydowska" (Jewish Papercuts). *Polska Sztuka Ludowa* 3: 135–46. (Polish, English summary).

——— (1967). "Paper-Cuts, a Folk Art." *Jewish Heritage* (Washington, D.C.) 10, no. 2 (Fall).

——— (1970). "Découpages en papier juifs," *7ème Congrès International des Sciences Anthropologiques et Ethnologiques, Moscou, 3–10 Août 1964* 7: 84–91.

——— (1971). "Paper-Cuts," in *Encyclopædia Judaica* 13: 44–45, 59–65.

——— (1972). *Paper Cuts for Shavuoth from the Estate of Dr. Josef Reizes*. Catalog of exhibition, with introductions by David Davidovitch and Giza Frankel. Tel Aviv: Museum Ha-Aretz — Museum of Ethnography and Culture, pp. 3–5; 34–38. (Hebrew and English).

——— (1973). "*Migzeret n'yar yehudit bi-tzefon afriqa*" (The Jewish Papercut in North Africa), in *Hayyei ha-yehudim be-maroqo* (Life of Jews in Morocco). Jerusalem: Israel Museum, pp. 58–59. (Hebrew).

——— (1975). "*Shavuoslekh ve-reizelekh — omanut shel shavu'ot*" (Shavuothlakh and Reizalakh — Art of Shavuoth). *Ha-Aretz* supplement, 15 May 1975. (Hebrew).

——— (1976). "Papercuts throughout the World and in Jewish Tradition," in *The Papercut — Past and Present*. Haifa: Ethnological Museum and Folklore Archives (Catalog of Exhibition), pp. 9–7, 26–24. (Hebrew and English).

——— (1983). *Migzarot n'yar. Omanut yehudit 'ammamit* (Paper Cuts. A Jewish Folk Art). Tel Aviv: Massada. (Hebrew).

——— (1996). *The Art of the Jewish Paper-cut; Migzarot n'yar. Omanut yehudit 'ammamit.* Tel Aviv: Modan. (New edition, published posthumously in Hebrew and English).

Gingold, Barbara (Briana Orenstein) (1974). "Roisalech, Shavuoslech and You." *Young Judæan* (April–May): 16–19, and cover.

Gingold, Barbara (1976). "Revival of a Jewish Folk Art." *Hadassah Magazine* 58, no. 9: 17, 38–39, and cover.

——— (1978). "The Paper-Cuts of Yehudit Shadur." *Young Judæan* 66, no. 7: 10–13, and cover.

——— (1980). "Boomazhniye fantazii" (Paper Fantasies). *Tarbut* 1: 145–52. (Russian).

——— (1987). "A Papercut Center." *Hadassah Magazine* 68, no. 9: 56.

Goldberg, Olga (1985). "Dr. Giza Frankel" (with selected bibliography). *Journal of Jewish Art* 11: 78–79.

Goldberg-Mulkewicz, Olga (1984). "*Migzeret ha-n'yar ba-mizrah uva-ma'arav*" (The Papercut in the East and the West). *Pe'amim* 21: 150–53. (Review of Giza Frankel's 1983 book.) (Hebrew).

——— (1985). "*Mehkareha shel giza frankel, zal*" (The Researches of the Late Giza Frankel). *Mehkarei yerushalayim be-folqlor yehudi* (Jerusalem Researches in Jewish Folklore) 8: 99–108. (Hebrew).

——— (1987). "Współczesne Przemiany Tradycyjemej Wycziananki Zydowskiej" (Transformation of the Traditional Jewish Paper Cutout). *Polske Sztuka Ludowa* 41, nos. 1–4: 91–96. (Polish; English abstract, p. 226).

——— (1989). "Przenikanie Elementów Twórczości Ludowej Miedzy Społecznościa Polska i Zydowska" (The Mutual Penetration of Folk Elements between Polish and Jewish Communities). *Polska Sztuka Ludowa* 43, nos. 1–2: 105–12. (Polish; English abstract, p. 141).

Goldenberg, Amy (1994). *Papercutting: Reviving a Jewish Folk Art*. Northvale, N.J.: Jason Aronson.

Goldschmidt, Eddy (1931). *Megillath Esther, die Purimgeschichte für Kinder* (silhouettes by Irma Cohn). Hamburg: Paulinenstift.

Goldstein, Maksymiljan, and Karol Dresdner (1935). *Kultura i Sztuka Ludu Żydowskiego na Ziemiach Polskich. Zbiory Maksymiljana Goldsteina* (Jewish Culture and Folk Art on Polish Soil. Collections of Maksymiljan Goldstein). Łwow: Glowny Ksiegarmach. Reprint, Warszawa: Wydawnictwa Artystyczne i Filmowe, 1991, pp. 44–46, 53, 62, 79, 82, 162. (Polish).

Golnitzki, Heshil (1963). *Bemahzor ha-yamim. Mo'ed va-hol ba-omanut u-ba-folqlor ha-yehudi* (Religious and Secular Customs in Jewish Ceremonial Art and Folklore). Haifa: Jewish Folkore-lovers' Circle, pp. 37–40, 60, pls. 9, 38, 73. (Hebrew; English abstract).

Gonen, Rivka, ed. (1994). *Behazarah la-'ayyarah. An-Sky ve-ha-mishlahat ha-etnografit ha-yehudit 1912–1914. Me-osafei ha-muzeon ha-mamlakhti le-etnografia be-sanqt-petersburg* (Back to the Shtetl. An-Sky and the Jewish Ethnographic Expedition, 1912–1914. From the Collections of the State

Ethnographic Museum in St. Petersburg. Jerusalem: Israel Museum, pp. 64, 106, 141, 144, 146. (Hebrew; English abstracts).

Greenwald, Alice M. (1979). "The *Mizrah* — Compass of the Heart." *Hadassah Magazine* 61, no. 2: 12–13, and cover.

——— (1984). "The Masonic *Mizrah* and Lamp: A Jewish Ritual Art as a Reflection of Cultural Assimilation." *Journal of Jewish Art* 10: 87–101, and cover.

Gross, William L., ed. (1999). *A Mirror of Jewish Life: A Selection from the Moldovan Family Collection*. Tel Aviv: Tel Aviv University, p. 50.

Grossbard, Yehoshua (1970). *Paper-Cuts: Traditional Motives*, with introduction by Giza Frankel. Haifa: private printing.

——— (1983). *Paper-Cuts: Decorative and Traditional Motives, Second Book*, with introduction by Giza Frankel. Haifa: private printing.

Guberman, Jayne Kravetz (1984). *Contemporary Papercuts: Quest for Authenticity*. Paper presented at Living Tradition: Jewish Folk Creativity and Cultural Survival, New Jersey, May 13–15.

——— (1994). *Transformation of a Traditional Folk Art: The Revival of Jewish Papercutting*. Ph.D. Dissertation in Folklore and Folklife. Philadelphia, University of Pennsylvania.

Gur-Arie, Meir (1925). *Ha-halutzim* (The Pioneers). Collection of cut-out silhouettes, folk songs by various poets, with foreword by Mordekhai Narkiss. Jerusalem: Bnei Bezalel. (Hebrew).

——— (1947). *Duda'im* (Mandrakes). Collected silhouettes with children's verses by Miriam Wilensky-Stekelis. Tel Aviv: Penina. (Hebrew).

Haifa Municipality (1959). *Migzeret n'yar yehudit* (Jewish Paper Cut), with introduction by Giza Frankel. Haifa: Ethnological Museum and Folklore Archives. (Hebrew).

——— (1969). *Migzarot n'yar shel ha-tzayar yehoshua' grossbard* (Papercuts of the Artist Yehoshua Grossbard). Catalog of exhibition with introduction by Giza Frankel. Haifa: Ethnological Museum and Folklore Archives. (Hebrew).

——— (1976). *The Papercut — Past and Present*. Catalog of exhibition, with introductions by Dov Noy, Liora Bronstein, and Giza Frankel. Haifa: Ethnological Museum and Folklore Archives. (Hebrew and English).

Hallo, Rudolf (1928). *Jüdische Volkskunst in Hessen. Festschrift der Sinai-Loge zu Kassel*. Kassel, p. 41, plate V (on silhouettes of Jews).

Harel, Sarah (1980). *Jewish Papercuts — Old and New*. Folder of exhibit at the "Tower of David" Citadel in the summer of 1980. Jerusalem: City Museum.

———, ed. (1994). *Otzarot genuzim. Osafei omanut yehudit me-galitziya me-ha-muzeion le-etnografiya u-le-umanuyot be-levov* (Rediscovered Treasures. Judaica Collection from Galicia from the Lvov Museum of Ethnography and Crafts). Exhibition catalog. Tel Aviv: Bet HaTefutzot Diaspora Museum, pp. 6, 38–39, 40, 51. (Hebrew).

——— (1994–95). *Treasures of Jewish Galicia: Judaica from the Museum of Ethnography and Crafts in Lvov, Ukraine*. Tel Aviv: Beth HaTefutzoth, The Nahum Goldmann Museum of the Jewish Diaspora, pp. 62–63, 67, 71 (note 28), 73 (note 59), 75, 79, 80, 136–147, 160, 176–177, 179.

Hebrew Union College (1985). *Mizrah: Compass for the Heart*. Catalog of exhibition at the Brookdale Center, 15 Oct. 1985–14 March 1986, with introduction by Nancy Berman. New York: Hebrew Union College — Jewish Institute of Religion.

Hazen, Tim (1986). "Developing Diversity in Technique." *Papercutting World* 1, no. 2: 5–7 (on Rose Ann Chasman.)

Hoz, Yael (1986). *World Papercuts: Tradition. Art. Craft*. Catalog of exhibition. Haifa: Haifa Museum of Music and Ethnology.

——— (2000). "The Heart and its Variations on Jewish Bookbindings." *First Cut* 13, no. 1 (Winter): 18.

Josephy, Marcia Reines (1986). "Documents and Decorations: The Art of Jewish Papercutting." *Papercutting World* 1, no. 1: 10–16.

Juhasz, Esther [see also under Yohas, Esther] (1989). "*Migzarot n'yar*" (Paper Cuts), in *Yehudei sefarad ba-imperya ha-'othmanit* (The Jews of Spain in the Ottoman Empire), ed. Esther Juhasz. Jerusalem: Israel Museum, pp. 238–53 and see also two *ketubot* with cut-paper appliqué compositions, plate 51. (Hebrew).

——— (1989–90). "Paper-Cuts," in *Sephardi Jews in the Ottoman Empire: Aspects of Material Culture*, ed. Esther Juhasz. Jerusalem: Israel Museum, pp. 238–53, 222–23.

Kahane, Ruth (1977). "Folk-Art of Paper-Cutting." *The Canadian Jewish News* (Toronto), 16 Dec. 1977.

Kaniel, Michael (1979). *Judaism*. The Art of World Religion Series. Poole: Blandford, pp. 58–59, 62–65, etc., and see photo opp. p. 58.

Katz, Elias (1966). "Eine Misrachtafel." *Judaica Bohemiæ* 2, no. 1: 41–55.

Kerp-Schlesinger, Irma G. (1977). "Joods Knipwerk," in *Leer Knippende Zien*. de Bilt: Cantecleer, pp. 86–90, 106. (Dutch).

——— (1979). "Jüdische Scherenschnitte," in *Scherenschnitte*. Ravensburg: Otto Maier, pp. 94–102, 120.

Kleeblatt, Norman L., and Gerard C. Wertkin (1984). *The Jewish Heritage in American Folk Art*. Catalog of exhibition at the Jewish Museum and Museum of American Folk Art, with introductions by Robert Bishop and Joan H. Rosenbaum, and an essay by Mary Black. New York, pp. 26–27, 39–40, 45, 49, 51, 53, 54–55, 57, 59, 64, 71, 74, 88, 90–91, 98–99, 102–103, 115.

Kurz, Otto (1972). "Libri cum characteribus ex nulla materia compositis." *Israel Oriental Studies* 2: 240–47.

Landsberger, Franz (1955). "Illuminated Marriage Contracts," *Hebrew Union College Annual* 26: 503–42. Reprinted in Joseph Gutmann, ed., *Beauty in Holiness*. New York: Ktav, 1970, pp. 370–413, and see especially pp. 381–82.

Lasky, Julie (1994). "Following a Paper Trail Winding Through the Ages" (book review). *Forward* 12 (August): 9–10.

Lilientalowa, Regina (1908). *Święta Żydowskie w Przeszłości i Teraźniejszości* (Jewish Holidays in the Past and the Present). Krakow: Nakladam Akademii Umiejetności (reproductions of Jewish papercuts are appended to the text). (Polish).

London, Hannah Ruth (1970). *Miniatures and Silhouettes of Early American Jews; Combining the Two Volumes, Miniatures of Early American Jews and Shades of My Forefathers*. Rutland: Tuttle. Reprinted from the original editions, Springfield 1941 and 1953.

Mann, Vivian B., and Richard I. Cohen (1996). *From Court Jews to the Rothschilds: Art, Patronage, and Power 1600–1800*. Munich & New York: Prestel, p. 192.

Marach, Ines Miriam, Antonio Pirazzini, and Micaela Vitale (1994). *Ebrei a Lugo. I Contratti Matrimoniali*. Introduction by Shalom Sabar. Lugo: Galeati, pp. 21, 42–43, 48–49, 50–51, 52–53, 60–61, 70–71, 72–73, 106–12, 122–23, 125–26. (Italian).

Metken, Sigrid (1978). "Misrachtafeln und Leluje aus Polen," in *Geschnittenes Papier*. München: Callwey, pp. 201–202, 218–20.

Museum Ha-Aretz (1972). *Paper Cuts for Shavuoth from the Estate of Dr. Josef Reizes*. Catalog of exhibition, with introductions by David Davidovitch and Giza Frankel. Tel Aviv: Museum Ha-Aretz — Museum of Ethnography and Culture. (Hebrew and English).

Narkiss, Mordekhai (1944). "*Ḥittuv n'yar yehudi*" (Jewish Paper Carving), in *Ofaqim le-ḥinukh u-le-tarbut* (Horizons for Education and Culture). Tel Aviv: Sifriyat Poalim, pp. 28–34. (Hebrew).

Neeman, Jacob (1983). *Jewish Paper-Cuts*. With introduction by Bezalel Narkiss. Haifa: private printing.

Noy, Dov (1986). "*Trumat giza frankel le-ḥeker ha-tarbut ha-'ammamit shel yehudei polin*" (The Contribution of Giza Frankel to the Study of the Popular Folk Culture of the Jews of Poland). *Proceedings of the Ninth World Congress of Jewish Studies*, Div.D 2: 49–54. (Hebrew).

Pařík, Arno (1980). "Die Bildersammlung." *Judaica Bohemiæ* 1, no. 16: 75–78, and photo #24.

Piercy, Marge (1999). "Snowflakes, my mother called them," in *The Art of Blessing the Day: Poems with a Jewish Theme*. New York: Knopf, pp. 9–10.

Rakitin, Vasilii and Andrei Sarabianov, eds. (1994). *An-Sky, Semyon: The Jewish Artistic Heritage*. Introductory article by Abram Efros, text and commentary by Alexander Kantsedikas. Moscow: RA, p. 45.

Reizes, Josef (1924). "Jüdische Volkskunst." *Das Zelt* (Wien) 2: 51–53, 77–78.

Riemer, Jack (1994). "'Jewish Papercuts' is a Work of 'Art'" (book review). *South Florida Jewish Journal* (October).

Ronnen, Meir (1980). "Cutting Out Judaica." *The Jerusalem Post Magazine*, 4 July 1980, pp. 1, 3, N.

Sabar, Shalom (1986/87). "The Beginnings of *ketûbbah* Decoration in Italy: Venice in the Late Sixteenth to the Early Seventeenth Centuries." *Jewish Art* 12/13: 96–110.

——— (1990). *Ketubah: Jewish Marriage Contracts of the Hebrew Union College Skirball Museum and Klau Library*. Philadelphia: Jewish Publication Society, pp. 62, 99, 114–16.

——— (1993). *Mazal Tov: Illuminated Jewish Marriage Contracts from the Israel Museum Collection*. Jerusalem: Israel Museum.

——— (1994/95). "Domestic Wall Decorations and Folk Papercuts," in *Treasures of Jewish Galicia: Judaica from the Museum of Ethnography and Crafts in Lvov, Ukraine*, ed. Sarah Harel-Hoshen. Tel Aviv: Beth HaTefutzoth, The Nahum

Goldmann Museum of the Jewish Diaspora, pp. 136–47.

Sadan, Dov (1959). "*Le-darko shel minhag shavu'ot: ha-shoshantonet*" (The Way of a Shavuoth Custom: The Little Rosette). *Maḥanayim* 39: 73–80. (Hebrew).

Samuely, Nathan (1892). *Das Rosele. Kulturbilder aus dem jüdischen Leben in Galizien.* Prag: J. B. Brandeis.

Schüler, Irmgard (1938). "Purimschmuckblatt vom 18 Jahrhundert." *Jüdisches Gemeindeblatt* (Berlin) 28, no. 11: 5.

Segel, Benjamin Wolf (1892). "Roiselech und Fahnen der Galizischen Juden." *Globus* (Braunschweig) 65, no. 15.

Shachar, Isaiah (1971). *Osef feuchtwanger. masoret ve-omanut yehudit* (The Feuchtwanger Collection. Jewish Tradition in Art). Jerusalem: Israel Museum, pp. 52, 53–54, 56, 57, 58, 235–36. (Hebrew).

——— (1981). *Jewish Tradition in Art: The Feuchtwanger Collection of Judaica.* Jerusalem: Israel Museum, figs. 110, 112, 114, 783; pp. 50, 52, 244–46.

Shadur, Joseph and Yehudit Shadur (1990/91). "Three Papercuts from Jerusalem." *Jewish Art* 16/17: 6–11.

——— (1994). *Jewish Papercuts: A History and Guide.* Berkeley: Judah L. Magnes Museum; Jerusalem: Gefen.

Singer, Suzanne F. (1986). "Paper-Cuts — An Ancient Art Form Glorifies Biblical Texts." *Bible Review* 2, no. 2: 28–35.

Soltes, Ori Z. (1994). "A Jewish Craft, Lost and Found" (book review). *Moment* (October): 99.

Spamer, Adolf (1930, reprint 1980). *Das Kleine Andachtsbild vom XIV bis zum XX Jahrhundert.* München: Bruckman, p. 203.

Tal, Miriam (Yoram) (1959). "*Moshe reifer, mevasser ha-tziyur ha-dimyoni*" (Moshe Reifer, Harbinger of Fantastic Art). *Hed Ha-Defuss* (Teveth 5719) 12. (Hebrew).

Tel Aviv Museum (1955). *Ta'arukhat migzarot* (Exhibit of Cuts). Catalog of exhibition with introduction by Giza Frankel. Tel Aviv: Ginza Circle for Jewish Art. (Hebrew).

Ungerleider-Mayerson, Joy (1986). *Jewish Folk Art from Biblical Days to Modern Times.* New York: Summit, pp. 73–74, 75–76, 80, 86, 90, 100–101, 103, 174, 239, 243, 244, 245.

Verhave, Joke and Jan Peter Verhave (1994). "Jewish Papercuts" (book review). *Knip-pers* 11, no. 3 (September): 3–7, & back cover. (Dutch).

Wachtel, Lillian (1983). "The Exquisite Art of Jewish Papercutting." *Reform Judaism* 11 no. 2: 24–25.

Waletzky, Tsirl (1989). "The Language of Art." *Sh'ma', A Journal of Jewish Responsibility* 19, no. 371: 75–76.

Weinreich, Uriel (1954). "Paper Cutouts from Eastern Galicia." *Yiddishe Folklor* 12 (January). (Yiddish; English summary).

Weyl, Robert, Freddy Raphael, and Martine Weyl (1977). *L'imagerie populaire juive en Alsace.* Cahier 4. Pfaffenhoffen: Musée de l'imagerie peinte et populaire alsacienne de Pfaffenhoffen, p. 2 of text, no. 5.

Wischnitzer-Bernstein, Rachel (1936). "*A shir-ha-malosl in berliner yiddishen muzei*" (A Shir-ha-malosl in the Berlin Jewish Museum). *Heften far yiddisher kunst.* Vilno: YIVO 1 (Nov.–Dec.): 14–16. (Yiddish).

Wisniewski, David (1996). *Golem.* New York: Clarion Books.

Wisnitzer, Yosef (1943). *Migzarot, ma'asseh yedei yosef visnitzer* (Cutouts, the Handwork of Yosef Wisnitzer). With introduction by David Davidovitch. Tel Aviv: Printing Workers Union.

Yaniv, Brakha (1979). *Migzeret ha-mizrah — 'avodah seminaryonit "be'ayot be-ḥeker ha-yetzirah ha-omanutit ha-ḥazutit"* (The Cut Mizraḥ — Seminar Paper in the Problems of Studying Representational Folk Creations). Jerusalem: Hebrew University. (Hebrew).

——— (1982). "*Migzeret ha-mizrah*" (The Cut Out Mizraḥ). *Meḥqarei yerushalayim be-folqlor yehudi* (Jerusalem Researches in Jewish Folklore) 4: 105–11 and 4 plates. (Hebrew).

Yeshiva University Museum (1974). *The Giving of the Law: Sculptures by Hanna Geber and 19th C. Jewish Folk Art Papercuts for Shavuoth.* New York: Yeshiva University.

——— (1977). *Papercuts: A Contemporary Interpretation by Tsirl Waletzky's Work.* Exhibition catalog with introduction by Janet Blatter Warman. New York: Yeshiva University.

Yohas, Esther [see also under Juhasz, Esther] (1989). "Battles Between Pen and Scissors." *Art in Israel* 1, no. 3: 6–10.

Ziasewa, L., and B. Shangina (1969). "*Yiddishe kolektzies inem leningrader etnografishen muzei*" (Jewish Collections in the Leningrad Ethnographic Museum). *Sovetish heimland* 1: 147–48. (Yiddish).

Ashkenazi, Eliezer (of Poland), ed. (1849). *Sefer divrei ḥakhamim* (Book of the Sayings [Acts] of the Sages). Metz: J. Mayer Samuel, 70: 47–55. (Hebrew).

Barash, Moshe (1988). "Reflections on Tombstones: Childhood Memories," in *Artibus et Historiae* (In honor of Rachel Wischnitzer), ed. Józef Garbski and Vivian B. Mann, 17, no. 9: 127–35.

Bialer, Yehuda L. (1967). "Symbols in Jewish Art and Tradition." *Ariel* 20: 4–16, 21: 5–22.

Breier, Alois, Max Eisler, and Max Grünwald (1934). *Holzsynagogen in Polen*. Reprinted Tel Aviv: Sohar (n.d.), pp. 39, 54–60, and appendix pp. 1–23.

Cohen, A. (1949). *Everyman's Talmud*. New York: Dutton.

Cohen, C. (1896). *Geschichte des Einhorns*. Berlin.

Danin, Avinoam (1984). "The Seven-Branched 'Menorah', Apples of the Cretans, and the Isle of Caphtor." *Israel — Land and Nature* 10, no. 1: 27–29.

Davidovitch, David (1968). *Tziyurei qir be-vatei knesset be-polin* (Wall Paintings in Synagogues in Poland). Jerusalem: Bialik Institute. (Hebrew).

Davis, Eli, and Elise Davis (1977). *Jewish Folk Art over the Ages: A Collector's Choice*. Jerusalem: Rubin Mass.

Diamant, Max (1937). *Jüdische Volkskunst*. Wien und Jerusalem: R. Löwit (on tombstones in the Czernowitz cemetery).

Dutton, Denis (1983). *The Forger's Art: Forgery and the Philosophy of Art*. Los Angeles: University of California.

Encyclopædia Judaica (1972). Jerusalem: Keter.

Feliks, Jehuda (1962). *The Animal World of the Bible*. Tel Aviv: Sinai.

Ferguson, George (1966). *Signs and Symbols in Christian Art*. New York: Galaxy.

Fisher, Yonah, ed. (1979). *Omanut ve-umanut be-eretz-yisra'el ba-me'ah ha-yod-tet* (Arts and Crafts in the Land of Israel in the Nineteenth Century). Jerusalem: Israel Museum. (Hebrew).

Frankel, Ellen, and Betsy Platkin Teutsch (1992). *The Encyclopedia of Jewish Symbols*. Northvale, N.J.: Jason Aronson.

Gibert, Soledad (1973). "Variadades sobre Otto Kurz: 'Libri cum characteribus ex nulla materia compositis'." *Al Andaluz* 38: 243–47.

Ginzberg, Louis (1909). *The Legends of the Jews*. Philadelphia: Jewish Publication Society.

Goberman, D. (1993). *Jewish Tombstones in Ukraine and Moldova*. Masterpieces of Jewish Art. Moscow: Image. (English and Russian).

Goldstein, David (1987). *Jewish Mythology*. Twickenham: Hamlyn.

Goodenough, Erwin R. (1954–1968). *Jewish Symbols in the Greco-Roman Period*. New York: Pantheon.

Grassi, Liliana et al. (1984). *Italian Ketubot: Illuminated Jewish Marriage Contracts*. Milan: Amici dell'Universita di Gerusalemme.

Gutmann, Joseph (1969). "Leviathan, Behemoth and Zis: Jewish Messianic Symbols in Art," in *Hebrew Union College Annual*. Cincinnati: Hebrew Union College — Jewish Institute of Religion, pp. 219–30.

———, ed. (1970). *Beauty in Holiness*. New York: Ktav.

——— (1983). *The Jewish Sanctuary*. Iconography of Religions 23, no. 1. Leiden: Brill.

Hareuveni, Noga (1980). *Nature in our Biblical Heritage*. Kiryat Ono: Ne'ot Kedumim.

Huberman, Ida (1986). "The Double-Headed Eagle." *Proceedings of the Ninth Congress of Jewish Studies*, Div.D 2: 45–51.

——— (1988). *Living Symbols: Symbols in Jewish Art and Tradition*. Tel Aviv: Massada.

Hubka, Thomas C. (1996). "*Beit ha-kenesset be-gwozdziec — sha'ar shamayim: hashpa'at sefer ha-zohar 'al ha-amanut ve-ha-adrikhalut*" (The Gwozdziec Synagogue — Heavenly Gate: The Influence of the Book of Zohar on Art and Architecture), in *Eshel Beer-Sheva*, vol. 4 (Myth in Judaism), ed. Ḥavivah, Pedayah, pp. 263–316. (Hebrew).

——— (1997). "Jewish Art and Architecture in the East European Context: The Gwoździec–Chodorów Group of Wooden Synagogues." *POLIN* 10: 141–82.

Idel, Moshe (1999). "*Binah*, the Eighth *Sefirah*: The Menorah in the Kabbalah," in *In the Light of the Menorah: Story of a Symbol*, ed. Yael Israeli. Jerusalem: Israel Museum, pp. 142–46.

Israeli, Yael, ed. (1999). *In the Light of the Menorah: Story of a Symbol*. Jerusalem: Israel Museum.

Jackson, Nevill Emily (1911). *The History of Silhouettes*; London: The Connoisseur.

——— (1938). *Silhouettes: Notes and Dictionary*. London: Methuen.

Juhasz, Esther (1999). "The Amuletic Menorah:

The Menorah and Psalms 67," in *In the Light of the Menorah: Story of a Symbol*, ed. Yael Israeli. Jerusalem: Israel Museum, pp. 147–51.

The Jewish Encyclopedia (1902). New York: Funk & Wagnalls.

Kampf, Avram (1978). "In Quest of the Jewish Style in the Era of the Russian Revolution." *Journal of Jewish Art* 5: 48–75.

Kanof, Abraham (1969). *Jewish Ceremonial Art and Religious Observance*. New York: Abrams.

——— (1990). *Jewish Symbolic Art*. Jerusalem and Woodmere, N.Y.: Gefen.

Kayser, Stephen S. (1959). *Jewish Ceremonial Art*. Philadelphia: Jewish Publication Society, pp. 9–21, and see photo p. 161.

Klagsbald, Victor (1997). *A l'ombre de Dieu: dix essais sur la symbolique dans l'art juif*. Louvain: Peeters.

——— (1997). "La Menorah et le vêtement de Dieu," in *A l'ombre de Dieu: dix essais sur la symbolique dans l'art juif*. Louvain: Peeters.

Krajewska, Monika (1983). *Time of Stones*. With introduction by Anna Kamienska. Warsaw: Interpress.

——— (1989). "Symbolika Płaskorzeźb na Cmentarzach Zydowskich w Polsce" (Symbolism of Reliefs in Jewish Cemeteries in Poland). *Polska Sztuka Ludowa* 43, nos. 1–2: 45–59. (Polish; English abstract on pp. 140–41).

Landsberger, Franz (1969). "Old-Time Torah Curtains." *Central Conference of American Rabbis Journal* (Jan.): 149ff; and in Joseph Gutmann (1970). *Beauty in Holiness*. New York: Ktav, pp. 122–63.

Lissitzky, El(iezer) (1923). "*Vegen der mohilever shul*" (On the Mohilev Synagogue). *Milgroim* 3: 9–13. (Yiddish).

Loukomski, George K. (1947). *Jewish Art in European Synagogues*. London: Hutchinson. (Photo of papercut, p. 177.)

Malkin, M., and S. Yudovin (1920). *Idisher folqs-ornament* (Jewish Folk Decoration). Vitebsk: Y. L. Peretz Association. (Yiddish). Reprinted Tel Aviv, 1970, with introduction by David Davidovitch. (Hebrew).

Mellinkoff, Ruth (1974). "The Round-Topped Tablets of the Law: Sacred Symbol and Emblem of Evil." *Journal of Jewish Art* 1: 28–43.

Metzger, Mendel (1976). "Style in Jewish Art of the 17th and 18th Centuries in Relation to the Baroque and the Rococo." *Gazette des Beaux Arts* (Nov.): 181–93, and separate introduction.

Millgram, Abraham E. (1971). *Jewish Worship*. Philadelphia: Jewish Publication Society of America.

Petrášová, Markéta (1988). "Collections of the Central Jewish Museum (1942–1945)." *Judaica Bohemiae* 1, no. 24: 23–38.

Posner, Raphael, Uri Kaploun, and Shalom Cohen, eds. (1975). *Jewish Liturgy: Prayer and Synagogue Service Through the Ages*. Jerusalem: Keter.

Rowidowicz, S., ed. (1974). *Moses Mendelssohn. Schriften zum Judentum I*, vol. 7. Stuttgart.

Sabar, Shalom (1984). "The Use and Meaning of Christian Motifs in Illustrations of Jewish Marriage Contracts in Italy." *Journal of Jewish Art* 10: 47–63.

Sadek, Vladimïr (1980). "From the Documents Related to the War Time Central Jewish Museum in Prague." *Judaica Bohemiae* 1, no. 16: 5–8.

Schachar, Jesaia (1960). *Melakhat ha-arig ha-yehudit. Jewish Textiles*. Jerusalem: Bezalel National Museum. (Hebrew and English, but texts not the same.)

Scholem, Gershom G. (1965). *On the Kabbalah and its Symbolism*. New York: Schocken.

Schreiber, Adèle (1997). *Einhörningen; Djuret som ingen skådat men många skildrat* (The Unicorn: An Animal Never Seen but Much Portrayed). Stockholm: Carlssons. (Swedish).

Schrire, Theodore (1966). *Hebrew Amulets: Their Decipherment and Interpretation*. London: Routledge & Kegan Paul.

Shepard, Sanford, ed. (1987). *Shem Tov, His World and His Words*. Miami: Ediciones Universal.

Volavková, Hana (1966). *Schicksal des Jüdischen Museums in Prag*. Praha: Artia.

Werblowsky, R. J. Zwi, and Geoffrey Wigoder (1965). *The Encyclopedia of the Jewish Religion*. New York: Holt, Rinehart & Winston.

Wischnitzer-Bernstein, Rachel (1935). *Gestalten und Symbole der Jüdischen Kunst*. Berlin: Scholem.

——— (1966). "Judaism and Art," in *The Jews*, 3d. ed., vol. 2, ed. Louis Finkelstein. Philadelphia: Jewish Publication Society, pp. 1322–48.

Yaniv, Bracha, (1989). "The Origins of the 'Two-Column Motif' in European Parokhot." *Jewish Art* 15: 26–43.

Yaniv, Bracha, Zohar Hanegbi, and Shalom Sabar (1988). *Hebrew Inscriptions and their Translations*. Jerusalem Index of Jewish Art, Survey of Synagogues. Jerusalem: Hebrew University Centre for Jewish Art. (Hebrew and English).

Yarden, L. (1971). *The Tree of Light: A Study of the Menorah — the Seven-Branched Lampstand*. London: East and West Library.

Yeshiva University Museum (1979). *See and Sanctify: Exploring Jewish Symbols*. New York: Yeshiva University.

Yevreyskaya Entsiklopediya (Jewish Encyclopedia) (1906–1913). St. Petersburg: Institute for the Publication of Jewish Studies & Brockhaus-Efron. (Russian).

Zobrowski, Mark, and Elizabeth Herzog (1952). *Life is with People: The Jewish Little-Town of Eastern Europe*. New York: International Universities Press.

ACKNOWLEDGMENTS

Many persons have helped with this book, among them old friends, and others with whom ties of friendship formed out of their involvement. Our debt of gratitude extends to scholars, experts, museum curators, owners of papercuts, skilled art photographers, artists working in the papercutting medium, and to individuals and foundations that have provided financial support. All have enriched us with their knowledge, understanding, and generosity. Many of them, caught up in the excitement of rediscovering some long-forgotten Jewish papercut, provided important leads that set us off on new, sometimes unsuspectedly rewarding tracks. We list them here in alphabetical order and apologize for any unintentional omissions:

The late Tzvi Aldouby (Tel Aviv); American Jewish Historical Society — the late Nathan M. Kaganoff (Waltham, Mass.); Batya Apollo (Kibbutz Gonen); Miriam Atlas (Jerusalem); Ami Brown (Tel Aviv); British Museum, Dept. of Prints and Drawings (London); the late Jerry Cohen (Teaneck, N.J.); Yeraḥmiel Cohen (Jerusalem); Paul Dahan (Brussels); Esther and Michael Davidson (New York); Zusia Efron (Jerusalem); Michael Ehrenthal (New York); Yitzḥaq Einhorn (Tel Aviv); Eretz Israel Museum Ethnography and Folklore Pavilion — Nitza Behruzi (Ramat Aviv); Allen Field (Larchmont, N.Y.); Avraham Frank (Jerusalem); Barbara Gingold (Jerusalem); Saul and Shirley Gladstone (Amherst, Mass.); Jewish and Comparative Folklore Department, Hebrew University — Olga Goldberg-Mulkiewicz and Gabriela Rabi (Jerusalem); Adina and Yitz Gordon (Englewood, N.J.); Yitzhak Greenfield (Jerusalem); William L. Gross (Ramat Aviv); Cissy Grossman (Irvington, N.Y.); Haifa Museum — Ron Hillel; Penina Halevi (Kibbutz Ḥatzor-Ashdod); Abraham Halpern (New York); Sarah Harel-Hoshen (Tel Aviv); Harvard College Widener Library, Judaica Division — Charles Berlin (Cambridge, Mass.); Hashefela Museum — Moshe Israel (Kfar Menaḥem); Hebrew Union College Skirball Museum — Grace Cohen-Grossman, Tal Gozani, and Suzanne Kester (Los Angeles); Hispanic Society of America (New York); IBM Art Collection — Gloria Sullivan (Armonk, N.Y.); Freda Howitt (Jerusalem); Islamic Museum — Rina Ofek (Jerusalem); Israel Museum Judaica Department — Iris Fishoff, Daisy Raccah-Djivre, and Edna Basud (Jerusalem); Israel Museum Library — Naama Meron (Jerusalem); Israel Museum Visual Resources Department — Amalyah Keshet and Tanya Zhilinsky (Jerusalem); Jewish Museum — Claudia Nahson and Barbara Treitel (New York); Jüdisches Museum der Schweiz — Katia Guth-Dreyfus and Suzanne Benewitz (Basel); Jüdisches Museum Wien — Gabriele Kohlbauer-Fritz and Christa Prokisch (Vienna); Imrich Kónya (Prešov, Slovakia); Monika and Stanislaw Krajewski (Warsaw); Itala Laba (Jerusalem); Evelyn Landsberg (Erie, Penn.); Naftali Lifschitz (Haifa); Mishkan le-Omanut — Galya Bar Or and Ayala Oppenheimer ('Ein Ḥarod); Musée Alsacien — Malou Schneider (Strasbourg); Musée d'Art et d'Histoire du Judaisme — Laurence Sigal and Odile Lemonnier (Paris); Musée Juif de Belgique — Daniel Dratwa and Zahava Seewald (Brussels); Múzeum zidovskej kultúry — Pavol Mešťan and Katarína Kušanová (Bratislava); Schweizerisches Museum der Kulturen — Dominik Wunderlin (Basel); Ruth Nathan and Edgar Nathan III (New York); Alan Paris (Jerusalem); Rabbi Norman R. Patz (Cedar Grove, N.J.); the late Hans Peskens (Bossum, Holland); Fred Raphael (Strasbourg); Stella Rebhuhn (Haifa); Zina and Menahem Regev (Jerusalem); Shalom Sabar (Jerusalem); Judith Sharon (Jerusalem); Daniel Sperber (Jerusalem); Itzhak Sperling (Gent); Spertus Museum of Judaica — Olga Weiss (Chicago); Molly and Manny Steinberg (Los Angeles); Simche Stern (Jerusalem); Michael Strassfeld (New York); M. E. Szapiro (Paris); Temple Anshe Hesed (Erie, Penn.); Temple B'rith Kodesh — Sue Klein and Blanche Pelton (Rochester, N.Y.); Topkapı Sarayi Müzesi — Filiz Çagman (Istanbul); Edward Tuck (New York); Joke and Jan Peter Verhave (Malden, Holland); Lee K. Vorisek (Metairie, La.); Sidie Weiskopf (New York); Weizmann Archives — Meirav Segal (Reḥovot); Westfries Museum — Tonny Jurriaans (Hoorn, Holland); the late Robert Weyl (Strasbourg); David

H. Wice (Philadelphia); Ruth Winston-Fox (London); Wolfson Museum, Hechal Shlomo — Brakha Yaniv (Jerusalem); Ḥava Yaʻari (Jerusalem); Yeshiva University Museum — Sylvia Hershkowitz and Bonni-Dara Michaels (New York); Židovské Muzeum v Praze — Michaela Hájková, Olga Sixtová and Štěpán Kovařik (Prague).

We also want to single out the talented photographers — Ran Erde, David Harris, Robert E. (Bob) Mates, Zev Radovan, and Vladimir Vinitzky — upon whose skills we made impossible demands to conjure up maximal contrasts and sharpness from old, faded, occasionally fly-specked original papercuts. They took up the challenge willingly, sparing no effort to ensure the best possible results.

The maps were drawn by Robert C. Forget (Dorchester, Mass.).

PHOTO CREDITS AND COPYRIGHTS:

The individual photographers listed below (followed by the figure numbers) supplement the photographic services of the museums and institutions indicated in the captions to the relevant illustrations. The photographic material in this book is protected under copyright of all the museums, institutions, and private owners who allowed reproduction of their holdings.

Douglas L. Burg (Sioux City): 4.31; Lilo Caster (Los Angeles): 4.13, 4.30b, 9.1; Mikuláš Červeňanský (Bratislava): 5.20; Debbie Cooper (Jerusalem): 9.0; Paul Dahan (Brussels): 2.24c; Frank J. Darmstaedter (New York): 2.25; Ran Erde (Tel Aviv): 2.18, 3.15b, 3.21, 3.31, 5.5, 5.6, 6.9, 8.4, 8.8b; Mark Fainstein (Erie, Penn.): 4.10; John R. Forsman (Los Angeles): 4.25; Barbara Gingold (Jerusalem): 2.24a, 7.9a; Mario Goldman (Paris): 4.22a; William L. Gross (Ramat Aviv): 4.21b; Yaakov Harlap (Jerusalem): 7.13a, 7.13b; David Harris (Jerusalem): 3.7, 3.15a, 3.27, 3.30, 3.41, 4.1, 4.3, 4.5b, 4.6, 5.2, 5.3, 5.27, 8.7b, R-2b; Avraham Hay (Herzliya): I-1; Sigal Kolton (Tel Aviv): 5.8, 8.2; Monika Krajewska (Warsaw): 5.10, 5.13; Robert E. Mates (Englewood, N.J.): 2.2, 3.25, 3.33, 3.38, 4.16, 4.17, 5.12, 5.16, 6.3, 8.1a, R.1; John Parnell (New York): 2.25, 2.36, 4.29; the late Hans Peskens (Bossum): 2.33; the late Yaʻaqov Pinkerfeld (Tel Aviv): 2.43, 4.21a; Zev Radovan (Jerusalem): 3.6, 3.22, 3.23b, 3.24, 4.11, 4.12a, 4.12b, 4.15a, 4.19, 4.20, R-0; Foto Sadeh (Haifa): R-2a; Joseph Shadur (Jerusalem): 1.12, 1.13a, 1.13b, 1.20, 1.23a, 2.21, 3.28, 3.39, 5.9a, 5.9b, 5.17, 7.6a, 7.6b, 7.11a, 7.11b, 8.3c, 9.4; Sotheby's (New York): 4.27; Grant Taylor (New York): 4.24; Oskar Tauber (Haifa): 7.10a, 7.10b; Vedel (Copenhagen): 4.14; Vladimir Vinitzky (Paris): 2.4, 3.2, 3.26, 9.2; D. Widmer (Basel): 3.11b, 3.29b; Robert Zinck (Boston): 3.23a.

INDEX

NOTE: Names, terms, and words that appear on almost every page of the text and captions (e.g., Central and Eastern Europe, menorah, *mizrah*, *shiviti*, etc.) are not included in this index. Notes are indexed by chapter and note number. For instance, "n2/12" refers to note 12 in chapter 2.

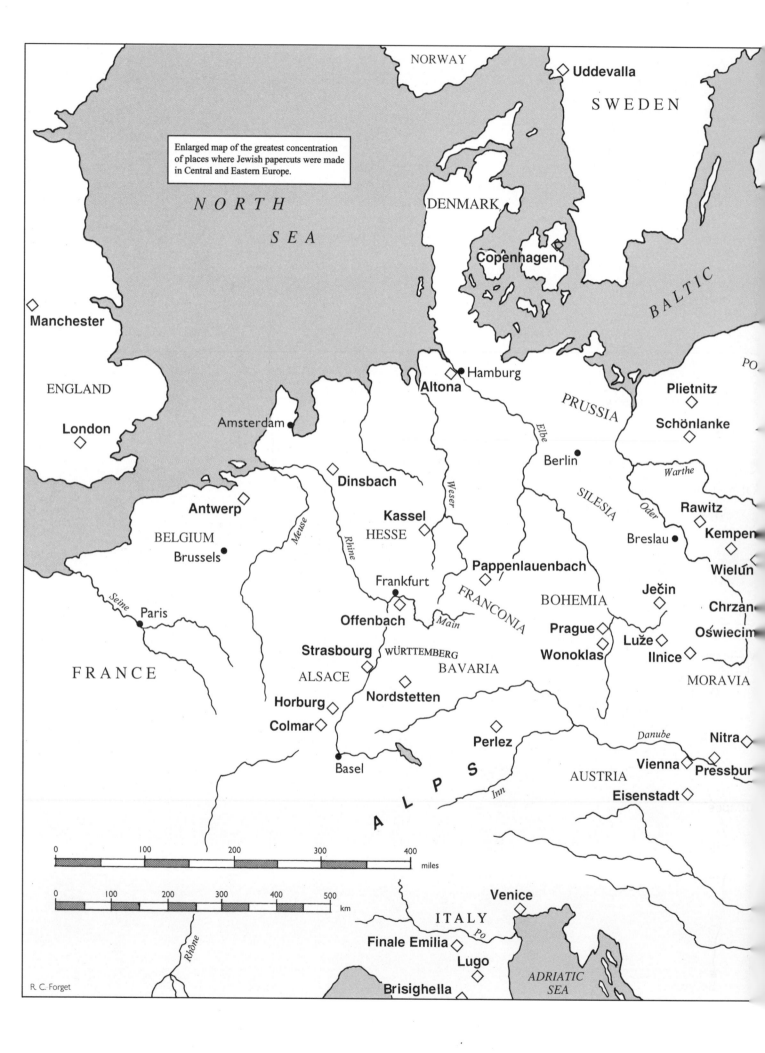

Enlarged map of the greatest concentration
of places where Jewish papercuts were made
in Central and Eastern Europe.

NORTH

SEA

NORWAY

SWEDEN

Uddevalla

DENMARK

BALTIC

Copenhagen

Manchester

ENGLAND

London

Hamburg

Altona

PRUSSIA

Plietnitz

Schönlanke

Amsterdam

Dinsbach

Elbe

Weser

Berlin

Warthe

SILESIA

Oder

Rawitz

Antwerp

Kassel

HESSE

Breslau

Kempen

BELGIUM

Brussels

Meuse

Rhine

Pappenlauenbach

Wieluń

Frankfurt

BOHEMIA

Ječin

Chrzan

Seine

Offenbach

Main

FRANCONIA

Prague

Luže

Oświecim

Paris

Wonoklas

Ilnice

Strasbourg

WÜRTTEMBERG

BAVARIA

FRANCE

ALSACE

Nordstetten

MORAVIA

Horburg

Colmar

Perlez

Danube

Nitra

Basel

Inn

Vienna

Pressbur

AUSTRIA

A L P S

Eisenstadt

0 100 200 300 400
miles

0 100 200 300 400 500
km

Rhône

Venice

ITALY

Po

Finale Emilia

Lugo

ADRIATIC

SEA

Brisighella